FRANK W. BENSON

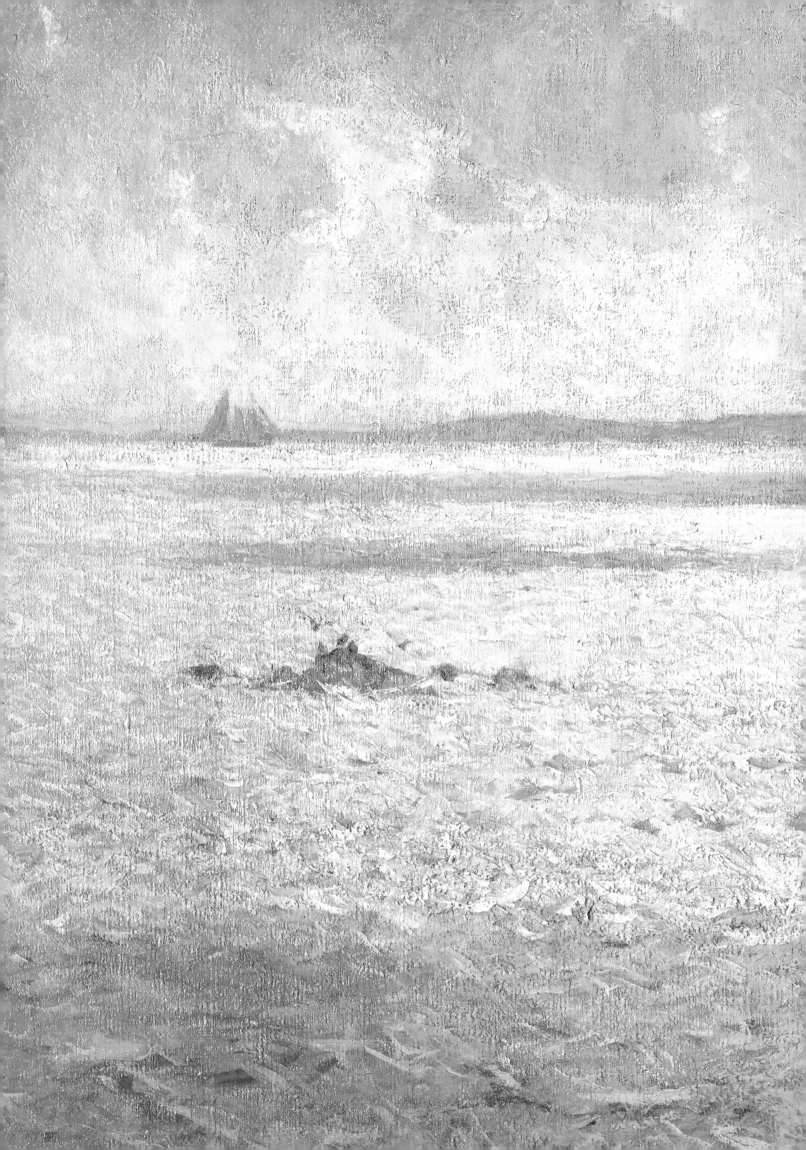

FRANK W. BENSON
American Impressionist

FAITH ANDREWS BEDFORD

RIZZOLI
NEW YORK

To the memory of my mother, Joan Lawson Andrews
—F.A.B.

Pages 2–3: *Shimmering Sea*, detail of plate 84.

First published in the United States in 1994 by Rizzoli International
Publications, Inc., 300 Park Avenue South, New York, New York, 10010

Reprinted 2002

Book and jacket design by Abigail Sturges
Supervising editor: Charles Miers
Editor: Elizabeth Kugler
Compositor: Rose Scarpetis

Library of Congress Cataloging-in-Publication Data

Bedford, Faith Andrews.
Frank W. Benson : American impressionist / Faith Andrews Bedford.
 p. cm.
 Includes bibliographical references and index.
 ISBN 0-8478-1609-5
 1. Benson, Frank Weston, 1862–1951—Criticism and interpretation.
2. Ten American Painters (New York, N.Y.)—Membership. 3. Impressionism
(Art)—United States. I. Benson, Frank Weston, 1862–1951. II. Title.
ND237.B4595B44 1994 94-4638
759.13—dc20 CIP

Printed in Italy

PHOTOGRAPH CREDITS

All photographic material was obtained directly from the institutions
or owners indicated in the captions except for the following:

The author: frontispiece, plates 3, 7, 9, 10, 15, 25, 33, 48, 72, 86, 91, 95, 106, 113,
121, 122, 126, 141.
American Art Search: plate 107.
Babcock Galleries: plate 84.
Berry-Hill Galleries, Inc. (Helga Studios, photographer): plates 1, 4, 5, 8, 11, 13, 15,
16, 18, 27, 35, 36, 44, 50, 56, 70, p. 10, 79, 81, 87, 93, 96, 100, 101, 102, 106, 108, 110,
114, 117, 120, 123, 124, 126, 127, 128, 129, 131, 134, 135, 136–139, 141, 143–148.
Coe-Kerr Gallery: plate 134.
Essex Institute: 2, 39, 51, 64, 77, 103.
Fine Arts Museums of San Francisco: plate 69.
Gerold Wunderlich & Co.: plates 47, 94, 136.
M. R. Schweitzer Gallery: plates 45 and 82.
Edward and Deborah Pollack: plate 29.
Richard York Gallery: plate 68.
Vose Galleries of Boston, Inc.: plates 12, 17, 131.
Photographers:
Thomas Cinoman: plate 55.
Bill Faust: plates 10, 79, 135.
William Phinney: p. 10.
Clive Russ: plates 12, 17, 131.
Ed Watkins: plate 29.

CONTENTS

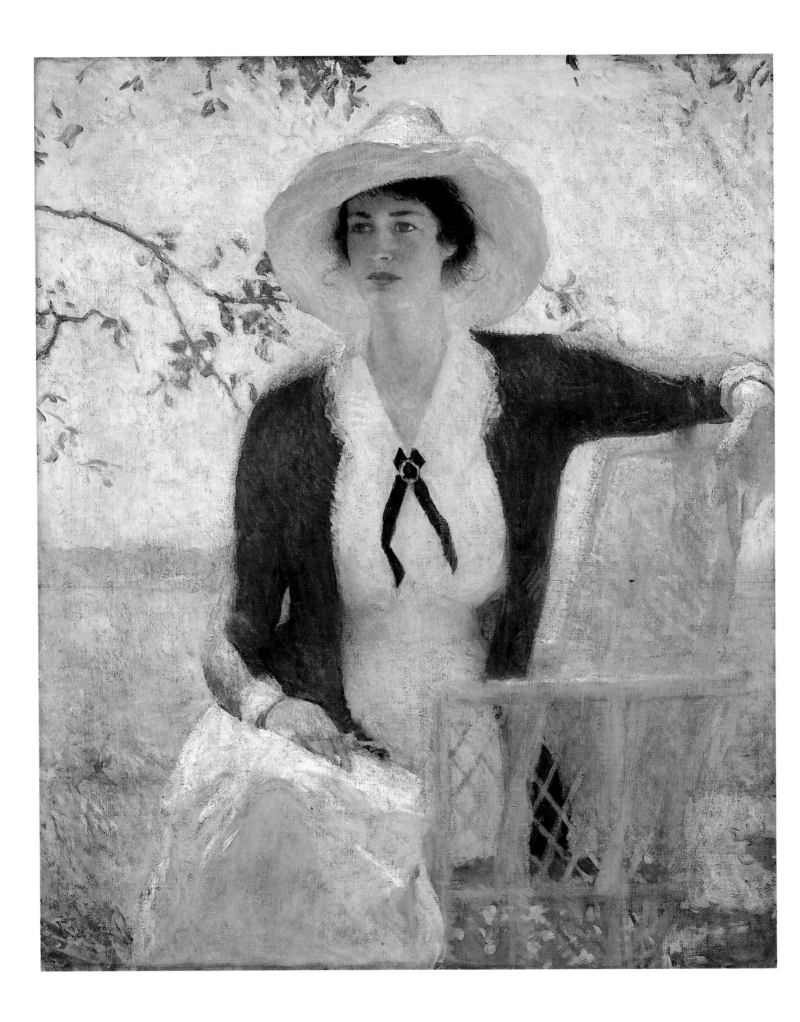

ACKNOWLEDGMENTS

Sixteen years ago, when I first began researching the life and work of Frank Weston Benson, I thought being a descendant would make writing a biography a simple matter. What I discovered was that while my family had wonderful stories about him as a doting uncle or loving grandfather, few knew much about his actual career: his struggles with the politics of the art establishment, his training, his thoughts on art. Now, after years of research, miles of travel, hours of interviews, and thousands of pages of documents, I have found that much long-held theory proves to be false. The man that people knew as grandfather, uncle, friend, and teacher has come together in a whole that has surprised many of his descendants as well as art historians.

I am indebted to my family for sharing with me not only their vivid memories, recollections, stories, and anecdotes, but also their family journals, diaries, photographs, and letters, which were so important in piecing together Benson's public and private life. With respect for the privacy of family members still living and other interviewees who wish to remain anonymous, I have identified them only by their initials in the Notes. To the many old family friends and Benson owners who gave me so much of their time, I am very grateful.

For too long Benson was known either as an etcher and painter of sporting scenes or as an Impressionist. The retrospective of Benson's work, held in 1989 at New York's Berry-Hill Galleries, gave the public an opportunity to view his entire oeuvre: the beauty of his early works in oil as well as his finest achievements in watercolor, etching, and wash. For Jim and Fred Hill's unswerving belief in the importance of presenting Benson's achievements in all media, I am extremely grateful. Their loan of many of the photographs reproduced in this book is greatly appreciated.

To begin a biography of Benson, it is essential to travel to Salem, Massachusetts, where he was born and lived out his life. There, at the Essex Institute, his papers are carefully preserved; its staff, especially Prudence K. Backman, Jane Ward, Eugenia A. Fountain, and Dean Lahikainen earned my sincere appreciation.

It is impossible to list all of the people in American and European museums, libraries, and academic centers as well as the many art historians who have assisted; however, the following individuals were particularly helpful: Sheila Dugan Brock, Bruce Chambers, Stephanie Eha, Susan Faxon, William Gerdts, Susan Hobbs, Amy Kaczur, Rob Leith, Karen Smith Shafts, and Robert Vose, Jr.

Elizabeth deVeer, biographer of Willard Metcalf, generously shared her original manuscript and her sources, helping me bypass many false leads. Cynthia Kennedy Sam, granddaughter and biographer of Bela Pratt, also graciously shared many of her grandfather's letters. John Ordeman, author of a privately printed book on Benson's etchings, was equally generous with his time and resources.

I am indebted to the staff of Rizzoli, especially my editors, Charles Miers and Beth Kugler, my compositor, Rose Scarpetis, and my book designer, Abigail Sturges, who guided this book through the maze of publishing.

To my husband, Bob, goes my deep appreciation for his patience, help, and understanding, and to my father, James Andrews, many thanks for his editorial assistance. Finally, I must thank my mother, Joan Lawson Andrews, whose pleasure and pride at seeing her grandfather's life put into print carried me through the long hours of research and writing. To her memory this book is dedicated.

F.A.B.

My Daughter Elisabeth, *c. 1915. Oil on canvas, 44 × 37". Collection of the Detroit Institute of Arts. Special Membership and Donations Fund with contributions from Philip, David, and Paul R. Gray and their sister, Mrs. William R. Kales, 1918.*

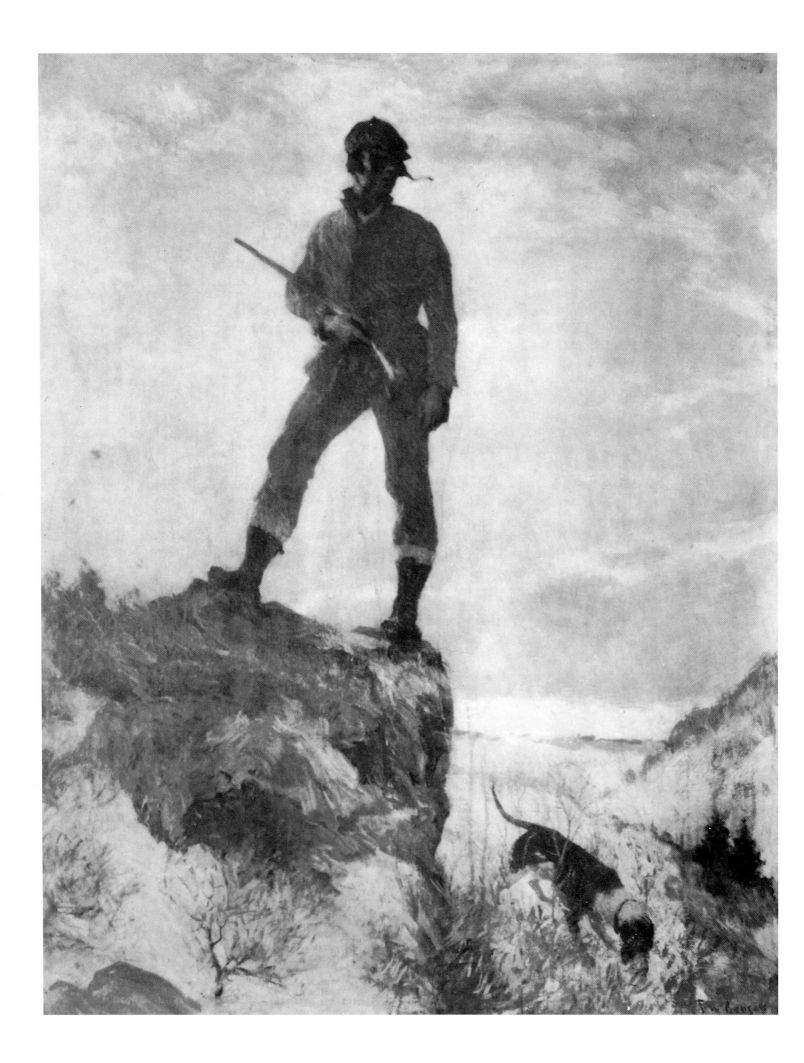

INTRODUCTION

William H. Gerdts

Frank Benson painted some of the most beautiful pictures ever executed by an American artist. They are images alive with reflections of youth and optimism, projecting a way of life at once innocent and idealized and yet resonant with a sense of certain, selective realities of contemporary times. That he could succeed in this—that he could reconcile this seeming dichotomy—may ultimately be Benson's most formidable achievement.

Benson's painting of the 1880s and the early and mid-1890s—those works painted during his student years in France, and then back in New England—should not be dismissed as tentative or immature pictures, which they are not. Some of his portraits exhibit a combined sensitivity and elegance that compares favorably with much of the finest portrait work being executed in the United States at the time, while his landscapes painted at Monadnock in 1889 exhibit a unique color sense and Tonal vision. These constituted a reflection of the Tonalist movement, contemporary with Impressionism in America, in which artists sought and critics and patrons were drawn to poetic, sometimes spiritual resonances derived, in part, through the dominance of variations of a single color in the forms portrayed or insinuated through an atmospheric veil. But especially noteworthy from this period are Benson's contributions to the mural painting renaissance that began in 1893 at the Columbian Exposition in Chicago; Benson's involvement began the following year when he was commissioned to execute representations of the Three Graces and the Four Seasons for the vault and wall of the south corridor of the new Library of Congress building in Washington, D. C.

I think, though, that Benson's most fascinating creations of this period are his glowing images of female loveliness seen in the reflected glow of lamp- and firelight, painted in the years 1891–1893. These experiments in indoor luminescence, with pale-skinned young women dressed either in black or in white and illuminated in a roseate glow, are remarkable pictures almost without precedent in American art. Their strong Tonal contrasts ally them to the Realist tradition still strong at the time, but their coloristic investigation and their involvement with light, albeit not outdoor light, relates to contemporary Impressionist explorations of which Benson would certainly have been well aware, both during his years in France and then back in the United States. The source for such imagery is not certain, but these pictures bear some similarity to the female representations of the French painter Albert Besnard, an artist allied with the Impressionists who was especially admired at the end of the nineteenth century on both sides of the Atlantic, though his achievements are now little known. Such conceptions were not unique to Benson, though he may have investigated such dramatic illumination more fully and profoundly than other American contemporaries; Edmund Tarbell, his good friend, colleague, and fellow teacher at the Museum of Fine Arts School in Boston, treated somewhat similar subjects in such works as his 1891 *The Opal*. But as Faith Andrews Bedford clearly demonstrates in her groundbreaking text, Benson and Tarbell never cloned each other's work. Though contemporaries grouped many of the Boston figurative painters under the designation of the "Tarbellites," the work of each of the leading members of

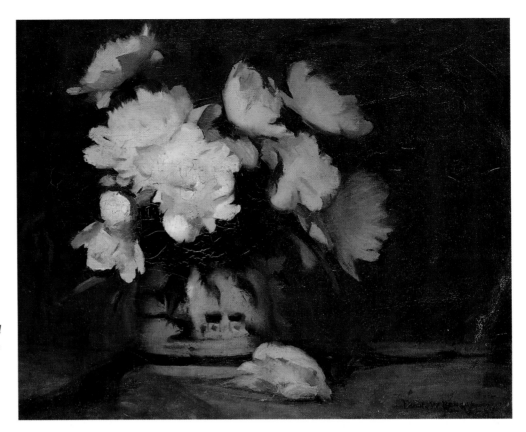

Still Life—Vase of Peonies, *1893. Oil on canvas, 24 × 30". Private collection. Given the mastery of still life demonstrated in this earliest known example by Benson of such a work, it is puzzling that the artist did very few still lifes prior to 1919.*

the group—Benson, Tarbell, Joseph DeCamp, William Paxton, and Philip Leslie Hale, as well as many extremely talented if less renowned professionals—was distinctive in both a qualitative and comparative sense. And none was more so than Benson's.

I believe it is of great consequence that Benson made his most significant breakthrough in out-of-doors painting in 1898 with *My Children in the Woods* (currently titled *In the Woods*), executed exactly the same year that the group of The Ten American Painters, of which he was a member, inaugurated its first exhibition. Though The Ten became a predominantly Impressionist-oriented association, and although the critics invoked this identification even earlier than it was really appropriate, Benson certainly did not adopt the strategies of that movement because of his affiliation with his Ten colleagues. But it is, I think, undeniable that this association, and the critical plaudits that his outdoor work began to receive early in their annual shows, strengthened Benson's convictions concerning the course his art was taking. From then on, for over a decade and a half, Benson created one masterpiece of outdoor painting after another: *The Sisters* of 1899, *Eleanor* of 1901, *Sunlight* of 1902, *The Hilltop* of 1903, *Calm Morning* of 1904, *Children in the Woods* of 1905, *Summer Afternoon* of 1906, *Eleanor* and *Portrait of My Daughters* of 1907, *Evening Light* of 1908, *Summer* of 1909; *The Reader* and *Family Group* of 1910, *Sunshine and Shadow* of 1911, *Summer Day* of 1912, *Afternoon in September* of 1913, *On Lookout Hill* and *The Hilltop* of 1914, and *Mother and Child* of 1915. What should be recognized here is that many of Benson's Boston colleagues were moving indoors during this time, motivated by the Vermeer revival championed in print by Philip Hale in 1904 and welcomed by the critics who praised the first great product of that artistic movement, Tarbell's *A Girl Crocheting* of that same year, calling the picture one of the greatest American paintings of the time. This revival of keen interest and eventually ardent admiration for the genre scenes of the Dutch seventeenth-century painter Jan Vermeer began in France in the 1860s. It reached its culmination in the United States, and especially in Boston, in the early years of the twentieth century. Benson, all the while, was producing some of his finest outdoor pictures, replete with air, and wind, and bright sunshine, often extending through boundless space.

This does not mean that he was immune to the fascination of Vermeer's aesthetics; such renowned pictures as *A Rainy Day* of 1906, *Girl Playing Solitaire* of 1909, *Examining*

the Lace of 1910, *The Lesson* of 1911, *Light from a Window* of 1912, *The Open Window* of 1917, and *The Sunny Window* of 1919 suggest that he continued to explore the subtleties of Vermeerian strategies through much of his career, even after he began to lessen his concentration on outdoor figure painting. These pictures often present complex psychological as well as spatial and luminescent problems, as light filters through windows only partially visible, and figures appear somewhat enigmatic in the resulting penumbra.

Both groups of paintings correspond to the range of works Benson exhibited in the annuals held by The Ten American Painters, whose final, retrospective show took place at the Corcoran Gallery of Art in Washington, D. C., in 1919, which again I think is not coincidental. From 1905, the year that Tarbell's *Girl Crocheting* was shown with The Ten, the Boston contingent, Benson and Tarbell especially, was seen as dominating those annual shows, but it is significant that the entries of those two artists were not generally homogeneous. While Tarbell continued to exhibit indoor works in emulation of *Girl Crocheting*, Benson distanced himself from the Vermeer revival by emphasizing outdoor pictures, showing five of them in the 1909 annual. And if Tarbell's painting was likened to the Old Master Vermeer, Benson's pictures were viewed as very similar to those of the modern Spanish artist Joaquín Sorolla, whose high-keyed renderings of figures, especially children, on Mediterranean beaches were tremendously popular in the United States. But the identification of the members of The Ten as part of the vanguard of American art, even Benson who was certainly aesthetically one of the most advanced, did not endure long. Just as critics were praising the artists, the Boston members particularly, as espousing a new "modern" classicism, Ashcan School urban realism was flinging a challenge that culminated in the show of The Eight at New York's Macbeth Gallery in February 1908—even the group's identification suggests a gauntlet thrown at The Ten. And by the time of the European Modernist "invasion" at the Armory Show held in New York City and then Chicago and Boston in 1913, Benson was showing fewer outdoor pictures and concentrating instead on more traditionalist Vermeer-inspired indoor pictures. The critics who had championed The Ten, particularly the Boston contingent, in the previous decade, concluded in 1913 and afterwards that The Ten had little reason to continue, while the work of the Bostonians was correspondingly disdained.

Nevertheless, by 1919, when The Ten exhibited together for the last time, Benson's art, much more than any of his colleagues, had taken a radical shift. If he was not going to essay urban realism or experiment with Modernist strategies developed in Europe, he

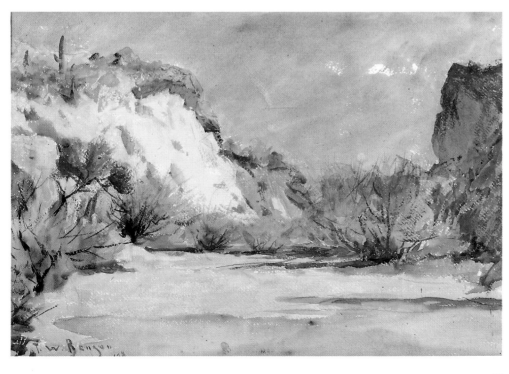

Hassayampa River, *1928. Watercolor on paper, 14 × 20⅞". Private collection.*

did move away from the feminine-and-family themes that had occupied him until then and concentrated upon male-oriented sporting subjects. This theme was not unknown in his earlier painting, but it now became a preoccupation, more in the media of watercolor and etching than in oils. On the other hand, in his oil painting, Benson did not abandon the upper-class clientele he had courted for decades, but rather, in a second innovation in about 1920 he turned to the realm of still-life painting, where he produced some of the most sumptuous examples of formal arrangements of (nature-based) fruit with (man-made) objets d'art to be found in the twentieth century.

There are those who have difficulty today accepting the values implicit in Benson's art, because of the fact that they lie primarily in the realm of quality; that he was not concerned either with aesthetic innovation nor with socially challenging subject matter. For those who view the art of the nineteenth and twentieth centuries as a constant "progression," from Neoclassicism to Impressionism, from Impressionism to Abstract Expressionism, and then on to contemporary movements, Benson's once advanced manner would seem to have foundered upon the rocks of conservatism and not kept up with newer, avant-garde tendencies. But Benson, his colleagues, and his patrons valued craftsmanship over expressivity, tradition over innovation. To their critics, both in their own time and today, such values may seem increasingly inoperative, but to the artists and their appreciative audience they must have appeared desperately needed in the face of artistic tumult and chaos. And in fact, I believe that they still are, perhaps more than ever in this era of cynical exploitation of the arts on the one hand, and their reduction to manipulative instruments within the agenda of political correctness on the other.

Likewise, Boston artists generally were not drawn to the cafés and other night spots of entertainment that attracted the French Impressionist painters and also their New York contemporaries, such as Everett Shinn and John Sloan. The Bostonians almost surely believed, and probably rightly, that their patrons—men *and* women, it should be added—would not have approved of, let alone supported paintings that smacked, even slightly, of the demimonde. Benson's art, as that of many of his closest contemporaries, appealed to an elite, well-to-do segment of society, a particularly traditional New England aristocracy. But those individuals, after all, were the primary patrons of the arts. And they wished to see their own values and the values of their class reflected in the works which they hung on their walls. They, along with the artists themselves, accepted the idea and ideal of timeless beauty and preferred its representation to mundane reality, let alone sordid ugliness. Theirs was a reality too, however, for they believed in nurturing relationships between parents and their children and among siblings; they relished for their families a wholesome environment, in the sunshine, by the sea, out-of-doors. They provided for themselves and their families a home environment of tasteful furnishings, fine garments, and healthy board. And for themselves, they enjoyed their leisure, away from their professional urban commitments, and often away also from hearth and home, communing with nature while they followed piscatorial and hunting sportsmanship.

Perhaps the greatest criticism voiced in recent years of Boston figurative Impressionism has been the avoidance by Benson and his colleagues of issues of gender. While in Benson's brilliant watercolors, etchings, and oils, men pursue their interest in hunting and fishing, a survival of their traditional role of provider, women are here relegated to their societal place, within the home and family. They are shown usually at leisure, perhaps reading, but sometimes completely passive and even bored, while playing a game of solitaire, or admiring themselves and their personal possessions in a mirror. If they do needlework, they do not sew shirts, but embroider, or mend lace. Even out-of-doors, their most strenuous effort is often to hold a parasol. Radical and progressive social issues were as foreign to Benson's painting as to many of his patrons. His was an art of harmony and beauty, not of drama and turmoil. But it reflected not only the world that appealed to his patrons and patronesses but his own world, too—after all, his models were almost invariably his own family enjoying their own environment. And above all, Benson's painting reflected the ideals, if not the reality, not only of a masculine bias, but of humanity at large. Such an accomplished articulation of these ideals is hardly to be faulted, but rather admired; the story of that accomplishment is realized here.

FRANK W. BENSON

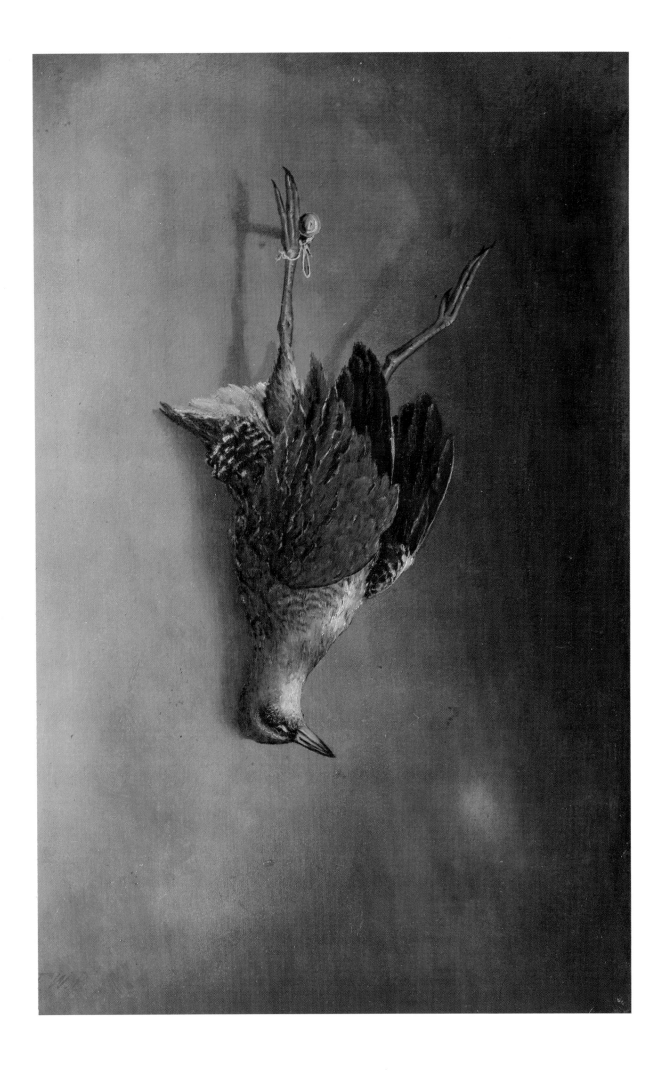

YANKEE ROOTS

One had [an] interest in the Old Masters, and . . . good engravings on one's walls. But the Old Masters were, after all, foreigners. There had never been any in New England. Art, defined in a general way, was something itinerant if not dissolute. An artist—a peddler, indeed— could have amiable qualities but should hardly be trusted with one's daughter or one's spoons![1]

Frank Weston Benson was twenty-one years old when Maine novelist Blanche Willis Howard characterized the New England attitude toward artists in her 1883 novel, *Guenn,* set in a French summer art colony. Just ten years old when he began to sketch the sailboats and dories of his native Salem in the margins of the family journals, Benson grew up in a culture that long remained wary of careers in aesthetic pursuits.

From the close of the Revolution to the embargo preceding the war of 1812, Salem, Massachusetts, was the capital of the shipping industry in New England. Since before the Revolution, Salem shipowners had sought to establish commercial ties to the most remote corners of the world, seeking markets that had previously been monopolized by the merchants of France, England, and the Netherlands. In 1784 a Salem ship, *The Grand Turk,* first rounded the Cape of Good Hope; a year later, the same vessel became the first from New England to make landfall in China and India. By 1800 the town's preeminence in the lucrative trade with the Far East was assured. Over the next hundred years the ships of Salem touched almost every port from the Far East and South America to Europe. From American shores, as Salem's most famous citizen, Nathaniel Hawthorne, once said, "India was a new region, to which only Salem knew the way."[2] The exotic fragrances of coffee from Arabia and cinnamon and nutmeg from the Spice Islands permeated the long wharfs and great storehouses of the harbor. The first elephant to be imported into America arrived in Salem in 1796.

Although by 1860 the Indies had disappeared as ports-of-call for Salem vessels, the Custom House continued to record dozens of foreign entries and the bustling activities of Salem's harbor filled Frank Benson's early world. From the wharves of the Derby family or the vast storehouses of the Crowninshields came silks, teas, and porcelain from China, wine from Madeira, figs and raisins from Spain, ivory and dates from Africa. Benson loved to entertain his grandchildren with stories of how he and his brothers would sit on the wharves with their legs dangling over the water watching as the ships unloaded their cargoes. They would try to guess the contents of each barrel, bale, and crate.

Benson's great-great-grandfather, Thomas Benson, was among those Salem men who secured privateering commissions from the embattled colonial government during the Revolution. Benson's grandfather, Captain Samuel Benson, signed on to his first boat at age seventeen, became a skipper of his own vessel at age twenty-two, and became Member No. 210 of the East India Marine Society when he successfully sailed around both the Cape of Good Hope and Cape Horn. His ship *Liza Mary* had sailed to the West Indies; his brig *Reaper* had been boarded by pirates off Gibraltar.

15

Samuel Benson and his wife, Sarah Maria Prentiss, herself part of a Salem seafaring family, lived at 46 Washington Square.[3] Built in 1850, the Second Empire three-story home stood out among the many earlier Federal and Greek Revival homes surrounding the original village common. Four large marble fireplaces graced the first floor. A curving staircase led to six bedrooms on the second floor and several smaller rooms on the third: one for billiards and the rest for the servants' lodgings and storage. The house was ample for Captain Benson and his wife, their sons George and Emery, and their sons' families. Salem Common had originally been a swampy area where wild berries grew and sheep and cattle pastured. By 1802 it had been filled, leveled, converted to a militia training ground, and renamed Washington Square. A wrought-iron fence with gates designed by Salem's famed architect Samuel McIntire replaced the early oak slats; the original poplar trees gave way to graceful elms. Generations of Bensons grew up regarding the Common as their front yard.

Samuel Benson's prominent position in local maritime commerce earned him the right to his own house flag, whose pale yellow and blue colors greeted him when he returned from long journeys. Like other Salem sea captains, he collected many exotic treasures from the China trade. Some he donated to Salem's East India Marine Society (later the Peabody Museum), a wonderful storehouse of oddities brought back from Far Eastern voyages. Its tiny carved ivories, Chinese brocades, huge sea turtles, and rare stuffed birds filled the imaginations of Salem children. But Captain Benson kept the best for himself. His house was filled with oriental treasures: scrolls and screens hung on the walls, silks in intricate patterns graced the windows, and carved wooden stands supported colorful ginger jars. The family dined on blue-and-white Canton china, and cuttings of peonies, then an exotic flower from China and Japan, grew in the garden.

When Frank Benson was born in his grandfather's house, in 1862, New England was beginning to change through the force of its own prosperity; both his family and his town reflected this transformation. Salem was a relatively shallow port; as shipping moved to deeper harbors and the economy of the coastal region turned increasingly on its factories, the Industrial Revolution came to this harbor city.[4]

George Wiggins Benson, anxious to find profitable outlets for his capital, actively encouraged the local Naumkeag Mills to transform itself into the Naumkeag Steam Cotton Company; he soon became a prosperous cotton merchant in Boston. He married Elisabeth Frost Poole, daughter of another Salem maritime family. The couple's first child, Georgiana, was born in 1859; their second, Frank Weston Benson (named for a family friend and neighbor), was born on 24 March 1862, just a week before Captain Samuel Benson died.[5] Four other children—John, Henry (called Harry), Arthur, and Elisabeth—completed the family by 1873.

Benson's social world was an intricate weave of Salem families who had also grown prosperous on the maritime trade; his early life was filled with family gatherings. Dozens of aunts, uncles, and cousins lived within walking or biking distance of his home and stories told there about privateer Thomas Benson inspired the children's pirate games. Family journals suggest that experimentation and creativity were encouraged; each of the six children had a toolbox and a weekly allowance with which to buy chemicals, books, lumber, and hardware (and, only occasionally, sweets). John and Harry experimented with the new art of photography, building their own cameras and turning one of the storage rooms on the third floor of their house into a darkroom.

The Bensons supplemented their children's education with a full slate of afternoon and evening lectures, exhibitions, and demonstrations. The family frequently attended lectures at Salem's Lyceum, the Athenaeum, and the Essex Institute. In February 1876 the children crowded into the Lyceum's hall to watch Alexander Graham Bell demonstrate his new telephone. After witnessing the transmission of the first news story ever sent over wires, they badgered their father into buying stock in Bell's company. Scattered among the many cheerful notations about Bell stock in the family journal are several mentions of other stocks that did not perform as well; the children's explanations of these declines in value demonstrate their early training in business and may account for their later business acumen.

The social and spiritual needs of their children also did not escape the Bensons. Music classes, dancing lessons, membership for the boys in the Salem cadettes, and masquerade balls at Hamilton Hall were all part of their lives. Frank Benson's early letters describe spirited banjo "fests" at the homes of many Salem friends; he later taught banjo as an art student in Boston. Although Frank Benson married into the Unitarian Church and later became, as he put it, a "wedding and funeral" churchgoer, weekly Episcopal church services were something the Benson family never missed.

Like other families of means in the postwar era, the Bensons escaped Salem each summer when the low, closed harbor became humid and dank. The many points of land jutting into the Atlantic north of Boston had been used as summer retreats since early in the century. Rambling wooden houses with wide, breeze-catching porches dotted the New England shoreline. The Bensons summered each year just south of Salem, at Peach's Point in Marblehead.[6] They sailed often on their boat, the *Viva*, which was wintered in Portland. From May through October, a captain and two crew sailed Frank's father to work each day in Boston—a more enjoyable trip than the airless carriages of the train. The family cruised the Massachusetts shoreline and along the coast of Maine. Each child also had a small sailboat; Frank was given his at the age of twelve.

By the age of seventeen, Frank was a tall and lanky fellow (over six foot three) and an ardent sportsman. In summer he played tennis almost every day, often on the backyard court of the Barton Square home of Salem physician Edward Peirson, whose three daughters and two sons were the Benson children's frequent companions. Winters usually found him at "the Crib," where he excelled at boxing. In 1882, writing to a close friend, Dan Henderson, he reported that he was "sparring about 4 times a week. . . . Tim told me last lesson that I was getting 'clever' . . . and might spar with expert gentlemen of the club after a few lessons more." A highlight of this interest was attending an exhibition match at the Crib, where John L. Sullivan served as referee. Benson wrote, "I was introduced to him there. He is a splendidly formed man, but looks brutal in the face as a matter of course."[7] And always, there was hunting and fishing; his diaries reveal that he found time almost every weekend from spring through fall to take to the fields and streams of Essex County.

Salem was surrounded by open, rolling country. The fields, marshes, inlets, and brooks that lent their names to many of Benson's paintings were his for the tramping. His father gave him his first shotgun and taught him to hunt the wildfowl and shorebirds that teemed along the North Shore. Among his family and friends there was always someone with whom he could shoot. Writing to Henderson in 1895, he reminisced:

> We used to spend our Saturdays chasing coot and old squaws [various wildfowl] in Salem Harbor. Then, after working hard all day to get one bird, in we would assemble at Sam Shrum's or mine and chew the rag until we were so sleepy we couldn't hold up our heads. What a minute account each had to give of each movement of every bird seen and every shot missed. It was almost criminal to miss an easy shot in those days, so many excuses had to be invented. One word would have served for all in my case if it had been invented then. I was generally "rattled," I think, when you and I went ducking.[8]

Two birds shot on one of these trips became the subjects of his first oil paintings (plate 1). Nailing them to a barn door to ripen, Benson then portrayed them, in the words of a later critic, "with stark and youthful realism, . . . exactly as they hung, suspended ingloriously by the feet."[9] This painting, along with a companion piece, *Snipe*, is his earliest known work in oil.

Practicing his newly chosen craft, the sixteen-year-old Benson confided in his mother his wish to be an artist. He later recalled, "My mother used to go into a little room in the top of our house, the little room where we put the winter clothes at No. 46, and there she painted and forgot all about the rest of the world. I think she was as fond of it as I but never had any teaching. Wouldn't she even have enjoyed my work if she had lived longer?"[10]

Indeed, Elisabeth persuaded George to let Frank go to the newly founded School of

the Museum of Fine Arts in Boston, colloquially known as the "Museum School." With grave reservations, George consented. The life of an artist was far from what he would have chosen for his eldest son, and he was seriously worried about Frank's ability to support himself, much less a future wife and family. The lot of an artist was not an easy one; few aspiring painters ever achieved even modest success. Small wonder, then, that a few years later, when his second son, John, announced he too wished to be a painter, George thundered, "Oh no you won't. I can only support one artist!"[11]

George Benson's attitude was not unusual. Most young Salem men followed their fathers into the merchant shipping business or related industries. Some sought further education, usually at Harvard, but often at one of the excellent "training schools," such as the Massachusetts Institute of Technology, where courses in engineering, drafting, architectural drawing, and mechanics had prepared students for industrial occupations since 1865.

That nineteenth-century New Englanders remained skeptical of the notion that art could be a credible occupation is evident in the slower development of art institutions in the region. New York and Philadelphia both had academies offering formal instruction in art since the early 1800s, but New Englanders who wanted to study art were able to receive only private instruction before the Civil War. Since 1810 Bostonians had been

able to view and purchase art at the firm of Williams and Everett, and Frank had often visited the growing number of art galleries in Boston as he walked with his father to his Purchase Street office. Since the late 1820s Bostonians could attend occasional art exhibitions at the Boston Athenaeum or, after 1855, at the Boston Art Club; but a full-fledged community of associations, galleries, museums, and schools of art did not emerge in New England until several years after the Civil War.

Benson was eight when the Museum of Fine Arts first opened in Boston; six years later, in July 1876—the country's centennial—Benson family journals noted the museum's grand opening in its new Gothic-style edifice on Copley Square. Even before the opening, supporters of the arts began working toward the establishment of the region's first art academy.

An enthusiastic committee—including the artists William Morris Hunt, John La Farge, and Frank Millet—pointed out that the museum's large, well-lit basement offered ample space for an art school. To Millet fell the responsibility of securing an instructor. He wrote to Otto Grundmann, a young German portraitist and figure painter whom he had met as a student in Antwerp. Grundmann accepted Millet's offer and sailed from Liverpool, arriving just in time for the opening day of the new school on 2 January 1877. Assisted by Millet and Charles C. Perkins, Grundmann oversaw the work of a growing enrollment (numbering 147 pupils by the end of the first year).

The Museum School's first group of students included many men who later became Benson's close friends and associates. Edward Simmons would join him in the group known as "The Ten," as would Willard Metcalf, who was also to spend many hours fishing and painting at Benson's side.[12] Ernest Fenellosa, son of a Spanish music teacher and a Salem shipping magnate, would one day become a leading expert on Asian art; his collection had a strong influence on Benson's later finely wrought wash drawings and etchings.

By 1880, when Benson entered the Museum School, the classes had grown so large

that they had entirely taken over the basement of the museum; extra space had to be created in the large attic and another instructor, Frederick Crowninshield, was added to the faculty. Boston-born and Harvard-educated, Crowninshield had studied at the Ecole des Beaux-Arts in Paris and at other schools on the Continent for eleven years. Perhaps most important, the school finally began a life class despite "the horror of some of the Trustees at the idea of a nude model in their chaste Museum."[13]

Benson's own class, considered by the school's historian to be "the school's banner class," included many who later became successful artists[14] (plate 2). Edmund C. Tarbell (who first entered the school in 1879) had begun his art education in an evening course at the Massachusetts Normal Art School. The recognized leader of the so-called Boston School of painters, Tarbell's life and name would be closely linked with Benson's. Robert Reid, with whom Benson edited the Museum School's magazine, *The Art Student,* would later join him as a member of The Ten. John J. Redmond taught with Benson in Salem, and Swampscott native Phillip Little shared a Salem studio with Benson. These three, all from the North Shore, commuted together to Boston on the early morning train.

It was also at the Museum School that Benson began his lifelong friendship with Joseph Lindon Smith. "At sight, Frank Weston Benson . . . and I became chums," Smith later wrote. "He was nearly three years my senior and far above the average height of boys this age. We worked together in class, played together, and were seldom seen apart. Naturally we were nicknamed 'The Long and the Short of It.'"[15]

Smith's family was as unenthusiastic about career prospects in art as George Benson had been. A native of Pawtucket, Rhode Island, Smith's love of drawing and sketching caused his parents to worry about his "idleness." However, the quality of his work so impressed his elderly cousin, the poet John Greenleaf Whittier, that he urged Smith's parents to allow him to study art. Reluctant at first, they eventually allowed him to study privately with Whittier's friend Dr. Ware at the Massachusetts Institute of Technology (then located in Boston). There, Smith's lively caricatures of his classmates caused Ware to remark, "This is not the school for you; your school is across the road, the Boston School of Fine Arts."[16]

Benson's journal entries reveal the excitement he felt at his new school. His notations tell of his first lessons in drawing "from the antique," which involved depicting an arrangement of a large collection of plaster-cast ornaments, heads, torsos, and classical figures. By winter he had begun painting and drawing busts from posed models. In the fall of 1881 he wrote, "Began a copy of one of the old masters in red chalk"—his first monotype—and "began stumping under Grundmann," a process that involved drawing a figure in pencil and then using a "stump," a hard cylinder of paper, to rub and blend the lines.[17] During this period, Benson also began working in watercolor, a medium to which he did not return with any intensity until much later, when his reputation as a painter in oil was firmly secured.

During his second winter at the Museum School, Benson worked at copying old masters, and by January he had attended his first anatomy lecture. Unfortunately for Benson, the Museum School's brilliant anatomy teacher, Dr. William Rimmer, had died in 1879, the year before Benson matriculated. A physician as well as a sculptor, Rimmer had required students to draw dissected cadavers, a practice that would have benefited Benson. Judging from the desultory remarks in his journal about the quality of the Museum School's anatomy lectures, he learned little. His later figure work was sometimes criticized for problems with form and proportion. He was aware of his shortcomings in this area; when his daughter Eleanor began to paint in 1926, he insisted that she study anatomy at the Museum School for several years.[18]

Benson and his classmates regularly visited exhibitions at such Boston galleries as Doll and Richards, Williams and Everetts, and Noyes & Blakeslee.[19] The students also visited the home of Quincy Shaw, Boston's foremost collector of paintings and antiquities, who would later be one of Benson's patrons, as well as his neighbor on Cape Cod.[20]

Grundmann encouraged his students to enter their works in exhibitions, and in the spring of 1882, suggested that Benson exhibit some of his pieces in the annual Salem Art

PLATE 2
Benson's Museum School class, c. 1882. Benson, in a straw hat, is standing, second from the right. Joseph Lindon Smith is to his right.

19

Show. The favorable reaction to his works—two crayon portraits, two marine views, three landscapes, and a portrait of Mr. Waters in oil—so heartened Benson that he vowed to complete fifty works before returning to the school in the fall. Well on his way to reaching his goal by September, Benson accepted Crowninshield's invitation to join the sketching and drawing class he taught at Kenmore, a large mansion he rented in the western Massachusetts town of Richmond. A December 1882 article in *The Art Student* described the atmosphere at Kenmore as quite different from the regimented programs of the Museum School. "Each aspirant was free to choose and use any material, all school discipline being cast aside and perfect freedom the order of the day." Kenmore's grand foyer was turned into an exhibit hall; the students spent their evenings presenting dramatic readings of the *Iliad* or the *Odyssey*, singing, or playing charades on the wide staircase. From a letter Benson sent to Henderson upon his return to Salem, it is difficult to tell which aspect of his stay he enjoyed most. "I have been at Richmond a couple of weeks working hard making 3 or 4 oil sketches every day," Benson wrote, adding with youthful exaggeration, "I had an immense time there as there were 13,000 girls working together and the country [was] beautiful."[21]

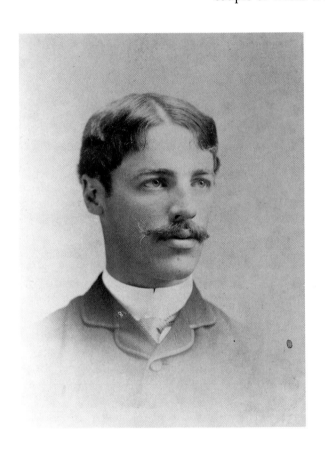

While Benson was studying art, his brothers, John and Harry, continued their work in the new science of photography. They experimented with developing, toning, and printing, and their photographs were soon in demand among family and friends. The possibilities of photography intrigued Benson, and he and several friends had his brothers record their canvases in photographs. William Bicknell, a fellow art student who later became an illustrator, paid Benson's brothers handsomely. "Frank took our picture of Bicknell's studio up to Boston today and he liked it first rate," Harry wrote. "He sent the money down by Frank."[22] Through his brothers' work, Benson began to see photography as an aid to his painting, especially his summer works. Photographing his models in the required pose, he would then work on the painting outdoors as long as he could. As Benson added the finishing touches in his studio he would use the photographs to refresh his memory.[23]

While still a student himself, Frank began his career as a teacher of art (plate 3). He and John Redmond were hired by the city of Salem to teach evening drawing classes, which had been offered free to the public since 1872. Benson took his work very seriously, buying materials for his students and sharing his art books and magazines with them. He collected his first paycheck as an art teacher on 11 January 1882 (forty-two dollars for six weeks of work). The difficulties of his work as an art teacher are reflected in a letter to Henderson. "Drawing school is still running same as ever and Redmond and I go to instruct the Salem youth every Tuesday and Friday evening at 7 p.m. So whenever you think of me on those evenings . . . you may be sure I am trying to make deaf Mrs. Coombly understand by signs that her drawing is all wrong while Redmond is on the other side of the room wrangling with Kitty Stone and trying to convince her that such a foot as she had drawn is impossible."[24]

The following year, Benson wrote to Henderson, "I haven't got the drawing school this winter as the committee had serious objections to Redmond, and I wouldn't serve without him."[25] Such a comment is typical of Benson, whose stubborn Yankee principles caused him to take firm stands on matters in which he strongly believed. Several times Benson risked his own interests or the security of a position to stand by those whom he felt had been wronged.

In his third year at the Museum School, Benson edited *The Art Student* with Robert Reid and May Hallowell. Looking for a new form of illustration, he decided to experiment with etching. Sir Francis Seymour Haden, a British surgeon and well-known

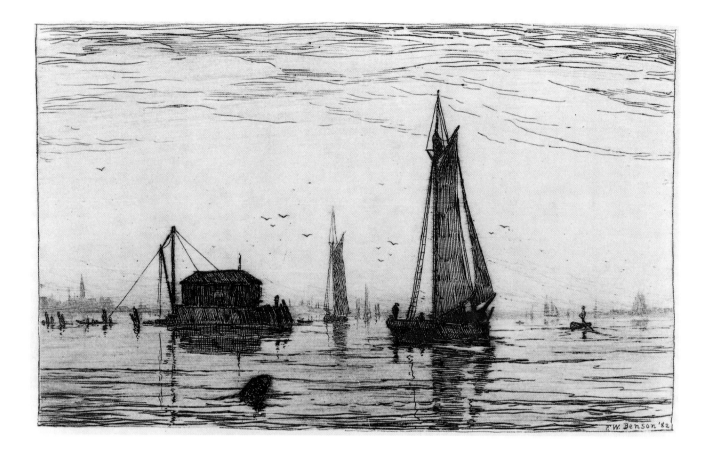

PLATE 4
Salem Harbor, 1882. *Etching on paper, 4⅞ × 7⅞". Private collection. Benson's first etching shows a well-developed sense of composition, a clear understanding of spatial relationships, and glimpses of the mastery of light for which his later etched works were famous.*

etcher, was in Boston at this time and had lectured at the museum. Frank bought one of Haden's early etchings, *By Twickenham* (1862), and, as he later told a friend, he was inspired to try his hand at the medium. Some of Benson's later landscape etchings reveal clearly the influence of the older artist.

Using Lalanne's *Treatise on Etchings* as a guide, Benson spent the entire last week of October completing his etching plate, which he then sent to N. Daniels, a Boston printer who published *The Art Student*. In mid-December Benson proudly brought home copies of the issue featuring his first etched work. Of this view of Salem harbor, made on a steel plate, Harry wrote, " I think they are fine."[26] (plate 4)

Although the simple picture of boats and their reflections in the glassy water was as good as many of those in the shop windows of Boston, Benson abandoned etching for another thirty years. "I made three or four plates," he wrote in 1932 in response to an inquiry about his early work in etching. "I had studied drawing from nature for two or three years, [but] I found I did not know enough of drawing to be able to make etchings. I went on with my studies, drew and painted from nature and, when I was 50 years old, began to etch again."[27]

In March 1883 Benson and his father journeyed to Cuba and Puerto Rico, where Frank filled his sketchbooks with drawings of native people carrying baskets on their heads, pigs lounging on the deck of their ferry boat, and of himself, his long legs touching the ground as he rode a donkey through the marketplace. Inspired by foreign travel, new places to sketch, and a feeling that he had outgrown the Museum School, Benson was more than ready to follow the flood of young American art students abroad.

A few years training in Europe was almost a prerequisite for a young American artist of the period. With the encouragement of both Grundmann and Crowninshield, Benson and Joseph Lindon Smith set off for France together to enroll in one of the most popular art schools in Paris, the Académie Julian.

For his twenty-first birthday, Frank was given his parents' blessing, a ticket to Paris, and one thousand dollars, as well as the strict instructions that he was to come home when the money ran out.

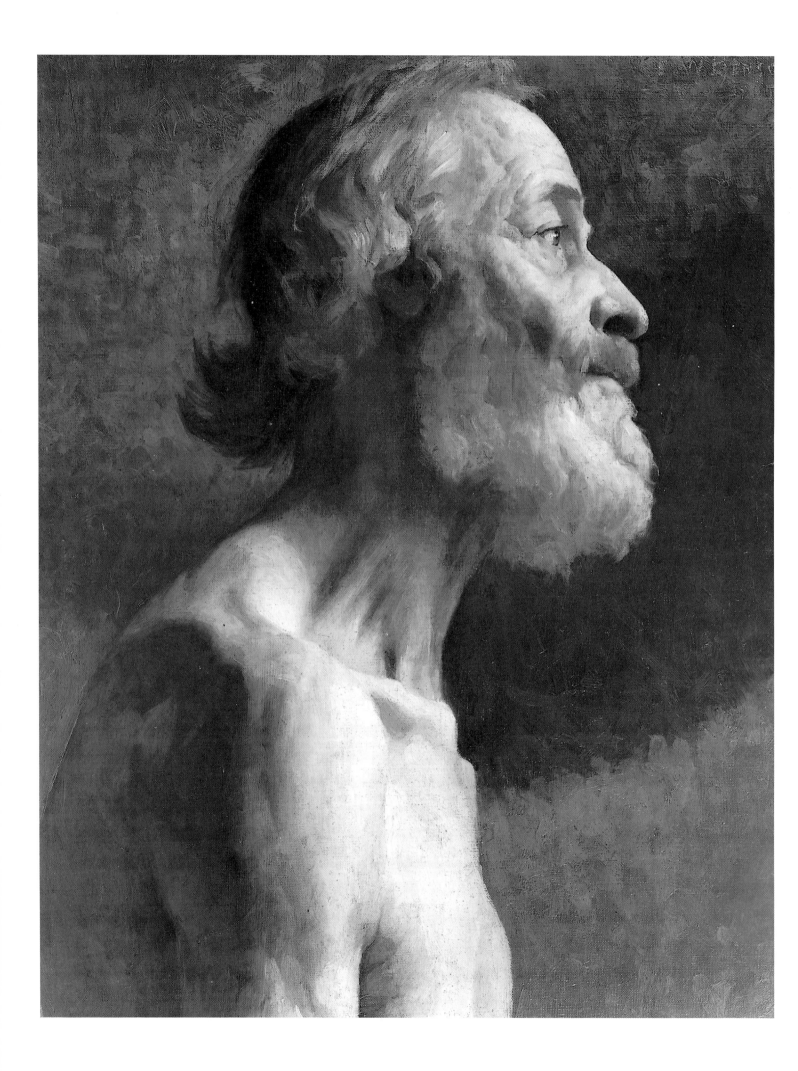

PARIS DAYS

PLATE 5
Portrait of an Old Man, *1885. Oil on
canvas, 20½ × 15½". Private collection.*

While his friends from the Museum School were taking up charcoal and paper once again, Frank Benson was in a carriage bound for Connecticut, where he joined Joseph Lindon Smith for the crossing from Stonington to Liverpool, England. It was an easy passage, and Benson wrote to Henderson that "when the moon grew big enough, we had dances on deck and played the banjo and serenaded the deck parlor."[1]

Smith's mother, raised as a Quaker, had been aghast when she learned of her son's desire to study in Paris. She had not been impressed by the family's 1878 tour of the city; her fears for his moral and spiritual well-being nearly prevented her from letting him go. Once again, Whittier intervened, assuring her that "a good boy can remain good even in an evil city."[2] She needn't have worried; Joe was a dutiful son, faithfully writing his parents every Sunday.

The two friends survived a rough Channel crossing and obtained lodgings at the Hotel de l'Univers on the Right Bank just a few blocks from the Seine and a fifteen-minute walk from the Académie Julian. For sixty-five francs a month the two had rooms on the fourth floor of the large building at 10 rue des Petits Champs (plate 6).

Although the Ecole des Beaux-Arts was considered the most prestigious place to study, foreigners had to apply for admission through the ministry of their own country—a process that could take many months. Examinations had to be taken and letters of introduction secured. If a student did not want to submit to the pressures of competing for a place at the Ecole or felt he needed to improve his skills before taking part in the *concours des places* (entrance examination), he could enroll in a special school or an independent atelier at which there was usually a less formal atmosphere and more individual attention could be obtained from the teachers. Both the Académie Suisse and the Académie Julian were very popular alternatives with Americans. Benson's and Smith's letters indicate that they planned to spend a short time at the latter to see how it suited them. Many Boston painters studied at "Julian's" in the 1880s and 1890s, including Arthur Wesley Dow, Abbot Fuller Graves, Maurice Prendergast, Dennis Miller Bunker, and Philip Hale (who would later teach with Benson). Several of Benson's friends, such as Stacy Tolman (who had sketched with him the summer before at Kenmore), put in a year or two at Julian's and then were sponsored by one of the instructors for a place at the Ecole. But Benson did not have that kind of time. He figured his thousand dollars would last about two years; after that, he was going home to be an artist.

Benson's first day at the Académie was a dizzying round of paying fees, obtaining supplies, and securing good positions in the classroom for drawing the model. After paying the entrance fee of two dollars, he added five dollars for a one-month course (plate 7). As new students, Benson and Smith were greeted with shouts of *"nouveaux"* and demands for payment of a *pourboire* for treating everyone to a glass of wine. When they'd "paid up," Joe wrote, the *massier* or headman, "Theriat, rose up on a high chair (a way they have of doing when there is a hubbub and they want to say anything important) and

sang out, 'Here, Fellows, are *nouveaux* who have paid.' The crowd then, with one accord, took their pipes and cigarettes from their mouths and cheered."[3]

Frank and Joe were spared the more raucous treatment that *nouveaux* had received in earlier years. A favorite initiation during the model's rest was to have two *nouveaux* strip to the waist, or entirely, and engage in a duel with loaded paintbrushes using their palettes as shields. The duel would end either when they were entirely covered in paint or when they collapsed in exhaustion. One *nouveau* recalled being disrobed and ordered to get up on the table and sing. "To sing would have been an utter farce in the pandemonium which was going on. Some one at last shouted to the model to get up at once and never mind me. This she did, and, as I dared not get down, there stood the pair of us, as nature made us side by side. The situation was full of possibilities for the practical jokers, so we were ordered to 'pose groups' by the noisy ones, despite the protests of those who wished to work."[4] It was no wonder that Julian maintained a separate atelier for women.

At the time that Benson and Smith began their studies in Paris, the Académie Julian consisted of several ateliers; theirs was the largest. From their lodgings it was a short walk through the marketplace of Les Halles to the old, dun-colored building at 48 rue St. Denis Faubourg. It is still possible to enter through a large carriage door and, adjacent to the interior courtyard, find a narrow staircase that leads to the old studios. The artist Philip Hale recalled, "The lower story was given over to the making of feather mattresses—and a pleasant odor of the arsenic used in curing feathers rose to the students above. There were three very large rooms and two smaller ones."[5]

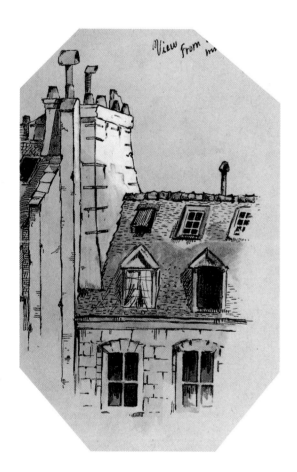

Over the entrance to the studios were quotations from Ingres: *"Le dessin est la probité de l'art"*; and *"Cherchez le caractère dans la nature."* Smith wrote to his mother that the ateliers were overseen by a "fellow who . . . pays the models, sweeps up the floor, sells bread, etc. [He] is a funny little chap and they have a good deal of fun with him. Then there is an oldish man who comes in every day who sells charcoal, paper and other materials and still . . . another old gent who walks in but twice a week who sells photographs of the Salon pictures."[6]

The proprietor of the Académie, Rodolphe Julian, was an artist himself; it was rumored that he had been a wrestler. Hale describes him as "a big, round rouse, Provencal, broad shouldered, powerful with a Phoenician face in which good humor and cunning were mingled. . . . He had at one time studied art himself, but though he was a fairly good draughtsman, he had not vital artistic quality. Still, his knowledge of drawing stood him in good stead and he would sometimes, when a professor failed to appear, give a critique which was not lacking in acuteness."[7] Julian was often at the school, usually coming in on Monday mornings to "set the pose" for the week and to make a careful pencil sketch of the model in his large sketchbook.

What prompted Julian in 1869 to challenge the existing ateliers of Jean-Léon Gérôme or Alexandre Cabanel or the established Académie Suisse, is not known. According to the artist William Rothenstein, Julian himself used to tell the story of how, "at his wits' end for a living, he hired a studio, put a huge advertisement, 'ACADEMIE DE PEINTURE,' outside, and waited day after day, lonely and disconsolate. Finally, he heard a step on the stairs; a youth looked in, saw no one, and was about to retire, when Julian rushed forward, pulled him back, placed an easel before him, himself mounted the model-stand [and declared] 'L'Académie Julian est fondée!'"[8] Ten years later, Julian had become such a powerful figure in the art world that he was awarded the *Croix de la Legion d'honneur* by the government in recognition of his services to French art. Many of the instructors at his academy were on the juries of the prestigious Salon, and his influence there was legendary.

Although Julian prepared students for the Ecole, as did the other independent ate-

liers, many artists preferred the greater flexibility of teaching at his Académie. Whereas other studios were open only in the mornings, Julian's was available to students from dawn until dusk and was only closed on Sundays. Although students were not required to enter competitions or be in attendance when teachers made their critiques, the combination of freedom and discipline was so compelling that, by 1889, Julian had more than six hundred students enrolled at several different locations. Julian's stature was sufficiently strong to enable him to attract such well-known artists as Adolphe Bouguereau, Jules Joseph Lefebvre, Gustave Boulanger, Tony Robert-Fleury, and Lucien Dourcet to teach without pay. "No students get more attention from their teachers than we do at Julian's from old Boulanger and Lefebvre," Smith wrote home, seemingly in defense of his training. "There is not any atelier in Paris where the professors come more than twice a week . . . [but] we have two teachers who are the best men in France and who take interest in us. . . . Julian does not pay either of his teachers. They come for nothing so that, if a good man is turned out, people say 'Oh, a pupil of [Lefebvre and Boulanger].'"[9] Indeed good men were "turned out." Seven of Benson's future associates in The Ten studied at the Académie: John Twachtman, Edmund Tarbell, Thomas Dewing, Robert Reid, Edward Simmons, Willard Metcalf, and Childe Hassam.[10]

In clannish fashion, Benson and Smith kept company with their own. "There are lots and lots of Americans and Englishmen here, more than there are Frenchmen," wrote Smith. "Out of a class of 70 fellows, I think 40 or 45 are English-speaking."[11]

Evenings were spent at lively dinners that lasted well into the night and which were taken at favorite nearby restaurants such as La Crémerie or Duval's. Mornings were a different matter. "We get up at 7, make our coffee, eat our roll and go off to the studio, work until 12 and then breakfast," Benson wrote to Henderson after his first few days at Julian's. "Next month we work dawn until dark and shall continue to do so through the winter. For purposes of study, this is a great place, but I don't think I like Paris and I know I don't like anything about Frenchmen except their language. That is charming and I am trying hard to learn it. Of the boasted French politesse, I have seen nothing. Perhaps this isn't the season for it. I think it has migrated south for the rainy season."[12]

Students worked in the atelier every day, including Christmas. Sundays, however, were saved for church and for writing letters home. They were surprised, even shocked, to see how the Catholic city of Paris kept, or rather did not keep, the Sabbath. In one letter, Benson told of a Sunday when it seemed that "all Paris was going to the horse races. The broad avenue up through the Champs-Elysées was crowded with buses, cabs and all sorts of vehicles going toward L'Etoile. It seems queer, but they always have their races on Sunday afternoons, and they are largely patronized too."[13] Benson, who had been confirmed in the Episcopal church shortly before he left home for Paris, was never a very religious man, but he nonetheless kept the Sabbath. He never painted on Sundays, nor did he indulge in sports or other amusements. Years later, when on hunting and fishing trips with his friends, he would put aside his rod or gun on Sundays to read or write letters instead.

Benson's first year at Julian's was spent in mastering the discipline and techniques of drawing the model under many different circumstances and lightings. Drawing the human figure from life was the core of academic art education not only at the Ecole but also at the independent ateliers. In a letter to Henderson, Benson expressed his growing realization that "art is a long study and seems longer and longer as I dive into it.

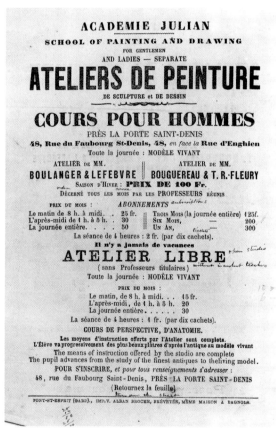

PLATE 7
Benson's fee schedule, Académie Julian, Paris, 1883. Private collection.

Generally, it proves longer than life, but it is the most interesting thing in the world." He added, "How happy I should be to stay here and study if only my family were here. I get very homesick sometimes, but digging into work is the best antidote and I try not to let myself be idle long."[14]

As a subscriber to most of the art magazines of the period, Benson had undoubtedly read with interest of the work of the French Impressionists, especially their plein-air paintings. Critical mention of this movement was first published in America in 1875 and was, for the most part, hostile—as was criticism of their work in their France. The painters who had originally exhibited in revolt against the Salon style and system in 1874, organizing an exhibition under the auspices of *La Société Anonyme des Artistes, peintres, sculpteurs, graveurs, etc.,* were given the name *"Impressionists"* in a contemptuous comment made by a critic of Monet's *Impression: Sunrise.* J. Alden Weir, who was later to become a close friend of Benson's and a fellow member of The Ten, wrote of his first exposure to the work of the Impressionists at their third exhibition in 1877: "I never in my life saw more horrible things . . . They do not observe drawing nor form but give you an impression of what they call nature. It was worse than the Chamber of Horrors."[15]

In 1880—when Benson was in his first year of art school—Samuel Benjamin, in his book *Art in America,* criticized the Impressionists for their lack of poetry and spirituality but nevertheless argued that their technique presented a "keen appreciation of aerial chromatic effects and for this reason are worthy of careful attention."[16] It is quite probable that Benson absorbed Benjamin's words. It is not known whether Benson saw Manet's *Shooting of Maximilian* when it was exhibited in 1879 at Boston's Studio Building gallery, but it is very likely that he was able to attend the "Foreign Exhibition," hung in September 1883, shortly before he left for France. Tarbell drew several illustrations for the handsome catalogue that accompanied the display of paintings by the Impressionists Manet, Monet, Renoir, Pissarro, and Sisley. Organized in Boston by Paul Durand-Ruel, a Paris dealer and staunch advocate of the Impressionists, the show generated only a few reviews, mostly negative. Nonetheless, given Benson's eagerness for new ideas about art, Benson undoubtedly sought out the revolutionary work of the Impressionists during his student years in Paris.

Hoping to paint *en plein air* themselves, Benson and Smith made day trips to the outskirts of Paris—to St. Cloud, Suresnes, Charenton-le-Pont, and Creteil in search of sketching sites. Although these places were accessible by trolley or barge, the two usually hiked in an effort to conserve funds. "Paris is the greatest place to make one spend money I ever saw, thousands of things on every side that a fellow wants to buy," Benson exclaimed in a letter to Henderson. "I wish I had twice as much money as I have. I can tell you, I never had to deny myself half as much as I do now."[17]

To help keep homesickness at bay, Benson started a "sparring club," where he and his friends could box or fence in the evenings. He was fascinated by French boxing and eager to learn this new method. "They box with their feet and scientifically too, sparring with both feet and hands and an expert can easily kick anywhere from your nose to your feet and it takes a good deal of practice," he wrote to Henderson. "It is very pretty and is great exercise."[18]

Evenings at the Hotel de l'Univers were often spent in song fests. Benson and Smith played mandolin, guitar, and banjo. When they joined the student across the hall who had a piano and another friend brought his flute, the rollicking music would bring other fellows up from floors below. Their singing spilled over into the studio at Julian's and the Frenchmens' rendition of American favorites brought gales of laughter from the American contingent. Benson painted Smith practicing his guitar in front of the small fireplace that struggled to keep them warm in the damp Paris winter (plate 8). Although the students were still drawing with charcoal at the Académie, the boys worked in oils in their own quarters.

Their first exposure to M. Boulanger came one morning at Julian's, when he critiqued the students' drawings. "Old B. is a smart old boy," Smith wrote home. "He comes in to correct the drawings at the stroke of eight and the fellows who are late he

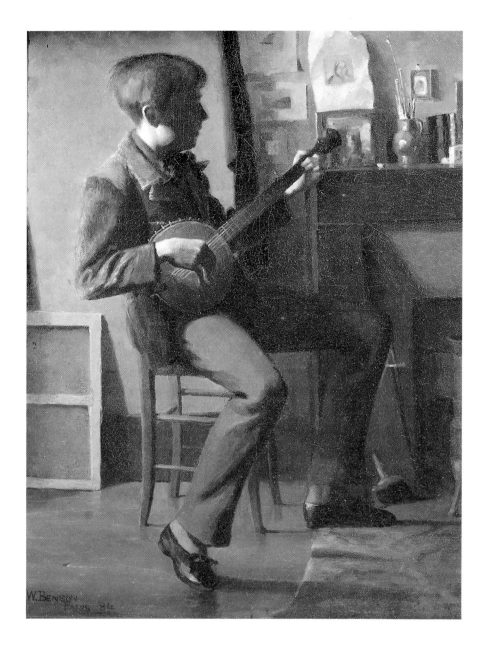

PLATE 8
Portrait of Joseph Lindon Smith,
*1884. Oil on canvas, 25½ × 20¾".
Private collection. The two art students
painted each other's portraits and care-
fully shipped them home to America as
proof to their parents that their tuition
was well spent.*

won't correct unless they can get to their places ahead of him . . . coming so early as he does, he catches a lot of fellows every time and so does not have so many [drawings] to correct. It is quite a job to correct over a hundred men in four hours." Describing Boulanger as an "oldish looking man with an almost bald head [with] . . . a sort of fuzz growing up," Smith added in surprise that "he wears no white collar but a flannel shirt."[19]

Boulanger seemed to terrify the students. He "had a mustache like a walrus and when he sat facing a man's work, he often said 'Phufft,' and the whiskers stood straight out from his face." Smith later told his daughter, "If the picture pleased him he would leave the whiskers standing out straight, but if he pressed them back into shape, that was a very bad sign."[20]

Lefebvre was by far the more popular of the two instructors, and Smith wrote to his mother that "I like him better than old Boulanger!!! (of course) but so do most of the men at the Atelier."[21]

At Julian's, the only way to get a good position near the model was to place well in the weekly composition contests. Those who placed in the top six positions were al-lowed to take any seat of their choosing; the other students' names were read off in an arbitrary order.

The weekly *compos* and the monthly *concours,* or contests, were discouraging for Benson. Not until April was Smith able to write home with good news: "Great Success!!!

27

On composition last Sunday, Benson No. 1 (!!!) and Smith No. 3 (!!!) . . . complete surprise for both of us, much more so for Frank who has never had a decent mark before this."[22] He illustrated his letter with a small cartoon showing Benson as a peacock and himself as a rooster, chests puffed out, strutting about the studio with large placards declaring "No. 1!!!" and "No. 3!!!" hanging from their necks.

In early May Benson and Smith went to see the paintings at the Salon and found them "wonderful." They spent several hours there on their first visit and were so inspired that, upon returning to their lodgings, they began a portrait of their garçon. That spring, John Singer Sargent's Salon portrait of Madame Gautreau, was the talk of Paris. The sitter, born Virginie Avegno in Louisiana, was brought to Paris by her ambitious, widowed mother and married well to a wealthy shipowner and banker, Pierre Gautreau. Although she was dismissed by "society" as an *arriviste*, her striking looks were not ignored, least of all by Sargent, who enlisted a mutual friend to introduce her. Sargent sketched her in several different poses before he hit upon the dramatic pose that he submitted to the Salon (see plate 30). Sargent realized it was a daring work: the deep décolleté was hardly modest and the black of her dress contrasted boldly with her skin. The public outcry was enormous: people felt it revealed more than a portrait should. The press denounced the work and Madame Avegno and her daughter, fearing for their already insecure social status, demanded it be removed from the Salon. Sargent, encouraged by fellow artists, stood his ground. As his friends all agreed, he merely had represented her exactly as she was. They correctly deduced that the outrage was basically directed at the presumptuous sitter and the painting merely added fuel to the fire. For Sargent, born in Florence of American parents, this was the first public criticism he had received. His expectations that a portrait of a well-known Parisian figure would increase his portrait commissions were dashed; in point of fact, several clients who had been considering commissioning him withdrew their interest. The melodrama was so distasteful to Sargent that when the painting was sold to the Metropolitan Museum of Art, after Madame Gautreau's death, he requested that it be titled "Madame X," thereby banishing her name.

The outrage at Sargent's painting was not lost on the art students of Paris. Benson and Smith had spotted the lady herself while they were sitting in a café in the Bois de Boulogne. "We saw the great Parisienne beauty driving out with her 'Pa,'" wrote Joe. "She is powdered like a clown in the ring and has a very peculiar profile."[23] They wondered, was it best to maintain artistic integrity and paint honestly what one saw or was it better to please the sitter and be assured of commissions? The question was discussed in the ateliers of France for months to come.

As summer approached, the crush of bodies and the ever-present smoke of countless pipes and cigarettes at the Académie became oppressive. As Philip Hale noted, "On a hot July day, what with paints, dirty Frenchmen, stuffy air, nude models, and the place below, this room stank worse than anything I can think of."[24] Benson and Smith had listened eagerly to their comrades' descriptions of the many country haunts to which the artists of Paris dispatched themselves in the summer and they decided on Concarneau, a quiet fishing village in Brittany. "There are many very strong painters at Concarneau, among them is [Jules] Bastien-Lepage," Joe wrote home. "He may not be there this summer though as he was very sick in Paris . . . and several times his life was despaired of. . . . [Alexander] Harrison, one of the strongest American landscapists . . . is there and is a fine fellow, helping anyone who asks him."[25]

At the end of June, Benson and Smith left for Concarneau, where several of their friends from Julian's had already settled. They took two rooms on the top floor of the popular Hotel Grand for five francs a day. "There is an old walled town and a new one. . . . The languages they speak are French and Breton and not a single word can you make out," Joe described in a letter home. "There are about 1,500 boats that go out twice in the day and at night also and it is a beautiful sight to see them all standing out. . . . all the men are fishermen."[26] What the men unloaded onto the docks, the women packed into little tins; the town's economy hung on the continued abundance of sardines. Frank and Joe ate the small silver fish, in different disguises, for dinner every night.

The arrival of summer artists had brought a slight betterment to the meager existence of the people of Finisterre, as Normandy and Brittany were called. Although American artist Everett Shinn had visited Concarneau in 1866, it wasn't until Edward Simmons settled there in 1881 that the town began to attract substantial numbers of American artists, including Alexander and Birge Harrison, Arthur Hoeber, Clifford Grayson, Walter Gay—all previous sojourners at Pont-Aven—and "Shorty" Lazar and Howard Russell Butler. The nearby artists' colony of Pont-Aven, which predated Concarneau's settlement by artists by a dozen years, was by 1884 home to an international community of over one hundred artists—some famous, most not. Today, Pont-Aven is probably best known for having been a haunt of Paul Gauguin, who first painted there in 1886. Benson and Smith had seriously considered Pont-Aven, but Benson was eager to sail again and missed the sound of the ocean; Pont-Aven was several miles inland, on a tidal river. The artists in residence at Concarneau and Pont-Aven traveled back and forth between the two towns frequently, and the friendly rivalry between the two colonies gave rise to lively games of baseball and much artistic criticism and discussion.

The care and feeding of these men created a veritable "cottage industry." The artists brought their families, their disciples followed, and the tourists were not far behind. The hotels flourished, and many of the townspeople found work as models.

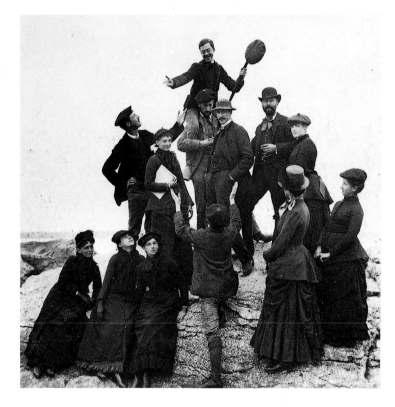

Inspired by these intertwining circumstances, Blanche Howard, a native of Bangor, Maine, summered in Concarneau and wrote a novel entitled *Guenn: A Wave on the Breton Coast*. First published in 1883, it is the story of the fiercely independent Guenn, who, unlike the other village girls, steadfastly refused to model for the dashing artist Hamor. The novel was loosely based on the activities of Edward Simmons and the actual inhabitants of Concarneau. Guenn's ultimate surrender and love for the artist so touched the hearts of her readers that American tourists came in droves the following summers in search of the real villagers. Simmons's and other artists' renderings of the pretty village girls in their quaint Breton costumes were a brisk part of this "literary" summer trade.

Among the Americans fascinated by Guenn were the women of the Peirson family, Benson's childhood friends from Salem. Over the winter Benson had written to Ellie Peirson, three years his senior, and had learned that she, her widowed mother, and her sister, Katie, planned to include Normandy and Brittany on their European grand tour that summer.

The Peirsons arrived in Concarneau at the end of July, and the pace of the boys' lives quickened considerably. Daily arrivals of established artists, students, and tourists swelled the crowd at the long dinner tables at the Hotel Grand and kept both the maids and Madame scurrying to fill the glasses. "Madame is very attractive and much like her description in *Guenn*." Ellie noted in her diary. "Guenn is about and is [really] Louise Nevis. . . . We saw 'Hamor's' studio which is now occupied by Mr. [H. H.] Robinson [an English artist]. The studio was very attractive and we saw the door where the ghost of Morot was supposed to be. It is now nailed up."[27] Benson had teased Louise into thinking Ellie and Katie were his sisters, but the perceptive girl, whom Ellie described as "tremendously independent," obviously noted more familiar behavior on Benson's part.[28]

The high point of the summer was the almost daily contact with established artists. Alexander Harrison, Arthur Hoeber and Clifford Grayson had all taken an interest in

Benson's work, and Harrison, always generous with his time, had critiqued many of his and Joe's pictures. "Yesterday, some men from Pont-Aven came down to see us," Joe wrote. "[Willard] Metcalf, the artist who went down to the Zuni Indians with Cushing, was among the number and he told us a lot of interesting stories about them. He liked F. and my work up at the atelier and they seemed to think we were booming it along well."[29]

The art students were welcome in the established artists' studios as well and gained much from observation of these men at work. Ellie wrote, "We visited Mr. Grayson's studio [and] saw a photo of his Salon picture of this year called *Ahoy*. It is now creating a sensation in Chicago together with Mr. Harrison's marine. It was 'Guenn' calling to some fishing boats."[30] Two weeks later, when Grayson got word that he had sold his picture for twelve hundred dollars, he treated the crowd to champagne.

The arrival of Simmons completed the group. "'Hamor' arrived last night with his wife and baby," Ellie noted in her diary. "He is very attractive looking . . . and talks a great deal. His wife is a funny looking little thing, great eyes and a great black bang close down to her eyebrows." Finding Simmons amusing at first, she later noted, "Mr. Simmons grows rather a bore, I think, he talks so incessantly."[31] Nonetheless, Simmons joined the group of artists, students, and friends in excursions to religious festivals in Pont-Aven, evenings of song and dance, and picnics on the beach (plate 9).

That summer, Benson painted Ellie's portrait as a gift for her mother. The painting required many hours of sittings—more, Smith suspected, than might actually have been necessary. "Frank is working on a portrait of Miss Peirson," he wrote to his mother. "I think he is overdoing it, it is not as good as it was a week ago and, though I should never dare to say so, it is a case of 'dead mash'. . . . Sturdee says he knew Benson was 'mashed' on her the first time he saw them together."[32] (plate 11). Ellie's sketchbook is filled with little pictures and sentiments drawn or written by many members of the comradely group; among them is a delightful series of sketches by Benson and Smith of a long walk, full of adventures and mishaps (plate 10).

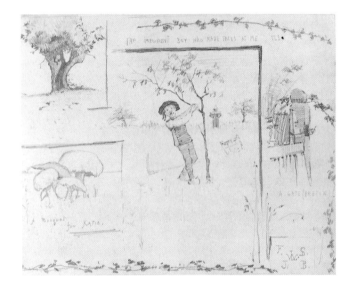

PLATE 10
Ellen Peirson's Concarneau sketchbook. Private collection. The cartoonlike quality of these drawings, done by Benson and Smith together, is seen in later works by both men.

Despite the fictional account of "Guenn's" refusal to sit for artists, Frank often hired Louise as a model; her cousin, Jeanne, sat for Joe. The two began several works they hoped would win them acceptance to the Salon's spring exhibition. "Frank has already begun his boats leaving the fishing grounds. He is at home painting the water as he has painted it a good deal before," wrote Smith. "Jeanne . . . is the very prettiest girl in the town . . . fine dark eyes . . . and poses like a barn door. In Boston you have to pay a model 75 cents an hour!!! while here a girl will pose splendidly all the afternoon for a franc."[33]

Although advised by some of the older artists to create large and heavily worked canvases, either a landscape or a seascape or one with a classical, religious, or historical theme, Benson and Smith preferred views of peasants *en plein air*, an approach that had been gaining acceptance at the Salon. Of this latter style, Bastien-Lepage was a master. It was he who had cemented the group of artists at Concarneau, and Benson and Smith had looked forward to rubbing elbows with him that year. But Joe wrote, "Harrison said that Bastien-Lepage was intending to come down here in a few weeks. He is sick with cancer of the stomach and is not expected to live very long. Of course he will do little or no work but as he is fond of dropping into the ateliers, we may see him often and perhaps get the benefit of a criticism."[34] Bastien-Lepage's influence on this generation of American artists is evident. Having begun as a painter of genre scenes of French peasant life in the late 1870s, he stressed careful studio draftsmanship and atmospheric tonalism. His style appealed to the young artists studying in Paris, for he painted directly from nature but did not stray into the avant-garde of Impressionism. His use of

silvery rather than umber glazes was perfect for portraying the Brittany gray *enveloppe* that suffused the misty seaside of Concarneau. Alexander Harrison was a close friend of Bastien's, whose influence can be seen in Harrison's paintings of the Brittany seacoast. Although Benson regretted not being able to meet and work with the older artist in Concarneau, the spirit of Bastien-Lepage's work was passed on through the criticisms given him by Harrison.

Bastien-Lepage's death the following December, at age thirty-six, seemed to put a pall on the artists' enthusiasm for Concarneau. With the central focus of the colony gone and the increasing tide of tourists and "Guenn-seekers" filling up the hotels, Simmons, Grayson, Hoeber, and Harrison sought other, less discovered summer retreats.

In early November 1884 Benson and Smith returned to a Paris enlivened by the presence of the Peirsons, who had decided to remain there for the winter, and by the arrival of two Museum School friends, May Hallowell and Helen Hinds. At Julian's, they also discovered other American friends. "Clarkson, Tarbell, White and Callendar, all chums of ours in Boston, . . . have been here some weeks and were delighted to see us," Smith wrote home.[35] Willard Metcalf, whom they had met in Concarneau, was also studying at Julian's that year.

Their new hotel at 66 rue de Seine, was at the corner of boulevard St. Germain—the very heart of the artists' quarters—and not far from their studio in the Hotel de Paris at 24 rue Bonaparte. "It is a very nice room and they have completely covered the walls with sketches and 'properties,' or fabrics, of various stuffs and colors," Ellie wrote in her diary. "It is awfully pretty."[36] It was here that Benson completed a number of works, including a portrait of his fellow student Charles Fox and a self-portrait.

The walk to Julian's was much longer from the Left Bank, but it took them through the Louvre, just across the Pont des Artistes. That winter, despite the bone-chilling fierceness of the wind that whipped down the Seine, Benson and Smith made many trips to the museum. Benson most admired the paintings by Rembrandt and Titian, particularly the latter's *Man with a Glove,* which he called "one of the greatest of the world." Fifty years later, Benson told the *Boston Sunday Herald,* "When I was studying in Paris I lived right near the Louvre and went over nearly every day to look at that Titian and I never could get to the end of it. Now I keep a reproduction of it right near where I dress in the morning and look at it every day."[37]

PLATE 11
Portrait of Ellen Peirson, *1884. Oil on canvas, 21 × 18". Private collection. Benson painted this portrait in Concarneau.*

Like most students of their day, Benson and Smith often took their easels into the Louvre's great halls to copy the use of light and shadow, or form and composition in masterworks. Not only did they improve their skills, but they also peddled their copies to tourists, a time-honored occupation for Parisian art students. Philip Hale, later an instructor with Benson at the Museum School, managed to prolong his stay in Paris for many years by this method. Close by could usually be found "Old Duval," who, Joe wrote, "always makes the study from the very same place and has made hundreds of pictures of the same room. He has a harvest in rich Americans who buy his pictures. . . . He writes on every picture 'M. Duval, born 1795,' so you see he is not a young bird. There he is every day from 10 til 4:30 always painting on the same subject."[38]

That winter, working primarily in oils, Benson and Smith spent the afternoons in their studio and the mornings at Julian's, where they continued to enter the weekly *concours*—with mixed results. Often Benson painted an old man who was a familiar fixture at the various ateliers of Paris. This model, possibly Père Fruscot or Père Bainville, portrayed biblical figures: Job, Noah, or Moses (plate 5). The morning that Frank was adding the final touches to his *Portrait of an Old Man,* Boulanger was making his way

through the students, bestowing critiques here and there. Boulanger rarely spoke except to give a few directions for needed changes or to say *"pas mal,"* but at Benson's canvas he paused for what must have seemed like an eternity. The crowded studio grew quiet as everyone strained to see what had caused the master to stop. *"Mon cher jeune homme,"* Benson remembered him saying, "your career is in your hands!" The words passed from student to student with a gathering buzz. "If you carefully analyze the personality of your model, you will do very well." The class cheered. Little work was done the rest of the morning as the fellows crowded around Benson's canvas, clapping him on the back. When the model took his break for lunch, everyone piled down the stairs to their favorite restaurant where they celebrated late into the evening. No one returned to their easels that day.

In Paris as in Concarneau, the Peirson ladies proved to be a great distraction from work. Benson and Smith took daily tea with them at their lodgings at the Hotel du Quai Voltaire and every weekend was spent in their company. Their group of friends, often numbering a dozen, went to plays and concerts, skated in the Bois de Vincennes, strolled along the Seine as far as the Trocadero, and climbed Montmartre.

The sightseeing trips were enjoyed more by Benson than by Smith, but Joe always went along anyway. As Ellen wrote in her diary after a trip to Versailles, "(Joe) only went because Frank did. He can't bear to have Frank leave him behind!"[39] Although these lines may well have expressed the frustrations of a woman who would have preferred to have Benson to herself, they were more probably the amused observation of a clear case of hero-worship. That Smith idolized the older Benson is reflected in his letters home. His correspondence speaks of plans that would "never separate" the two.

On one of these excursions they visited the Parc Monceaux to see the Statue of Liberty, which was about to be sent to New York. The previous year, the Pedestal Fund Art Loan Exhibition had been held in New York to raise funds for the base for the statue. William Merritt Chase and J. Carrol Beckwith organized the show, which included two works by Manet as well as a Degas painting. The critical response, which Benson undoubtedly read in his art journals, was mixed, but, in a prophetic statement, the critic for *Art Amateur* wrote, "All the good painting by the men who will come into notice during the next ten years will be tinged with impressionism."[40]

The parades and celebrations that preceded the statue's departure probably inspired the small oil sketch *Paris Parade* (plate 12). Although the work of the French Impressionists was not exhibited during Benson's Paris stay, it is quite likely that he saw these "radical" paintings for they were displayed in several private galleries despite being still held in contempt by most French artists and critics alike. Although Benson does not speak of this new school of painting in his letters, *Paris Parade* may have been an attempt to capture the essence of what he might have seen of this daring new method of painting. If so, this painting shows that he picked up several hints from the "revolutionary" painters, for it demonstrates many of the Impressionists' techniques: the high-keyed, sunny colors are applied with broken brushstrokes; the bright sense of light results in a dissolution of forms; the rough texture giving an illusion of atmosphere through the scintillation of reflected light. The composition of this casual street scene, which is far from formal—a bit of happy action caught on canvas. Many years later, as Benson's daughter Eleanor was learning to paint, Benson told her, "Those things which you do when you are freshly inspired and excited by the beauty of what you are seeing before you are important things. . . . There is a certain inspiration which comes when you work quickly and surely and [are] enthusiastic about the beauty of the light."[41] As Eleanor struggled to become an artist herself, Benson often dropped by her studio and critiqued her work. Upon his departure, she quickly transcribed his words into a small notebook. Existing records of Benson's theories of painting are almost nonexistent; these critiques are the major source for Benson's thoughts on art and the technique of painting.

In mid-March the Peirsons finally left for Italy, having already extended their Paris stay several weeks beyond their intended departure. Ellie confessed to her diary that she nearly wept, and Smith wrote home that Benson was "very lonely and grouty."[42] Benson's own sadness was quickly buried in frantic preparations for the Salon. To be

PLATE 12
Paris Parade, *c. 1885. Oil on canvas, 12½ × 7⁹⁄₁₆". Private collection. Done while Benson was a student in Paris, this painting is his first known work in the Impressionist manner.*

accepted at the Salon, to have his painting hung among the most famous contemporary artists, brought great prestige to an American artist—both at home and abroad—and was a great source of national pride. The two had received favorable comments on their pictures from Julian and their classmates and hoped that Boulanger might feel the same. Years later Smith would tell of their disastrous visit to their teacher:

> We had chosen to visit M. Boulanger on a day which, unbeknownst to us, he always entertained several ladies for tea and sherry. We'd had a devil of a time finding a cab in the driving sleet. With some twine we'd tied the pictures to the roof of the vehicle and headed for Boulanger's studio which was up near the Arc de Triomphe. Every now and then the wind would get underneath the canvases and practically lift the cab from the street. They whirled around like windmills. Dripping wet, our paintings covered in ice, we finally arrived at our destination.
>
> To reach his studio we had to climb a narrow circular staircase with our enormous canvases bumping and scraping against the cerulean blue wall. The noise we were making caused Boulanger to peer over the railing. Through the open door we could hear feminine laughter and the clinking of tea cups. He glared at us and we wanted to turn back, but we were too far up for that. The higher we climbed the frostier the air emanating from the apartment seemed.
>
> Now, Boulanger was a miniaturist and his place was full of tiny easels. Our pictures were about six feet long and we couldn't see where to put them. Frank placed his on one of the little easels trying to attain a level aspect as it waved drunkenly on the teetering affair. The master grimaced and said,"Fishing boats coming or going on an iron sea?" Not wanting to be subjected to a similar ordeal, I was starting with my picture for the door. But Benson caught me slipping in the puddle of water that had drained off the pictures. "No you don't," he exclaimed. I had to stand and face the music. I'd painted a picture of a tramp with a false leg surrounded by curious children, who now, to my jaundiced eye, appeared rather spindly creatures. "Tell me, little one," Boulanger said, "Explain this curious phenomenon. Explain the interest all those little children show in a single wooden leg when each of them has two?" With a raucous burst of laughter he bade us adieu.[43]

Perhaps it was this encounter with Boulanger that made Benson realize that, as he used to tell his grandchildren, "Every painting has two painters: the one who paints it and the one who, when it is finished, hits the first one over the head and takes it away."[44] With no time left to rework their paintings, Benson and Smith joined the throngs of artists headed for the Palais de l'Industrie to enter their paintings in the Salon. Standing in the long line of hopefuls, the two finally reached the large desk, where their four works were measured, numbered, and sent along to the jury of forty men, elected by the artists themselves, who would evaluate each work. Smith explained the process to his parents: "Old Julian always comes in to the atelier and finds out his fellows' numbers. Then he gives those to Boulanger or Lefebvre and they keep their eyes opened when those numbers are called. . . . Then, when any fellow gets in, old Julian is the first one who finds it out. . . . I shall be on pins until I know."[45]

For the next two weeks every letter home expressed the agony of waiting. Despite being told that they were among Julian's "most promising pupils," the two friends learned early in April that none of their works had been selected. "Old Julian is very much worked up about it and says he is very, *very* much surprised," Smith wrote. "He seemed very sorry for us and told us that this mustn't make any difference to . . . (he) says there has been great unfairness among the jurymen this Salon, and he did all he could for us but to no purpose it seems."[46]

Despite their disappointment, Benson and Smith continued to hope that the two pictures they had sent to the Royal Academy in London might still be accepted. Both paintings were begun in Concarneau; Smith's was of Jeanne playing with some children and Benson had painted Guenn/Louise posed on a cliff overlooking the storm-tossed waters off the Breton Coast (plate 13). The pearl gray light that suffuses the work and the careful modeling of the figures testify to the influence of Alexander Harrison (and,

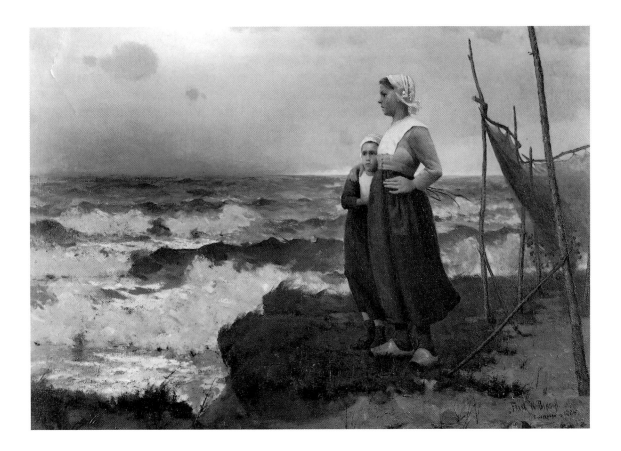

through him, Bastien-Lepage) on Benson's painting. In the waves of *After the Storm* we
see a brief hint of Benson's experimentation with the Impressionist treatment of light as
he touches it to the tips of the curling fingers of waves that crash against the headland.
Shortly before leaving Paris, Benson received word that *After the Storm* had been ac-
cepted by the Royal Academy—the British equivalent of the Paris Salon. His delight at
being able to return home having had at least one picture hung in a prestigious Euro-
pean show was tempered by Smith's disappointment in yet another rejection.

The acceptance of Benson's painting by the Royal Academy gave him a strong sense
of accomplishment. But, as he packed up his many canvases and sketchbooks for his re-
turn to America, he realized that he had accomplished more than a simple hanging at an
exhibition. Although his time at Julian's had resulted in a mastery of drawing from the
figure and a firmer command of the highly finished work that was the mark of a good
academic painter, it had also brought him the highest praise Boulanger had ever lavished
on a student's work. Perhaps more important than his formal studies and his observa-
tions at the Salon and the Louvre were the friendships Benson made in Paris and Con-
carneau. The free and easy spirit of *amitié* that united the many young Americans in the
various ateliers created a climate for honest evaluation of each others' work. Encourag-
ing each other when they were having difficulty, rejoicing in their successes, the art stu-
dents formed a bond that, for many, would last a lifetime. Through the generous criti-
cism of older artists such as Grayson, Metcalf, and especially Harrison, Benson reaped
the results of their years of study with other masters, notably Bastien-Lepage. Arthur
Hoeber took Benson to exclusive Paris art clubs such as Le Cercle Artistique et Litteraire
and Cercle de l'Union Artistique, Simmons corrected his drawings, and Grayson lent
him a studio. Benson took home far more than just paintings.

With a mixture of sadness and excitement, Benson and Smith boarded the train that
was the start of their journey home. A group of friends from Julian's saw them off. Their
time in France—the training, the friendships, the experiences—would affect them for
years to come. As Benson wrote to Smith shortly after his eightieth birthday, "Didn't we
have a marvelous two years in Paris! It may be that it means more to me that I've never
been away from home since then."[47]

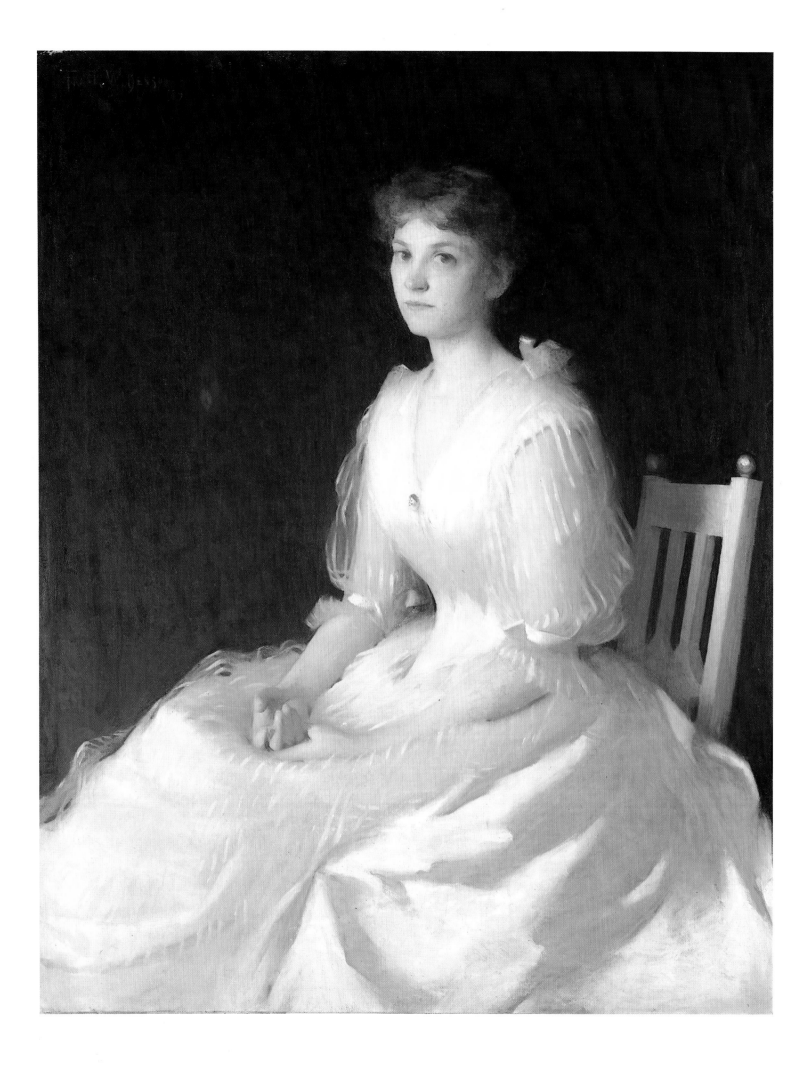

CHAPTER 3

NEW BEGINNINGS

As their ship steamed home across the Atlantic, Benson and Smith spent long hours planning their careers. They would begin by painting portraits, for that was the usual entree into steady work for a new artist. Perhaps they might have to do a bit of magazine or newspaper illustration, or teach, all time-honored ways of meeting one's art expenses; but they both hoped they would find customers for the plein-air work they had begun the previous summer at Concarneau. The way to acceptance of these works had been paved for them by several artists. Bostonian William Morris Hunt openly acknowledged his debt to the influence of French painter Jean-François Millet, an artist who received much praise in American art literature of the time. Millet's popular, life-sized scenes of peasant life inspired many artists, including Bastien-Lepage whose monumental *Jeanne d'Arc* was greatly admired when it was seen at the Museum of Fine Arts in Boston.

The young artist John Singer Sargent, born in Florence of American parents, had had great success with a painting of peasant life done on the coast of Normandy and titled *Oyster Gatherers of Cancale.* It was his second work to be hung at the Salon; he sent another version to the first exhibition of the Society of American Artists, where it received much praise, was immediately sold, and quickly made its way to the Museum of Fine Arts, Boston.

Benson and Smith quickly rented studios and hung their paintings, took out small advertisements in the *Boston Evening Transcript* and the *Salem Evening News,* and waited for what they hoped would be a steady stream of patrons. Despite his vow that he and Benson would never separate, Smith established a studio on School Street in Boston, while Benson and Phillip Little rented a studio together in Salem from an old family friend, James Robinson.[1] Their first atelier was on the top floor of Number Two Chestnut Street, long known as the "Studio Building." Built in 1826, this graceful brick double house was home to several artists and musicians as well as a private school. Robinson became Frank's first patron when he commissioned him to paint a portrait of the first president of the Salem Common Council, John Glenn King.

The friendship between Frank and Ellie that had begun in childhood and blossomed in Concarneau and Paris deepened through their letters. Shortly after her return from Europe, Ellie wrote in her diary, "My engagement has been out now for a fortnight and seems to have pleased all Salem and we really surprised a great many people although we did not expect to do so. I was overwhelmed with the most beautiful flowers for three days after the engagement came out and at night, when put to soak, they filled four washtubs. . . . people are beginning to invite us out together" (plate 15).[2] Their engagement lasted three years, for Benson felt he needed to establish himself as an artist and to prove to Mrs. Peirson that he could support Ellie and the family they planned to have. He was hopeful but pragmatic. He knew that only a small number of artists ever achieved true financial success.

Benson was part of a generation of artists able to capitalize on the developing

PLATE 14
Portrait in White, *1889. Oil on canvas, 48⅛ × 38¼". The National Gallery of Art, Washington, D.C. Gift of Sylvia Benson Lawson. This portrait of Ellen Peirson Benson, wearing her wedding dress, was finished the year after her marriage.*

enthusiasm for art in New England after the Civil War. By 1881 Boston historian Arthur Dexter felt confident in stating, "No city has more genuine love of art or more earnest followers of it than Boston."[3] The Museum of Fine Arts presented its first exhibition of contemporary European and American painting in 1879 and held an annual show of new American works each year through 1885. In addition to the museum, by 1880 the artists' clubs of Boston were engaged in presenting a full round of exhibitions in the city to audiences numbering in the tens of thousands. The oldest of these, founded in 1855, was the venerable Boston Art Club, which provided instruction in art as well as sponsored exhibitions. By 1881, its membership had swelled to eight hundred members, and it was engaged in building an elegant new headquarters in Back Bay. When "men of trade"—admitted to offset the heavy costs of the new clubhouse—began to outnumber the artists, many long-time members sought other clubs. Since active involvement in the arts was mandatory for members of the Paint and Clay Club (established in 1880), it attracted many artists just embarking on their careers, Benson among them. Perhaps because the club's membership included so many artists who were young and European-

trained such as Hassam, Bunker, Tarbell, and Metcalf, the Paint and Clay Club was dubbed the most liberal and innovative of the Boston art clubs. Its highly successful shows often attracted close to twenty thousand people a year. It was here that Benson began a long friendship with William Howe Downes, a leading art critic and writer for the *Boston Transcript,* who later became a chronicler of Benson's career.

As an alumnus of the Museum School, Benson was also a member of the Art Students Association. Founded in 1879 by members of the first graduating class, it held exhibitions of members' work twice a year in space rented with dues and fees. By 1891 the group had opened its membership to anyone interested in art; ten years later it changed its name to the Copley Society. Another alternative for artists was the St. Botolph Club. Originally founded in 1879, its purpose was "the promotion of social intercourse among authors and artists and other gentlemen connected with or interested in literature and art."[4] Their headquarters facing the public gardens quickly became a center for major exhibitions and a focal point for the Boston art world.

St. Botolph's embarked on what would be a long history of innovative and important exhibitions. At its first show, in 1880, John Singer Sargent's portrait of his painting teacher Emile Auguste Carolus-Duran was the beginning of Bostonians' acceptance of new approaches to portraiture. Their ancestors (and Sargent's, too) had sat for serious portraits by John Singleton Copley, but Sargent was establishing a new model for how to paint a portrait. Through his travels and studies in Europe, Sargent had absorbed the bravura style of Hals and Velázquez and had been greatly influenced by the painterly manner of his teacher's work. His casually elegant portraits managed to be both refined and opulent (perhaps a shade too much so for dignified and modest Bostonians). Sargent's success with paintings of men, their faces dramatically lit against dark backgrounds, and women, dressed in elegant gowns and posed in well-appointed interiors, was not lost on Benson.

Portraiture was not the easiest way to make money, but it was the most efficient way for Boston artists to support themselves in the 1880s. As commissions were slow in coming, Benson spent the first months in his new studio honing his skill by painting members of his family. He asked his sister Elisabeth to sit for her portrait as a surprise for his mother. His French training is evident in the tight brushstrokes, highly polished finish, and careful modeling of the face of this solemn, big-eyed girl (plate 16). To while away his time, Benson painted a portrait of his new fiancee, as well as another self-portrait, which was far more defined and polished than the one he had done in Paris the preceding year. Benson exhibited these portraits, as well as some of his canvases from

Concarneau and Paris, in his studio and entered as many exhibitions as possible. His submission to the Royal Academy, *After the Storm,* sold quickly and friends urged him to submit a new work, *The Storm,* to the prestigious annual show at the Pennsylvania Academy of the Fine Arts in Philadelphia.

By the time he had returned from his training in Paris, most of the major art museums in America held annual shows in which the paintings to be hung were selected by a jury of well-respected artists. Such a position was in itself an honor and in time Benson would become a frequent member of such juries or "hanging committees." But at this point in his life, to gain acceptance to one of these shows was honor enough. Like most young artists, Benson submitted works not only to shows held at museums but also to those organized by artists' organizations. Benson knew such exposure would help make his name and possibly his living. Unlike today, in Benson's time paintings could be bought directly from museum exhibitions.

As his first submission to a show at the Boston Art Club, Benson sent two portraits, possibly his self-portrait and the portrait of Joe Smith that he had painted in Paris. Writing in January 1886, the reviewer for the *Boston Transcript* noted that the portrait of a young man showed "a good deal of life and character."[5] At this exhibition, Benson saw paintings sent from abroad by Willard Metcalf, who had divided the past year between studies at Julian's and trips to Brittany and Normandy. Also at this exhibit were works by Childe Hassam. Benson had seen some of Hassam's early watercolors of New England scenes in 1882, but in the intervening years, Hassam had traveled widely in Europe, executing paintings of Venice, Holland, and Spain. He had taught art classes in Boston and begun painting atmospheric scenes of Boston streets in the rain. Shortly after the close of this exhibition, Hassam returned to Europe to study at the Académie Julian; his earliest Parisian painting, *A Shower, Rue Bonaparte,* echoes the deep perspective and palette of his previous Boston works.

In the fall of 1886 Benson submitted work for the first time to the National Academy of Design in New York City. Formed in 1825 as an offshoot of the New York Drawing Association, the academy restricted its membership to professional sculptors, architects, painters, and engravers. Its exhibits were the first in the United States to consist entirely of new works by living artists. They were so successful that the admission receipts covered the expenses of both the school and the exhibition itself. Because of its leading role in increasing the public understanding and reception of contemporary American art, the academy has been hailed as the leading force in establishing New York as the premier "marketplace" for both European and American art.

Benson's submission, *Moonlight* (unlocated), was favorably compared by one critic to the seascapes of his Concarneau friend Alexander Harrison (plate 18). Another reviewer called *Moonlight* "a capital performance," adding that "the sense of unresting waters is prettily conveyed without leaving an impression of a noisy or busy picture.... The artist has certainly made a moonlight that has extra sentimental value."[6] Another friend from the previous summer, Arthur Hoeber, wrote Benson hearty words of congratulation upon seeing his work. Slipped into an envelope on which Benson had written "My first sale in New York, 1886," the note reads, "I wrote you on varnishing day and now have the pleasure of adding that your *Moonlight* is sold. Congratulations—on your good fortune."[7]

Benson wasn't the only man to achieve success in New York City that year. The Parisian art dealer and champion of the Impressionists Paul Durand-Ruel had been invited by the American Art Association to organize an exhibition of Impressionist paintings in New York City. The show opened in March and proved to be so popular that it was transferred in May to the larger space of the National Academy. The crowds streamed into the academy's headquarters at Twenty-third Street and Fifth Avenue and gaped at the nearly three hundred paintings, including works by Degas, Manet, Pissarro, Monet, Renoir, Seurat and Sisley. In the first gallery, as if to mollify the more traditional exhibition-goers, were fifty paintings by more conservative, popular artists. Entitled "Special Exhibition of Works in Oil and Pastel by The Impressionists of Paris," the show received extensive press coverage, ranging from enthusiasm to censure, though of

PLATE 15
Ellen Peirson shortly before her engagement to Frank W. Benson.

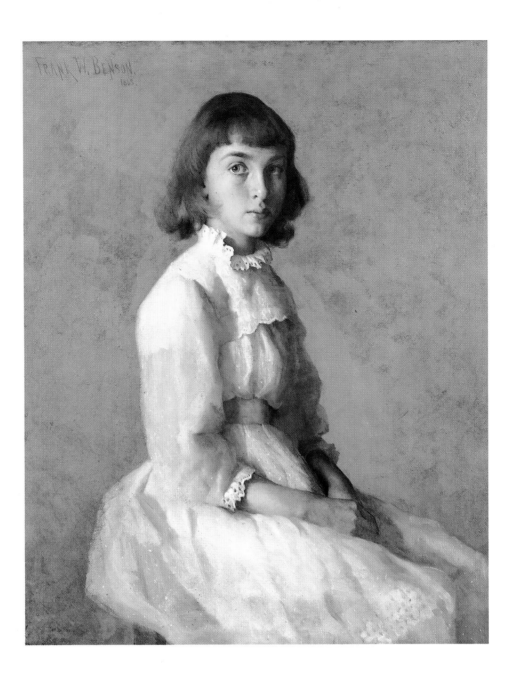

PLATE 16
Portrait of My Sister (Portrait of
Betty), 1885. *Oil on canvas, 35½ ×
29½". Private collection.*

a far less hostile kind than the early French reaction to such works. It is quite likely that
Benson journeyed down to New York to see this controversial show; most of the Boston
artists did.

In ensuing years, a small cadre of collectors, artists, and writers turned Boston into
the second largest center of the Impressionist movement. Desmond Fitzgerald, who was
a friend of several of the men who would become known as American Impressionists
and who would eventually became one of Benson's patrons, recalled in an essay for the
catalogue of a Monet exhibition in 1905 that when he had supported that artist's work
twenty years earlier, he had been "hooted at as a crazy admirer of a crazy movement."[8]
Many Boston artists helped local collectors obtain these newly fashionable works, but
Benson's friend, the critic William Howe Downes, admitted being both repulsed and
fascinated by the work of these radical painters.

Although Benson was far from radical, portrait commissions were slow in coming.
He must have been pleased to be offered a teaching position with the Portland Society
of Art. He had exhibited his portrait of Smith in the fall of 1886, which may have led to
the offer. It is also possible that Charles Fox, whose portrait Benson had painted in Paris,
had told Benson about the newly formed school in his native city. Operating informally
since 1884, the school officially opened in December 1886, and Benson appears to have
begun teaching there in the spring or fall of 1887.[9] In two five-month terms in Portland,

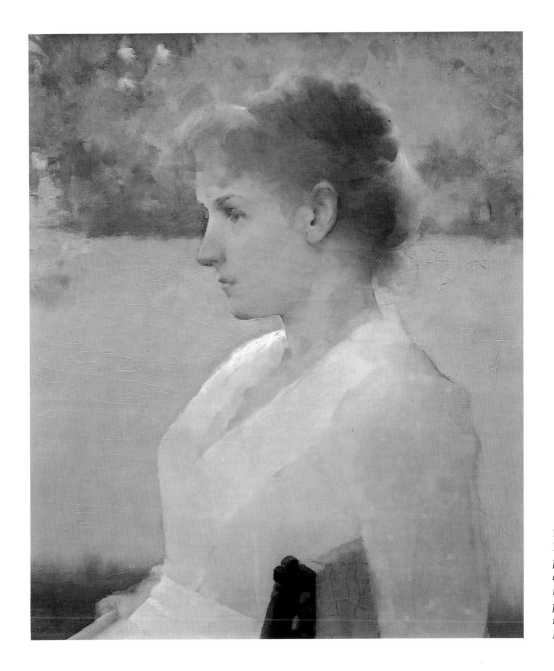

PLATE 17
In Summer, *1887. Oil on canvas,
present dimensions 25 × 21" (original
dimensions unknown). Private collec-
tion. Originally nearly life-size, this
painting was cut down under Benson's
instructions by his oldest daughter,
Eleanor, herself an artist.*

he taught some eighty students to work from casts, to draw with charcoal and crayon, and to paint in oils.

By the winter of 1887, when he exhibited at his second Boston Art Club show, Benson was able to display one of his first commissioned works, a portrait of Mrs. J. L. Williamson, as well as another portrait of Ellie, dressed in a dark green gown wearing a hat of the same color. The art critic for the *Transcript* admired Ellie's portrait, calling it "very sympathetic" and "very delicate and sweet in the color and handling of the flesh." He added, "The right hand is particularly good"—an interesting comment, given Benson's later complaint to his family that "hands are the hardest part."[10] That summer Benson again painted Ellie, posed in the gardens behind the Peirsons' Barton Square house. Titled *In Summer,* this painting was his first work to be exhibited at the Society of American Artists, then considered one of the most important shows in the United States (plate 17).

The society was founded in 1877 as a reaction against the conservative policies of the National Academy of Design. When a new generation of artists returned from years of European training, their paintings were attacked for their "foreignness"—the lack of a smooth finish, the sketchiness, the light palette, the absence of a "typically American idiom"—and denied admission to the academy's annual exhibition. But the young artists were proud of their paintings, which portrayed the old monuments of civilization, classical motifs, and finely modeled figures in groups never before attempted by

American artists. Four of the founders of the society—Weir, Twachtman, Chase, and Dewing—would later become members of The Ten, and most of Benson's contemporaries—the prominent painters of America's next generation—joined the society. Much as the Impressionists had revolted against the rejection of their works by the Paris Salon, these new *refusés* quickly organized their own exhibition.

In spite of holding separate exhibitions dedicated to a liberal admission policy, the society never totally broke with the academy; many artists remained or became members of both. Animosity simmered between the two groups for years, fueled by the bitterness of the young painters of the society who felt that American buyers would prefer to pay outrageous sums for a mediocre painting by a European or an American abroad rather than pay a modest sum for a better painting done in America by an artist trained in Europe. The year the society was founded, Weir's brother wrote to him in Paris, "There is no interest in art here now—the outlook was never so discouraging. Stay over there as long as you can."[11]

In addition to the honor of admission to an exhibition, an artist's foremost hope was that the hanging of his painting might prompt a sale or a positive critical mention in one of the important art journals, or both. In that respect, Benson was not disappointed; *In Summer* was the first of his paintings to receive comment in a national publication and was later selected for the International Exposition of 1889 in Paris. The painting appears to be an attempt to combine some of the principles of the "new" Impressionism with the more accepted plein-air treatment of atmosphere and the academic emphasis on fine modeling. The critic for *The Nation* described the portrait as "clean and fresh in color, and very good in ensemble" and declared Benson to be a "a painter of whom much may be expected."[12]

Undoubtedly encouraged by the critic's comments and determined to meet these "expectations," Benson resigned his teaching position in Portland and moved his studio to larger quarters at 145 Dartmouth Street in Boston in the fall of 1888. Dennis Miller Bunker and Edmund Tarbell were already working in this large building; Willard Metcalf would soon join them. Benson's new studio was only a few blocks from the Museum School, where Smith had been hired as the school's first instructor of design and decorative drawing. Benson had corresponded with Grundmann while in Paris, and the proximity both to his former teacher and to Smith must have been an added attraction.[13]

Frank and Ellie were married in the big granite Unitarian church on Salem's Essex Street on October 18. They honeymooned in various little towns of New Hampshire and at the newly completed Wentworth Hotel in Newcastle, which overlooked the mouth of the Piscataqua River, Portsmouth harbor, and the Atlantic Ocean. The newlyweds bought their first piece of furniture on their wedding trip—an antique sideboard. Ellie wrote to her mother about it, adding, "The country looks beautiful all about, but the roads are deep in mud. . . . After all, I forgot my silver tea ball. Do you think it would be safe to send my plainest one by mail?"[14] For a young woman used to traveling with her own silver tea ball, life with a struggling artist would require some adjustments. The young couple returned to Salem and moved into a small house at 77 Lafayette Street, only a few blocks from their families. Without his previous teaching salary and with both studio and house rent to pay, it was indeed an uncertain time for Benson. Years later he would recall, "The year after we were married, I only made 400 dollars, and I thought the end had certainly come."[15]

Judging from the date on Benson's portrait of Ellie's uncle, Samuel Parkman Tuckerman, that entire sum probably came from this single commission. Tuckerman, an accomplished composer, first met Benson when he visited the Peirsons in Paris in 1885; he saw the young couple often, as he lived in Boston.

Benson used the early months of his marriage to paint a study of his new wife, long considered one of his best and most sensitive portraits (plate 14). In *Portrait in White*, Ellie appears to be somewhat self-conscious, almost shy, as she sits somewhat stiffly in the plain wooden chair. This painting shows a marked departure from his previous portraits: while the simple composition and quiet palette reflect Frederic Porter Vinton's influence, the freer application of paint, lighter brushwork, and delicate delineation

predate Benson's move towards Impressionism. The rapport between artist and model is evident, making the viewer feel almost like an intruder. Only rarely exhibited, this painting hung over Benson's mantelpiece until twenty years after his death.[16]

In January 1889 Willard Metcalf joined Tarbell, Bunker, and Benson at the Dartmouth Street studios. He had shipped dozens of paintings home from his long stay in France for his first one-man exhibition at the St. Botolph Club. In the four years since Metcalf had left Benson in Paris, he had painted in Algeria (and won an honorable mention at the Salon for a work completed there) and settled, in 1887, in Giverny, where Claude Monet had been living for four years. There Metcalf, considered to be the earliest member of Giverny's American contingent, worked with the small nucleus of painters—Theodore Robinson, John Leslie Breck, and Theodore Wendel—who followed him as the first Americans to settle in this charming village. While not sacrificing the precepts of Bastien-Lepage and Harrison or the teachings of Julian's, Metcalf's paintings began to show a lighter palette, heightened values, and variegated brushstrokes.

Although Metcalf's show at St. Botolph's received critical acclaim, his work did not sell well. Theodore Wendel's latest works could be seen at the same time at another exhibition in Boston, affording critics an opportunity to compare the two recent *retournées.* They were quick to note the modernity of both painters, but Wendel was felt to be the Boston painter whose work came closest to emulating that of Monet.

Reentry into the American art world could be difficult for many young artists returning from Europe. The strong support of art in France, demonstrated by state supported schools and by awards for excellence caused dissatisfaction among Americans who had witnessed their own government's indifference to the arts. Several young artists returning to Boston found the taste of the typical Bostonian too traditional. Despite the fact that some artists, William Morris Hunt in particular, were guiding wealthy Bostonians in their selection of art, collectors were slow in buying the works of the young Americans. Benson's and Metcalf's contemporaries—Paxton, Hale, and most emphatically Bunker—have all been quoted as saying that Boston was not the place to be an artist. Bunker, who had painted with Sargent the year after Sargent had spent a summer with Monet at Giverny, adapted techniques from both men's work in a style that was loose in composition and bright in color. Returning from Europe to teach at the newly founded Cowles School in Boston, he found that his work was considered "unsettling" in New York but "radical" in Boston. Calling the city everything from a "deplorable place" to an "accursed town," many young artists—fully half of the soon-to-be-famous Ten American Painters—left Boston for the greener art pastures of New York. By the spring, Metcalf would add his name to that of Simmons, Reid, Hassam, and Dewing by taking a studio in Manhattan. Bunker would soon follow.

It is clear that not all New England artists shared the opinions of Bunker and Hassam, for there were always plenty of artists available for "crits" at the Dartmouth Street studios; it was here that Benson began to paint his "studio pieces." His earliest known "interior with figure," *By Firelight,* is the first of a series of paintings in which he combined graceful women in elegant gowns with carefully arranged objets d'art illuminated by flickering flames or muted lamplight (see plate 26).[17] Part figure study, part still life, these lamplit and firelit scenes disappeared from Benson's oeuvre when he moved in 1893, to a new studio on St. Botolph Street, where illumination was provided by two tall windows rather than fires and oil lamps.

By Firelight is probably a study of his youngest sister, Elisabeth, who died two years later, at the age of nineteen. Although the artists' models of Boston began slipping their cards under his door as soon as he opened his studio, Benson lacked the funds to hire professional models this early in his career. Though not portraits, subtle likenesses of his sisters, Georgiana and Elisabeth, and his wife, Ellie, can be seen in many of his earliest studio pieces. Photographs reveal that Benson, possibly influenced by Thayer, transformed the women in his family into an ideal: heavy brows were thinned, round noses were straightened, cheekbones highlighted, mouths made smaller. As his eldest daughter, Eleanor, once wistfully recalled, "He always made us far more beautiful than we were."[18]

By Firelight was not exhibited at the National Academy until 1892. One critic, having seen a similar work in the series the previous year, noted that it was a "picture rich in feeling."[19] Another reviewer touched on Benson's use of light when he remarked that the painting was an "exceedingly clever study in illumination, like his treatment of lamplight last year."[20] Although these works do not have the traditional hallmarks of Impressionism, Hamlin Garland, a knowledgeable writer on art, classified them as Impressionist because of their emphasis on color and light.[21]

In May 1889 Frank Tompkins, the teacher of the life class at the Museum School, resigned and the school's board voted to appoint Edmund Tarbell to fill the position. While the other instructor at the school, Joseph De Camp, had taught there for three years, the board "had concerns about offering De Camp a raise in salary because, though valuable in many respects, he had not been entirely satisfactory."[22] Obviously angered by the lack of salary increase, De Camp quit the following week, leaving the board in the position of having to find a replacement for instructor in antique drawing. After the position was refused by two other men, the board offered it to Benson. The news of a permanent position could not have come at a more welcome time; the Bensons had just learned they were expecting their first child.

Frank and Ellie were not the only ones who were pleased with the school's offer, for according to a letter written from Europe by Joe Smith to his mother, Benson, like so many Boston artists before him, "had made up his mind to go to New York this winter and settle there." Joe added that the Peirsons and Bensons were "all very glad that he is to be in Salem still." And George Benson's fears for the financial security of his artist-son were finally allayed, for as Joe added, "This position at the Art Museum, which will bring in $900, will certainly make his father look bright enough."[23]

That year the Bensons summered in Dublin, New Hampshire, a quaint New England village nestled at the foot of Mount Monadnock. Joseph Smith was probably there as well, for he had been invited to Dublin about this time by Mrs. John Singleton Copley Greene, a Boston heiress, to paint her daughter's portrait. Mrs. Greene gave Joe and his parents (who lived with him until their deaths) a piece of land at Loon Point on Dublin Lake. The Smiths built their first summer house there in 1890.[24]

Mount Monadnock had been a magnet and an inspiration for the writers and philosophers of New England since the 1830s; by 1850 the nearby towns were being visited by vacationers seeking summer refuge from the heat of the cities. But Benson (and, undoubtedly, Smith as well) was drawn to Dublin to study with Abbott Henderson Thayer.[25] Thayer, born in Boston, had been working in New York and had studied in Paris at the the Ecole des Beaux-Arts atelier of Gérôme in the late 1870s. Miss Mary Greene, a cousin of Smith's patron, urged Thayer to visit Dublin and promised to build him a house as well as a studio if he would set up an art school there. The Bensons spent the summer in a little cabin on the south end of the lake. There, Mrs. Greene had erected a few rustic cottages and loaned them to various musicians, artists, professors, and other "persons of arts and letters," gathering together a sort of "Salon." The heady, creative, and slightly bohemian flavor of this group earned for the little colony of cottages the sobriquet "The Latin Quarter."

That summer, Benson painted many views of Mount Monadnock and the surrounding countryside. This mountain and the nearby woods, which he had hiked as a boy, appear frequently in his paintings and those of Thayer (plate 18). Indeed, their respective studies of the Dublin landscape look so similar that it is easy to imagine these two painters seated on their campstools not far from each other, painting the same view. Just as the paintings of the French Impressionists reveal them to have had "sketching parties" at particularly picturesque sites, so too the artists of Dublin—Thayer, Benson, Smith, and later George de Forest Brush, Rockwell Kent, and Barry Faulkner—often packed their traps upon their backs and hiked together to a favorite spot where each painted the scene in his own particular style.

A brief note in the diary Benson kept of his fishing trips sets the stage for a lifelong friendship with Thayer, whom he deeply admired and who was a great influence on his early years as a painter. "I got [fish] more or less every day . . . over 100 in all," Benson

wrote. "Thayer caught one of just one pound and Struthard a big one."[26] It is not surprising that the first bonds of friendship between these two should be through sport. Just as Benson's first painting was of a bird he had shot, Thayer's first work had been of a fish he had caught and arranged in a still life on the grass. Their mutual love of wildlife featured prominently in their correspondence and paintings.

The two painters were both drawn to the challenge of representing the protective coloration of fish and animals. Wildlife figure prominently in their later works and Benson's acceptance of Thayer's principles of camouflage is clear in several of his later watercolors of wildfowl[27] (see plate 136). Thayer's influence on Benson's watercolor studies of birds in their natural habitat was strong, as was his influence on Benson's portrayal of women. Thayer, eleven years Benson's senior, was convinced that true artists were given a "divine gift of vision." His idealized portrayals of young women as angels or madonnas often showed them clothed in heavenly raiment, complete with wings and halos (plate 19). Although Benson painted more mortal girls, the idea of women as divine creatures intrigued him as can be seen in the subtle circular background of *Decorative Head* suggestive of a halo (plate 20).[28] In the mid-1890s, when Benson was commissioned for a series of murals for the Library of Congress, critics found a good deal of evidence of Thayer's influence in the allegorical representations of the seasons. But as Benson began to discard his decorative figure motif and adopt his own unique handling of young womanhood, critics noted more the differences between the two men's styles: Benson's young women were fresh, real American girls while Thayer's women were romantic visions of otherworldly goddesses.[29]

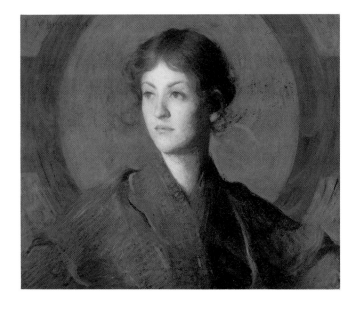

While Benson and Thayer painted in Dublin, *Portrait in White* was charming the reviewers when it was first hung that July in Boston at an exhibition at J. Eastman Chase's gallery on Hamilton Street. Benson and Tarbell probably thought it a clever tactic to hang their portraits of their wives side by side. The art critic of the *Boston Transcript* wrote, "There are two remarkable portraits by two remarkable painters of this locality. . . . Mr. Benson surprises us with a charming portrait of his wife, by far the best painting he has ever shown. . . . Both these canvases emphasize what was said in these columns not long ago, that Boston still maintains her old-time supremacy in the field of portrait painting."[30]

Despite the critic's comments, Benson's portrait commissions were still slow in coming. During his first year as an instructor, the majority of his portraits were of family and friends: Ellie's brother Horatio, Mr. S. D. Bush and his wife, and a work known as *Girl with a Red Shawl,* for which Benson's older sister, Georgianna, is considered to be the model (plate 22). Benson also completed a portrait of his close friend Edmund Tarbell. Given to Tarbell's wife, Emeline, to celebrate the birth of their first child, Josephine, the portrait was called a "spirited likeness" with a "keen appreciation of character" by critics.[31]

That fall marked another first for Benson; his painting of Orpheus (misprinted in the checklist as *Orphans*) was awarded the third Hallgarten prize at the National Academy of Design. *Orpheus* was praised as "a charming idyll" by the critic for the *Boston Transcript,* who wrote, "The figure is well drawn, the whole well conceived and the landscape is of a soft Corot-like quality of green which is poetic and beautiful."[32] The comparison with Jean-Baptiste Corot, the French landscape painter of the Barbizon school whose misty, atmospheric work portrayed the personal moods of nature, is informative; the comment also indicates why Benson's works were being accepted by the

conservative National Academy when so many of his contemporaries were still being snubbed—he included enough of the traditional "safe" academic tenets in his work to please the jury at the academy while he continued to experiment with enough of the new techniques to be included in the Society of American Artists' shows.

The eclectic nature of Benson's subject matter during this period indicates that he was tentatively experimenting with different genre. *Head of Saint Cecilia*, exhibited in 1889, *Pomona*, shown in 1896, and *Orpheus* appear to be Benson's only known excursions into truly classical themes.[33] In the following decade Benson completed several allegorical figures representing the seasons and the three graces, although the biblical and classical subjects so often painted by his French teachers do not appear in Benson's work.

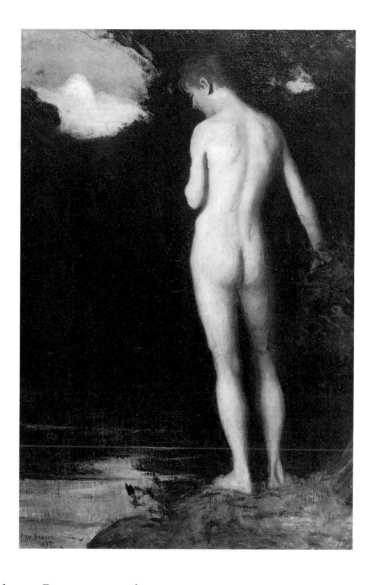

Orpheus is Benson's first known nude; he is thought to have painted only one other, *The Bather*, bought for the Rhode Island School of Design by his patron, Isaac C. Bates (plate 21). As a student, Benson sketched nudes in life class, one of which, a study of a prone male, still exists. But while many of his contemporaries painted the nude figure, Benson did not. It may have been that the ghosts of his Puritan forefathers combined with Victorian morality to prevent Benson from using such a theme in his work. It might also have been that he knew these works simply would not sell well in a Boston whose citizens so ardently supported such groups as the New England Society for the Suppression of Vice, an organization founded while Benson was in Paris.

Nonetheless, *Orpheus* brought Benson the first of many prestigious marks of recognition. Beginning with the Hallgarten, he was to win prizes almost every year, capturing nearly every award in the art world. Indeed, thirty years later, his friend Willard Metcalf wrote to congratulate him on winning the Logan prize in Chicago: "I am surprised only because I thought you had already taken it. Well, now! There isn't anything left for you and someone will have to inaugurate some new prize somewhere."[34]

On 30 January 1890, the Bensons' first child was born, a daughter, whom they named Eleanor. As his first "home-grown model," Eleanor would be immortalized on canvas many times: sitting with her cat, picking flowers with her mother, picnicking in the woods. As she grew older she was *Girl with the Veil, The Reader, The Seamstress*, and many other titles. Later, when she became a mother in her own right, her father painted her with her little son, Benny, on a garden bench. When Eleanor's brother and two sisters were born, Benson would often paint them together; his sunlit paintings of his children are among his best known works.

The year 1890 brought with it not only an expanding family but an expanding audience for Benson's work. In addition to the National Academy show, Benson exhibited at the Pennsylvania Academy (*Orpheus*), the Boston Art Club (*A Study*), the Society of American Artists (*Portrait of a Young Girl*), and, for the first time, at the St. Botolph Club. The invitation to be part of an exhibition at the St. Botolph Club was an honor for the young instructor. The first club in Boston to host one-man exhibitions of Monet and Sargent, it would, in 1900, be the site of Benson's first one-man show.

Benson's heavy exhibition schedules and teaching responsibilities made him eager for summers away from Boston. In what would become part of a life-long pattern, Benson took his wife and new baby and headed, once again, for the cool summers of northern New England, where he began a painting, obviously influenced by Thayer, of Ellie

PLATE 21
The Bather, *1897. Oil on canvas, 39½ × 27½". Collection of the Museum of Art, Rhode Island School of Design, Providence, Bequest of Isaac C. Bates. This work and* Orpheus *(unlocated) are Benson's only known oils of nudes.*

47

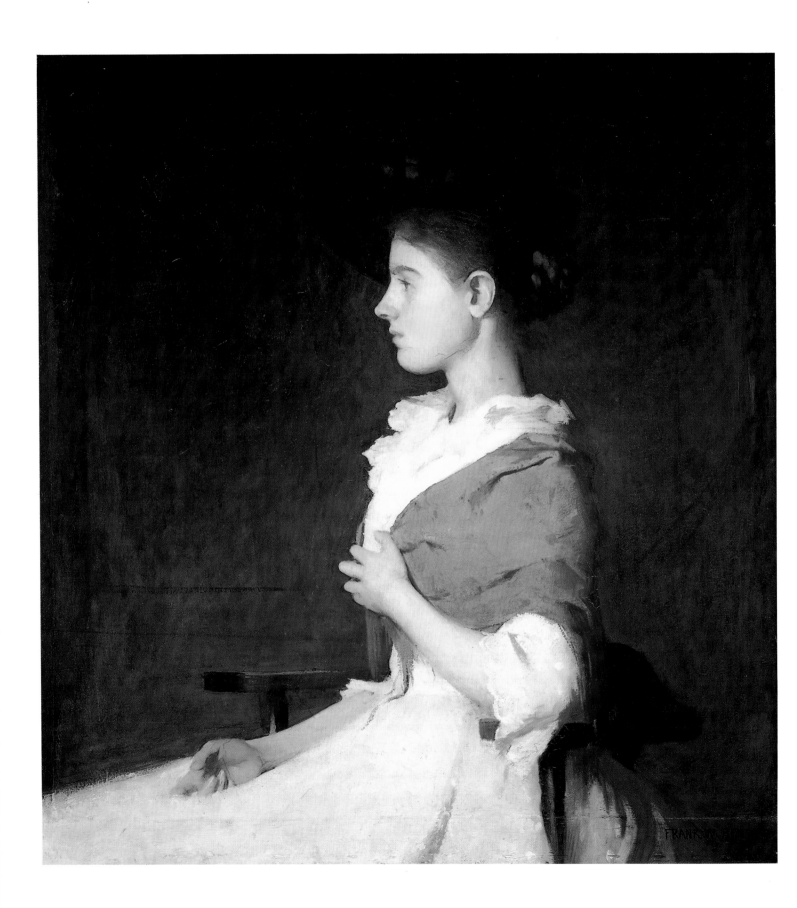

as the goddess of summer (it would not be exhibited for six years, see plate 38). Benson is best known today for the works that he did during the summer months. In 1890 the Bensons returned to Dublin, where Frank helped Joe Smith and his father build their first house on Loon Point. They also put up a barn studio which was often used by local artists, scientists, and inventors. Smith's father, once reluctant to see his son pursue a career in art, set up a framing shop for Joe's paintings in one part of the barn. Joe would spend the rest of his life summering in Dublin; the Bensons would return for the next four summers. Two years later, the Tarbells visited the Bensons in Dublin, where Tarbell completed his famous *Mother and Child in a Boat,* no doubt from the porch of his cottage overlooking the lake.[35]

With a portfolio full of paintings begun in Dublin, Benson returned to Boston, where he found a larger studio in the Harcourt Studios Building at 32 Irvington Street, an easy walk from the Museum School. But the beginning of Benson's second year there was marred by an unexpected tragedy: the death of Otto Grundmann. Although the school had never had an official director, Grundmann had been regarded as its principal instructor. In a hurriedly called meeting, the board of the school voted to "engage Messrs. Benson and Tarbell to teach the Life Class twice a week at a salary increased pro rata, until a permanent teacher can be engaged."[36] The previous June, Benson had noted that he was doing the work that had formerly been done by two men. With Grundmann's class to teach, he was overwhelmed.

A subcommittee, formed by the board to find a permanent director for the school, wrote to Walter Gay, an American artist living abroad, "concerning the possibility of securing a good man in Paris." Learning that his "opinion was . . . decidedly unfavorable, as all the men whom the school would desire were unwilling to leave Paris " the committee looked closer to home. "In view of the very satisfactory results obtained by the school under its present system," the board voted to ask Benson and Tarbell to remain in their present capacity and raised their yearly salaries to fifteen hundred dollars, a substantial increase over their previous salaries.[37]

Benson's rapport with his students was strong. Although board minutes reveal that he ruled with a firm hand, his students affectionately dubbed him *Cher Maître* in reference not only to his use of French terms in his critiques and his penchant for speaking French with students who had been abroad, but also for his patient and encouraging manner.[38]

Many years after her graduation, one of Benson's students wrote of her classes with "dear master" and compared them to those of another instructor, Philip Hale. Of Hale, she wrote, "You couldn't quite hear what he was saying, but it was awful. You could tell that by the looks of his victims. . . . He would roar. . . . I knew Mr. Hale only a year and half for at the end of that I entered 'Paradise' [Benson's life class]. What a change to get Mr. Benson, so calm and just! What a relief from Mr. Hale!" But, she added, her classes with Benson seemed almost too tame, "something was missing, the smell of powder, the roar of battle, the explosion and the gathering up of the remains."[39]

Much as he enjoyed teaching, it was not Benson's first love—painting was. In the spring of 1906, when the Pennsylvania Academy of the Fine Arts offered him a teaching position, he was already spending two days a week teaching life drawing and was clearly jealous of the time spent away from painting. The Philadelphia position, he wrote, "would take too much of the time that I need to give to painting. . . ."[40] That he felt teaching could hinder an artist's ability to paint was reflected in a letter he sent to Philip Hale's biographer: "He was a great teacher and he loved to teach to the detriment (I think) of his work—that is, he gave too much time to teaching, but his heart was in it and younger people got the benefit."[41]

After two decades of being a teacher, Benson came to believe that a person could not be taught to be an artist. He felt that "There is no such thing as teaching a person anything. You may be helped toward learning by a hint someone has given you, but anything you really learn has got to be learned by experience and only by working and solving the problems yourself."[42]

PLATE 22
Girl in a Red Shawl, *1890. Oil on canvas, 32¼ × 32¼". Courtesy, Museum of Fine Arts, Boston. Bequest of David P. Kimball in memory of his wife: Clara Bertram Kimball Fund. This has long been considered by the family to be a portrait of Benson's sister Georgiana.*

49

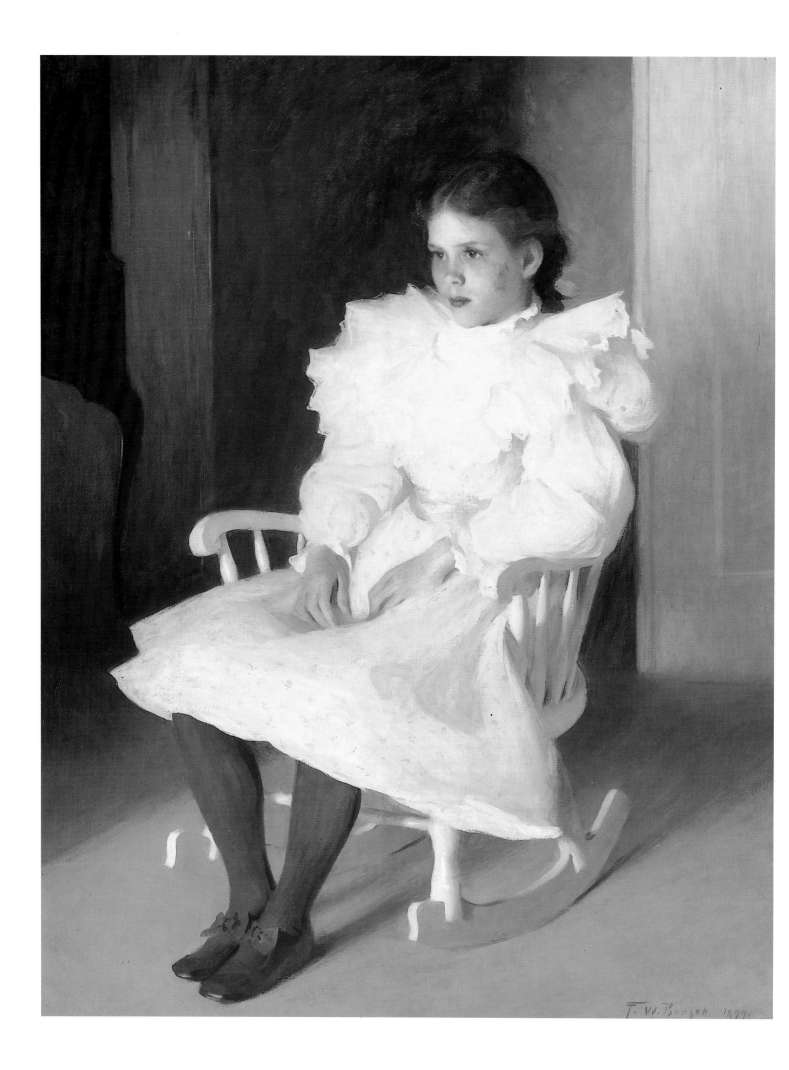

CHAPTER 4

PORTRAITS
AND PRIZES

When J. Eastman Chase invited Benson and Tarbell to hang eleven works each in his gallery in the spring of 1891, the two young instructors must have been delighted but overwhelmed. Benson's expanded duties at the Museum School and the energies he devoted to his teaching, as well as the orchestration of the shipment of various paintings destined for annual art exhibitions, left him little time to complete the works he would soon display at his first major show in Boston. Indeed, smudges of paint on the gilt frames are evidence that he continued to work on his canvases even after the supposed final moment of framing.

In addition to several works that had been shown before, Benson hung a portrait of Edmund Tarbell, which he had given to the Tarbells upon the birth of their first daughter, Josephine; the critics hailed it as a "spirited likeness."[1]

Along with the likeness of Tarbell, Benson hung several other portraits and a recently completed summer painting. This "vigorous landscape with the cool greens and blues of Dublin" so pleased one of the gallery visitors, William Minot, that he not only purchased it on the spot, but also commissioned Benson to paint his portrait the following year.[2]

The art critic for the *Boston Transcript* found much to praise in this show. "[Benson's] portraits show keen appreciation of character. . . . The *Portrait of a Young Girl in Pale Pink* is one of the best works in the exhibition." Of the portrait of Mrs. Bush, the critic remarked, "It cannot be regarded as canvas and paint. It's a living and sympathetic presence." One of the most admired works in the exhibition was Benson's new figure study *Twilight* (plate 27). The critic found *Twilight* very successful in depicting "both lamplight and fading daylight. . . . [The model's] white gowns are pearly and cool while the sharp warm light of the lamp glows upon faces and figure in glints that are true and effective."[3]

The Boston writer was not alone in admiring Benson's *Twilight*. A few months later, the jury at the National Academy of Design awarded it the Thomas B. Clarke prize for best American figure painting. Although Benson had exhibited in Chicago as early as 1889, when *Orpheus* was shown at the Inter-State Exhibition, *Twilight* was his first entry to the annual exhibition of painting and sculpture at the Art Institute in Chicago. Noting that *Twilight* had been awarded the coveted Clarke prize, the *Chicago Morning News* nonetheless complained, "As a picture that could appeal to the taste of many people not artists, it cannot be called a success because the composition is awkward and the drawing quite faulty, especially in the areas of both figures." After further criticism, however, the writer noted, "as a study of tone values it is distinctly interesting. . . . He has succeeded here in giving some very charming effects. . . . The deep shadows all through the picture are certainly interesting and very skillfully rendered."[4]

As Tarbell and Benson went to collect their pictures from Mr. Chase, they couldn't fail to notice the exhibition that was taking their place. Bright, sparkling canvases by Monet, Pissarro, Sisley, and Manet lined the walls where only three days before their

PLATE 23
Gertrude, *1899. Oil on canvas, 50 × 40". Museum of Fine Arts, Boston. The looser paint application and softer delineation of this portrait prefigure Benson's move to an Impressionist approach to portraiture.*

own paintings had hung. Certainly the "light from a red shaded lamp, fall[ing] upon flesh and gowns, tinting them in the most charming color" pleased the *Boston Post* critic Desmond Fitzgerald as he studied Benson's *Twilight,* but it was nothing like the light from the French paintings.[5] *Bâteaux echoués—port Dieppe, Champs de Coquelicots, La Ravine de la Petite Creuse*—scenes of boats and fields, bridges and valleys, seas and villages—all glittered and shone before the two young artists.

While Benson's handling of the light of fire and lamp was garnering praise, his move towards Impressionism was slow. Tarbell, on the other hand, had shown full assimilation of Impressionist concepts in the previous year with *In the Orchard* (plate 24). Its quick short strokes convey the shimmering effects of light and form, and color is bright and light. Desmond Fitzgerald, long a collector and champion of Impressionism as well as an art critic, admired Tarbell's "daring attempt at a portrayal of light."[6]

During this period, Tarbell painted out of doors frequently and soon developed a personal approach to Impressionist concepts. Yet Benson, his closest friend and fellow teacher, remained in the studio except for an occasional landscape. While Tarbell was discarding much of what he had learned at Julian's, Benson was continuing in the refined, polished, and academic manner. Why, when Tarbell seemed to embrace so wholeheartedly the philosophy of Impressionism, was Benson still holding it at arm's length? Perhaps part of the answer lies in Benson's cautious, conservative nature. Contemporary comparisons of the two friends depicted them as opposites: Tarbell was regarded as impetuous, outspoken, daring, argumentative; Benson was considered sanguine, thoughtful, diplomatic. They complemented each other well as directors of the Museum School, posts that the two artists would continue to hold for the next two decades.

Benson's close friendship with the critic William Howe Downes may also have influenced his decision to approach Impressionism with caution. The following year Downes lambasted the movement, calling it "humbug" and "pretentious" and described the technique as a "mass of daubs which would not deserve serious consideration, were it not for the pernicious influence exerted upon the susceptible young painters who suppose that they must follow the latest fashion in painting."[7] Benson was his own man, not one to slavishly follow the movement of the moment.

Even though this new art form was still viewed with disdain in many corners of the art world, it was nonetheless gaining momentum in America. The previous year Theodore Robinson had won a prize for an Impressionist winter landscape at the Society of American Artists exhibition, the first time the work of an American Impressionist had been awarded a prize by a jury. Benson's friend from Paris days, John Twachtman, had had his first one-man show in New York that year as well; his Impressionist landscapes were found "charming" by the critics. At J. Alden Weir's first one-man exhibition, also held in New York in 1891, the critics noted that he appeared to have become a plein-air painter despite his abhorrence of the movement a decade before. As Twachtman wrote to his brother, "My eyes, I feel, have been opened to a big truth. . . . It is not a fad or a wild fancy."[8] That an artist of Twachtman's stature and respectability should adopt these "new" methods was of no small import.

In Boston, the Impressionists were also exhibiting in force. Earlier in 1891, Benson had attended a memorial exhibition of Dennis Miller Bunker's work at the St. Botolph Club, where he saw a large display of Bunker's colorful, sparkling oeuvre. The St. Botolph Club also held an exhibition of the work of John Leslie Breck (who had followed Benson at Julian's and had summered at Giverny) in November 1891. Although

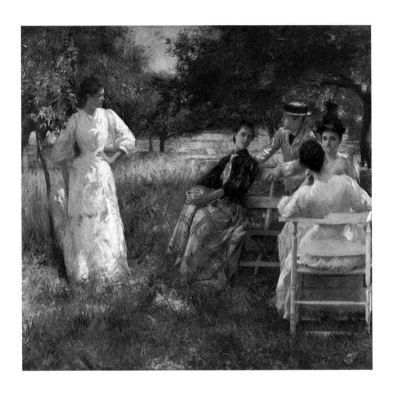

PLATE 24
Edmund Tarbell, In the Orchard, *1891. Oil on canvas, 60½ ×65".*
Daniel J. Terra Collection, 1.1992.

the paintings had unleashed a torrent of criticism, some writers felt there was much to admire in them. The effect of Giverny on Robinson and Wendel was also evaluated that year when their works were seen at a combined show in Boston. Although William Howe Downes continued to call Impressionism a fashion and a fad and predicted it would run its course, the movement was actually gaining momentum.

Despite his continuous exposure to his contemporaries' translation of Impressionism, Benson did not become what the critic Greta referred to as "an imitator of Monet." Writing of the many appearances of Impressionism in Boston, that critic continued: "Is there, then, any emancipation in the new style, except for the strong man who emancipates himself anyway? Is there anything in it for the rank and file of painters but the substitution of one set of conventions and prescriptions for another? And is it a gain for art, for beauty, for charm or refinement of popular taste, to substitute for harmony and tone wanton and impudent vagaries and crudities?"[9] It would appear that for Benson, this period in his life was one of limited experimentation; he never strayed far from well-ordered reality based on academic principles. Only when he moved beyond figural work did he invoke a more loosely conceived style.

That June, the birth of a son, named George Emery after his grandfather, appears to have been the impetus for Benson to realize a long-held dream of "having a shack somewhere by the sea where [he] might fish and shoot ducks and shorebirds."[10] For many years he and Ellie's brother, Edward Peirson, and her sister Margaret's husband, Morris Richardson, had talked of such a place. It was probably the newfound security of a contract with the Museum School, coupled with the income from the Clarke prize and an ever-increasing number of portrait commissions, that permitted Benson, together with Edward and Morris, to buy a small rustic farmhouse overlooking a salt marsh on Cape Cod. It had neither electricity nor plumbing but Benson embellished its simplicity by decorating the walls of the living room with large, life-sized murals of geese. Although it was primarily a male preserve, the three families would occasionally travel to Eastham together, where the children engaged in archery contests or hunted for Indian relics.

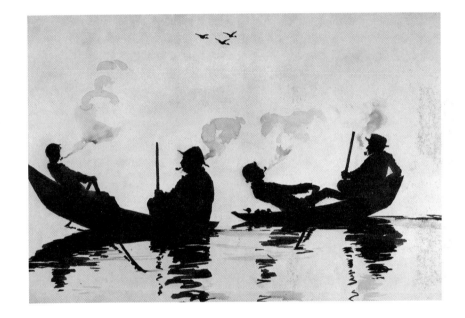

PLATE 25
Hunting at Eastham, c. 1896. Ink wash on paper, dimensions unknown. Private collection. This cartoon portrays, on the left, Edward Richardson valiantly trying to row a boat containing his rotund father, Morris, and, on the right, Benson, his long legs nearly filling the boat, pulling on the oars as his brother-in-law, Edward Peirson, perches in the bow.

For Benson, who took rod or gun and headed outdoors as often as he could, having a place of his own was a wonderful escape from the pressures of work. Benson's notes in the log at the Eastham farmhouse document frequent outings and a light-hearted existence that are not reflected elsewhere in his writings (plate 25). As Benson wrote to Henderson, "I enjoy our place on the Cape more than any gunning I ever did anywhere else. I suppose it's because I own it myself and so take more pride in that. Our house is completely furnished, it's a regular hunters' house full of everything pertaining to shooting. We have an old seafaring man who cooks for us and does all the work about the place. Each of us has his own room and we keep old clothes and plenty of ammunition and rubber boots so we don't have to carry anything but our guns when we go down. There are lots of ponds where we get an occasional snipe and teal and good pickerel fishing, flounder spearing, clam digging and plain fishing."[11]

The three men and their sons usually spent the week after Christmas in Eastham and Benson made five or six additional trips during the spring and fall, often accompanied by friends, many of them artists. As Benson wrote to J. Alden Weir, "It will do you good to live for a week where you smell salt marshes and overlook the sea and sand dunes."[12] In 1895, after winning two prizes in one week, Benson wrote to Dan Hender-

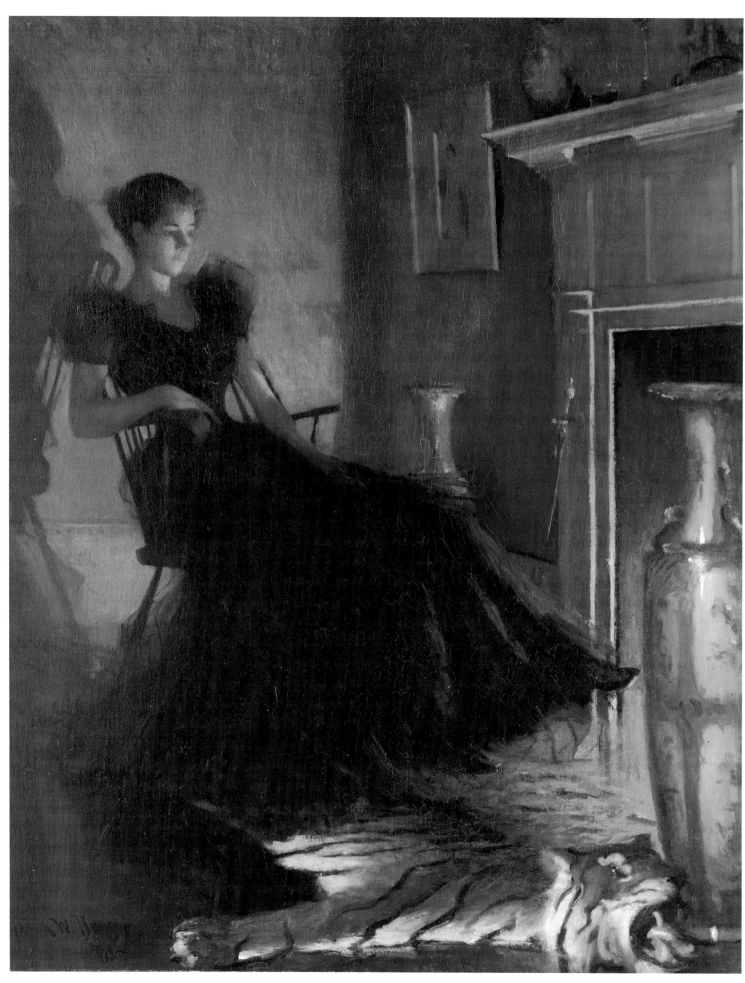

PLATE 26
By Firelight, *1889. Oil on linen, 40 ×
32½". Schwarz Gallery, Philadelphia.*

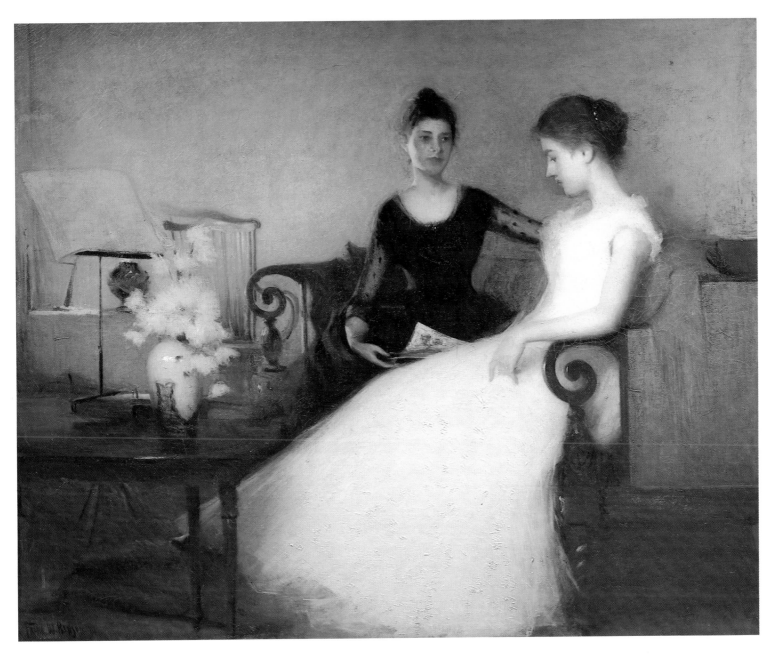

PLATE 27
Twilight, *1891. Oil on canvas, 39½ ×*
49½". Private collection.

son, "I have been working harder than ever before, so, when I got the prize, instead of the usual dinner celebration, I invited three of the fellows to go to Eastham and spend three days with me. They were all artists and good fellows, though not keen gunners. It was just as well, for the ducks had forsaken Eastham, apparently."[13] The names of many of Benson's artist friends appear frequently in the log entries, among them, Metcalf, Tarbell, Wendel, De Camp, and Pratt.

The need for a life out-of-doors was deeply ingrained in Benson; the family journals describe him as a child who rarely stayed inside. It was simply a matter of time until Benson blended his love of the outdoors with his need to paint and created the plein-air works for which he is so well known. The lovely old flower beds and borders that Captain Samuel Benson originally laid out behind his house were the site of many a childhood game of hide and seek. They were undoubtedly the inspiration for *In an Old Garden*, one of several paintings Benson sent to exhibitions in 1892. Its appearance at the annual exhibition at the Pennsylvania Academy of the Fine Arts garnered a review in which, for the first time, Benson was considered an Impressionist.

As the *Philadelphia Times* noted, "The Impressionist pictures are not all here, but the group . . . includes the work of . . . several Boston celebrities, Benson, Tarbell and

Enneking are among the latter."[14] The critic for the *Philadelphia Press* concurred and, in an article on Monet's Impressionism observed, "The influence of the new method is at once apparent if one contrasts the partial consciousness of it present in Mr. Frank Weston Benson's *Twilight* . . . [with] the complete surrender to the new view . . . apparent in *In an Old Garden*."[15]

Although the term *Impressionist* had been applied to Tarbell's work two years earlier by the New York art critic Royal Cortissoz, in reference to *Three Sisters—A Study in June Sunlight* and *In the Orchard*, this review appears to be the first application of that label to Benson. However, despite what the critics may have felt, it is not likely that Benson considered himself an Impressionist in the early 1890s. Since his closest friend, Tarbell, was clearly working in the Impressionist manner and many of his friends were experimenting with it, it is understandable that critics would try to find elements of this new style in Benson's work as well. Although he acknowledged that he was successful with the effects of light—particularly firelight and lamplight—he did not feel he had begun to master plein-air work until about 1898, when he painted *In the Woods*. Writing to Smith College, which acquired the work (see plate 45), he said, "I think I might call it my first successful out of doors picture of figures though I attempted quite a good many others."[16]

Benson's early excursions into plein-air work have been largely overlooked. In addition to *In Summer* and the now-lost *In an Old Garden, Mother and Children* of 1893 is a charming, idyllic study of his family in a sunlit, flower-strewn meadow. Other very early plein-air works also exist and several other titles for unlocated paintings would indicate an outdoor setting (see plates 28 and 33). *Orpheus, The Bather*, and *Summer*, as well as Benson's later studies for his Library of Congress murals, also depict figures in the out-of-doors. Though not as highly keyed as his later, more truly Impressionist works, these canvases dispel the notion that, in the early 1890s, Benson was solely a studio painter or that his only out-of-door works were landscapes.

That his circle of friends did not consider the Impressionists their mentors is reflected in an irreverent remark made in the Eastham farmhouse log by Arlo Bates, a hunting companion, regarding a tall tale Benson had been spinning. "Within my heart," Bates wrote, "I felt he has been exposed to the dangerous influence of those mad creatures, the Impressionists, and probably paints wearing too high collars."[17] Despite Benson's rejection of the term, art critics quickly began associating him with other artists

who were clearly practitioners of Impressionist methods. The most obvious of these, of course, was Tarbell. Art historians have long linked the two together in light of their shared studio, their successful two-man shows, their many years of summering together in Newcastle, New Hampshire, and, most important, their joint leadership of the Museum School.

Sadakichi Hartmann, an enormously influential aesthetician at the turn of the century and founder of an art journal, coined the term "Tarbellites" to lump together the painters of Boston: Tarbell, Benson, De Camp, Paxton, and Hale. He faulted them for being "technicians" and completely lacking in individuality. "One is never sure which of them painted this or that picture. This year De Camp exhibits a picture which seems to be technically a facsimile of Benson's picture of last year and next year Benson will come forth with a canvas that looks like a Tarbell of several years ago."[18] The artists no doubt bridled at being lumped together, but no one could deny that, centered around these five men, there emerged a "Boston School of Painting"—one that emphasized carefully modeled figural work. That many of their paintings depicted the human figure is understandable. The figure is an academic subject and these men all spent the majority of their days teaching the finer points of drawing from the model.

While Benson's and Tarbell's work invites comparison, their stylistic development took different routes. During the time that Tarbell was working out-of-doors, trying to capture the dappled or dazzling effects of sunlight, Benson was concentrating on the more muted effects of interior light thrown from the dancing flames of a fire or the gentle glow of an oil lamp. Many years later, as Tarbell retreated indoors to produce works reminiscent of Vermeer, Benson began to place his figures in the shimmering sunshine on windswept hills or in the filtered light of a forest. Eventually, critics found his palette brighter and his sunlight effects more brilliant than those seen in the plein-air work of Tarbell.

The company of other artists had always been important to Benson, so he was delighted when he, Tarbell, and Smith were invited to join Boston's Tavern Club, which was founded in 1884 in a few small rooms directly below the studio of Frederic Porter Vinton, a rising Boston portraitist and Benson's future mentor. Founded as an eating club, the chief diversions were outings, billiards, and annual theatricals, written and performed by the members. But the club's main function was to provide a meeting place for like-minded men, most of whom were (according to a privately printed reminiscence written in 1934) "either artistic of temperament or in close sympathy with those having this temperament."[19]

Benson's Boston life revolved around the club. Names of fellow members appear time and again in his fishing journals, hunting diaries, and in the log of the farmhouse at Eastham. The sales records of Benson's many shows read like a Tavern Club membership list, for members were frequent Benson collectors.

Benson and Tarbell painted decorations for the billiard room, which club members had added to the small, dark, wood-paneled building. Before it was installed on the large wall in the club between the two black marble mantelpieces, Benson's panel of ducks flying over Nauset Marsh was displayed at the Copley Society. The *Boston Transcript* enthusiastically reported, "[It depicts] the spacious landscape on Cape Cod comprising the sand dunes in the foreground and a broad, flat expanse of marsh beyond, cut up by tidal streams and lagoons with the sea in the distance. . . . A great flock of wild geese flying over the landscape [makes] a sort of spiral pattern of birds across the sky which is partly clouded. . . . These clouds take on beautifully tinted lights of a golden hue from the sun."[20]

Benson' continued experiments with light can be seen in *By Firelight,* first exhibited at the Society of American Artists' show of 1892 (plate 26). The model's diaphanous black dress is a dramatic counterpoint to the warm glow of the fire and the exotic tiger-skin rug. It was undoubtedly this latter element that inspired its purchase, for it was bought by Mrs. P. T. Barnum, wife of the famous circus impresario. Noting that the painting's effects of illumination were similar to Benson's National Academy entry of the previous year, *Twilight,* the critics found it laudable and an excellent variation on a

PLATE 28
Frank W. Benson painting Mother and Children, *1893. Private collection.*

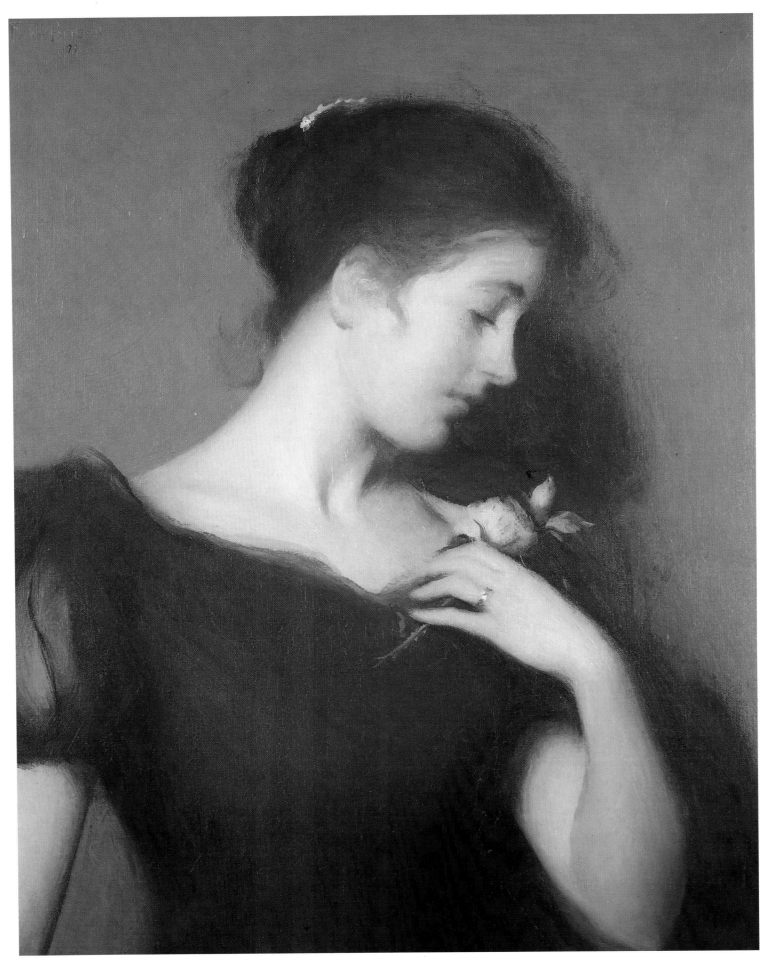

PLATE 29
Woman Holding a Flower, *1899.*
Oil on canvas, 26 × 22". Collection of
Jeffrey and Dana Cooley.

theme. Perhaps the most interesting comment was made by Clarence Cook in *The Studio*. In a compliment that held something of a note of warning he wrote, "[It is] a picture rich in feeling and with just enough, and not too much, of that artificial lighting sometimes too dangerously experimented with by this artist even whose failures have been interesting."[21] Its immediate sale may have prompted Benson to continue this theme the following year: *Firelight,* a brilliantly executed study, shows a young woman in a white dress seated before an unseen fire, her hand outstretched toward the flickering flames. The warm glow of the fire pervades the whole canvas and touches the dress, the walls, and the model's face with glimmers of gold and opalescent color.

These paintings of attractive young women did much for Benson's burgeoning portrait career. In Frederic Porter Vinton, Benson found a true mentor for portraiture. Vinton's restrained, masterful portraits had been in great demand in Boston before Benson's return from France, and Benson had achieved the same sort of success with similarly dignified portrayals of "men of stature." Although John Singer Sargent's arrival in Boston in 1888 challenged Vinton's place as the city's leading portraitist, Sargent's dashing, theatrical style appealed to a different type of client. Sargent's first one-man show at the St. Botolph Club in 1888 had attracted attention in the press, and he was quickly overwhelmed by commissions from the leading families of Boston society. But, several years later, families who had wanted Sargent to do their daughters' likenesses were now seeking out Benson as well.

All three men were members of the Tavern Club, and it was here that Benson became friends with the prolific Sargent. Correspondence indicates that Sargent stayed at the Copley Plaza when in Boston, and Benson's children remember their father occasionally lending his studio to Sargent, when he was in town. Judging from the correspondence, their friendship was a strong one.[22]

Despite this bond, the portraits executed in Boston by Benson and Sargent have very different qualities. From Vinton, Benson borrowed the dignity and self-assured demeanor the older artist was so adept at conveying. In studying Sargent's work Benson appears to have focused on light and pose. But there is none of Sargent's hauteur in Benson's portraits, nor are the sitters remote. There is an immediacy to Benson's work; the models are real people, not figures on a stage. Sargent's women are imperious, with challenging gazes; proud heads are balanced on long necks; Benson's models are direct and serious, demure and graceful (plates 29 and 30). Although Benson's studio paintings sometimes contain elements of Sargent's dramatic posing, his portraits tend to be composed in a simple manner; his models stand quietly or sit upright in a chair.

Despite the varied nature of Benson's portrait work, a common theme runs through his commissions of this period, as well as through his interiors with figures—the effects of light on the subject. Whether defining the tips of the ruffles of a little girl's dress, casting a glow on a sitter's hair, or suffusing the whole work, Benson's mastery of light made him much in demand as a portraitist.

Benson's daughter Eleanor recalled that he would often give his sitter a choice of background and would be amused if asked to invent a spreading tree or seascape for a studio portrait. His own preference was the striking contrast of pale fabric or skin tones against a dark or mottled ground, as in his portrait of little Gertrude Schirmer, daughter of the Boston music publisher (plate 23). The delicate pink fabric of the child's dress and the soft ruffle about her neck contrast with the lacquered white chair in which she sits. The somber background and shadowed outline of a mahogany highboy serve as a dramatic foil to the composition. In this work, the sureness of application of paint

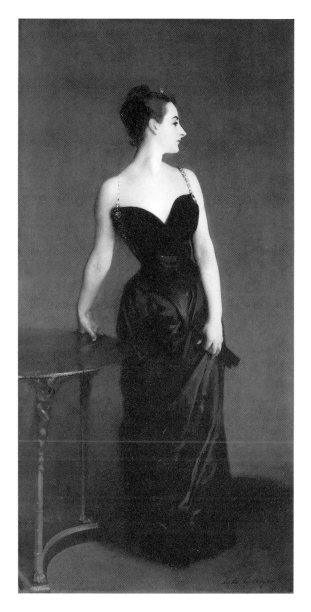

PLATE 30
John Singer Sargent, Madame X, *1884. Oil on canvas, 82⅛ × 43¼". Metropolitan Museum of Art, New York. In sharp contrast to Benson's demure painting of a young woman in black, this portrait of Mme. Pierre Gautreau caused such a scandal at the Salon that Sargent was forced to leave Paris and seek commissions in London.*

59

produces a contrast of shimmering textures within a controlled composition and recalls Benson's advice to Eleanor. "Sargent was said to 'dash' his paint onto his canvas . . . Lay the paint on where it should go and *don't touch it again.* Never puddle around and go dab, dab, dab."[23]

Although Benson enjoyed children, he found them a challenge to paint. Frances Proctor Wilkinson recalled sitting for Benson's portrait of her sister, her grandmother, and herself: "Although I was only three when painted by Mr. Benson, I remember the sittings clearly. The studio was two stories high and the easel stood near the bottom of the stairs. Once, he told me that if I promised to sit still for three minutes, I could be a train and run between his legs, which were the bridge."[24] To get his nephew Phillip to sit still for a portrait, Benson had to bring him strawberry shortcake each morning.

Dealing with restless children was difficult enough, but it was particularly frustrating for Benson when family members complained about his work, especially since he

charged them a reduced fee. He was told a waist was too large, or a sitter was too skinny. He was asked to paint one child twice because her sister would not sit still, and he was instructed to darken the graying hair of another sitter.

Little wonder, then, that Benson was so grateful to the Schirmer family for the license they allowed him in painting the portrait of their daughter, Gertrude. Responding to Gustave Schirmer's note of appreciation, he wrote, "I have had a great pleasure myself in doing it, more so than often falls my lot in doing work for other people. This comes . . . from the freedom you allowed me in all ways. Few people know enough to allow such freedom from interference or I think they would always get better pictures. . . . I could not wish that any of the conditions had been different."[25] Benson once said that the frustrations of trying to please his clients sometimes made him want to throw away his brushes. But he was in great demand as a portraitist and could ill afford to turn down the business.

Although portraits were his mainstay, they took time away from more creative work, such as a large studio piece, *Lamplight: A Study in Red, Black and Gold,* which he sent to the National Academy. This painting of a young woman in black suggests the influence of such Spanish painters as Fortuny and Ribera. Unlike Whistler, who often titled pictures as studies in various colors, Benson rarely used this device. However, *A Study in Red, Black and Gold* is an apt description for this striking painting. The deep, rich gold of the reflected lamplight bathes the entire left half of the painting and is echoed in the shimmering oriental screen. As the light fades toward the middle of the canvas, the shadows deepen and the model's black dress dissolves into shadow. Against the foil of mellow gold and velvet black, her shawl and hair ribbon make a bright splash of vermilion.

The pattern and form of this and Benson's other paintings of this period underscore his growing attention to "design." In later years he would say, "Picture making has become to me merely the arrangement of design within the frame. It has nothing to do with the painting of objects or the representation of nature." This realization was a turning point for Benson. "I grew up with a generation of art students who believed it was actually immoral to depart in any way from nature when you were painting. It was not till after I was 30 . . . that it came to me, the idea that the design was what mattered. It seemed like an inspiration from heaven. I gave up the stupid canvas I was working on and sent the model home. Some men never discover this . . . design is the *only* thing that matters."[26]

At the Museum School, Benson's and Tarbell's growing success was reflected in the student enrollment, which by 1893 had nearly doubled. The teaching staff needed to be increased and Benson strongly recommended that the school offer a position to Philip Hale, who had recently returned from abroad.[27] As an aid to understanding the human figure, Benson felt it important to offer a class in sculpture and was pleased to learn that the school had appointed Bela Pratt, an assistant to the renowned sculptor Augustus Saint-Gaudens, as the school's first instructor in this subject. The two men became fast friends and summer neighbors.

Considering the excellence of the Museum School, the failure of Benson and Tarbell to be named associate members of the National Academy in 1893 caused a storm of protest in Boston newspapers. Both had been exhibiting works at the academy's annual shows for several years, and Benson had won several of its prizes. Compelled to make a public explanation for the academy's action, its president stated that, while Benson's and Tarbell's talent and ability were beyond question, "there were but five vacancies and [the academy] desire[ed] to fill them with artists who live in New York."[28] To many, this weak rationale was a slap in the face of Boston painters by the powerful New York art establishment. Although Benson and Tarbell were elected academy associates three years later, this incident was only the first in a volley of verbal attacks and counter-attacks between groups of artists in Philadelphia and New York and those in Boston as they struggled to establish their claims to supremacy.

A unifying force among artists in America was the completion of the World's Columbian Exposition in Chicago in the spring of 1893. Many of the art schools had sent exhibitions to the exposition, a showcase for arts and industry; the Museum School was no exception. The board sent Benson and Tarbell to Chicago in May to set up the school's exhibition in the Hall of Liberal Arts, and the school's annual report noted that the school won an award "in drawing and watercolors, for excellence of methods and results in training students and in forming a fine artistic taste."[29] The school was subjected to a constant stream of visitors from other art schools for months following the awarding of this prize.

The "White City," so named for its acres of sparkling white Beaux-Arts architecture, represented in both concept and scale the American Renaissance, a period from 1876 to 1917 when an emphasis on classical forms and themes in the American arts that aspired to echo the spirit of the European Renaissance. The Chicago fair brought together architects and artists subsequently identified with the American Renaissance movement. They took part not only in the submission of works but in the designing of the buildings, the grounds, and particularly the mural decoration. America's growing wealth and economic power created a new cosmopolitanism that demanded greater sophistication in the arts.

The mural decorations at the fair reflected the European training of their creators filtered through an American idiom. Several of Benson's friends were offered commissions to paint these murals: Edward Simmons, whose friendship with Benson dated back to their days together in Concarneau, Robert Reid, his classmate from art school days, J. Alden Weir, and John Twachtman. These men were closely linked to Impressionist methods, and it was clearly the intent of the director of the mural project, Francis Millet, to present this "new style" of painting in the traditional format of mural painting.

Many of the paintings accepted for hanging were by women artists. The expatriate American artist Mary Cassatt came from France to execute a mural with the theme of "Modern Woman." She set her figures *en plein air* to capture the brightness of colors seen in sunlight. Her design did not depict women as goddesses emblematic of social and technological change but as simple, modern women picking the fruit of the Tree of Knowledge and passing it on to younger women and girls.

Benson's choices for the three works he exhibited at the exposition won him two prizes and echoed Cassatt's themes. *Figure in White, Girl with a Red Shawl,* and his *Portrait in White* all presented modern woman as calm, contemplative, and graced with an assured presence, not draped with allegorical symbolism or mythical trappings. Later critics would laud him for presenting a "refreshing portrait of the new American woman." Although none of the paintings Benson exhibited at the exposition could be

PLATE 31
Portrait of Col. Thomas Wentworth Higginson, *1893. Oil on canvas, 50 × 40". Harvard University Portrait Collection, Cambridge, Mass. The Colonel Club commissioned Benson to paint this portrait of Higginson, who was the commander of the first black regiment in the Civil War and an ardent reformer.*

61

labelled Impressionist, his portraits of women echoed in their handling of light Cassatt's murals high above the vast hall of the Women's Building (plate 32).

During the many days that Benson spent in Chicago installing the school's exhibition, he had ample opportunity to examine the American painters' new works. That there were almost no French Impressionists included in that country's display of paintings is understandable given the makeup of the French jury, which included such traditional academicians as Gérôme, Bouguereau and Benson's old instructor, Lefebvre. But many American collectors lent their recently purchased French works to the private loan collection. Thus, the paintings of Monet, Renoir, Pissarro, Degas, and Sisley were in ample supply, available for comparison with their American disciples.

However, many art historians feel that the Columbian Exposition brought about the vindication of American Impressionism. The awarding of medals to such artists as Tarbell, Twachtman, Robinson, Metcalf, and Hassam, whose work was clearly in the Impressionist mode, signaled the jury's acceptance of this type of painting as a new and valid form.

In the summer of l893 the Bensons returned to Dublin for what was to be their last season there. They had had another daughter, Elisabeth, that year and the growing family stayed in their usual tiny cottage for only a short while—just long enough for Benson to paint a portrait of Colonel Thomas Wentworth Higginson (plate 31). The influence of both Vinton and Sargent can be plainly seen in the shadowed planes of the sitter's face and his direct gaze. The somber palette of the clothing and background serve to highlight Higginson's face and hands.

Just why the young family changed summer places is not known, although the worlds of Joseph Lindon Smith and Benson were becoming very different. Joe was a bachelor and a world traveler, Frank was now the father of three. Though the bonds of friendship would always remain strong, they saw each other infrequently after 1893. Besides, Dublin was landlocked: a little pond dominated by a looming mountain. Benson, born in a seafaring town, an accomplished sailor of his own boat at age twelve, undoubtedly missed the ocean. Perhaps during the past winter he and Tarbell had talked of their previous summer's visit to Newcastle, New Hampshire, and the opportunities for painting there.

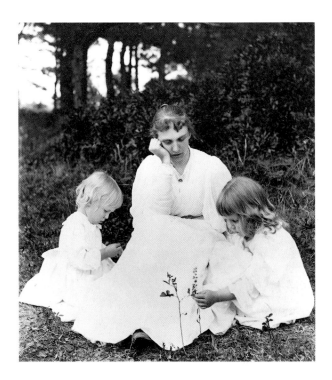

Whatever the reasons for the change, the Bensons spent the remainder of the summer of l893 with the Tarbells in Newcastle. The following year Benson and Tarbell began a summer art school there, charging pupils six dollars a week.

Hearkening back to his own student days when Frederick Crowninshield took several of the Museum School students to western Massachusetts for a summer sketching class, Benson tried to impart to his summer students many of the elements he taught in his winter classes at the Museum School. But recalling the close friendships and simple pleasures of the art students' life in Concarneau, he kept his classes relaxed and informal; criticisms were given to the students only twice a week.

Outdoor art schools were flourishing in the early 1890s; several of Benson's contemporaries had taught or were teaching summer classes by the year he and Tarbell began theirs. Joseph De Camp had taught young women on Boston's north shore; Theodore Robinson instructed pupils in rural New York and New Jersey; John Twachtman had begun a summer class in Cos Cob, Connecticut, where he was soon joined by J. Alden Weir; William Merritt Chases's summer school in Shinnecock, Long Island, was very popular and famous, due to the press attention it received in the art journals. The critics noted the tremendous influence these summer art schools had on the development of an artist's perception of atmosphere, color, and light.

Inspired by the summer light, Benson and Tarbell themselves later painted for Newcastle's Town Hall a large canvas that depicts the gates of Fort Constitution at the entrance to Portsmouth Harbor. This painting, which became a backdrop for the many

plays given in Newcastle in the summer, is the only known work that the two painted together.[30]

That summer, Benson also began several works that he completed during the coming winter. One of these was *Mother and Children*, his first known family group portrait. This canvas of Ellie with Eleanor, aged three and a half, and George, a little over two, sitting in a grassy meadow picking wildflowers is an important one, for it shows one of Benson's early attempts at plein-air work. The painting itself is now lost, but from a photograph of it one can observe in its atmospheric quality the influence of Bastien-Lepage. The three figures are seen as through a summer's haze. The mother is quietly contemplating her children as they play with flowers. It is a simple scene in the everyday life of the leisure class, a theme Benson would return to frequently in later years as he captured his children at play (plate 33). A critic wrote that it "shows a chasteness of sentiment and a classical yet refined treatment, an expression of wholly mother love passes through every touch; there is a subtle modeling of the baby flesh, a pensive tranquility that gives Mr. Benson a unique niche."[31]

Packing up this work and several landscapes and ocean scenes, Benson returned home to a new year at the Museum School and a new studio on St. Botolph Street; which he and Tarbell would share. For more than ten years, until their workloads required separate studios, these two friends shared both their creative years and their creative space. It is interesting to observe that the two obviously loaned each other various accessories, furniture, and objets d'art for paintings. A ginger jar seen on a mantel in a Benson canvas turns up later on a table in a Tarbell work. A chair placed against a wall in a Tarbell interior is later used by a model as she tries on a hat in a Benson canvas. It was not until years later, when the two men dismantled their individual studios and the various objets d'art, drapery, and furnishings descended to their families that the actual ownership of certain pieces was established.

In January 1894 Benson exhibited at the St. Botolph Club with his fellow museum instructors, Tarbell and Hale. Other artists in this show included Joe De Camp, now teaching at the Cowles School; Lilla Cabot Perry, who had painted at Giverny; Frederic Porter Vinton, Benson's close friend and mentor; and Theodore Wendel, named by critics several years earlier as Boston's leading proponent of the Impressionist school.

PLATE 34
Swan Flight, *1893. Oil on canvas, 32 × 40". Fogg Art Museum, Harvard University, Cambridge, Mass. Bequest of Dr. Arthur T. Cabot.*

PLATE 35
Portsmouth Harbor, *1895. Oil on canvas, 24 × 20". Private collection.*

Since many prospective customers would visit the show, Benson chose his latest portraits and figural works and two scenes begun at Newcastle the previous summer, *Below Portsmouth* and *Sunset.* Benson did several studies of the Portsmouth harbor and their atmospheric quality captures well the sea air (plate 35). Benson also hung a large canvas depicting the decorative effect of white swans sweeping across a wide expanse of pearl gray sky. *Swan Flight* is a pivotal work for it appears to be his first exhibited painting depicting wildfowl (plate 34). The spare design and large areas of open space in this painting are reminiscent of the Japanese prints Benson had seen in Ernest Fenellosa's collection. The painting was loaned to the show by Dr. Arthur Cabot, one of Benson's most avid collectors and closest friends. In *Swan Flight* Benson returned to birds, the subject that first inspired him to paint. He once told an interviewer that he had originally wanted to be an illustrator of ornithological texts. Although his art up to this time had departed greatly from the painting of wildfowl, it was a theme to which he would return often.

Respect for Benson's work and for his judgment was growing. In 1894 he was asked to sit on what was probably his first jury at the annual show at the Pennsylvania Academy of the Fine Arts. It was here that Benson and J. Alden Weir discovered not only an admiration for each other's work but a common love of fishing and hunting. Weir's scrapbooks abound with clippings of newsworthy stories of trout and bass and salmon, and he and Benson enjoyed several fishing trips together. He was a frequent visitor to

the farmhouse at Eastham. Also on this jury was John Twachtman, whom Benson had met in Paris when both were at Julian's. Their week together in Philadelphia was the beginning of a warm friendship.

Such jury duties were perhaps the equivalent of our modern-day conferences, where established professionals can eye the current crop of aspirants, and where new techniques and ideas are discussed, power struggles evaluated, and connections made. For Benson, it was one of his first close looks at the art world outside of Boston, and an opportunity to see how the method of selection and awarding of prizes functioned. For the next twenty years, Benson sat on juries and committees for almost every major show.

The spring of 1894 also marked the opening of the Jordan Gallery. Writing of its founding, a critic said, "Boston, with all her resources for culture has, until this year, lacked an art gallery of popular resort, a ground of common access for artists and the public. In the early spring of 1894, Mr. Eben D. Jordan, Jr., sent out invitations to well-known Boston artists who met . . . [and chose] 118 names. These were asked to contribute one or more of their works in the coming exhibition."[32] Benson sent *Lamplight* to the inaugural show; it brought him a prize—his first in Boston. By the time of the second exhibition, in the fall of 1894, there had been a change in the focus of the exhibition: "The subjects of the pictures were restricted to the fine possibilities of New England scenery and life."[33] At this show, Benson once again won first prize in oils for his *Mother and Children* finished the previous year. Returning from another summer of teaching and painting at Newcastle, Benson sent his newly finished *Head of a Spanish Girl* and *Firelight* to the annual Art Institute show in Chicago, where *Firelight* won that year's Ellsworth prize.

A similar prize sparked serious controversy among art critics when Benson exhibited *A Winter Storm* and *A Story* at the Boston Art Club Show of 1895. The jury awarded *A Winter Storm*, a painting of wind-tossed waters with an imperiled sloop cresting a distant wave, third prize and one thousand dollars—the largest cash award he had yet received. The critics were outraged, not so much at the undeservedness of the prize but because Charles Woodbury didn't receive one. "Mr. Benson's marine is lively in action and well observed," one critic wrote. "One of the prizes, however, should have gone to Charles Herbert Woodbury's incomparable mid-ocean picture of the wake of an Atlantic liner. The two New Yorkers on the jury were in favor of giving Mr. Woodbury one of the prizes, but they were outvoted. Meritorious as Mr. Benson's marine is, it is outclassed by Mr. Woodbury's work and the New Yorkers were right."[34] Another paper's opinion, however, was far more scathing. Bemoaning the lack of an award for Woodbury, the critic stated, "The award of the third prize to Mr. Benson is positively ridiculous."[35] There is no mention of Benson's reaction to this furor but it is obvious from the large number of shows and exhibitions to which he sent work that he realized the value of exposure. His later business acumen is testimony to his understanding of publicity, marketing, and good press. Every time he won a prize, he gained several new portrait commissions. Indeed, it was not merely the honor that Benson appreciated, as is illustrated in a letter he wrote to Weir following the 1896 Boston Art Club Show where both had won prizes, Benson for his portrait of five-year old Eleanor (plate 36): "I was never so glad to hear that anyone had taken a prize as when I heard that you had the $2,500. Truly—old man—I congratulate you with all my heart and I hope you take as much satisfaction in it as I do in mine . . . I never needed it so much in my life."[36]

At the Society of American Artists, Benson hung five works, all, with the exception of *Autumn and Spring*, previously shown. By the time this work (actually two paintings, framed together) was exhibited at the Art Institute of Chicago its title better expressed exactly what it was: *Decorative Panels, Autumn and Spring. Study for Panels in Congressional Library* (plate 37). The change of titles between the two shows leads to the supposition that by the time Benson exhibited the works in Chicago, his mission had been accomplished—he had won the commission to execute a cycle of murals for the new Congressional library in Washington. The following year would be devoted to his mural work there.

After the Columbian Exposition of 1893, American interest in murals grew rapidly

both for public and private buildings. The exposition's espousal of classicism and civic ideals had a great effect on the appearance of American cities, which were responding to the country's newly acquired wealth and urban expansion with civic pride. For Benson, the opportunity to venture into a new and highly remunerative area of art was not to be missed. Many artists of the day adapted their easel style to encompass the techniques involved in mural work, Benson among them. All across America, architects were stipulating painted decorations for interior walls and ceilings. The Boston Public Library was nearing completion, as were the Philadelphia City Hall and the new Library of Congress in Washington. All were ready for the submission of sketches and studies from hopeful artists; judging committees were deluged with portfolios. Sargent had already been awarded commissions to paint large segments of the Boston Public Library as had Joe Smith, fresh from another tour of Europe. Like the Museum School, the library was on Copley Square, and Benson probably visited Smith there as he worked in the north lobby on his *Sea of Venice*—a depiction of that city's oriental commerce as the source of her wealth and fame in the Middle Ages. Also involved in the decoration of the Boston Library was the French artist Puvis de Chavannes, whose murals were greatly admired by artists and critics alike. Benson's own mural work reveals that he was influenced by the Frenchman's pale, ascetic figures, which were presented with a simplicity of design and conveyed a mood of arcadian tranquility. Benson's designs also reveal the strong background in figural and classical work laid down during his years in Paris, as well as the influence of Abbott Thayer.

Benson's fellow artists in the decorating of the Great Hall of the new library included many friends, among them Edward Simmons and Robert Reid (both of whom would later join him in forming The Ten). Ten years in the building, this magnificent Renaissance-style structure, located two blocks from the Capitol, was the first government building to have a full-time art director: Elmer E. Garnsey, who had been assistant to the artistic director Francis Millet at the Columbian Exposition. The library's one hundred decorations were commissioned to nineteen American artists. To maintain a harmony throughout the building, a master color scheme was established. Surrendering personal preferences to the unity of the whole, each artist decorated his allotted space within the guidelines.

Benson was commissioned to decorate the vault of the south corridor, as well as the wall below it. For the three octagonal panels of the vault he chose to represent the Three Graces: Aglaia, Thalia, and Euphrosyne. The smaller panels below represent the Four Seasons. The murals for Autumn and Spring are expanded versions of the smaller works Benson had exhibited that year. Benson also made now unlocated studies for Winter and Summer.

He immediately began work on the final cartoons, which he carefully graphed for enlargement into the final works (plate 39). The time and care he lavished on the decorations for the Library of Congress are evident. Newly cleaned and restored in 1965, the murals' fresh, pure colors look much as they did when Benson first painted them 100 years ago. The panels are alive: Winter's winds whirl around her, and the scent of the rose held by delicate Spring is almost tangible. The Graces sit serenely, contemplating the symbols Benson gave them to represent their virtues (plate 40).

Benson's paintings of classical themes incorporating contemporary American women pleased the critics. Pauline King wrote in *American Mural Painting:* "These delicate figures have clearly been inspired by high-bred American girls whose beauty is as much intellectual as physical. They are recognizable portraits of well-known types . . . to which is due the widespread fame of the attractiveness of our country." Chiding other artists who, "surrounded as they are by lovely faces and forms that are the admiration of the world, [still] rarely seem to . . . notice them, but repeat formal types and faces of studio beauties common the world over," she praised Benson for "his presentation of these fine and distinguished likenesses of contemporary womanhood."[37] Benson's allegorical women differ from the idealized women so often seen in the academic paintings of his French teachers Lefebvre and Boulanger. Foreign academic training and opportunities to learn from the art of the past had turned American artists away from their

PLATE 36
My Little Girl, *1895. Oil on canvas,*
44½ × 36". Private collection.

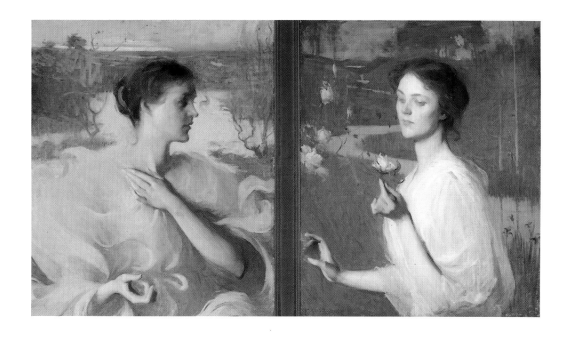

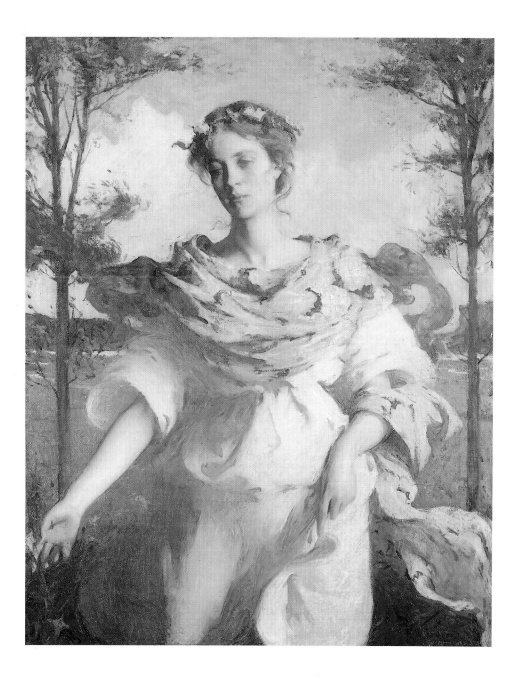

PLATE 37
Autumn and Spring, 1895. Oil on canvas, 30 × 25" (each painting). Museum of Art, Rhode Island School of Design, Providence. Bequest of Isaac C. Bates.

PLATE 38
Summer, 1890. Oil on canvas, 50⅛ × 40". National Museum of American Art, Smithsonian Institution, Washington, D.C. This painting was posed for by Benson's wife in Dublin the summer after the birth of their first child.

former preoccupation with native landscape painting, but now they were being urged by critics like King to seek in their own country new American motifs and to portray men and women as something other than warmed-over gods and goddesses. Benson's portraits of women were often praised as representative of the "new woman": healthy, active, educated, and of simple charm, not requiring artifice to enhance natural beauty.

The British art critic Charles Caffin found the mural works "striking . . . [The] contrast of dark and light in Mr. Benson's panels gives them decorative distinction; a nearer view reveals the emotional tenderness of detail."[38] He felt that the decoration of this major building would undoubtedly "lead to that artistic ideal, the formation of a distinctly American School of Mural Painting."[39] However, an American school of murals never developed, and these murals appear to be the only ones Benson ever executed except for the wall decorations he painted in his own homes. Although there is frequent reference to his having painted several "decorative panels," murals did not seem to be

something he wanted to pursue. Such a decision would be understandable given the long separations from his family and the arduous nature of the work. Edward Simmons wrote of his work at the library, "I shall never forget this experience. It was in the summertime, and a hot spell struck Washington. Anyone who knows the capital will realize what this means. I was under contract to finish it at a certain time, and here I was working in these little sealed domes . . . while the thermometer was so high that eighty people died one day from sunstroke. It was mephitic. I was so terrified that I almost lived on milk and limewater."[40]

Between his responsibilities at the Museum School and the mural work, Benson appears to have had little time for other work in 1896. The year before he completed the murals, he had exhibited in at least eight shows, hanging seven new works of which three were portraits. In the year following his mural work he sent nothing but previously exhibited paintings to the various annual exhibitions. The loss of portrait commission income was, however, more than offset by his fee for the murals. On Christmas Eve, 1896, he received a government check for two thousand dollars. That was a year's salary at the school and more than twice the highest price he'd put on any painting the year before. He could well afford to slow down his output for a while.

This mural commission probably inspired Benson to submit sketches in March 1896 to a jury appointed by the Commission for the Erection of the Public Buildings of Philadelphia. Benson's design for the competition was far more formal than his murals for the Library of Congress. His sketch, its background of a colonnade somewhat reminiscent of a Greek frieze, was judged by one Philadelphia art critic to be "one of the best allegorical treatments in the exhibition" when it was displayed, along with the other entries, at the Pennsylvania Academy of the Fine Arts in May 1896. The central figure of the composition represented the City of Philadelphia enthroned and supported on either side by her counsellors and lawmakers. For the north wall, Benson designed a central figure of Economy "with a book upon her knee and a coffer by her side, the ends of the seat being formed by figures of boys holding golden jars on their heads."[41]

Benson's friend Joe De Camp (who was, at that time, an instructor at the Pennsylvania Academy of the Fine Arts) took first prize for his allegorical treatment of Law with the Arts in Industries, and Benson took third for arriving "at the most adequate solution of the problem" of mural decoration.[42] Although Benson's award carried with it a prize of $750, none of the murals appears ever to have been completed.

To cope with the growing demands of exhibiting and transporting his paintings to the many exhibitions in which he participated, Benson retained an agent, the shipping

firm of Stedman and Wilder, based in the Grundmann Studios near the museum on Copley Square. One painting they sent throughout the country for both Benson and its new owner, Samuel Shaw, was a work entitled *Summer* (plate 38). Given the title and the nature of the painting, it might also have been a figure that Benson submitted to the Library of Congress committee as a representation of what his Seasons series would be. However, it is very different from the simpler women who adorn the ceiling of the library. It is interesting to note that it was painted in 1890, several years before Benson began to execute studies for the murals and six years before its first exhibition. After its completion Benson possibly deemed its allegorical nature not representative enough of his current style. But with the success of his murals, and the greater American appreciation of decorative work, he may have decided the time was right for its exhibition.

Its magnificence was not lost on the judges at the Society of American Artists' exhibit, for it was the 1896 recipient of the one-thousand-dollar Shaw Fund prize given for the best figural work. Writing of the show in *Harper's Weekly,* Royal Cortissoz noted, "Mr. Benson is deliberately decorative. . . . [His] figure is not a goddess; she is simply a charming woman. And there is no glamour of romance flung about her. . . . The very design . . . is graceful, original, and picturesque . . . a picture alive with unaffected emotion, with fragrant but quite earthly airs."[43] While the soft pastel colors, thinly applied paint, and swirling draperies and clouds reminded several critics of Puvis, the treatment of the subject was reminiscent of Thayer's deification of women; indeed, this work was done during Benson's second summer of painting with Thayer in Dublin.

Summer was much in demand for loans. In fact, Shaw loaned it out so frequently that in February 1897 he finally wrote to one museum director in exasperation: "I haven't seen the picture since the first of October last. . . . I will want the picture myself the later part of May to adorn the walls of my house when I give a dinner in honor of the artist getting the Shaw Fund for 1897."[44]

Shaw, who was the owner of the Grand Union Hotel opposite Grand Central Terminal in New York City, held a lavish dinner in honor of each year's prizewinner. The guest list was made up of previous winners, as well as other noted artists and art critics. At the dinner held in Benson's honor, one of the highlights of the evening was the signing of a large engraving Shaw had made of *Summer.* The twenty-two signatures on this family memento read like a Who's Who of the American Renaissance: Edmund Tarbell, Charles Curran, Kenyon Cox, Samuel Isham, H. Siddons Mowbray, J. Appleton Brown, and Childe Hassam, to name but a few.

PLATE 40
Europhysyne, *1896. Oil on plaster, dimensions unknown. Mural in the Great Hall, Library of Congress, Washington, D.C.*

It is somewhat ironic to find Benson being feted for a painting he had completed so long ago and for a work that now seems to have been a momentary experiment, far outside the scope of his usual work. But Benson was nothing if not an innovator. In the years between the painting of *Summer* and its triumphant display at the Society of American Artists' show, Benson won mural commissions and discovered there was a market for bird paintings—his first motif. He had also established himself as a leading portrait painter, made some forays into plein-air work, and begun to focus on design. He won prizes and recognition. Sitting in Shaw's banquet hall, he must have felt that he was finally established, a bona fide member of the art establishment. Benson's striving for personal excellence had taken him far; looking about the room at the accomplished guests, he could not have known that that same striving for perfection would soon have many of these men considering him a rebel and a traitor to the system.

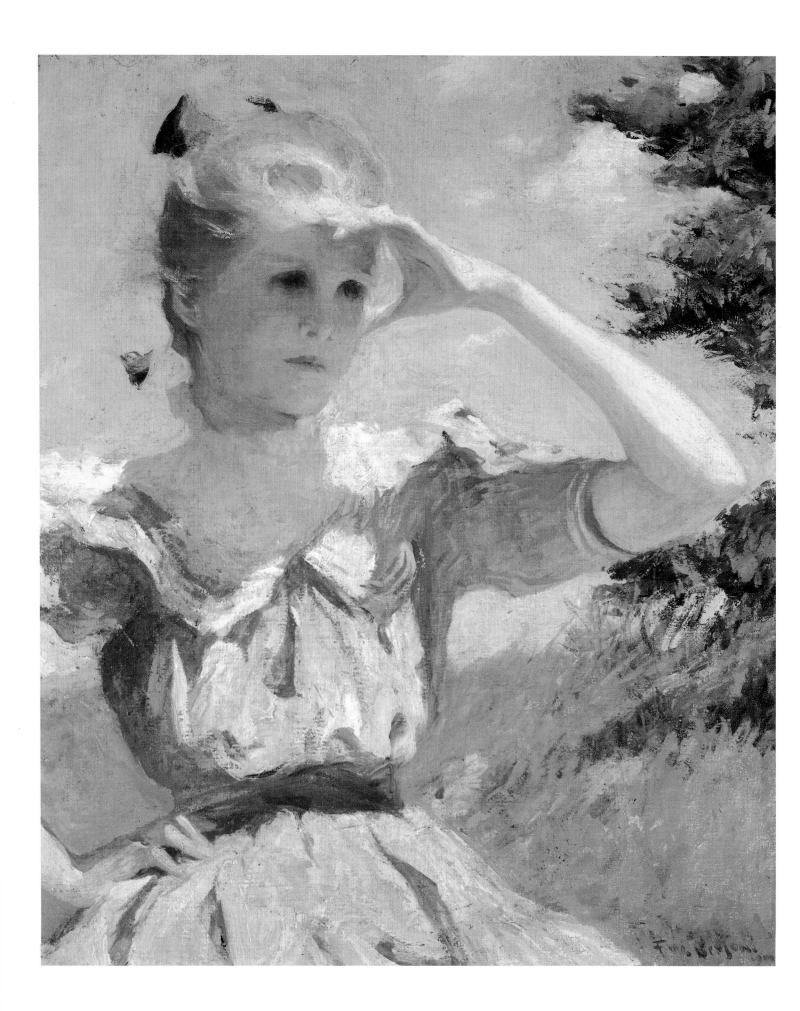

THE TEN

It is somewhat ironic that 1897, the first year Benson, who had been a perennial participant, did not exhibit at the National Academy, was the year in which he was elected an associate academician. Though somewhat tardy, it was an honor for him. Upon election, an artist was expected to present to the academy a self-portrait. Benson completed his heavily shadowed portrait within the next year. A full academician was also expected to present another work, a "diploma piece," of the artist's choosing. Although Benson was not made a full academician until 1905 (a hiatus of several years between the two levels of membership was customary), he painted his future diploma piece, *Portrait of a Child Sewing*, the year of his election as associate. The painting is a study in contrasts, with the effects of light and shadow strongly stated; the many shades of white used in the child's dress bring a pleasing vitality to the work. Benson's portrait of his son, George, seems almost to have been a companion piece. His use of clear, fresh color brightens this work, which is painted in a broad, simple, and direct way. Although Benson painted his daughters often, he only managed to capture George on canvas five or six times (plates 42 and 43).

Although Benson did not exhibit at the National Academy in 1897, he did submit a work to the Society of American Artists annual. He traveled to New York not only to oversee the hanging of his canvas, *My Little Girl*, there but also to serve as a member of the jury. Benson recalled, "We had large juries—25 or 30—and when the show was on, before the public opening, we, who liked each other's works, were looking over the results of the jury's work. We were pretty discouraged with the tone of the show."[1]

Artists' discontent with the society's shows had been growing steadily over the past few years. Although Benson had always exhibited there, his future compatriots in The Ten showed only seven paintings between them at the 1897 show. Several had refused to sit on the jury, as they felt the standards of selection had become too low. Indeed, some of the more experimental works by such artists as Tarbell and Weir were first seen at the academy, once considered far more conservative than the society. A group of artists led by Kenyon Cox were thought to control much of what went on at the society's shows. Cox, recognized as an unwavering academic, strongly opposed any form of Impressionism. Although several Impressionist works had been hung at the society's shows in the mid-1890s, one critic was relieved to see that the 1897 show was much more "rational" and wrote that the art seen there and at the academy's show was "rapidly swinging away from rabid impressionism."[2] Despite widespread acceptance by the public, critics still often disdained the works of the American Impressionists, much as most of the French press had vilified the works of their Parisian counterparts.

After selecting works that would hang in the society's show, a small group of jurors retired to the Players Club, a favorite New York gathering place for men of the arts. Metcalf had made the club a focus for his life in New York; fellow members included Weir, Hassam, Twachtman, Reid, Dewing, and Simmons. Benson visited there when in the city. It was here, Benson recalled, that the idea of forming a group separate from the society

PLATE 41
Eleanor, *1901. Oil on canvas, 29½ × 25". Museum of Art, Rhode Island School of Design, Providence. Gift of the Estate of Mrs. Gustav Radeke.*

73

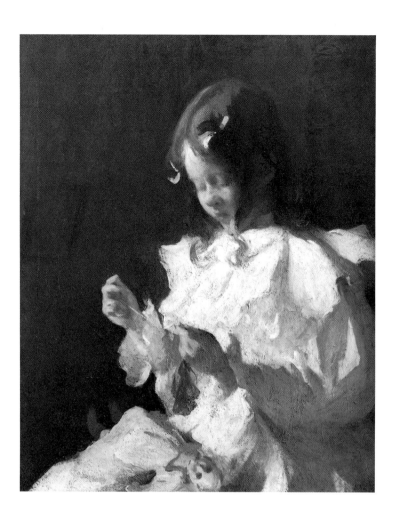

became reality. By December 17 Benson and nine friends—Childe Hassam, J. Alden Weir,
Robert Reid, Thomas Dewing, Edward Simmons, John Twachtman, Willard Metcalf, Ed-
mund Tarbell, and Joseph De Camp—had resigned from the society. The group's with-
drawal was ideological as well as practical. Distressed at seeing their works crowded in
with so many lesser paintings at the society shows, they decided to join together for the
purposes of exhibiting in a non-juried, well-hung show. Each artist was to show only a
few of his best works, and the hanging space would be divided into ten equal parts. If
sales of their paintings were enhanced in such a setting, so much the better. As Benson
noted, "There were never any formalities of any kind. We just met once a year to make a
show of our work."[3] The group had no officers and no juries and, for the first several
years, until they began to exhibit at the Montross Gallery in 1905, they organized and
hung their own shows.

Although various men have been credited with the idea of resigning as a group
from the society, Benson remembered, "I was with Twachtman and he was stating his
feelings freely, and then and there, the proposition was made that a small group of us
should split off and make our own show the following year. We knew each other so well
that there was no question of who should come into the group, and I am sure it justified
itself in its results. . . . I should have guessed that the proposition was put forth by
Twachtman, but that may be merely because I was with him at the time it happened."[4]

The relationships of the men in the group were long-standing. Benson and Reid
had attended the Museum School together and been editors of the student journal there.
In Concarneau, Benson worked with Simmons and Metcalf and met Twachtman while
at the Académie Julian. Tarbell and Benson shared a studio in Boston and taught to-
gether both during the summers in Newcastle and at the Museum School, where
De Camp had formerly taught. Teaching united many of the other men as well: Metcalf,
Weir, Twachtman, and Reid all taught at the Women's Art School of Cooper Union in
New York, and many of the New York members of The Ten also taught at the Art
Students League there. The friendship between Twachtman and Weir dated back to
travels together in Europe, followed by joint shows in New York. They had houses near
each other in Connecticut. (Hassam was a frequent visitor at Twachtman's residence.)

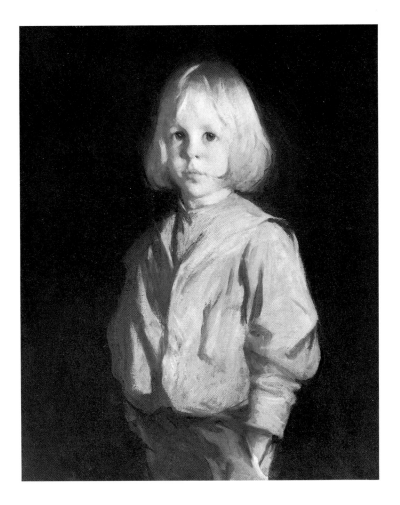

Connecticut was also the site of an artists' colony at the home of Florence Griswold in Old Lyme, where Hassam, Simmons, and Metcalf summered together. Mural commissions had brought together many of the men, and all had served together on juries and hanging committees at the annual shows of museums and societies. Originally, twelve were asked to join. Abbott Thayer was seriously tempted but declined on the grounds that the society needed him. Winslow Homer refused because of advancing age, although his regret at not being able to be part of such an exciting new venture is evident in his letter of refusal: "On receiving your letter, I am reminded of the time lost in my life in not having an opportunity like this that you offer."[5]

The group avoided naming themselves in a way that might have suggested the highly organized institutions they wished to eschew; their first catalogue merely announced, "The First Exhibition/Ten American Painters." It was the press who coined the name "The Ten."[6] It is understandable that their defection prompted comparisons with the revolutionary withdrawal of the French Impressionists from the venerable Paris Salon. However, most of The Ten were already established, well-known artists whose works were eagerly accepted at the most prestigious shows. Their paintings were admired by critics and art collectors, and several of the artists were quite successful financially. They were a far cry from the youthful rebels who had caused a scandal in Paris. Impressionism, however, did unite the two groups. Although not all the artists of The Ten were committed to this stylistic approach, the majority, especially Tarbell, Hassam, Twachtman, and Weir, were experimenting with various aspects of this technique. Had Thayer and Homer decided to join, the Impressionist label would not have been so easily placed on the group. But to call the members of The Ten the "American Impressionists" is to exclude such contemporaries who worked in this vein as Philip Hale, Robert Vonnoh, John Enneking, Guy Wiggins, and Emil Carlsen. Several members of the group were primarily tonalists or only made occasional forays into Impressionism. Benson, Metcalf, De Camp and Reid, were certainly not painting in an Impressionist manner in 1898, but a strong case can be made that their association with the group pushed them in that direction; Benson's own move towards Impressionism coincided with the founding of the group.

Although some conservative art critics were delighted at the exodus of what they

called "extremists" and looked forward to shows that would be more homogeneous, others were appalled at what they viewed as wholesale disloyalty and ingratitude. Benson and his friends were not prepared for this reaction. "ART SCHISM REGRETTED . . . REPROACHES FOR THE TEN PAINTERS WHO HAVE RESIGNED," read the headline of a New York paper. The story continued, "Some bitter feelings have been stirred up by the withdrawal . . . of the painters who, dissatisfied with the conduct of the SAA, would organize a society of their own."[7] One paper, however, took up the cause of The Ten, arguing "In short, the exhibitions seemed to the seceders to have grown too large and indiscriminate."[8]

Facing continued attacks in the press and feeling the need to explain their actions, the group wrote a short letter to the editor of the *New York Sun:*

> Gentlemen, in withdrawing from the Society of American Artists we had hoped to do so without undue publicity or causing any ill feelings. But, not succeeding in this, a statement seems to be called for from us as a body. A high standard in art is apparently impossible to maintain in an institution like the Society, as at present organized, from its imperative need of attracting the public in order to meet its large expenses. Recognizing this and feeling the uselessness of longer continuing a protest against abandoning the earlier ideals of the Society which were perhaps only possible when it was smaller, a protest in which we are forced to believe that we are in a minority, it has seemed wiser to resign and it is for these reasons we have done so.[9]

Benson escaped from the furor in New York by going to Philadelphia in January, where he was on the jury for the Academy of the Fine Arts annual exhibition. He hung three new works of his own there: *Girl Reading,* a charming picture of a young woman in a fluffy white dress, the previously exhibited *Portrait of a Child Sewing,* and his own *Three Children* (plate 44).

The painters of The Ten had planned to hold their first exhibition in March, only a few months after resigning from the society. The events of the intervening months made Benson's preparations for this important event difficult: on February 5, 1898, Ellie gave birth to their last child, Sylvia, and one month later Benson's father died. There had been a special closeness between Frank and his father, who, though once reluctant to see his first son become an artist, had come to delight in his success. As Benson wrote to Dan Henderson a few months later, "You know, we have never been separated from my father hardly more than a few months. My sister and brother were still living with him and it makes his loss the keener. For those at home . . . it is very lonely."[10]

Leaving Ellie with their new baby, Benson traveled to New York for the opening of the first show by The Ten. If the press had been expecting a show of works heralding a new movement by rebellious artists, they were to be disappointed. The only new idea to come from this group of established painters was the method of presenting their works. In January, Weir was quoted by the *New York Times* as saying that he and his friends wanted to follow the Japanese approach to showing art. Indeed, the March opening at the Durand-Ruel Galleries had a distinctly orientalist flavor, with each man showing only a few works in a spare, open arrangement that was harmonious and tranquil. The walls had been repainted to complement the paintings, and the catalogue was small and simple with the list of each artist's work preceded by one of his line drawings: in Benson's case, a sketch of a model's head. One reporter chafed at the idea of having to pay fifty cents admission to see the show, but the press reviews were almost uniformly positive—in marked contrast to the rancor shown when the group seceded.

It was probably not by chance that the new group chose the American gallery of Paul Durand-Ruel for its first show. The gallery was elegantly housed in an old mansion on Fifth Avenue with excellent natural lighting and high ceilings, but it was Durand-Ruel's reputation as an advocate of new movements in French painting that made him the choice of The Ten. Such a reputation could not possibly hurt this new effort.

The art critic for the *New York Herald* was among those generally impressed with the show. He wrote that the group's "showing at the Durand-Ruel Galleries of forty-five works does not especially differ from the Society exhibit in Fifty-seventh Street, except that the forty-five are all No. 1 things—really a Society show, with all the twos and

PLATE 44
Three Children, *1897. Oil on canvas, 24 × 32". Private collection. In this unusual composition, George and Betty face each other in profile; between them, turned away from the viewer, is Eleanor, long blond braids cascading down her back.*

threes and fours left out! One cannot help feeling that it is better thus—certainly more pleasing to the ten painters—though it affords little chance for the younger man to come up. To one seeing pictures all the time, this little gallery containing nothing but good pictures is a treat." He thought the grouping and simple framing of the pictures to be extremely discreet and found the whole room to be a "restful place." He observed that "Messrs. Benson and Tarbell show portraits and similar figure subjects little different from their contributions to the other shows, good in almost every respect."[11]

In comparing the work of the ten artists, the writer for the *New York Times* decided that, while many were clearly students of the Impressionist school, their works could not be called copies or even reflections of the French paintings. It is possible that the group timed its first exhibition to run concurrently with that of the Society of American Artists in order to give the public an opportunity to see both exhibitions. Critics making the comparison claimed that, although the influence of French Impressionism could be seen in both galleries, the work of The Ten was original and individual, while that seen at the society's show was merely a weak reflection of the French style.[12]

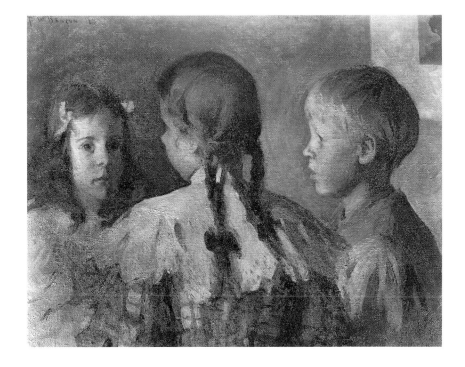

Benson's four paintings in the exhibition were remarkable for their similarity; all were studio paintings of elegantly clad models. His selection for this first show indicates that he was still concentrating on interior work, usually a single model in a setting rich with accessories. Each study was executed under particular lighting conditions, allowing him to demonstrate his mastery of light. *Figure in Yellow* shows a demure young woman softly lit from the left, her eyes are downcast and her shoulders are wrapped in a thin shawl. In *Girl Reading,* the model's ruffled white gown reflects bright lamplight as she looks down upon the book in her lap. *Profile* depicts a girl in a white dress playing a piano in a dimly lit room. *Twilight,* a single figure posed in a contemplative mood, was soft in focus and lit with a diffused glow rather than the focused lamplight used in Benson's 1891 *Twilight* (see plate 27). Although one reviewer found this painting "sentimental," his comment may simply reflect his surprise at the note of drama and stylization in Benson's new studio painting formula. Most often, Benson could be relied upon to produce canvases in which the models were shown in comfortable, uncontrived poses, expressing an air of quiet confidence. This model's pensive mood was a considerable departure from that style.

Beginning a practice that would continue for many years, The Ten sent its show to Boston, where it was installed in the St. Botolph Club in May. Benson, Tarbell, and De Camp, "the Boston Men" as they were called in many press reviews, may well have instigated this move, but it was not the only city to which shows of The Ten would travel. In ensuing years the group's shows were seen in Providence, Detroit, St. Louis, Philadelphia, Washington, Chicago, Milwaukee, and Pittsburgh, often in slightly abbreviated versions. The motivation for sending their works to so many different locations was undoubtedly commercial and the high cost of shipping so many works from city to city must have been offset by sales, exposure, and publicity.

The second show of The Ten, in 1899, was even more carefully hung than the first. The walls of Durand-Ruel's gallery were covered with white cheesecloth, stretched and held in place by gilt moldings, creating a hazy effect that complemented the many Im-

pressionist works. The *New York Times* called it "the cleverest and . . . the most artistic little art exhibit that the New York art public has seen in many years."[13] But other critics decried a fifty-cent admission fee to see just twenty-three pictures by only nine artists (Metcalf was not represented). Many thought that one separate exhibition of paintings by The Ten was enough. Some journalists were further put off by a hastily called press conference and the lack of a catalogue. Yet most critics felt that, despite its smaller size, the second show was of higher quality than the first, and several noted that it reflected the "extreme" or the "ultra" of the Impressionist school.

Perhaps it was the closer association with artists committed to Impressionism that led Benson to attempt, once more, an outdoor painting, *In the Woods,* which captured the play of sunlight on form and color (plate 45). He had ventured into this area before but, by his own admission, without much success. A perceptive writer for the

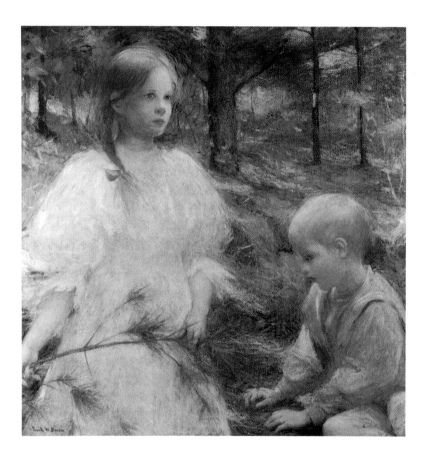

Commercial Advertiser noted "Benson seems not yet to have found his direction, if one may judge from the experimentings of recent years and a departure this season in the shape of a composition of two children, *In the Woods,* which, however, is altogether charming in the rendition of youth while it is decorative in color. The handling is a pleasing admixture of detail and breadth that is singularly effective and tells well on the walls."[14] The painting is noteworthy on several counts. It appears to be Benson's first excursion into the use of broken, prismatic light in an outdoor setting.[15] The brushstrokes are quick and light, almost feathery; the warm haze of the New Hampshire forest seems to shimmer; indeed, the following year, a critic of The Ten show dubbed several of the artists, Benson among them, "the Vibratory Seven." One critic, noting Benson's rendition of light, wrote, "There is air and space among the trees and the composition is well balanced. A passage that will probably appeal to painters is the effect of reflected sunlight across the front of the girl's gown and sleeves."[16] Another focused on the mood of the painting: "The hush of the forest has crept into their hearts: they are very still, perhaps a little awed. . . . While the fresh child-life, so full of possibilities, is the accent of the picture, it is not unduly detached from the surroundings. The subject is a single conception, and everything within the frame is contributory."[17]

This critic touched on an area Benson felt was extremely important when composing a painting. "Look continuously at the whole picture, not at parts," he once told his daughter Eleanor, "the unimportant parts of a picture should not be minutely described so that they will attract notice. . . . Go back again and again—I can't say it often enough—to the effect of things when you are looking at the *whole picture*."[18] *In the Woods* is indeed a departure from Benson's usual style. Although the focus on the effect of light is evident, gone is the academic detail and the smooth finish. The experimental brushwork surrounding Eleanor's head is in fact distracting. Yet in this painting there is the foreshadowing of Benson's Impressionist period, which spanned the next two decades.

In writing of Benson's painting, many reviewers commented that he had only sent one work; obviously they didn't realize it was probably the *only* thing he had to send. The summer that *In the Woods* was painted, Benson contracted typhus from prisoners of the Cuban-American war held in a fort in Kittery, Maine, across the river from Newcas-

tle. He drifted in and out of delirium for over four months and, according to a letter he sent to a museum director, his capacity for work was diminished for two years.

Benson returned to Newcastle the following summer to continue his recovery; he was eager to resume his work *en plein air*. Painting an outdoor portrait of his second daughter, Elisabeth, Benson tested his ability to portray a figure against white clouds billowing in an August blue sky (plate 46).[19] The evidence of Benson's new commitment to Impressionism is even more obvious in *The Sisters,* a sparkling portrait of his two youngest daughters (plate 48). This work was truly a landmark painting for Benson. In his first pure excursion into a high-keyed palette, Benson's dazzling light is reflected from little Sylvia's dress, Elisabeth's hat, the sea, and the sky. His evocation of warm summer air blows the girls' dresses and ruffles Sylvia's curls. Benson had placed figures outdoors before, notably in studies of his wife and children, but those canvases were far more subdued.

The Sisters was called "triumphant" when it was first exhibited in Boston. The reviewer for the *Boston Transcript* proceeded to devote an entire paragraph of flowery prose to its description: "It is delicious far beyond all expectations and, by all that is lovely, we hereby urge our readers to make a point to see this exquisitely beautiful picture. It is an ideally blithe vision of youth and summer sunlight, a spontaneous evocation of infantile grace and purity as delicate as a wild rosebud, as fresh as the morning dew on that bud, as happy as the laughter of lovers."[20] Such Edwardian effusiveness followed *The Sisters* wherever it was shown.

The Sisters won its first silver medal at the Carnegie Institute in 1899. Along with Benson's *Decorative Figure-Autumn* and *In the Woods* it was selected to be hung in the famous Paris Exposition of 1900, and it won the silver medal there. It took another silver medal at the 1901 Pan American Exposition in Buffalo (where it was purchased by the Academy of Fine Arts for its permanent collection). At the 1904 Louisiana Purchase Exposition in St. Louis, it took another prize, this time the gold medal. Loaned frequently, it never failed to draw crowds and accolades.

The following year William Howe Downes, the art critic for the *Boston Transcript,* wrote about Benson's work in a glowing article for *Brush and Pencil,* a well-respected art magazine of the time. Despite being discussed in various magazine and newspaper reviews, Benson's work had never been the sole focus of a piece in a national periodical. Downes covered many of the phases of Benson's work, from his early portraits through his murals to his more recent plein-air work. After praising *The Sisters,* Downes concluded, "It will be no light task to live up to a reputation such as that created by a canvas of these extraordinary qualities."[21]

It was as though Benson had crossed a threshold by eschewing the light of lamp and fire for that of the sun. Although Benson did not entirely abandon the effect of interior illumination, many of his interiors with figures began to be lit by the natural light from a window. For Benson, *The Sisters* was the true beginning of what most art historians call his Impressionist period. Although critics had been seeing hints of Impressionist methods in his paintings for many years, this label became more firmly attached with his membership in The Ten. Yet despite its accuracy, Benson was uncomfortable with the label. His granddaughter recalled that he never considered himself an Impressionist in the full sense of the word. "He used to call himself a "painter of light," she said and, indeed, he once told Eleanor, "I simply follow the light, where it comes from, where it goes to."[22] This is not to say that Benson did not admire the work of the French Impressionists or that of his American friends who were working in a similar manner, merely that he did not consider himself exclusively a member of that school.

His granddaughter felt that his reluctance to accept the Impressionist label was a reflection of his disdain for being pigeonholed into one category in art, possibly coupled with his modesty. He once told her that he had been experimenting with outdoor effects for many years but never felt he had got it quite right until he did *The Sisters.* She added that he seemed to feel that several of his friends—Twachtman, Metcalf, and Tarbell, in particular—really achieved the effects but it took him a long time before he felt confident in his ability to capture the essence of Impressionism. Watching her grand-

PLATE 45
In the Woods, *1898. Oil on canvas, 40 × 40½". Location unknown. Eleanor, dressed in white, stands holding a branch of an unseen pine tree while George, wearing a pale blue sailor suit, sits at her feet.*

father teach her mother about painting, this granddaughter wondered if he was slow to take up Impressionism because he was first and foremost a teacher and was reluctant to give up his strong emphasis on the figure.[23]

The works of Benson's Impressionist period show that he was hesitant in sacrificing the volumes of form for color. Giving his canvases a thin wash of pale gray, he would sketch with charcoal a well-defined drawing, then mass in the patterns of dark and light, as well as the broad patterns of color. Refining this lay-in, Benson would then carefully develop the secondary passages of the painting, paying close attention to the various color values of the forms. In giving his daughter a criticism, Benson once said, "Colors don't matter much—values are what you must get right—they are the only things that give any effect of sun and shadow. Don't mess around with your color and pat it down and smooth it out. Put it on and leave it. And make it strong."[24]

The final strokes that Benson used to complete the last layer of a painting were crisp and sure. He once told Tarbell that he thought Sargent's strokes looked like "fishhooks"; he avoided such stylization, preferring instead to build up his paintings with a series of small, daublike strokes in the manner of Monet or Sisley. In many of his works of this period, each separate stroke carries a different color; they act like facets of a jewel to highlight different tones. He used a heavy impasto of paint in many of his paintings, but his refusal to work on a canvas if the light changed is illustrated by the many instances of drybrush effect created when a semifinished work was put aside until the light was right and the previous layer of paint had dried.

That he admired the palette of the French painters is evident in his works after 1900. Retiring the earthy tones of his previous paintings, he began to employ more primary colors; he became adept at graying a color with a complement and accenting shadows with pure color. Benson felt shadows should have warmth and never be "slatey"; there is little black in his paintings of this period. Of a model's black hair, he once said, "Don't paint it with black paint even if it is black. Against that green background it must have a certain warmth."[25]

Despite his new high-keyed palette, Benson was still careful to employ what he said Tarbell called the "dirty colors." He felt that a picture that was too bright lost its maximum effect if there were no contrasting bits of dull color. He told Eleanor, "What gives charm to a picture is not the brilliant color—the strong contrasts, but the delicate bits, where one thing comes against another with no difference in value, and only a slight one in color. . . . The doing well of these bits is the most essential part of making an interesting picture. What makes the difference between a good picture and one where only the obvious differences are put down is how these delicate, intimate details are made."[26]

While *The Sisters* can be viewed as the beginning of Benson's Impressionist period, it also marked another milestone: it was the first outdoor work to spawn another major painting.[27] Once Benson had captured little Sylvia on canvas, he transferred her image to another work, *Child in Sunlight* (also called *Sylvia*; plate 49). As is true for several of his later "divided" paintings, *Child in Sunlight* was not copied exactly. Much more of a portrait than the first painting, it does contain numerous modifications. Sylvia is closer to the viewer; the pier on the right, with its little dory, is placed closer to the baby. The pier acts as a bracket, framing her figure between it and the small sailboat that has been added in the distance to her left. The willow branches which added interest in the upper part of the main picture are gone, as are Sylvia's bonnet and of course her sister Elisabeth.

In considering Benson's replication of a motif, it is quite probable that he knew of the serial paintings of the French Impressionists, such as Monet's studies of haystacks in various lights, several of which had been seen in Boston. But Benson's motives for creating such works were personal as well as financial, for almost everything he produced intended to be for sale. If he painted one of his children and could not bear to part with the work, he would sometimes copy it before selling the original (such as in *Mother and Child* or *Boy in Blue*). In some instances, Benson wanted to retain for himself (as in *Child in Sunlight*) or for a friend (as in *Portrait of Margaret Strong*) the single figure or portrait

PLATE 46
Portrait of Elisabeth. *c. 1899. Oil on canvas, 30 × 24". Private collection.*

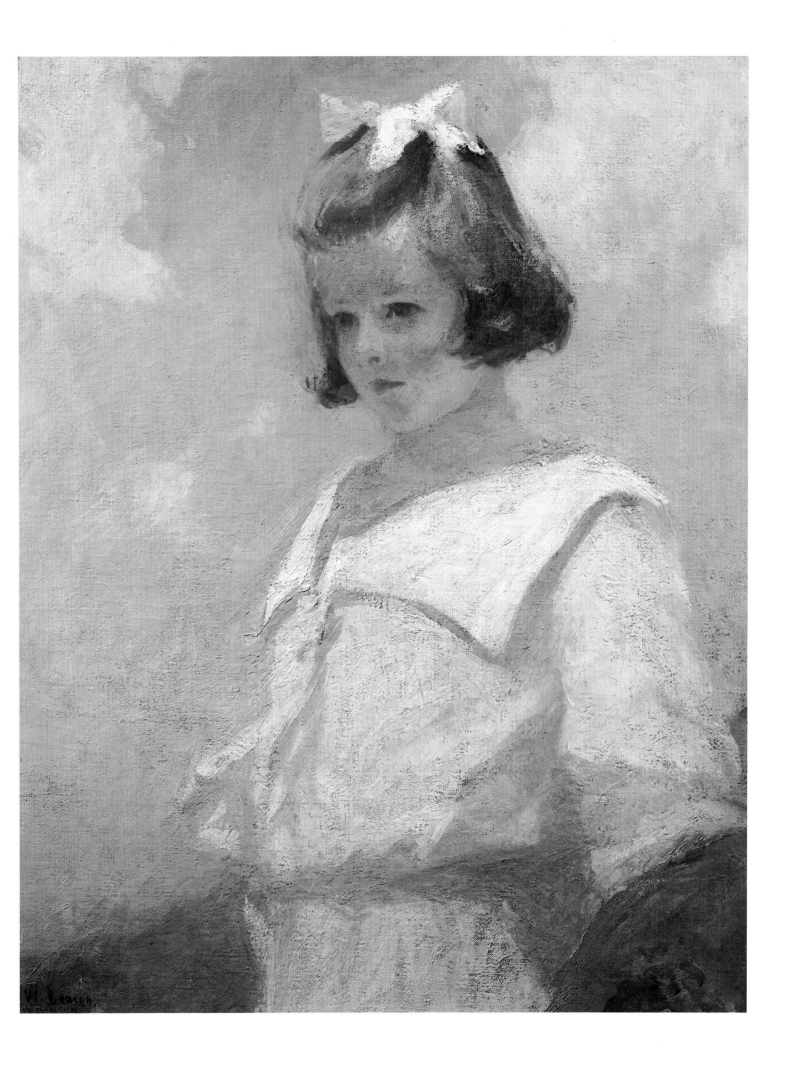

of a child drawn out from a larger work destined to be sold. But, in creating these works, he was acknowledging methods of the French masters.

Child in Sunlight and *The Sisters* were the beginning of Benson's chronicles of a sunny, prolific, and prosperous era for him and for his family. Of the dozens of sparkling outdoor works that Benson created during the next two decades, almost all were sold. Benson's move towards a comprehensive change in style struck a responsive chord. Patrons wanting a Benson portrait began asking for one in this "new" manner, and collectors, disappointed at not being able to buy the original version of an outdoor work, commissioned Benson to repeat it for them. The plein-air paintings Benson completed in the ensuing years reflect the idyllic world of his family at play at their summer home. But that summer home would no longer be Newcastle.

In 1900 the Bensons spent a summer in Ogunquit, Maine, a little coastal village where Charles Woodbury had a summer art school. That same year, a friend from the Tavern Club, Heman Chaplin, asked Benson to paint a posthumous portrait of his young wife and persuaded him to bring his family to visit North Haven Island, where the Chaplins had been building a house which Heman was now completing alone.[28]

North Haven, only eight square miles in size, is a short ferry ride from Rockland. It is the smaller of the two Fox Islands, which nestle together in Maine's Penobscot Bay.

PLATE 47
Wooster Farm, North Haven, Maine, c. 1905.

The lumber industry, which had earlier supplied wood for the kilns of the lime industry in Thomaston, opened large sections of the island for farming. By the time the Benson family came to North Haven, many of the island's farmers were raising sheep. North Haven lamb was prized in Boston, and the titles of some of Benson's summer works, such as *Sheep Pasture*, reflect this thriving industry.[29] During the 1880s, mackerel seining was at its height, and the log of the Bensons' summers reveal enormous catches of this fish.

While visiting the Chaplin family, the Bensons walked through the woods to call on Levi Wooster, whose farm stood on Crabtree Point, a narrow neck of land bordered on one side by Wooster Cove and on the other by the body of water between the two islands called, locally, the "Thoroughfare." Although the farm was not for rent that summer, the Bensons could see that it would be ideal for their needs. It had neither plumbing nor electricity, but the foursquare house with its large central chimney was big enough to hold their family as well as maids, pets, and visitors. The large barn would make an excellent studio. There were plenty of flat open fields for gardens and childrens' play. But mostly, there was light and space. The summer sun shone on the meadows with hot, almost Mediterranean light; the views were endless. Few trees broke the sweep of land, sea, and sky. To the west, the blue hills of Camden were barely visible through the hazy summer air and to the south, across the sparkling waters of the Thoroughfare, lay Vinalhaven Island. An old orchard grew close by the house, and a tall spruce forest stretched away from the barn. It was remote and quiet and Benson knew he could accomplish a great deal there (plate 47).

The discovery of North Haven was an event that would affect Benson's life and art

for years to come. The death that winter of Levi Wooster and the Bensons' subsequent renting of his farm began a pattern that would remain constant for almost the rest of their lives: winters in Salem and Boston, summers in Maine. Benson's letters to family and friends reflect an eagerness to return to Wooster Farm that only grew stronger with each passing year. Literally like a boy out of class, as soon as the Museum School closed for the summer, Benson would gather his family and head for Boston harbor, where they would catch the evening schooner bound for Bangor, Maine. After only a brief night's rest the family disembarked in Rockland at 4:30 A.M. and waited in the early morning darkness for the ferry, a side-wheel steamer named the *Mt. Desert*, which made a stop at the Fox Islands on the way to Bar Harbor.

In one of the earliest entries in the log that the family kept of their summers at Wooster Farm, Benson wrote, "The first year we got to the village by means of our sailing dory and sometimes the old horse we bought of Mrs. Wooster."[30] Through the woods, several small houses clustered around a small cove called Bartlett's Harbor; many of Ellie's and Frank's brothers and sisters rented these cottages over the years.

With the exception of the few outdoor works he had done in the summers between 1898 and 1900 in Newcastle and Ogunquit, almost all Benson's great plein-air paintings were done at North Haven. Their "joyous gaiety" and "holiday mood," so admired by critic and gallery visitor alike, were inspired by the crystalline air and light of Wooster Farm. Benson's paintings of this era reflect the idyllic world that North Haven became both for him and for his family.

Each morning, as soon as the silvery mist of fog had lifted, the children explored their favorite haunts. Days were spent fishing and sailing, picnicking on the beach, picking blueberries, and swimming. Clambakes, barn dances, and hymn sings filled the twilight hours, and evenings were spent reading by lamplight. It is a wonder that the children could be coaxed to pose for a painting.

Benson's first North Haven works include a canvas of his oldest daughter, Eleanor. Her pose, hand upraised to shield her eyes from the noonday glare, was one the children would repeat often in summer paintings of years to come (plate 41). When it was shown at The Ten's exhibition in 1902, a critic wrote that it "brims over with light and air and is really engaging.[31]

During the family's second summer in North Haven, Benson renovated the barn. He partitioned it down the middle and turned one half into a studio, in which he placed a large, high north window for good light. The other half was used for storage, and on rainy days it became an indoor playroom or tennis court. His children and grandchildren remember being allowed to play on the court only when their "Papa" was not working. They weren't supposed to go into his studio at any time, but, a few years later, a small note in the log in Benson's handwriting indicates that sometimes they did. "July 14— Children using my studio as a squash court."[32]

Below the barn was a tennis court.[33] In 1906, when the Bensons finally bought Wooster Farm and about twenty-five acres of land surrounding it, the court was one of the first improvements. Just before they left for Salem, Benson noted, "Gave orders to have the tennis court harrowed in the spring and directed Irwin [Dyer-the hired man] about enlarging the studio in the barn for next summer's use."[34] Four year earlier Dyer had built a piazza that extended across the entire front of the house and greatly increased the family's summer living area. On it he constructed a wide bench, featured frequently in Benson's summer works. The piazza became a favorite place for afternoon tea and tennis watching.

Benson loved his island retreat and invited many of his friends at the Museum School to visit. Bela Pratt, the instructor of sculpture at the Museum School, and his wife, Helen, needed no coaxing to try a summer on North Haven.

Benson also invited Joe De Camp to North Haven; their children were close in age and the families had become friends. De Camp's granddaughter has recalled, "Frank Benson took my grandfather across the bay [to Vinalhaven] to see an interesting piece of property that he thought he ought to buy . . . three old farmhouses and a couple of

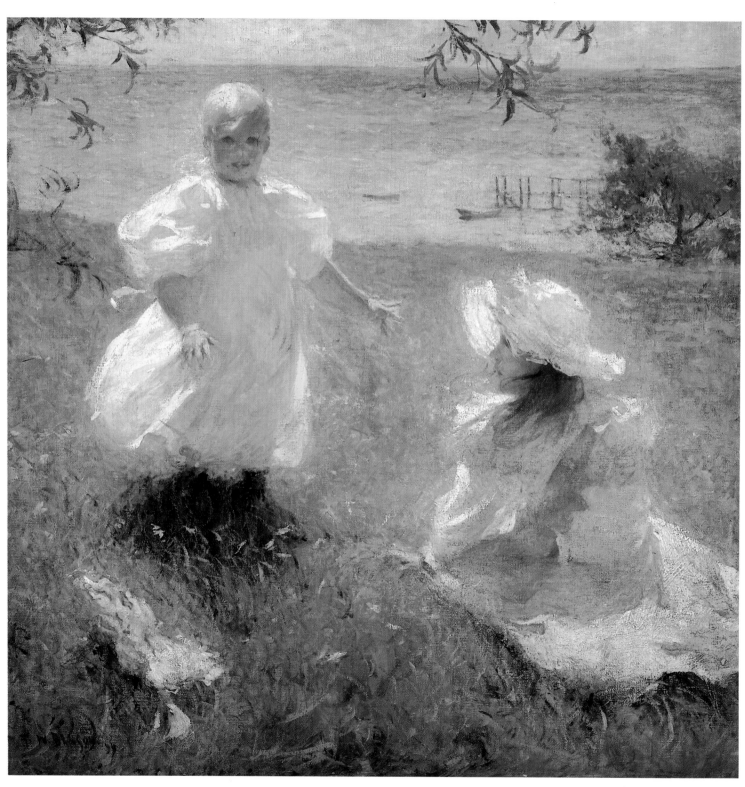

PLATE 48
The Sisters, *1899. Oil on canvas, 40 ×*
39½". I.B.M. Corporation, Armonk,
New York. This painting was greeted
with praise from the moment it was ex-
hibited at the Carnegie Institute in No-
vember 1899, where it immediately
won its first prize: $1,000 and the Sil-
ver Medal for Painting.

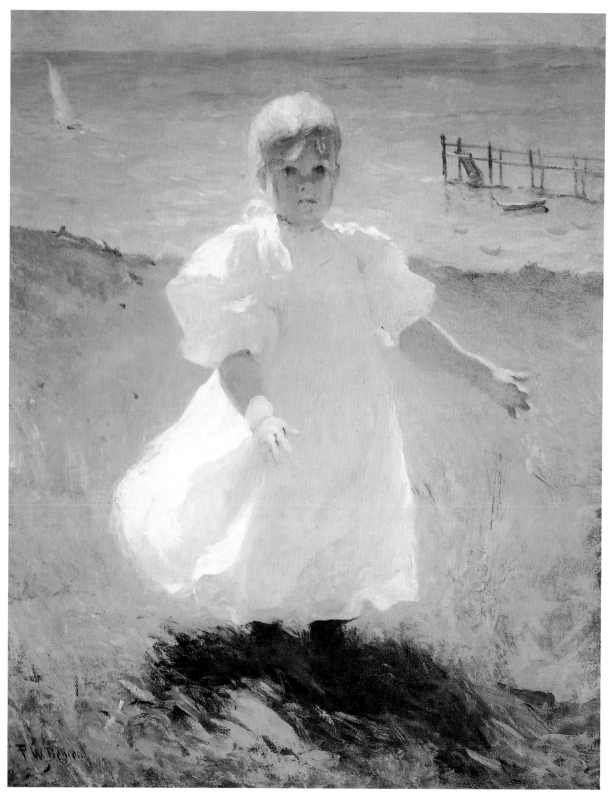

PLATE 49
Child in Sunlight, *1899. Oil on canvas, 30 × 24⅛". Private collection.*

outbuildings, a boat house and a smaller shack which his cook lived in. . . . The barn he converted into a studio and put a big north light into it."[35] She also noted that long-windedness, blustery gruffness, and temper were some of De Camp's less endearing qualities. Pratt was undoubtedly referring to these aspects of his character when he wrote to a former model, "Joe De Camp has bought a place down there. I expect the climate will be warmer and more breezy after this!"[36]

Frank and Ellie were both excellent golfers and over the years developed a small "golf course" at Wooster Farm. A short fairway, a few greens; it provided great entertainment and lively competition for friends and family. They played croquet and tried bowls but, because there was no large area of truly smooth, level grass, pitching horseshoes seemed to be more satisfactory.[37]

The other sport that engaged the energies of the Bensons was archery. A decade earlier, at the house at Eastham, the men of the family had set up an archery court and practiced diligently. A small entry in the log notes with pride that Ellie's nephew won

PLATE 50
Osprey, c. 1905. Charcoal on paper, date and dimensions unknown. Private collection. Benson rarely used charcoal for a finished work. This sketch of a pet osprey is one of two known surviving examples of work in this medium.

the National Archery Championships. Benson hand-carved many of the bows for the family, not only from native woods but also from woods he imported especially for the purpose. Smooth, graceful arcs, these bows were carved to the exact specifications of each child. Many of Benson's letters to Eleanor, away at college, are full of advice on archery:

> I could only find five arrows in Boston and I sent them yesterday. They may be too slender for the bow I sent you, but would fly well in a light bow. . . . I shan't let you shoot at thirty yards this summer, that is a foolish distance. You ought to practice at 40, 50 and 60 yards. . . . We'll have a lot of good shooting in North Haven this summer. I am going to send down a new target before we go.[38]

In addition to bows, one grandchild has recalled, "Papa enjoyed wood carving, fashioning marvelous chains from a piece of pine with interlocking flexible links, the end attached to a cage holding a captive ball."[39] One granddaughter has remembered the beautiful spoons he made for his grandchildren, each with a unique carving on the handle. Although Benson never took up sculpture professionally, his carvings were remarkable; an admirable pair of auks demonstrate his skill. Equally skilled at building kites, Benson loved designing them and teaching his children and grandchildren how to fly them.[40]

Benson also carved splints and miniature cages for the tiny hummingbirds that the children would find lying on the grass beneath the studio window. Wild birds were a part of each summer (plate 51). In the summer log of 1903 Benson noted, "Our pets consisted of one lamb, two fishhawk, a humming bird, pointer dog and two chickadees."[41] Just as in Abbott Thayer's home, the wild pets had the run of the house and had to be gradually weaned and returned to the wild before the Bensons returned home. In a rare charcoal sketch, Benson captured one of the family pets, possibly Fanny the Fishhawk or her sibling Bill the Grouch, perched on a limb with stately diffidence (plate 50). The birds of North Haven were to feature prominently in several of Benson's future wildlife studies.

It was just such a study that elicited praise when it was seen at the opening of Benson's first one-man show. Held at the St. Botolph Club, this retrospective exhibition brought together works as early as his *Girl with a Red Shawl* of 1890 and as recent as his painting of wild birds and his new summer paintings of his children. Nine portraits were also included. *Elisabeth* and *The Sisters* returned to Boston from Pittsburgh, where the annual Carnegie Institute show had just closed. Rhode Island School of Design lent *Autumn and Spring,* and fellow artist Dwight Blaney lent *Head.* From his hunting companion, Arthur Cabot, Benson borrowed *Swan Flight* and *Decorative Head;* he rounded

out the show with *Portsmouth Harbor, In the Woods,* his new *Twilight, Portrait of a Child Sewing,* and several wildfowl works.

As the *Boston Transcript* art critic noted, "Mr. Frank W. Benson . . . has traveled a good distance along the highway of art. . . . It was time to give us the opportunity to ascertain where he had got to and wither he was going. . . . The exhibition at the St. Botolph . . . responds to these queries so clearly and hopefully that it is in every sense a welcome event." Giving a thorough report of the show, he closed with what may be the first written critique of Benson's bird paintings:

> The collection contains . . . several studies for decorations consisting of wildfowl, which are exceedingly original in arrangement, in observation of movement and form and in the adaptation of these things to ornamental aims. Wild Fowl Alighting, No. 23, is particularly interesting for the novelty of the scene and the gusto with which the action is set forth.[42]

In the spring of 1900 Benson exhibited at a special show in Columbus, Ohio, entitled *America's Greatest Living Painters* as well as at the now well-ensconced Ten show, held once again at Durand-Ruel Galleries in New York as well as the St. Botolph Club in Boston. It was the first time Benson exhibited his paintings of wildfowl in New York, and for the critics there it was something new. The writer for the *New York Times* commented, "His two sporting scenes—*Wild Fowl Alighting* and *Early Morning*—evidently painted on the Chesapeake or Currituck marshes, are not only accurate in drawing and truthful in atmosphere and feeling, but will stir the gunner's heart. Especially good is the *Early Morning,* with the ducks in flight and the gray expanse of marsh and sky rose-flushed in the east with the dawn." But the same critic also grumbled, "The members of this body pride themselves on their freedom from convention and hence, unconventionally, do not supply a catalogue of their display. This may be refreshing as a novelty, but is not convenient to art writers."[43] Although the show only contained twenty-eight paintings, one writer noted, "The keynote of the little exhibition is cleverness. . . . The influence of the modern French masters invests all."[44]

In terms of the French espousing painting "impressions" of what they saw, Benson's years of observing the wildfowl on the marshes near Salem, on Cape Cod, and in the bays of the Chesapeake resulted in canvases of birds in flight or at rest where, in his own words, the "design was all." Moments spent with his own children at play were the inspiration for the joyous, sunlight paintings that won favor with all who saw them; suffusing these canvases was his mastery of light. Vignettes from his life, combined with his continuing experiments with the effects of light, became the hallmark of Benson's Impressionist period.

Benson's other painting in The Ten show, *Decorative Figure—Autumn,* is notable for being one of his first recorded full-length studio works in a purely decorative mode.[45] Whereas Benson's outdoor paintings are spontaneous and bathed in sunlight, this work has a full, sonorous, warm color scheme. The strong tones of the landscape background are rich and deep, and the harmony of the painting is pleasing with the red making a strong statement (plate 54).

This type of decorative work was an extension of Benson's carefully arranged

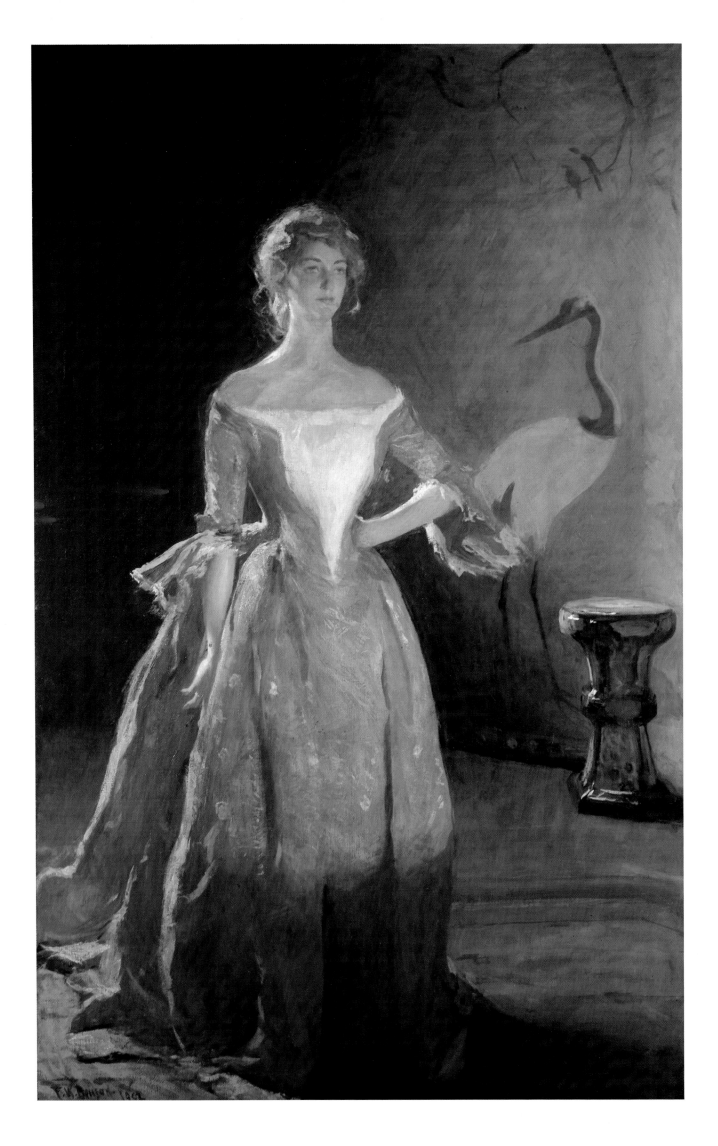

PLATE 52
Portrait of Mary Sullivan, 1902. Oil
on canvas, 84 ×54". Collection of Ira
and Nancy Koger. When this work was
displayed at the National Academy
of Design in 1906 (under the title
Portrait), it was awarded the Thomas
R. Proctor prize.

PLATE 53
A Woman Reading, 1903. Oil on
canvas, 42 ×30". Beverly Arts Associ-
ation (Chicago). John Vanderpoel
Gallery. This painting won a gold
medal at the Carnegie Institute's annu-
al exhibition in 1903. It was further
honored by being selected to hang at
the Munich International Exposition
in 1904.

PLATE 54
Decorative Figure—Autumn, 1900.
Oil on canvas, 39 ×31". Collection of
Ira and Nancy Koger. This formal,
elegantly composed canvas caught the
eye of Benson's friend Frank Duveneck.
Duveneck urged "his" museum in
Cincinnati to purchase it, writing, "It
seems to me that this would be a good
picture to have at that price [$500] and
. . . I think will be a good choice for this
year." Frank Duveneck to James Gest,
12 June 1900, Benson file, Cincinnati
Art Museum.

studio pieces. Although he continued to win praise for the sparkling outdoor works of his children, his winter months were still devoted to the teaching of the academic figure . . . and the painting of it, both in portraits and in interiors. A critic once compared the latter works to "the noblest work of the portrait painters of the late Renaissance . . . Van Dyck and Rembrandt."[46]

The comparison is valid when one considers the pose of Benson's subjects, the breadth and freedom of the drawing, the technique, and richness even in the white tints. Evident, too, is the influence of his friend Sargent, who frequently employed the device of placing a single figure, often in a dramatic pose, against a dark background (as in his *Portrait of Madame X* or *Portrait of Isabella Stewart Gardiner*). Yet Benson's figural works are far less stark than Sargent's, and they are more brightly illuminated than those of the Old Masters.

In Benson's almost life-sized painting of Mary Sullivan, his favorite model, the fabrics, elegant accessories, and striking backdrop are all subordinate to the light that falls on the figure (plate 52). When Benson first exhibited it, Arthur Hoeber wrote, "Painted with breadth and certainty, the work is impressive from its sincerity and earnest, if unconscious, rendering of textures and flesh, while the charm of femininity is ever present."[47]

Mary was also the model for another elegant interior with a completely different perspective. Seen from behind, she is the subject of *A Woman Reading*.[48] When he saw it at The Ten's fifth annual exhibition, one critic focused on Benson's treatment of light: "This figure receives the full discharge of sunlight behind: it brings out the carnations of neck and cheek, the colors of the robe, the big yellow embroidered flowers on the hangings of the background" (plate 53).[49]

Mary is also thought to have been the model for *Girl with a Gold Fan,* another typical, carefully composed arrangement that features a delicate young woman holding a fan and seated in a chair in front of a large Japanese vase. It was Benson's sole entry to both the Chicago and Cincinnati shows of 1901. When it was exhibited in the annual Philadelphia exhibition the following year, it awakened "awesome admiration" in the *Philadelphia Times* art critic, not just for "the daring assurance and perfection of the technique" but for its "stately" similarity to Old World interiors.[50] These paintings of genteel young women in richly appointed rooms were to remain a staple of Benson's oeuvre until the 1920s.

Mary Sullivan was a great favorite in many of the studios of Boston. She became more than just a model to both the Benson and Tarbell families, acting as an occasional nanny to the Tarbell children and helping the Bensons when they entertained. Her carriage and bearing suited Benson's needs, for she was tall and slim with finely chiseled features. She was known in Benson's family simply as Mary, or "the beautiful redhaired model." Although Mary's daughter recalls that her mother had a mass of golden hair which she sometimes referred to as "brassy," it was not in the least auburn. Recalling Benson's admiration of Titian as a student in Paris, it is not surprising that he emphasized the red glints in the hair of his various models, including that of his daughters.

Orphaned at a young age, Mary lived in Boston's Irish South End and was able to support herself by modeling and various domestic jobs. Tarbell and Benson, concerned that she would not always be in such great demand as an artist's model, pooled their resources and sent her to the best nursing school in Boston, the Massachusetts General Hospital. But Mary never graduated from nursing school. While doing part-time modeling in Philip Hale's studio, she met Stephen Codman, son of an old Boston family, who had met Hale while studying architecture at the Ecole des Beaux-Arts. He convinced her to stop school and they were married in a small ceremony in 1905; Edmund Tarbell gave the bride away.[51]

After reading some of the reviews that *Girl with a Gold Fan* received, Benson might well have wished he'd painted it over. Although the Philadelphia critic had admired the work, he nonetheless observed that "the delicately rounded arm" was "foreshortened upon the arm of the chair."[52] In terms of perspective, painters often made parts of the body smaller or shorter to denote distance or angle; unfortunately, Benson's

attempts at this sometimes failed. When this same painting was seen at The Ten show of 1901, another reviewer also faulted Benson's attention to anatomy: "A large portrait, most able in painting, is unfortunate in the artist's insistence on a neck that should either have been covered up altogether or else painted with a more kindly eye and hand. Yet Mr. Benson, with cruel directness, has lingered over the anatomical construction until the spectator may not escape it."[53]

In another work, *Portrait of a Lady*, seen the following year, the position of the left arm is awkward and clearly out of proportion. The critic Minna C. Smith, while noting that this painting is a "striking example of Mr. Benson's decorative bent" and admiring "the whole scheme of light and shade, [which] is brilliantly Bensonian," still observed that "a painting with such astounding drawing of the arms in odd sizes—yes, two lengths—will not rank with Benson's best pictures in the long test of time."[54] When it was exhibited at the 1902 show of The Ten under the title *Study*, the critic for the New York Daily Tribune was harsh indeed: "The arms . . . are badly drawn and around the throat the flesh tints are as sickly as the modeling is hard."[55] Although another critic was a bit more charitable, calling it "a charming figure, with the exception of the left arm, which is ungracefully disposed," it is clear Benson was not always adept at proportions.[56] Benson himself was not pleased with this work. Shortly after it was given to the Metropolitan Museum of Art, he wrote, "It is not one that I should have chosen to represent me."[57]

The Ten show of 1901 was not well received by the press. One reporter remarked that "the courtesy of a preview was withheld," but was somewhat mollified by the withdrawal of an entrance fee. Only nine men showed their work, causing at least one reviewer to comment that the missing man, Simmons, might wish to have the whole gallery to himself—a reflection on the size of the murals to which Simmons had been devoting himself at the expense, some felt, of his works on canvas.

The reviews of the show were the most negative of the group's twenty-year existence. The writer for the *Evening Post* felt that The Ten had become as commercial as the parent group from which they had resigned three years before; other critics faulted them for holding their exhibitions at the same time as those of the Society of American Artists, saying that they were not "good citizens"; one even complained about the paintings' titles. Royal Cortissoz, a writer for both the *New York Daily Tribune* and the American edition of *Artist*, who was later to become the group's staunchest advocate (as well as a close friend of Benson's) struck the only totally positive chord.

Amid this general criticism, Benson's three works—*Profile, Girl with a Gold Fan*, and *The Sisters*—were felt to be the best in the show. *The Sisters* was singled out for the strongest praise. One writer thought it "charmingly spontaneous and fresh in color and treatment" and was pleased that it "bids defiance to the pessimism and eroticism so prevalent in all forms of art just now."[58]

While the reviewer for the *New York Times* found *The Sisters* a "successful and beautiful attempt to paint in the open," he also tried, as several others had before him, to stuff all the artists into the same Impressionist box, then seemed surprised when they would not all fit. In a somewhat caustic tone, he described the air of their individual studios as probably being "full of atmosphere of a rather warm sort, vibrating, in fact, with expressions far less suited to interiors than the open air." He then lambasted Simmons for "not vibrat[ing] up to the proper standard of vibration," and dubbed Childe Hassam "an archvibrator." Poking fun at The Ten's name he concluded, "If the Vibratory Seven do split off from the Sacred Ten, they must consist of Messrs. Hassam, Reid, Benson, Weir, Twachtman, Tarbell and De Camp. All that Messrs. Simmons, Dewing and Metcalf have to do is to choose another seven from the Society of American Artists who have ripened since the Sacred Ten withdrew, and fill up their mystic number once more. . . . In time they may divide into a Four and a Three."[59]

Like so many other critics, this writer continued to look for what was similar among the men—other than their simple desire to participate in well-hung exhibitions of only the finest examples of their work. Impressionism was still controversial when The Ten broke off from the society, and its practitioners were usually viewed as young

PLATE 55
Sunlight, 1902. Oil on canvas, 44 ×
36". Pfeil collection.

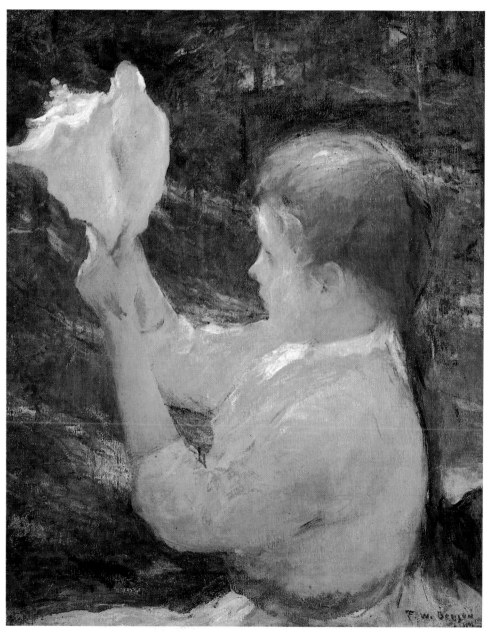

PLATE 56

Child with a Shell, *1902. Oil on canvas, 30 × 25". Private collection. Eleanor told her daughter that she remembered how her father kept her attention and pose by saying, "El, El, look into the shell," when she would get restless. Granddaughter NB, interview with the author, May 1987.*

revolutionaries. The men of The Ten were hardly that. By 1901 many of them were at the height of their careers and certainly not young. Yet reviewers continued to look for a unifying aesthetic or theme that would justify the group's continued bond (one which was predicted to last only a year or two).

By this time, a clear pattern had emerged in Benson's life. Autumn marked his return to teaching and to his Boston studio where his summer pictures received their finishing touches and frames before the first of the season's art shows in Chicago and Pittsburgh. The migrations of the wildfowl sent Benson and his friends on trips to the marshes near Salem and to Eastham, where Christmas would culminate in a week's gathering of the men of the clan. Winter brought the annual shows at the Boston Art Club and the Philadelphia Academy of the Fine Arts. With spring came the annual show of The Ten and those in Worcester and Cincinnati. Although he later added other shows to his calendar and special exhibits occurred often, these major shows had always claimed his participation and would do so for decades to come. Spring also meant the opening of the trout season, something Benson never missed.

Benson often selected a group of paintings that he would send, unchanged, from one show to the next. This consistency is helpful to art historians in determining whether a painting has been given a different title—usually by a museum director. When it disappeared from the "circuit," it had probably been sold, often in the city in which it was last seen.[60]

Benson withdrew his painting *Study (Portrait of a Lady)* from the group that had appeared in New York at the 1902 Ten show before that show traveled to Boston's St. Botolph Club; it was an obvious bow to the criticism that was heaped upon it in New York. Fortunately, the portrait of little Eleanor, which he had completed in North Haven the previous summer, garnered positive reviews. Although the majority of critics were not impressed with Benson's studio works, they felt his plein-air study of Eleanor was a "joyous, breezy, out-door view" and was "particularly effective and 'carries' across the room in a really remarkable way."[61]

Such reviews encouraged Benson to continue with his sunlit paintings of his children. Running through the meadows, sailing toy boats, flying kites, exploring the beaches of Wooster Cove, sitting quietly in the forest: Benson's children at North Haven were a source of inspiration for countless paintings. These works have a warmth and intimacy similar to the paintings of Mary Cassatt. Her canvases of children in informal settings caught in moments of reflection or at play won acclaim and steady sales, just as Benson's summer paintings did. Although there is no indication that Benson and Cassatt ever met, he was certainly aware of her work; she had exhibited widely in America and her work was in several Boston collections. Her murals had been seen at the Columbian Exposition.

Both artists were perceptive observers of the domestic scene. Unlike fathers who left home for work each day, Benson spent his summer hours with his family. Judging from family reminiscences, when he had completed his morning of painting, Benson was always available to his children—playing with them, swimming, fishing, and hunting with them. Thus, the intimacy of his summer paintings is understandable; their sensivity is based on Benson's response to the brief moment of childhood.

Yet there is a subtle difference between Benson's own children and their French counterparts in Cassatt's paintings—Benson's are more exuberant and vital. As one critic wrote, "What a relief it is to turn to Frank W. Benson's *Sisters*. . . . These are veritably children healthy, natural types, spontaneously represented, fresh, happy, lovable. What a joyousness of sunshine and buoyancy of bracing air."[62]

Eleanor's fascination with seashells charmed her father, and he painted two versions of her at play with a large shell she had found on one of her beach rambles. In one version, she is gazing into the shell, and in the other, she is listening to the "ocean's roar" (plate 62). It was undoubtedly the combination of mother and pet that kept little Sylvia distracted enough for short periods of posing in another work from the summer of 1902. The title, *Sunlight,* fully expresses the subject, for light fills the picture—highlighting the child's white frock and the bow in her hair, dancing off the flowers, the

94

grass, and the waves beyond. Benson captures well the freshness of the sea air and his fluency expresses the vitality of the outdoor life that was North Haven. As an inducement and reward for sitting still during the long, boring periods of modeling, Benson paid his children fifteen cents an hour. But, for four-year old Sylvia, money had little meaning; kittens did. In Philadelphia, this painting won the coveted Lippincott prize for the best painting in oils when it was hung at the Pennsylvania Academy of the Fine Arts the following winter (plate 55).

For Benson, immersed in painting his sun-filled world, the news of John Twachtman's death that August in Gloucester was an unexpected blow. He had enjoyed his company immensely and was deeply affected by his passing. Twachtman was a dynamic, outspoken man who aggressively championed The Ten. "What a loss we have sustained in poor Twachtman's death," Benson wrote to James Gest. "I suppose people now will begin to realize what a really great landscape painter he was."[63] Many of Twachtman's friends were fully aware that he did not receive the appreciation he deserved. His work was often refused at the National Academy shows and poorly hung when it was accepted. Weir, who had nominated him to the academy for many years without success, joined four other members of The Ten in writing a reminiscence of Twachtman in which they bemoaned the triumph of mediocrity over "unusual and superior things." As Thomas Dewing wrote, Twachtman "is too modern, probably, to be fully recognized or appreciated at present; but his place will be recognized in the future, and he will one day be a 'classic.'"[64] Benson and Dewing were right; like so many artists, Twachtman's greatness has been realized posthumously.

The year after his death, at the 1903 show of The Ten, five of Twactman's pictures, four of them winter landscapes, hung on a separate wall with a black wreath beneath. For the next few years, the group placed a black wreath near an empty space on the wall in his honor. It was not until shortly after the group's 1905 show that they decided to add another member in his place. Childe Hassam extended an invitation to William Merritt Chase and "The Ten" had a full complement once again.

While the critics may have found Twachtman too "modern" for their taste, they also found fault with other members of The Ten for relying too heavily on the successful themes of past years. Although the annual generally gathered favorable reviews, the critic for the *New York Daily Tribune,* in a rather scathing commentary, took both Benson and Tarbell to task for not moving in new directions:

> Their pictures are clever, but they have always been that and one cannot help feeling that painters so accomplished should by this time have learned to do something better than ring the changes on effects which might as well be left to men less gifted than they are themselves. In other words, we weary of praising Mr. Benson for such a decorative treatment of a gracefully posed figure as he gives us in his *Woman Reading.* . . . It is difficult to believe that these two painters have been endowed with so much natural taste and aptitude and have acquired so much facility only to go on wreaking themselves upon the hackneyed themes of their salad days. But in recording with sorrow that they have not gained in creative power, we must not ignore the fact that they are, at any rate, no less interesting than they have been in the past."[65]

The critic's complaint of "hackneyed themes" does not seem to fit, given Benson's new directions of both wildfowl painting and sparkling plein-air work. Perhaps it was because the reviewers expected the "bolters" from the society to be bold and daring radicals when in fact they sought a high degree of craftsmanship. The group's original purpose in resigning was a protest against large exhibits and a desire to be able to present their best works in a simple setting where each painting could be properly showcased. What united these men was their goal of creating an exhibition of excellent work and not simply the promotion of a specific aesthetic. That the men of The Ten depended for their livelihood on the sale of their paintings was a factor deemed perhaps too crass for critical mention. Many, especially Benson, were consummate businessmen and professionals. Considering that the preferences of their patrons were for scenes of great beauty painted with flawless technique, it is understandable that many of The Ten continued to turn out popular themes and commercially successful paintings.

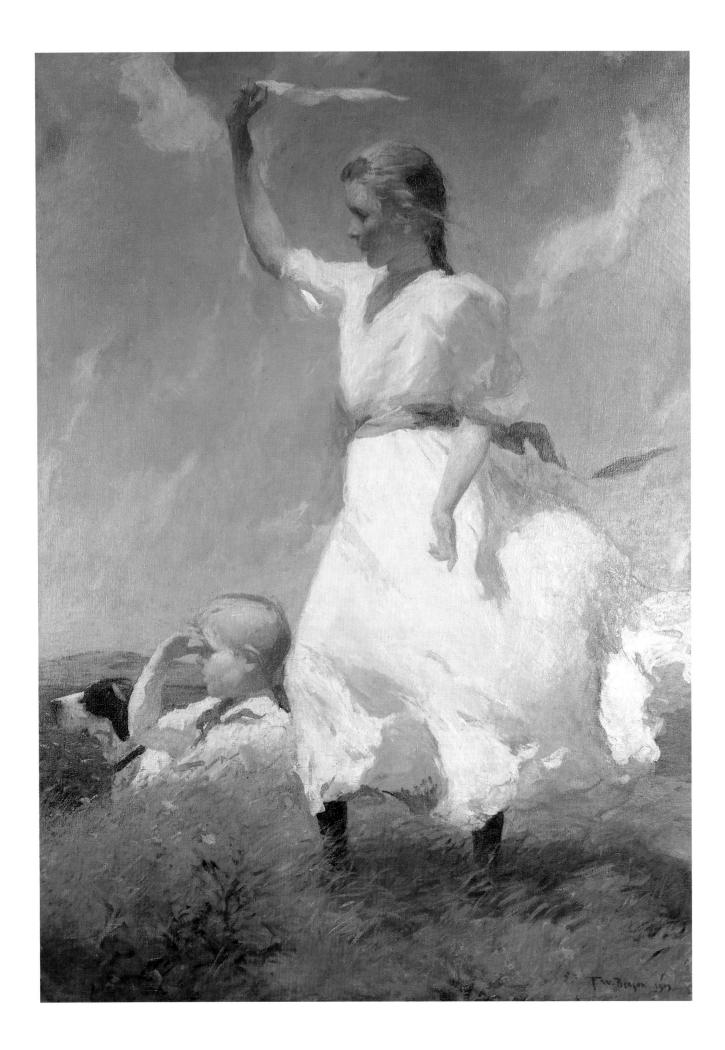

NORTH HAVEN SUNLIGHT

Under the combined leadership of Tarbell and Benson the Boston Museum School became one of the best known teaching institutions in the country. When the two men accepted the joint directorship in 1890, the school had been running in the red for several years. They made it financially solvent, places for admission were eagerly sought, and the number of students tripled during their tenure. Classroom space in the old museum building was woefully inadequate for the burgeoning institution. When the board of directors decided to build a new museum, a separate building for the school was included.[1]

By 1897 a fairly long and rigorous curriculum had been developed, according to a supplement to the Museum School's 1897 annual report:

> The applicants . . . are placed where their capacity warrants which is ascertained after a week's work with Mr. Hale. Those who have not acquired sufficient knowledge by previous training are placed in the beginners room to draw from plaster ornaments and heads. By the middle of the year, all the pupils . . . are in the galleries drawing from the antique. This most difficult and valuable work upon which so much stress is laid in the French schools, continues until the students become sufficiently proficient to be sent up to draw the whole figure from the nude under Mr. Benson. . . . [there] the pupil . . . begins by drawing the outlines of the figure in order to get the action; and, when fairly accomplished in this, is allowed to devote the whole week to the figure. When proficient in drawing in the character of the figure in light and shade, he is allowed to paint from still life in the afternoons under Mr. Tarbell.[2]

With the addition of William Paxton, whose elegant, polished paintings of women in interior settings had gained much praise, the school's faculty was indeed renowned. Teaching was important to Benson, but so was painting; he appears to have been able to strike a balance between the two. When the Pennsylvania Academy of the Fine Arts tried to coax him into joining their staff he refused. He had given the matter much consideration, he wrote, but felt that "it would take too much of the time that I need to give to painting. . . . I have work ahead to do that assures me a living with a chance to do a good deal of work just as I want to do it."[3] The freedom that his success had given him was something that few artists enjoyed.

The Museum School was well represented at the St. Louis Exposition of 1904, the centennial celebration of the Louisiana Purchase. Benson sat on the Massachusetts Advisory Committee, which helped plan the art exhibition, and Philip Hale was in charge of arranging the school's display; the students won the Grand Prize. In the annual report the school's directors boasted, "It was conceded even by representatives of other schools that our exhibit was far and away the best one in its class in St. Louis. Foreign visitors were so greatly impressed by it that several representatives of foreign educational institutions have since visited the school to find out more about it." They proudly added that several of the instructors as well as members of the Council of the School were "given more than ordinary recognition."[4]

PLATE 57
The Hilltop, *1905. Oil on canvas, 71 × 51". Malden Public Library, Malden, Mass.*

Benson had finished *The Hilltop* in time for the Exposition and sent it as well as *Woman Reading, Summer,* and *The Sisters* to St. Louis. He won a gold medal for mural decorations; *The Sisters* and *The Hilltop* each took a gold medal for painting. *The Hilltop,* which Benson had begun in the summer of 1903, depicts Eleanor and George on the hill in front of the farmhouse on North Haven. Eleanor waves gaily, as though beckoning toward a sailor on the cove, whose sparkling waters can only be glimpsed; George sits shading his eyes against the sun with Togo, the family pointer, beside him (plate 57). The combination of noonday light and the vigorous, breezy effect created by Eleanor's flapping handkerchief, make this painting a true evocation of a summer day.[5]

Nineteen hundred and four was Benson's year not only for tangible awards and medals but for honor and "more than ordinary recognition" as well. Both the Cleveland Art Museum and the St. Botolph Club mounted large one-man shows of his works. The twenty works at the *Free Exhibition of Paintings of Mr. Frank W. Benson of the Museum School of Boston* sponsored by the Cleveland School of Art early in 1904 came entirely from Benson's own collection. The show contained few of his newer works since these were out on the "museum exhibition circuit." Only *Fox Islands Thoroughfare* and a *Sketch for The Hilltop,* both done the previous summer, had not been shown before.[6]

The St. Botolph Club show in December was much larger. To fill the thirty spaces allotted him, Benson had to borrow almost half of the paintings. The other canvases were obviously finished just in time for the show, for they had never been exhibited before. Several studies were included, as well as *October,* a wall panel in a very decorative mode. In addition to several loaned portraits, Benson also hung an elegant new painting depicting a model trying on a large black hat (plate 58). The St. Botolph Club show also featured a painting that Benson had begun the previous summer. Titled *A Calm Morning,* it is a study of three of Benson's children fishing from a large dory in North Haven (plate 59). When *Calm Morning* was reproduced in *St. Nicholas,* a magazine for children, the writer observed, "Hidden somewhere about Mr. Benson's studio, I am convinced there is a little jar marked 'Sunshine' into which he dips his brush when he paints his pictures of the summer. It is impossible to believe that mere paint, however cleverly laid on, can glow and shimmer and sparkle as does that golden light on his canvas."[7]

Benson was extremely pleased with *Calm Morning.* Writing to James Gest, he said, "This is, I think, my best out of door work."[8] It was exhibited once again, at the University of Nebraska, before it was bought by Charles Coolidge, a friend from Museum School circles. Coolidge had seen the painting in Bela Pratt's studio, where Benson was storing it. Charmed by the resemblance of the Benson children to his own three, Coolidge bought it on the spot.[9]

Benson's belief that *Calm Morning* was his "best out of door work" reflects the confidence he at last found in his ability to portray the subtleties of light and shadow that plein-air painting offered. His early, tentative forays into outdoor Impressionism followed by his first successful attempt at capturing the nuances of sunlight in the forest (represented by *In the Woods*) were, by 1905, supplanted by an assured, mature style. The nervous, agitated brushstrokes of *In the Woods* later became animated and vigorous. Blacks and browns seem to have been banished from his palette as he ventured further into the complexities of color.

Benson had always been a man of the outdoors. No wonder, then, that critics praised the perfect unity between his figures and landscapes. Charles Caffin pinpointed this special relationship: "The children are not merely in the landscape; they are rather an emanation of it, forms in which the sentiment of the scene is focused and interpreted."[10] Benson experimented with several different versions of children in a boat during the summer of 1904; at least three known studies exist for *Calm Morning* alone.[11]

One morning, finding George and his friend Henry Chaplin playing in the dory, Benson painted them in a similar manner to *Calm Morning.* Benson did not finish *Two Boys in a Boat* until years later, when Henry came back from World War I and visited him at North Haven (plate 60).[12]

Benson's paintings of his children and their friends are part portraits, part impressions of childhood. Critics often felt Benson's paintings of children "embod[ied] very

98

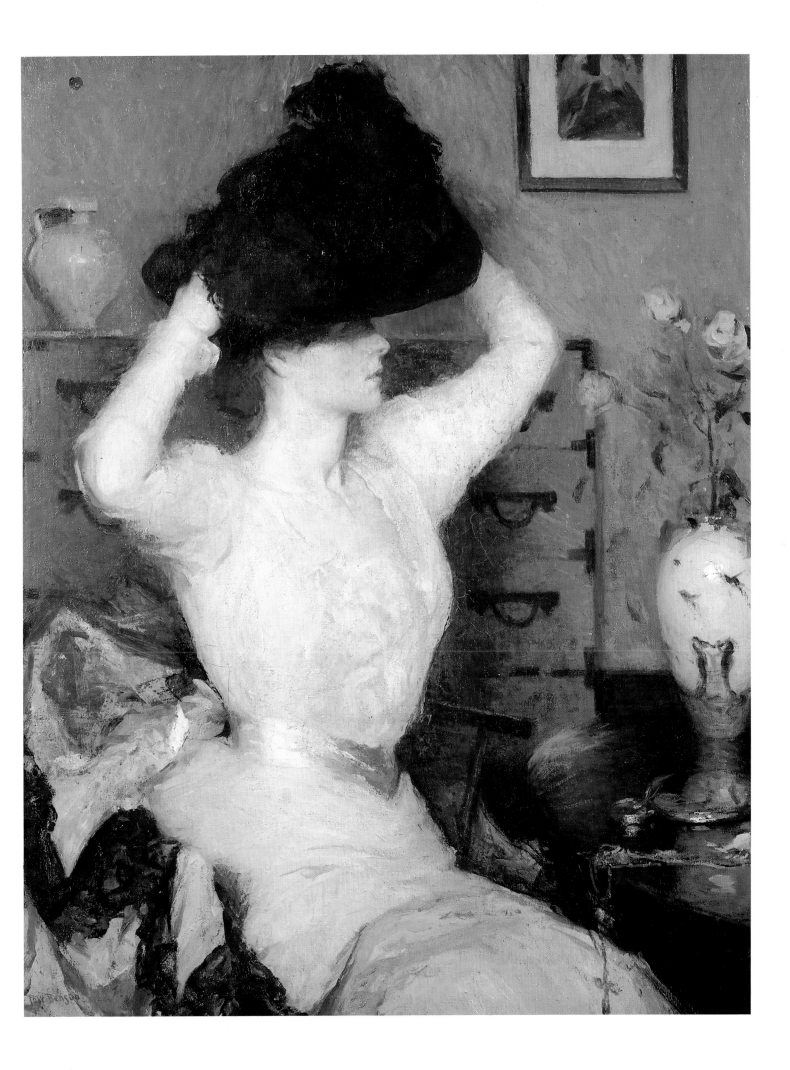

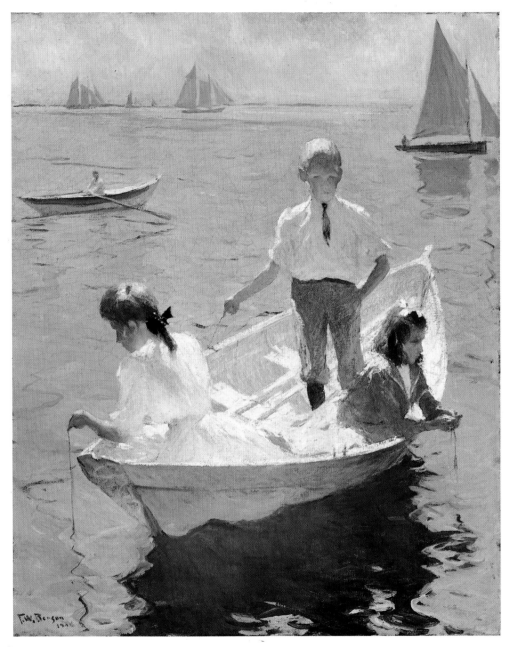

PLATE 59
Calm Morning, *1904 . Oil on canvas,
44 × 36". Collection of the Museum of
Fine Arts, Boston. Gift of the Charles
A. Coolidge family. As morning sun-
light shimmers on the waters of Wooster
Cove, Eleanor trails her line from the
stern, Elisabeth leans over the side, and
George stands in the prow of their dory.*

PLATE 60
Two Boys in a Boat, *c. 1904. Signed
and dated, 1920. Oil on canvas, 30 ×
23". Private collection. In a painting
reminiscent of* Calm Morning *(plate
59) George sits astride the prow of a
dory, sculling with a single oar while
his friend Henry Chaplin sits in the
stern.*

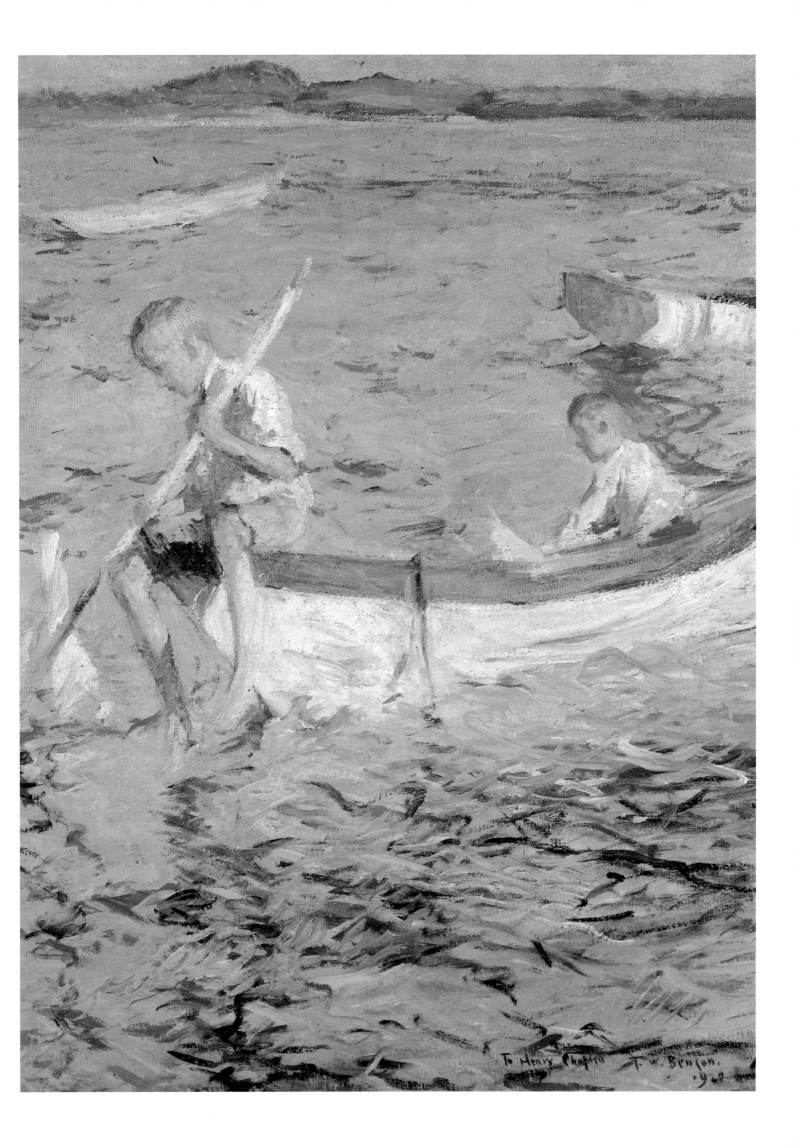

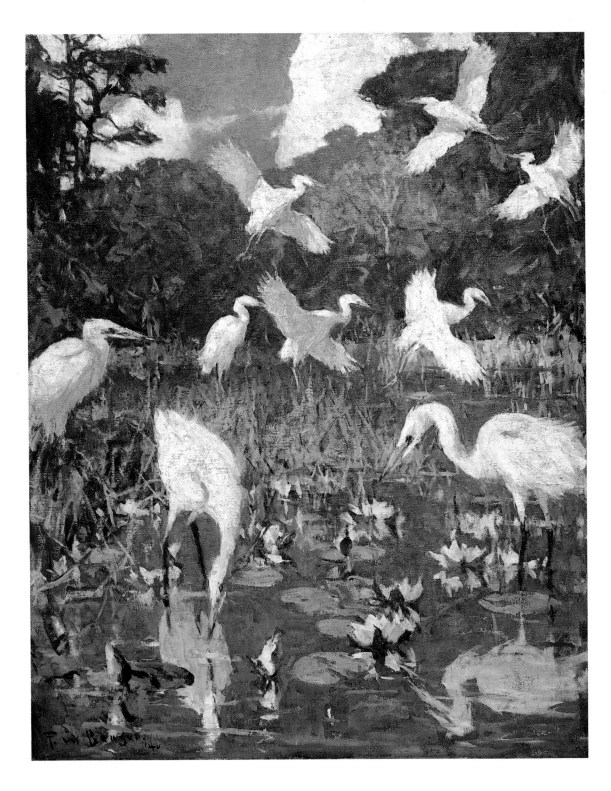

PLATE 61
American Egrets, *1940. Oil on canvas, 35½ × 24¼". Private collection.*

remarkably the ideals of this country."[13] Benson's Impressionism did indeed embody the American ideals of the day. The young country, whose bright future seemed assured by the prosperity of the Gilded Age, found a perfect symbol of joyous innocence in Benson's paintings. His children—happy and carefree—were held as the American ideal for families from Maine to California. Reproduced in newspapers and journals, these paintings captured the vitality and the youthful spirit of childhood.

Yet, despite their eagerness for depictions of a spontaneous and carefree life, Benson's collectors had a no-nonsense practicality that also demanded a certain amount of realism, a tradition deeply ingrained in American painting. Reflecting these intertwining sensibilities, Benson's outdoor works combine formal portraiture with Impressionist plein-air concepts in carefully designed compositions. While light bathes the figures, they do not dissolve; the teacher's methods can be discerned where forms and edges meet. Nor

is the landscape purely an "impression"; each object, be it boat, tree, or cloud, is carefully delineated. Nowhere does Benson allow his forms to dissolve into opalescent color, as the French Impressionists had done. Strong design elements balance the scant attention often paid to the models' features, and careful composition anchors the sunlit works. Impressionist though Benson's plein-air works of this period may be, his landscape is clearly American. The hazy, atmospheric quality of a Monet has been replaced by Benson's clarity of vision, suffused strongly with the crisp, consistent "American" light.

A few of Benson's contemporaries felt that true plein-air painters began and finished a painting outdoors. Benson once laughed at such a purist, saying, "The man doesn't know when to come in out of the rain."[14] But, although many of his paintings of birds were not created from start to finish outdoors, they were inspired there, and, as one critic said, they brought the outdoors inside.

His paintings of serene models posed in richly appointed interiors mirrored the affluence of this halcyon period in American history, and his outdoor works were a glimpse of the ideals of a nation at play. Much as he carefully composed the elements of his indoor works, Benson arranged and rearranged the many aspects of his particular vision of a world out-of-doors—especially the life at Wooster Farm.

The deep spruce woods that stretched from behind the Benson's home to Bartlett's Harbor provided endless hours of entertainment for the children and was the setting for many of Benson's "in-the-woods" paintings. It was also home to many of the birds Benson painted. Sunday afternoon walks through its cool stillness were a family tradition.[15] These walks with the children were often inspirations for later paintings, such as *In the Spruce Woods* or *Eleanor in the Pines*. Benson's children remembered their father's unfailing ability to retrace their footsteps and find the "perfect painting spot" they had come across on one of their Sunday strolls.

The spruce woods were home to many of the birds Benson painted—real and imagined. At the edge of the forest lay a small pool. Filled with wild water lilies and edged in iris, it was the subject of many of Benson's later watercolors (see plate 123). He painted it in all the changing colors and moods of the seasons. He also painted scenes of the pool full of herons or egrets—birds that had not been seen on the rocky shores of North Haven. Benson's "egret series," dozens of works done in oil, etching and drypoint, or watercolor, has often been considered by art critics to have been executed in Florida. Although Benson had made one or two trips to Florida prior to his first egret painting, he did not paint there. But he did observe (see plate 120). Later, viewing the cool blues and violets and vivid greens of his sunlit pool, he realized that it was the perfect foil for the snowy plumage of the egrets (plate 61).

Benson probably painted the lilypond first and added the egrets later, during his winter months in the studio. His ability to capture a scene in his mind's eye and to re-create it on canvas was a hallmark of many of his later sporting works. The landing of a flock of ducks, the rush of a V of geese overhead—these scenes came and went in a matter of minutes. Yet Benson was able to take the impression of the moment and transmit it to canvas with a verisimilitude that impressed critic and patron alike. Many of Benson's paintings of birds in a landscape explored pattern: he juxtaposed delicate branches and the birds that clung to them, or a clump of rushes and a group of ducks swimming through them. Obviously his eye was drawn to the design elements of nature, and such designs had a powerful effect on his memory and his painting. As he once said to his daughter Eleanor, "A picture is merely an experiment in design. If the design is pleasing the picture is good. . . . Few appreciate that what makes them admire a picture is the design made by the painter."[16]

In 1909 Ellie wrote in the Wooster Farm Log "F.W.B. brought back seven canvases more or less finished as summer's work."[17] Many of them are related to Benson's monumental painting of that year, *Summer* (plate 62). During the summer it would seem that various parts of this large picture were copied onto smaller canvases. Such a practice was not limited to *Summer*. The little portrait of Sylvia, *Child in Summer,* for example, was drawn from *The Sisters*. Three known versions of *Boy in Blue* exist; they were most probably copied from (or, in one instance, perhaps cut down from) a large two-figure

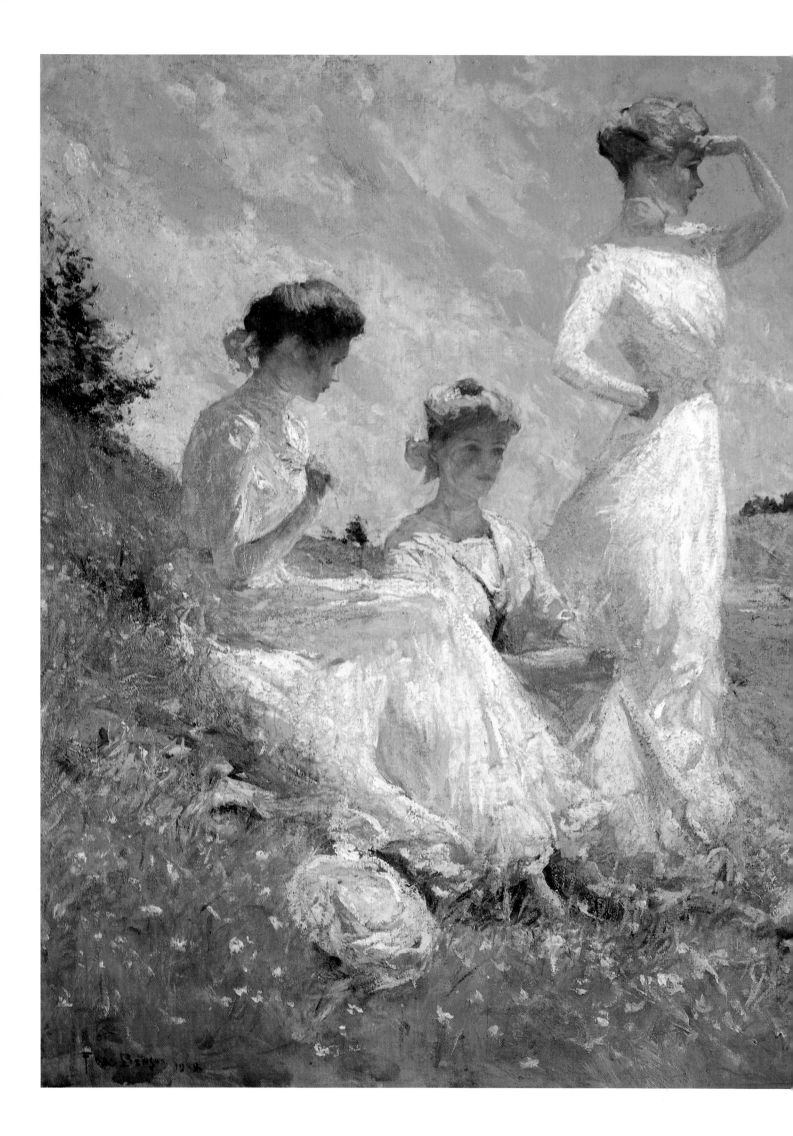

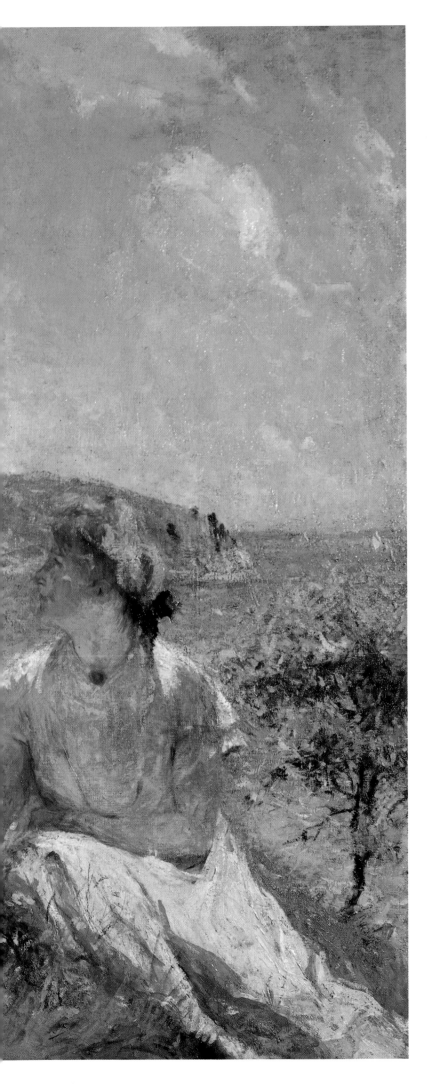

PLATE 62
Summer, *1909. Oil on canvas, 36⅜ × 44⅜". Museum of Art, Rhode Island School of Design, Providence. Bequest of Isaac C. Bates. In what is one of Benson's largest group pictures, Eleanor stands, shading her eyes against the summer sun, while Elisabeth and her friend Anna Hathaway sit to the left. The Benson's summer neighbor Margaret Strong is on the right.*

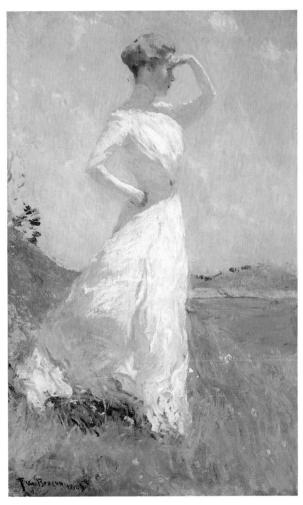

PLATE 63
Sunlight, *1909. Oil on canvas, 32¼ × 20". Indianapolis Museum of Art, John Herron Fund. Eleanor, minus her sister and friends, looks out across the waters of Penobscot Bay in a pose reminiscent of one of Benson's first North Haven paintings of her,* Eleanor, 1901 *(plate 41).*

work. Several finished canvases exist for portions of *The Hilltop. On Lookout Hill* has two related works.

Were these various related paintings "parts of the whole" or were the larger works actually a "sum of the parts?" It is known that Benson made single-figure studies for his larger works, but such smaller canvases as *Child in Summer* were not typical unfinished preliminary works for they were signed and exhibited (often titled *Study* or *Sketch*) at the most prestigious shows. Close comparison of the large figural groups with their smaller related works, conversations with family members about the creation of the larger paintings, and letters regarding the circumstances surrounding some of the works suggest that in the majority of cases Benson created his groups of two, three, and four figures first and then copied the individual figures to create separate works. Although he did occasionally insert a figure into a plein-air work, these paintings are not successful. Often, as in *On Lookout Hill* or the original version of *A Summer Day,* the figures are not in proper relationship, are painted in different manners, or form an awkward grouping.

Benson's reasons for doing this varied. For Reverend Strong he copied Margaret's portrait from *Summer.* In the case of *The Sisters* and *Boy in Blue* he drew out the figures of the toddler to keep for himself. It was difficult to part with paintings of his family, but painting was his living; he created canvases to sell, not to keep. It was probably this very reason—profit—that prompted Benson to create several works from a larger one. As he worked on a particularly stunning painting, he was probably reluctant to see such a beautiful motif used only once. Recognizing an opportunity to create many salable works from one, he painted the various smaller canvases and doubled or tripled his profits. In at least one instance, he combined several studies to make one painting (see *On Lookout Hill,* p. 155). The concept worked: without exception, the large figural pieces as well as the related studies, sketches, and the copies all sold.

PLATE 64

Elisabeth Benson, Anna Hathaway, and Margaret Strong at North Haven, c. 1909.

PLATE 65

Portrait of Margaret Strong, *c. 1909. Oil on canvas, 30 × 25". National Gallery of Art, Washington, D.C.*

Summer provides the best-known example of Benson's practice of making several versions of one work. From this large painting, Benson took the central figure and created *Sunlight* (plate 63). This striking canvas clearly illustrates Benson's problem when he "drew out" his daughter from behind the two girls on the left. In *Sunlight,* the area of Eleanor's skirt that was hidden behind Anna Hathaway in the larger picture is poorly worked. Obscured by the seated figure, the natural movement of the batiste fabric is invisible to Benson; thus, this area of drapery is awkward in the smaller work.[18]

The two figures on the left side of *Summer,* Elisabeth and her friend Anna, were copied for another composition, *In Summer. The Portrait of Margaret Strong* is almost identical to the right portion of the larger work, with minor adaptations made for a more pleasing single-figure composition (plate 65).[19] Margaret could well be the subject of a study for *Summer* which Benson gave to Pratt.[20]

In each of Benson's "parts of the whole," subtle adjustments have been made to adapt the figures to new compositions. Landscape elements are added or subtracted; figures are moved closer to the picture's foreground or placed on a different plane; accessories are placed in different positions. Benson's strong emphasis on composition and design usually led him to arrange his finished picture in advance. By posing his models as he wanted the final work to appear, Benson could modify positions, spatial

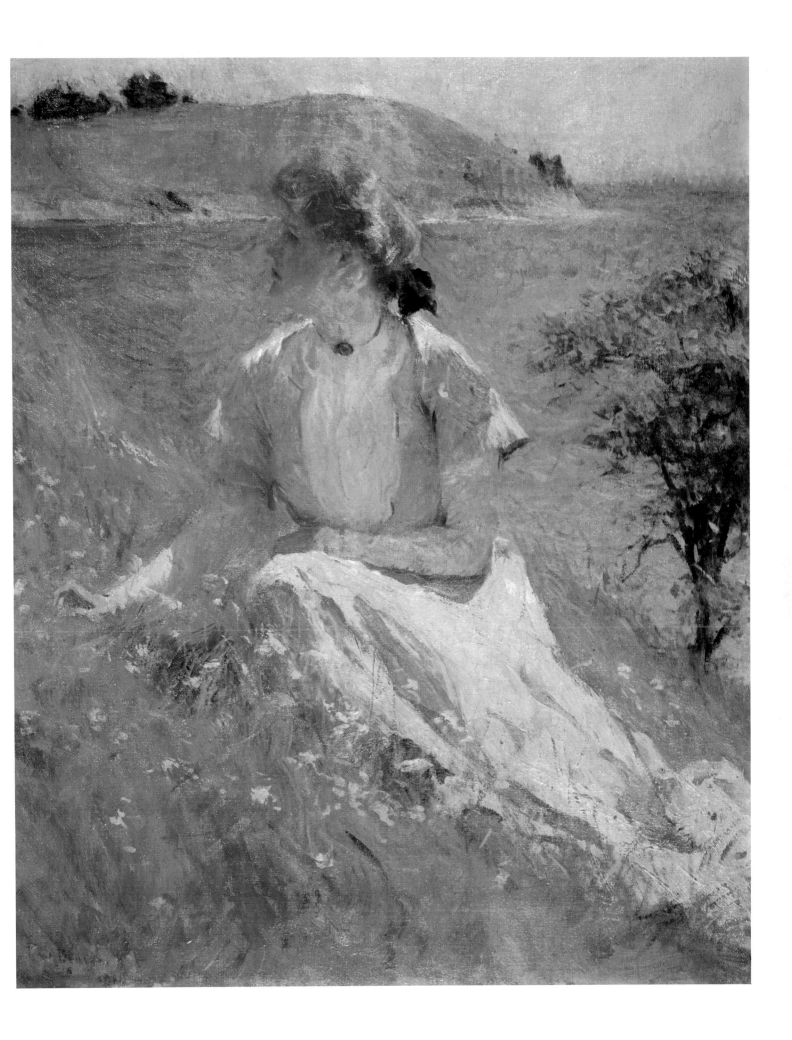

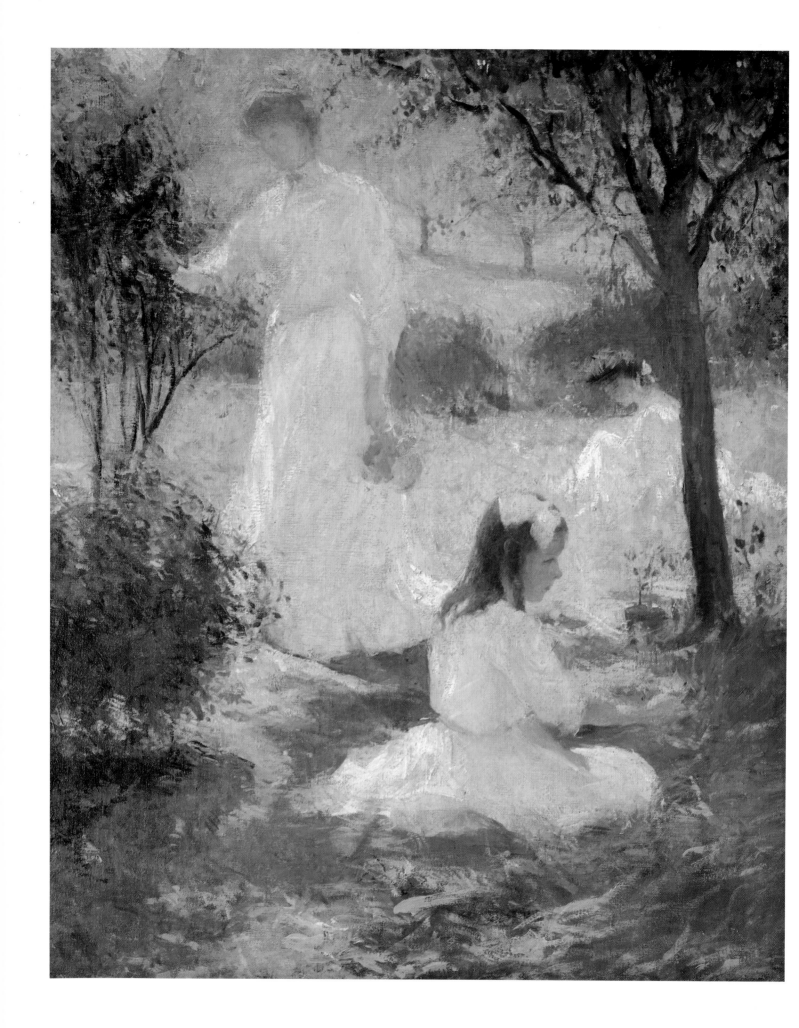

relationships and accessories for the final canvas. As he later told Eleanor, "A picture is good or bad only as its composition is good or bad."[21] Once Benson had arranged his large group picture, he would try other compositions as variations on the theme.

Benson's creation of several versions of essentially the same painting was unique. With few exceptions, no other member of The Ten was known to employ this technique, nor was it found commonly among the French Impressionists. Whereas Monet depicted the same motif under different lights, such as the haystacks and the Rouen cathedral series, in Benson's works the light remains the same and the motif undergoes slight changes. Benson captured a fleeting moment, full of light and atmosphere, then arranged and rearranged his models within that frame.

To help capture the brief moment of a pose, Benson used photography as an aid to the completion of his paintings. For the many variations of *Summer* there exist photographs; in fact, there is one photograph of a grouping of three girls without Eleanor's central figure for which no painting is known to exist (plate 64). Perhaps Benson decided that this grouping did not have the makings of a good painting; if he painted such a grouping, it is now unlocated. As an art student, Benson had compared his brothers' photographs of his finished canvases with photographs of the people or scenes he'd painted and found the concept intriguing. Years later he used the camera to fix the exact pose of his models as he photographed them in different groupings. He would then use the photos as well as the finished larger work as memory aids in the creation of the smaller vignettes. Often the photograph is so similar to the finished work that one wonders if the painting was literally created from the photograph. However, Benson's children recalled his skill with a camera, remembering how he could frame with his lens the exact scene he was painting. (But they also recall the hours they spent sitting for these paintings, wishing their father would indeed use photographs and not real models.) Benson's grandchildren also remember photographs being tacked to corners of paintings standing on easels about his studio (plates 66 and 67). They would often notice him outside the barn simply observing the light and its reflections from sky, meadow, and water. During the course of a morning's painting, they would see him come out several times, take a quick look, then duck back inside to paint a bit more.

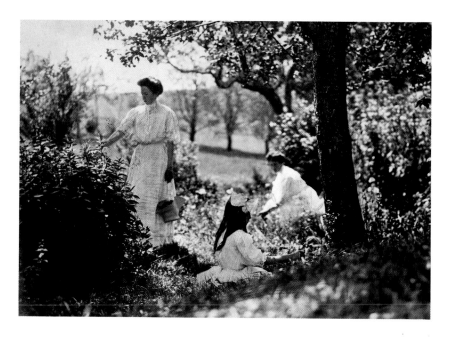

The use of photographs as aids to painting also appears to have been unique to Benson. Theodore Robinson, who painted with Monet at Giverny, was one of the few other painters also to use photographs as an assist to his work. He explained that "Painting directly from nature is difficult as things do not remain the same; the camera helps to retain the picture in your mind."[23] Benson's pragmatic acceptance of new technology was common in many aspects of his life. With the aid of cameras, a rainy day did not have to be a total loss for an otherwise plein-air painter.

It was during a week of typically foggy Maine days that Benson brought the views from Wooster Farm inside. Tired of the blank walls of the sitting room of the farmhouse, Benson began to paint frescoes above a chair rail. On each wall he painted what he saw from the adjacent window. The room was soon ringed with rocky shores and splashing waves, deep spruce woods, blue sky with billowing clouds. An imperious eagle was depicted clinging to the branch of a dead tree.[24] Even on days when Maine's ever-present fog hid the sea and hills from view, Benson could live with the out-of-doors that surrounded him.

PLATE 67
Eleanor, Elisabeth, and Sylvia in the garden of Wooster Farm, c. 1906. Benson's pencil marks, indicating areas he felt needed shading in the finished oil, are still faintly visible on this photograph.

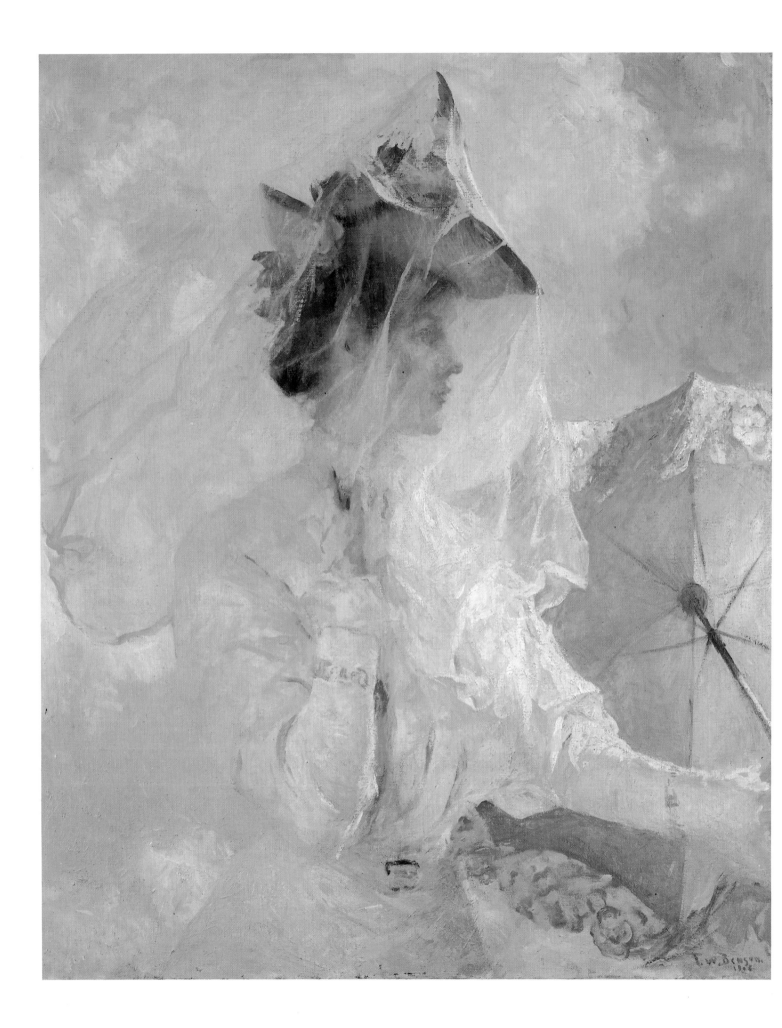

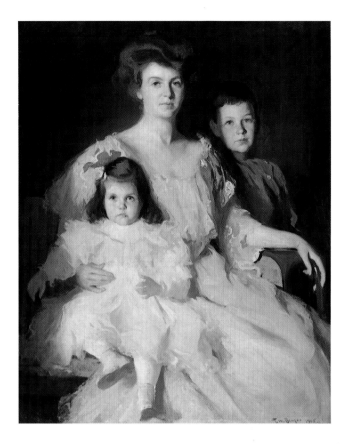

PLATE 69
Mrs. Robert Jones Clark and
Children, *1905. Oil on canvas, 50⅜ ×
40¼". Private collection.*

PLATE 70
Eleanor in the Pines, *1906. Oil on
canvas, 36 × 26". Private collection.*

PLATE 68
Against the Sky, *1906. Oil on canvas,
41 × 31¼". Private collection. When
the Corcoran Gallery of Art held its
first Biennial Exhibition of Contem-
porary American Art in 1907, this
painting won the silver medal and the
Thomas Glover prize.*

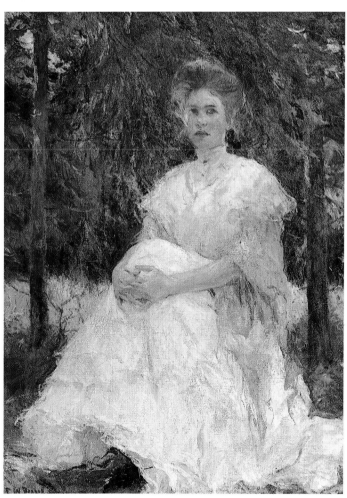

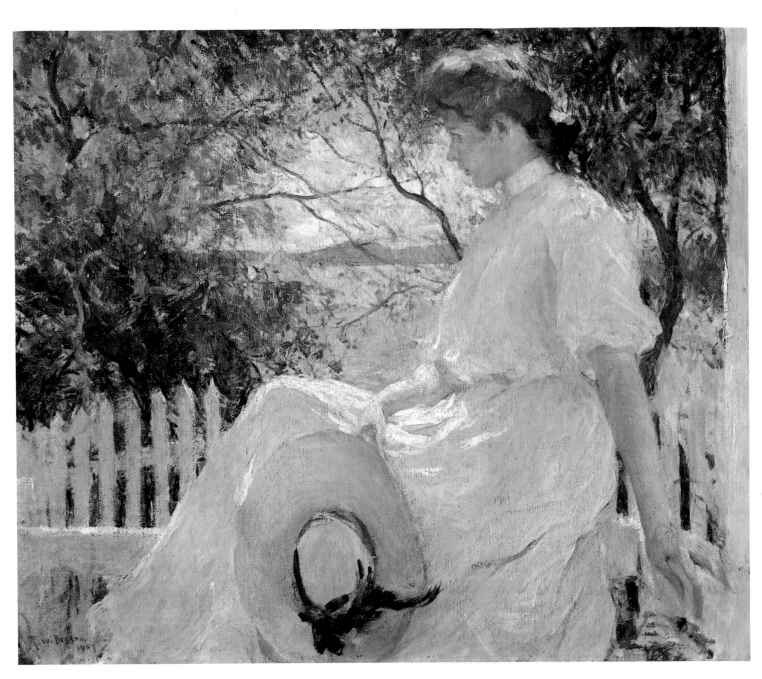

PLATE 71
Eleanor, 1907. Oil on canvas, 25 ×
30". Museum of Fine Arts, Boston.

Despite the heavy schedule of painting he set for himself at North Haven, Benson always made time for outdoor pleasures. Having worked outdoors or in his studio until noon, Benson would return to the house. After lunch and a short nap, he would be ready for relaxation . . . which in the Benson household more often than not meant some strenuous outdoor activity. Benson enjoyed the old family friends and neighbors who would drop by for tea in the late afternoons, but disliked the visits of people who wanted to see "the great artist." Although he didn't usually paint in the afternoons, the studio provided him with an easy escape from those who would fawn over him. It was always off-limits to visitors and, usually, to family as well.[25]

Benson's time outdoors and the quiet North Haven summers became more and more important to him as the demand for portraits increased and his exhibition schedule grew. In his spacious, two-story St. Botolph Street studio, he not only created his commercially popular images of interiors with figures but also received a steadily growing number of commissions for portraits.[26]

Though not comfortable with the title "society portraitist," Benson had painted several of Boston's leading families over the previous fifteen years. His work was in such demand that he had a long waiting list. His portraits of Mrs. Fitzgerald and her son and Mrs. Robert Jones Clark and her children are typical portraits of this period. The ladies are dressed in elegant white gowns; the children pose comfortably, gazing at the artist with alert interest (plate 69).

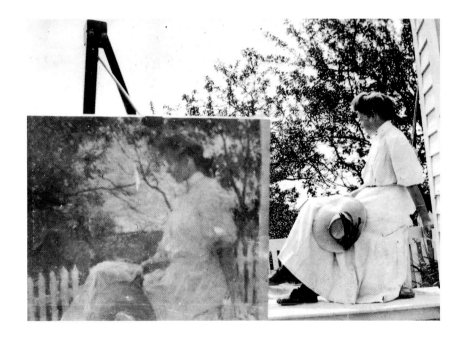

It is possible that Mrs. Fitzgerald was the wife or daughter-in-law of Desmond Fitzgerald, a well-known Boston art collector and critic who, in 1913, built a special room onto his suburban home to serve as an art gallery. A New York auction of his holdings, conducted shortly after his death, brought unprecedented prices for the works of living American Artists. "BENSON'S WORK AT HIGH PRICES" declared the headlines of a *Boston Globe* article, which continued, "The prices running up rapidly and at least a score of new high record prices were set for the more famous of the Benson creations."[27]

PLATE 72
Eleanor Benson and her finished portrait, 1907.

A show held in Chicago during January 1905 brings to light an interesting aspect of Benson's portrait work, for it was one of the first known examples of his willingness to travel for portrait commissions. Two portraits done in Chicago and three done in Milwaukee were hung at the Art Institute of Chicago in a special loan exhibition of portraits.[28] When Benson traveled across the country to do portrait work, he was occasionally accompanied by Tarbell. Benson's later portraits of men and women known to have been leading society figures in Philadelphia, Chicago, Wisconsin, Nebraska, Washington, and New York suggest that he continued to travel to do portraits until the early 1920s, when, except for recording personal friends and family, he discontinued such work.

In the spring of 1905 Benson was elected to the rank of full academician at the National Academy, a highly coveted honor. Benson's gift to the academy, his "diploma piece," was *Portrait of a Child Sewing*, the painting of Eleanor he had executed in 1897, the year he was elected an associate of the National Academy (see plate 42). The following year the Society of American Artists, faced with dwindling attendance at its exhibitions as well as an increasing number of resignations, merged with the National Academy. Founded in 1877 by a group of young artists who were discontent with the conservatism of the academy, the society's growing conservatism ironically forced it to join with the organization it originally opposed. But, there was still opposition to the National Academy. In a rather scathing review of the academy's eighty-first show, Arthur Hoeber

grudgingly allowed that a few innovations had been permitted but noted that the older members of the academy were still allowed, as a right, "certain wall space and the privilege of at least one canvas on the line." This inflexible rule made it difficult for a jury to hang a balanced show, and much of the good new work was crowded out to allow hanging room for paintings by what Hoeber referred to as "these incompetent though eminently respectable old gentlemen who have either fallen by the wayside, or who were never in the first place destined for the careers they have unfortunately chosen." He felt that their "unfortunate pictures lower . . . standards, offend . . . and . . . make for apathy on the part of the public." The 1906 show was, in his opinion, "unusually aggravating" due to the large number of poor pictures "which drag down the show to a hopeless low level." Nonetheless, he praised Benson's portrait of Mary Sullivan (which won the Thomas R. Proctor prize for portraiture): "Painted with breadth and certainty, the work is impressive from its sincerity and earnest, if unconscious, rendering of textures and flesh, while the charm of femininity is ever present."[29]

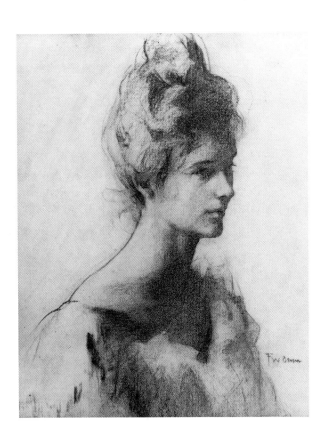

The charm of femininity must have inspired Benson that summer for he painted his daughters often. It would seem that Eleanor did little else but pose for her father; she appears in no less than seven of the paintings begun in 1906. It was a memorable summer for the whole Benson family; they had purchased Wooster Farm at last. Happy with the knowledge that this place was truly his own, Benson painted some of his most beautiful and well-known works.

One of these is *Against the Sky*, which depicts Eleanor wearing a peaked hat swathed in a veil, which a breeze seemingly extends in sweeping curves around her shoulders. The unbroken light of a summer day brings her figure, the drapery, and her yellow parasol up to a high brilliancy (plate 68). Calling it "one of the best things he has ever done," Minna Smith, the critic for *International Studio* magazine, wrote, "It is full of the breath of the open world. The artist's insistent youth is in it, that dower of a man gifted with love of all outdoors."[30]

Looking more like the sixteen-year-old girl she really was, Eleanor again posed for her father, this time in the spruce woods (plate 70). In *Eleanor*, we see her once again, balanced on the back of the white garden bench at the edge of the orchard. *Girl in a Pink Dress*, an alternate title, describes the picture well, for instead of white, Benson has chosen to dress her in a light pink (plate 71). Benson was pleased with this painting. He proudly propped it up on his easel and set it beside his patient young model. Then, he photographed the two together (plate 72). It is interesting to compare the two figures. Benson has thinned Eleanor's face and straightened her nose a bit; he also eliminated some of the branches between her and the Thoroughfare and lightened the color of the band on her hat so it would not be a distraction.

In *Portrait of My Daughters*, Eleanor is joined on the bench by her two sisters (plate 74). When this work was hung at the Pennsylvania Academy of the Fine Arts, it won the Temple Medal. Eleanor and her sisters were also the models for *A Summer Afternoon*. Posed on a grassy slope overlooking the Thoroughfare, the girls appear to have been watching the boats sail by when they heard their father call. Not exhibited until 1908, *A Summer Afternoon* was shown only a few times before it was bought by the St. Louis Art Museum in 1909. This picture was the focus of William Howe Downes's comments in an article entitled "The Spontaneous Gaiety of Frank W. Benson's Work." In a much-quoted paragraph, Downes wrote, "He sets before us visions of the free life of the open air, with figures of gracious women and lovely children, in a landscape drenched in sweet sunlight, and cooled by refreshing sea breezes. It is a holiday world, in which nothing ugly or harsh enters, but all the elements combine to produce an impression of natural joy of living."[31]

Indeed, Benson felt that the creation of beauty was the highest goal of art. To him, a picture was not merely a record kept for reference, but something beautiful in itself. The fact that the buying public wanted beauty, especially beauty removed from urban realities, was not lost on the members of the "Boston School," a name often given to Tarbell, De Camp, Paxton, Hale, and Benson. The carefree life portrayed in his summer paintings was just that. A frequent visitor to Wooster Farm recalls, "Everything always ran so smoothly there. Mrs. Benson always had everything so neat and clean with fresh flowers everywhere. She ran the house so effortlessly: the maids, the visitors, the food, even the pets. Things were quiet and happy there all the time."[32] With an atmosphere such as that, it is not surprising that Benson was described by Downes as one of "few living painters whose works are better calculated to give unalloyed pleasure."

Benson also painted his earliest known North Haven seascape that summer. When exhibited the following January at the St. Botolph Club, *Dancing Waters* was called "a captivating vision of a bright summer day down on the harbor—a day when everything shines and dimples and smiles. The little silvery blue waves are truly dancing, that is the word for it."[33] *Boats in Sunlight,* exhibited the following May, suggests that this painting was also begun at North Haven.

Given the large number of canvases Benson brought back with him that fall, it is little wonder that not all were ready for exhibition the following year. Three were completed for the winter shows: *Dancing Waters* was exhibited at the St. Botolph Club, *Eleanor* was hung at the Doll and Richards Gallery's twentieth annual exhibition, and *In the Spruce Woods* was exhibited in Worcester. The Worcester show, entitled, *A Collection of Paintings by Frank W. Benson of Salem, Massachusetts,* was Benson's first one-man show there. Gathering nine works, most completed during the past few years, Benson was able to display the many facets of his talent. Plein-air works were well represented. A marine and decorative panel, two portraits, and a still life completed the show.

An appearance of a still life in a Benson show is surprising for it has been widely considered that Benson's "first" still life was painted in 1920 and exhibited at the Art Institute of Chicago, where it won not only great praise but the Ellsworth prize as well. However, Benson painted his first known still life in oils in 1893 and completed several others over the next twenty-five years; he actually began his well-known "still life phase" in 1919. Just which still life was shown at the Worcester Art Museum is not known. It may have been Benson's 1893 still life of a vase of peonies receiving public exposure at last (see page 10) which also might have been the painting mentioned in a review of a small show Benson had in March 1906 at Rowland's Gallery in Boston. The writer for *Art Bulletin* commented, "A large still life composition is a wonderful piece of clever painting. With skillful handling of materials the color and glaze of the Japanese jar and the texture of the white tablecloth are especially convincing."[34]

Benson was also experimenting with another medium—pastel. In 1907 he wrote to James Gest, "[I have been] working hard at portraits all winter so that I have very few pictures at my command" to send to the spring exhibition in Cincinnati. Nonetheless, he offered an oil (*Portrait of a Young Girl*) and added, "I can send you in addition a pastel head if you wish it."[35]

Other than this and one other work, there is no record that Benson used this medium. In addition, several family members recall his disliking pastel intensely. In about 1926 he remarked to his daughter Eleanor, when he was teaching her to paint, "I do not like pastel. It is a poor medium, especially for portraits and figure work. I have never used it." When Benson did do studies for his major oils, he did them in oil, not pastel.[36] There are also no sketchbooks or drawings in charcoal, save a charming charcoal sketch of an osprey, which hung for many years in Benson's study. In addition, Benson contributed a head of a lady to a calendar of works by famous artists, including De Camp, Tarbell, Chase, Pyle, and Blashfield (plate 73).

Although Benson was approaching the height of his output of plein-air works and was winning awards almost yearly, he was not content to rest on his laurels. His works were selling steadily, and art critics were almost universally enthusiastic, yet Benson still felt the need to experiment with new mediums and motifs.

PLATE 73
Head of a Lady, *c. 1902. Charcoal on paper, 13¼ × 11¾". Collection of Mr. and Mrs. John L. Huber. This sketch, illustrating the month of September, was included in a calendar that benefited the West Chester, Pennsylvania, hospital.*

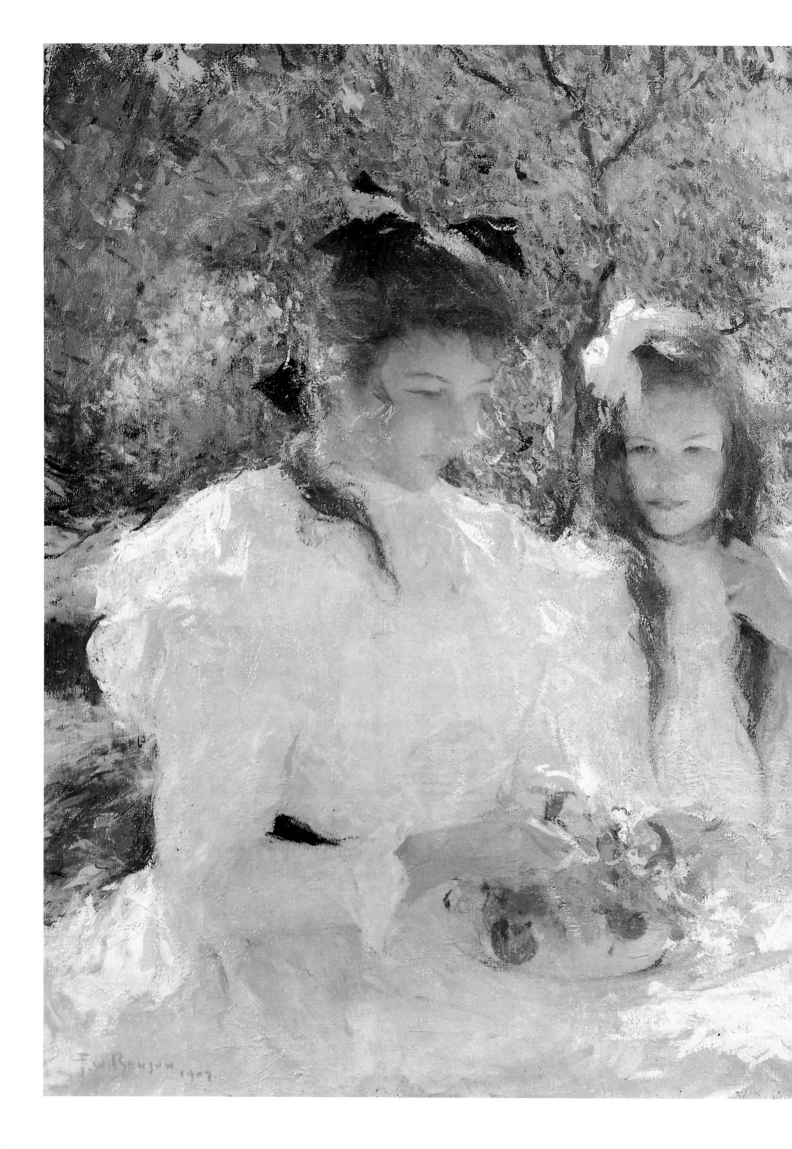

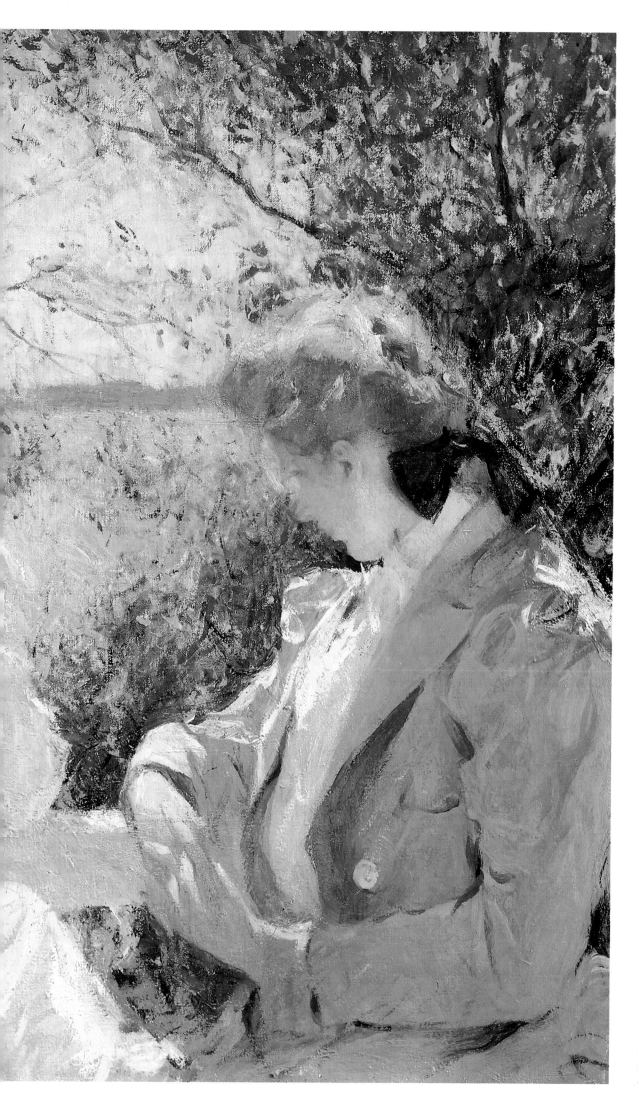

PLATE 74
Portrait of My Daughters, *1907. Oil on canvas, 26 × 36⅛".* *Worcester Art Museum. Elisabeth holds a basket of nasturtiums from her mother's garden as Eleanor rests her arm on the back of the seat. Sylvia stands behind her sisters, demurely holding a ringlet of her chestnut hair.*

Not surprisingly, those new themes were found outdoors. Beginning in the mid-1890s Benson's summers included a few weeks of fishing on Canada's Gaspé Peninsula. His yearly salmon-fishing trips broke up the intensive work that occupied him in summer as well as winter and helped him evaluate his paintings better for having been away from them. "I didn't paint but twice at Grand River," he wrote to Eleanor, upon his return to Wooster Farm, "but my things I left in the barn here looked good when I got back."[37]

The rivers Benson fished, his companions, their camps, boats, and catch would figure prominently not only in his etchings but also in works in wash, watercolor, and oil that were later considered to be of his "sporting period." The place names in his fishing diaries read like a catalogue for a 1920s watercolor show: *On Grand River, Down the Restigouche, On the Upper Kedgewick*. His friends and guides are portrayed in scores of works: *Pool on the York* (plate 127) depicts two men casting into a salmon river, *Poling the Rapids* is of a guide going upstream, and *The Salmon Fisherman* shows his friend Arthur Cabot fighting a big one.

Writing to Dan Henderson, Benson declared, "Salmon fishing seems to me the finest sport in the world. You feel as if you were hitched to a railway train when you get one, yet, if you handle him well you are sure to beat him at least. . . . if you make a mistake he will smash you up [and] if you don't drop the tip of the rod where he leaps, he will break something and you must watch like a cat for the leap."[38]

The inspiration these trips afforded him was immeasurable. One can imagine Benson composing a painting in his mind as he recorded in his diary the scene in one of the camps on the Grand River. "We camped at Round Rock and lay in the tents and smoked. [From there we had] a vista of the opposite hill between two cedars with a spur-like fir tree crowning the top of the ridge opposite. A star shone out and the fire burned at our feet. Later a yellow full moon showed over the hilltop and its wake on the river made it glimmer through the trees, otherwise silence—and later, snores."[39]

Benson was often elected the chronicler of these trips. His pen could sketch on the page as eloquent a picture of their trip as his brush could paint on the canvas. His most lyrical descriptions seem to come at the end of day or at its very beginning: "A clear lovely morning, quite cool with bright sunlight, mists from the night rain rising in little puffs from the ravines and the water glistening on every leaf and what seemed innumerable cobwebs."[40]

As Benson ventured further into the depiction of wildfowl and the life of hunters and sportsmen, he was actually returning to his roots. From the coves of Salem and the marshes of Essex County to the Breton coast and the dunes of Cape Cod, Benson had stored away the memories of these scenes. The sights and sounds of bird upon the water or in the air; the splash of a salmon as it leaped against the current—such images were finally finding their way from Benson's memory to paper and canvas.

Benson had been painting wildfowl for many years, and these canvases had been selling well. His oils of wildfowl hung in many a sportsman's study. However, oil obviously didn't meet all his needs for depicting the many aspects of game birds. Benson had experimented with wash drawings in the 1890s. His first known black-and-white watercolor was done in 1898 of some coots. But, for reasons unknown, Benson abandoned the medium for many years. In 1906 and 1907, using a watercolor brush and a delicate wash of black, Benson created several more wildfowl portraits in this medium.

Redhead Ducks, the earliest example of Benson's wash drawings to be owned by a museum, has about it the air of a rough draft; lily pads, never finished, are pencilled in and patches of white indicate changes in composition (plate 75). After completing *Redhead Ducks* in 1907, it would appear that Benson waited several years before exhibiting any of his wash drawings. When they were first seen, they earned both praise and instant sales. The positive reviews these drawings received in the press in 1913 would indicate that Benson had been continuing to experiment with this new medium in the intervening years.

The summer of 1907 brought many visitors to North Haven, among them Willard Metcalf, who sought its quiet and solitude after his young wife, Marguerite, ran away

PLATE 75
Redhead Ducks, *1907. Watercolor wash on paper, 13½ × 19½". Museum of Fine Arts, Boston.*

with one of his students.[42] Benson and Metcalf painted together and on 9 September Eleanor wrote in the log, "Mr. Metcalf departed with two canvases."[42] After finishing the paintings in his New York studio, Metcalf sent one to Benson and signed it "en souvenir," a fitting sentiment between two friends who had first met so long ago in the little French village of Concarneau. The painting, a watercolor of the Thoroughfare entitled *Ebbing Tide*, depicts what Metcalf called "Benny's front yard."[43]

Metcalf was on the jury for the 1908 show at the Pennsylvania Academy of the Fine Arts where Benson hung four works. Metcalf wired Benson from Philadelphia, saying "The Temple Medal is yours. Congratulations from Metty."[44] Although he hung three other critically acclaimed works, his *Portrait of My Daughters* was not only the best of the three but, as the award declared, the best of the show.

Shortly after the Philadelphia show, an art critic worried, "The Philadelphia people appear to be getting a bit stirred up because so many of the honors conferred by the Pennsylvania Academy come to Boston artists. In a recent article on the subject, the rather envious temper was manifested and it is intimated that the Boston artists formed a clique for the purpose of backing each other up and hand each other all the good things." Noting that there was nothing to this story and that the awards were, of course, not controlled by any one locality, the writer concluded that the reason so many awards came to the Boston men is "because they are doing good work and that is all there is to it."[45] But, these perceptions did not disappear, and in coming years, they would have far-reaching repercussions.

Benson's work was seen widely in 1908. A grueling schedule of at least a dozen shows sent his paintings crisscrossing through the eastern half of the country. If the public missed one of these many shows, they could read about his work in a growing number of periodicals which were doing feature articles about this successful artist. Two pieces by leading art critics appeared in *New England Magazine* and *International Studio*.

The appreciation of his work, as demonstrated by praise in the media, awards, and sales, was reaffirming. But perhaps the accolade most meaningful to Benson was the sale in 1908 of his *Eleanor* to the Museum of Fine Arts, Boston. When the Museum announced its acquisition in their bulletin they compared Eleanor to Benson's murals for the Library of Congress. Stating that Benson had translated into "terms of New England reality" the more classical goddesses of his "Graces," the writer noted, "The landscape becom[es] that of our own coast, the marble seat and colonnade a farmhouse piazza and picket fence, and the figure realizing instead of idealizing the delicacy and vivacity of American girlhood."[46] It was Benson's first work to be purchased by his "hometown" museum, and his letters to the director indicate his pleasure.[47]

Although Benson was pleased by the painting's sale, it was a bittersweet time; Eleanor, his oldest daughter, had just begun Smith College. Her father had tutored her in French and Latin and she was ready for more. Benson's letters to Eleanor are full of advice and family news, interspersed with wry humor and, not infrequently, admonitions about saving money. That he missed her greatly is clear. Although he would continue to portray her in many summer paintings, his first home-grown model had left home. The little girl who first inspired Benson to work "toward an ideal which is difficult in proportion to its rarity [an] ideal [which] includes much of what may be called abstract beauty, loveliness and sweetness" was now a young woman leaving home for a life of her own.[48]

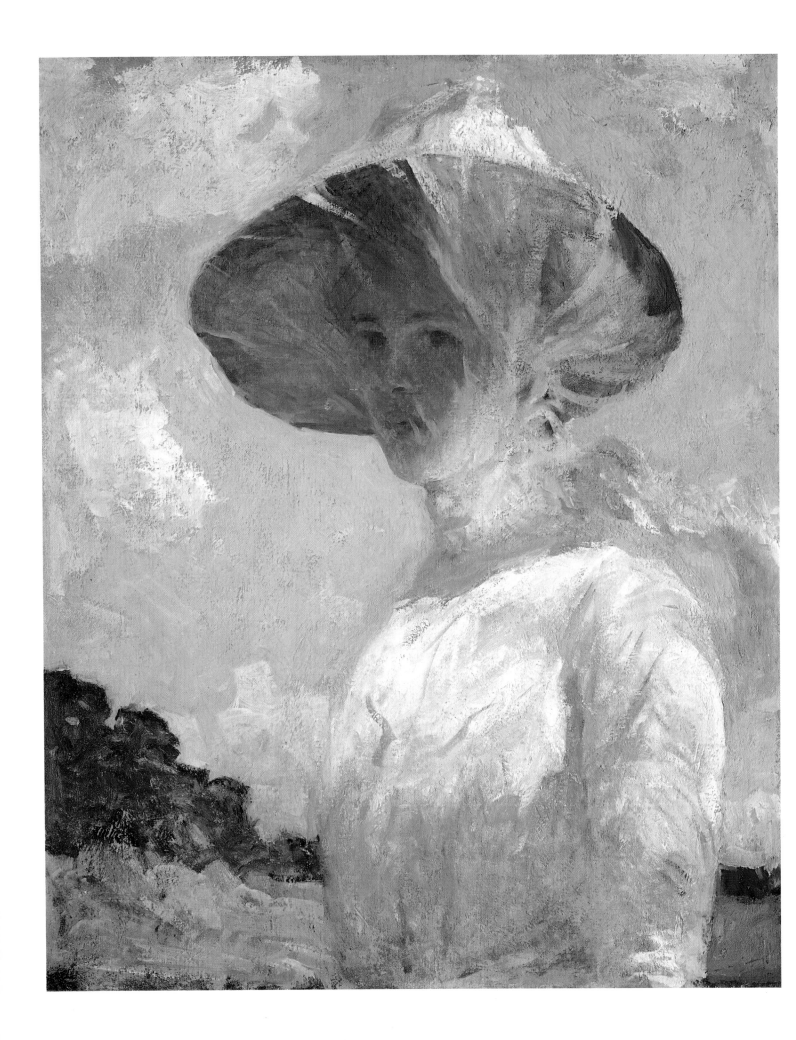

CHAPTER 7

PRAISE AND POLITICS

B enson sometimes complained that he had trouble finishing works he started in
North Haven. Perhaps, once away from the sun-drenched hillsides of his is-
land home, he had difficulty re-creating the atmosphere. No matter how well
lit his St. Botolph Street studio was, it wasn't Maine. Several times, in letters to
friends, he expressed frustration at his inability to complete certain paintings. "I am
afraid I haven't another I can send you," he lamented when James Gest wrote to him de-
siring "one of his best" for the Cincinnati show. "They won't get finished! You know
how it is."[1]

One painting that Benson was able to finish to his liking was *Girl Playing Solitaire,*
which was bought by the Worcester Art Museum after it won the Norman W. Harris
prize at the Art Institute of Chicago. This new prize was the institute's highest honor;
Benson was the first artist to receive the silver medal and its accompanying honorarium
of five hundred dollars.

An artfully arranged work, this study of a model in a white dress playing solitaire
in an elegant setting was praised as well as criticized. Benson's old friend Vinton felt it
was "wonderfully full and rich in its tone and [in] its decoration scheme a superb
work."[2] However, a reviewer for the *Philadelphia Inquirer* thought that Benson "should
have called it the 'Colonial Chair,' 'Reflections,' 'Two candlesticks' or some such title,
for all the accessories of the picture are better painted than the lady herself. Not only are
the face and hands not studied but under the shimmering dress, it would puzzle an
anatomist to find a place for the woman that should be there." He concluded with a crit-
icism that would be laid on the Boston painters with increasing frequency and would
find its voice again in the 1980s. Writing of Benson's other works of girls outdoors, the
critic remarked: "All deal with those anemic types of femininity done in a correspond-
ingly bloodless way. One longs to stand a Renoir in Benson's studio that he may see
how a man of blood and muscle deals with the problems of sunlight and figures."[3]

There were few complaints of "anemic femininity" at Benson's one-man show at
the St. Botolph Club in 1910. Almost all the works for the show were borrowed from pa-
trons. Bela Pratt lent his "red-haired girl," now called *Sunlight Study,* and Isaac Bates
lent the finished larger work called, for this show, *Sunlight* (by the following fall, it was
being lent by Mrs. Isaac C. Bates under its present title, *Summer*).[4]

Benson wrote of his gratitude to one lender, saying of the show, "It has proved the
most successful one I ever had."[5] As so few of the works were for sale, we can only as-
sume that Benson measured success in terms of attendance, recognition, and forthcom-
ing commissions.[6]

Of the twenty-five works, eight were portraits, underscoring Benson's continued
activity in this area. Of these, perhaps the most engaging was the one he had done the
previous summer of a little boy. Where the other portraits had sitters posed seriously in
formal attire and interior settings, *Laddie* shows a little boy dressed in a white smock
toddling beneath branches of a tree towards the viewer. One of the earliest examples of

PLATE 76
Study for "Young Girl with a Veil,"
c. 1909. Oil on canvas, 30 × 24¾".
Private collection. Although the where-
abouts of the finished painting is un-
known, this study of Eleanor in a veil
hung in Benson's home until his death.

121

a commissioned plein-air portrait, it may well have inspired Benson's clients to request similar works. From this point on, several of his portraits placed the sitter in an outdoor setting.

Summer sunlight predominated in many of the paintings in the show. After giving a cursory nod of approval to these works, the critics focused their praise on Benson's "North Haven paintings." While the newspaper reviews were welcome, Benson obviously treasured most the appreciation of his peers. Letters of congratulation, carefully mounted in his scrapbook, give witness to the esteem and affection of his many friends. Prominent among these notes was one from Frederic Porter Vinton, Benson's mentor and comrade at the Tavern Club, who, "having been under the weather," wrote: "Your exhibition at the club set me up amazingly. It was a real tonic. I feel the refreshing breezes on the lower Maine Coast with its bright cool color in your outdoor work and in the interiors, exquisite color values and 'D—d refined.'" He added that he was sure Benson was well aware of all this, but "sometimes a kind, sympathetic word from a brother-brush, as I know myself, having had not a few from you on my own accord, comes not amiss as we jog on."[7]

In January Benson was on the Boston section of the Pennsylvania Academy jury, which selected works for this important annual Philadelphia show. The jury's job was to select a large number of paintings from regional artists. A selection committee and the director of the academy would then make the final decisions. Boston always was well represented, but this year its representation was unusually large. "More pictures chosen here than any other city," bragged the *Boston Herald*. The manager of the academy, John E. D. Trask, was quoted as saying, "Boston has the largest and best school of artists in America."[8] These were welcome words indeed to the ears of New England's painters, but they only added fuel to the long-smoldering discontent of those who charged favoritism of the Bostonians.

The previous year, when Benson had been awarded a prize at the Pennsylvania Academy of the Fine Arts, several New Yorkers and Philadelphians charged that there was a strong clique of Boston artists awarding one another all the honors. Like so many rumors based on jealousy, this one continued to grow. Philip Hale, now as often found writing on art as creating it, remarked: "There is a measure of truth in the thing, not the conspiracy part, that I will ever deny, but the Boston painters certainly do get a lot of prizes, there is no denying that, especially if you count in the expatriated Bostonians in New York.[9] But the fascinatingly funny part of it all is the idea that the Boston painters get together and devise deep laid plans. One fancies them meeting in Faneuil Hall and drinking 'Death to New York' in blood." Pointing out that there were only two Bostonians out of eleven members on the Pennsylvania Academy jury that awarded Benson his prize, Hale scoffed, "Think of it! Two! These two brutal Bostonian bullies bossed the poor timid little New Yorkers and Philadelphians about 'til they did their bidding. I don't think so."[10] Although Hale laughed at such nonsense, the perception remained that the Bostonians somehow controlled the exhibitions and finagled the awards, and the continued grumblings grew louder with each passing year. In a world where winning a prize or hanging a work in a favored spot meant increased commissions, competition was fierce. Such political infighting had recent precedents. The French Impressionists cried foul when their work was not accepted at the Paris Salons, and the Americans had grumbled when their work was rarely awarded prizes there. The Society of American Artists had formed in protest at the poor hanging of their works by a group of "entrenched conservatives" at the National Academy, and The Ten had resigned from the society because they felt the society's shows were mediocre and they did not want their paintings seen in such company.

The rivalries between cities were mostly based on which metropolis could claim to be the "reigning" art center. In the period before World War I, America's newly rich were eager to spend their money on tangible trappings of wealth. The artists of the major cities all vied for a piece of the golden pie. Although there was no truth to the jealous mutterings of the unmedaled painters, their accusations strained relations between artists of the major East Coast cities.

PLATE 77
Eleanor Benson posing for The Reader.

The art world was recognizing that the painters of "the Boston School" were "technically brilliant." Despite the artists' individual styles, their choice of subject matter and treatment did share a certain similarity. All three men were enjoying increased commissions and demand for their work. In particular, Benson's outdoor canvases of his daughters were quickly sold.

One such work received positive reviews on its first showing. *Young Girl with a Veil*, a painting similar in fashion to *Against the Sky*, shows Eleanor in a veiled hat. The handling of the features beneath the light veil is masterful. At the inaugural exhibition of the Newport Art Association in William Morris Hunt's old studio, this work was praised for its "delicate and high pitched effect of color."[11] In the photograph Benson took of Eleanor posing for this picture, the oft-used ruffled parasol is included. However, in the original study for *Young Girl with a Veil* as well as in the finished canvas, the parasol has disappeared (plate 76).

Eleanor photographed her family frequently that summer. In one photograph which captured them as they lounged on the garden bench, Elisabeth struck a pose that Benson was to duplicate in a painting of her and Eleanor that he finished the following year. This now unlocated work is titled *Sun and Shadow* (see plate 86).

Exchanging her camera for a book, Eleanor became the subject of *The Reader*. Also titled *A Summer Idyll*, this informal arrangement once again introduces the familiar parasol; this time it shades the book in the model's lap, rather than the model herself (plate 78).

It is interesting to contrast the painting with the photograph that Benson took of Eleanor posing (plate 77). The picket fence, a distracting element in the photograph, has almost disappeared in the finished work, and the pillow on which Eleanor sits becomes merely a shadow.[12] A reviewer in Boston noted the unfortunate effect of electric lights when used to illuminate another of Benson's "parasol" pictures: "With each snap of the switch, some of the sunlight faded out of the parasol until, when all the lamps were on it, it had become a mere yellow blob. It was a curiously vivid illustration of what artificial light can do to spoil a picture, to take all the light out of it."[13]

Benson's entries in the shows of 1911 were fewer than in past years and were comprised mostly of older works. His frustration with not being able to finish paintings is illustrated in two letters he sent to his old friend at the Cincinnati Museum, James Gest: "I want always to send two if I can for your show and I will do my best to get the interior done that I am working on."[14] But two months later, he sadly admitted, "I fear I shall not be able to send you the other canvas. I just can't get it the way I want it and may have to leave it unfinished over the summer."[15]

Benson's inability to "get it the way I want it" sometimes drove him to the brink of despair. His grandchildren clearly remember his coming to the lunch table in North Haven after a morning in the studio. "He would sit there with his head sunk in his big hands and just stare at his food," recalled one granddaughter. "Then, later, he would come to dinner beaming. It was as though the sun had come out after a week of rain."[16] The breakthroughs in his painting could dispel his frustration. His other periods of depression, a nameless despondency which could haunt him for days, were harder to understand.

Some of Benson's low periods were undoubtedly brought on by fatigue. As he once wrote to Eleanor when she was learning to paint: "Of course you can't paint all day and do well. . . . You will inevitably get stale in your work and lose interest in your subject when the work doesn't go well. . . . I have miserable days over my work when I don't want to speak to anyone. That is because you tire your faculties trying to coordinate things and they look worse than they really are."[17]

The usually steady, even-tempered Benson was generally not given to moods or behavior so often considered part of creative genius. Because he was thought by the

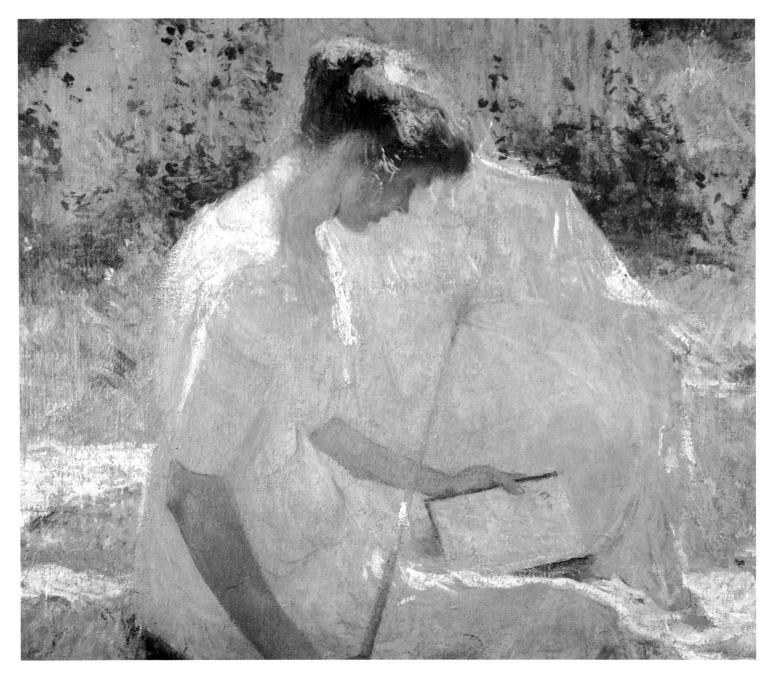

PLATE 78
The Reader, 1910. Oil on canvas,
25¼ × 30". Private collection.

PLATE 79
Ellen in the Woods, c. 1902. Oil on
canvas, 16 × 12⅛". Private collection.

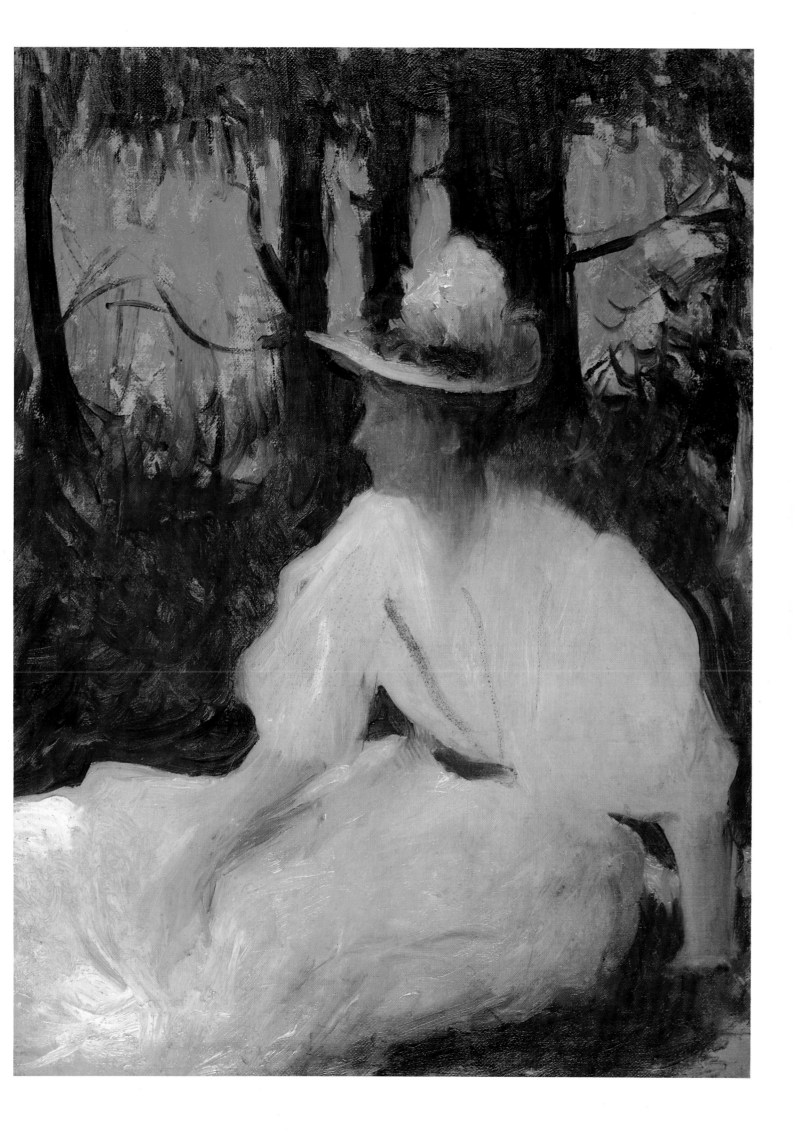

family to be about as far away from having an "artistic temperament" as a man could be, these periods of depression concerned them. Bela Pratt also worried about these spells and shared his concern, in a letter to his mother, who was fond of Benson. "Frank is less blue than he used to be and he told me the other day that he had had no headaches for a number of weeks."[18]

In Pratt, Benson had a true friend and confidant. But for the most part, in typical, stoic New England fashion, Benson kept his worries to himself. Since financial concerns were often uppermost in his mind, to hedge against lean times, Benson began to squirrel away his resources. When he sold a painting, he would buy stock. In this manner, he gradually built up a strong portfolio that gave him a sense of security when

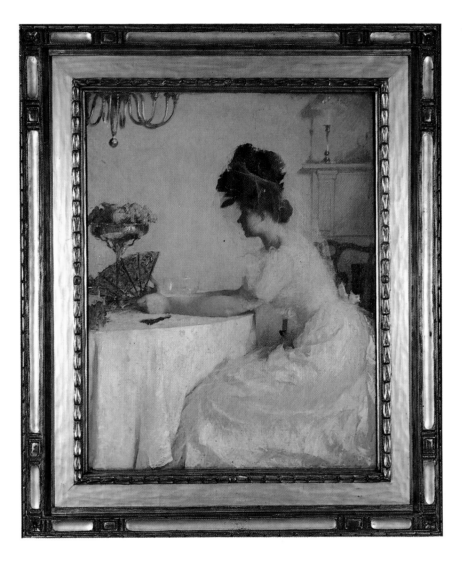

buyers were few. Once, after Benson had sold several paintings at a Boston exhibition, Pratt wrote, "This seems to cheer him up a great deal."[19]

Despite interviewers' descriptions of Benson as "hale and hearty," "a fit and athletic man," "tall and robust" well into his eighties, he did have periods of poor health. Adding to his frequent migraine attacks, Benson was developing a stomach condition. At one point, trying to regain a sense of well-being, he accepted an invitation from his old friend Gus Hemenway to spend a week on his boat in Florida. Pratt, who was a close friend of both, again wrote to his mother: "Frank has had a return of his headaches and I am a little worried about him. You see, we can't get buttermilk down here and the tablets which we brought seem not to be much good. I have a bottle of culture which I got in Boston, but he absolutely refuses to take any."[20]

Although the exact nature of Benson's condition is not known, it was at about this time that more frequent references to illness begin to appear in his letters to friends, dealers, and museum directors. These periods of poor health help to explain gaps in his productivity.

One of the shows to which Benson never failed to send work was the annual exhibition of The Ten in New York. By now a permanent fixture in New York art circles, The Ten's exhibitions were being held at the Montross Gallery, whose large open space was preferred over Durand-Ruel's by artists and critics alike. Shown in 1905, such works as *Calm Morning, Afternoon Sunlight,* and *In the Spruce Woods* reflect the qualities Benson best loved to paint: the tranquility of early morning and late afternoon, the effects of sunlight, and the delicate play of light and shadow often found in a wooded setting. A small study of Benson's wife, Ellie, sitting in a wooded glade at the edge of a meadow illustrates the elements he found so captivating (plate 79). *Ellen in the Woods* is a rare work, for of the many sparkling, outdoor paintings Benson did at North Haven, his wife is featured in only two: this one and *Evening Light.*[21]

Benson had begun this study hoping to use it as an aid in the completion of a larger work. But Ellie refused to pose again for a final canvas, and Benson did not feel he could do justice to the sitter and the dappled forest light by using the study as a model. This small painting was Benson's personal favorite; it hung in his studio for many years.

In the late 1920s, when he began to teach his oldest child, Eleanor, to paint, he gave her *Ellen in the Woods* as an example of plein-air painting. It encompasses all the broken prismatic light and sparkling color of his larger paintings of this period.

While such bright outdoor works continued to be seen in The Ten's shows, Benson was returning to one of his earliest themes—the sea. The following year, when he hung a marine at the 1906 exhibition of The Ten, the critic for the *New York Times* was not impressed: "*Coasters in Harbor* is a big sketch in grays with a very high horizon. Pale gray troubled sky, gray schooners at anchor seen from the stern and dark bluish gray water occupy a large part of the canvas and not very convincingly either. It has no life and offers too much the suggestion of a pattern."[22] Nevertheless, from this point on, Benson painted one or two marines each summer.

By 1906 The Ten's exhibitions were beginning to expand from one show in New York and Boston to other shows on the East Coast as well the Midwest. The group that started out so simply was, in its desire to increase exposure, getting more complex. They rotated among them the duties of arranging the shows, but the burden often fell to a responsible few. That fall, the group exhibition traveled to Boston for a special show at the Kimball Gallery. The St. Botolph Club did not host the show, as it had in years past, because they had offered Metcalf a one-man show that would coincide with The Ten's exhibition. Metcalf was assigned the job of putting both shows together. But, perhaps fearing a repeat of his first financially disastrous one-man show at the St. Botolph Club or under the influence of another bout of drinking, Metcalf caved in and had to abandon the arrangements to Benson.

The opening of both exhibitions was a success as well as a reunion of The Ten. Judging from letters from Hassam to Weir, several of the men traveled to Boston to support both Metcalf and their group. They were rewarded. Metcalf sold ten out of eighteen paintings and reaped great accolades.[23]

By 1907 the men of The Ten had long since handed over the arrangement of their shows to Newman Montross, owner of the Montross Gallery. Benson sent him three North Haven pictures—*A Rainy Day, Eleanor,* and *Portrait of My Daughters*—and a new interior, *Girl with a Veil.* By the time the show reached Boston, Benson had added several canvases. One critic noted, "Of recent years, his trend has been toward decorative effect and it is that, one may guess, which he thinks most about and which gives him the greatest pleasure." Of an interior he commented, "It is difficult to describe the charm of the thing, but the room swims in light and atmosphere."[24]

In 1908 the Pennsylvania Academy was the scene for the tenth anniversary celebration of The Ten. Each man was urged to try to send ten paintings, and the resulting exhibition of nearly one hundred works was their largest exhibition to date. Covering the show for the *Boston Transcript,* William Howe Downes wrote, "Mr. Benson chose for his ten works a group which represents all the sweetness and charm of his sunlight summer visions." After rhapsodizing over *Eleanor* ("The thing is so full of joy and spontaneity that it made the day happy"), he turned his attention to the other "indescribably delicate and luminous pictures of his daughters in their light summer gowns." Downes mentioned that most of these works had already been seen in Boston but to see "so many of his choicest canvases brought together" was nonetheless a wonderful "revelation of what a painter is, of what he is doing, of what he stands for. . . . There is no one to excel him in freshness, purity, sweetness, freedom in the joy of living."[25]

Most of the critics preferred Benson's outdoor works; but his recently completed interior, *Girl with a Veil,* drew admiring comments (plate 80). Although one critic called the veil "deftly and delicately painted," he nonetheless felt that this work was overshadowed by Benson's other paintings.[26]

By the time The Ten's show moved to New York City, the number of paintings had been reduced to twenty-seven. Even so, Arthur Hoeber called it "the most complete display of modern American work we have yet had, the standard being unusually high and well maintained." Hoeber's article for *International Studio* was a reflective look on The Ten's past decade. The man who had been a summer comrade in 1884 to three of The Ten—Benson, Simmons, and Metcalf—had himself become more of a writer on art

PLATE 80
Girl with a Veil, *1907. Oil on canvas, 40 × 32". Collection of the Rainier Club, Seattle. The painting's original gilded frame shows Benson's preference for the simplicity in design and craftsmanship that spurred the Arts and Crafts movement within the decorative arts.*

127

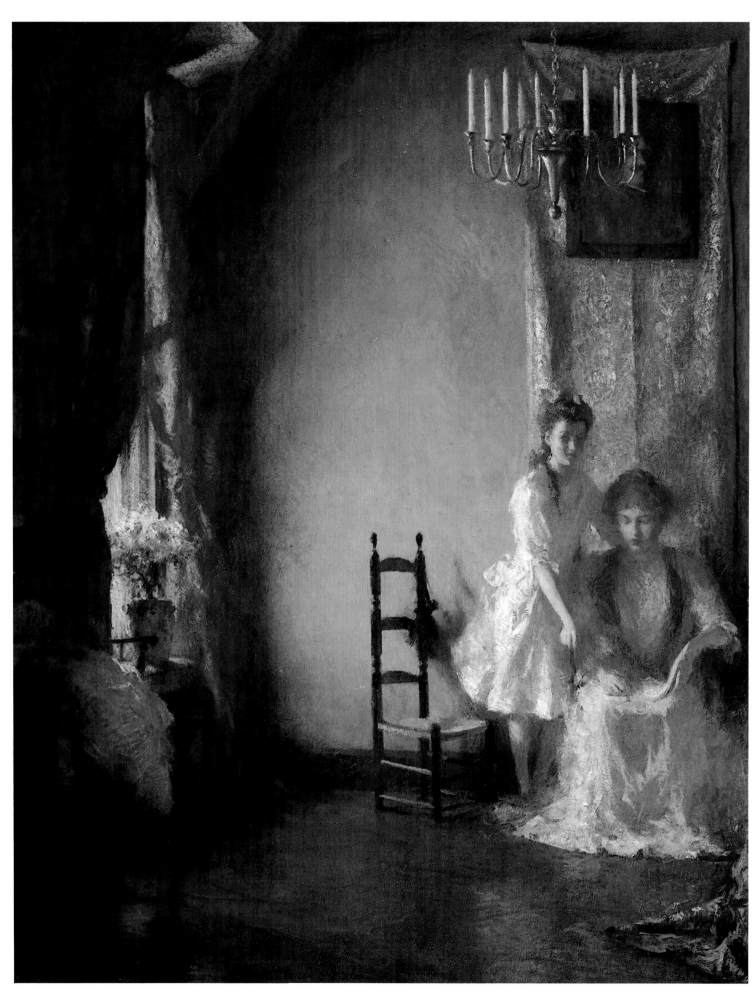

PLATE 81
The Lesson, *1911. Oil on canvas,*
50 × 40". Private collection.

than a creator of it. Singling out several of Benson's paintings for mention he wrote, "Mr. Benson knows well his metier, painting with certainty and capacity, securing his results with a freedom of touch, a healthiness of method that cannot be over-commended."[27]

The following year, Benson exhibited two North Haven works at The Ten's show: *A Summer Afternoon* and *Elisabeth,* although just which *Elisabeth* is not known. Benson had completed two paintings of his second daughter in the past three years. In the first one she is seen wearing a light straw hat and a Chinese mandarin coat, the ruffled edges of her summer dress peeking from beneath its voluminous sleeves. The other *Elisabeth* shows her sitting beneath a tree with her dog. Benson also hung his new *Evening Light,* begun the previous fall. The new work employed a very different outdoor palette from that which Benson usually employed. The lengthening shadows of the trees foretell winter's coming, and the light that glows from the painting is mellow and warm, not hot and vibrant (plate 83).

Although Philip Hale, writing in the *Boston Herald,* thought *Evening Light* was "a brilliant and effective performance," this departure from his usual palette seemed to disappoint the critic for the *Transcript,* who wrote, "[The problem is] one of grading sunlight into the more delicate hints of evening. His evening colors are a little hard, that is, for him."[28]

The 1910 exhibition of The Ten was held at Newman Montross's new gallery on Fifth Avenue. In its spacious, well-lit rooms, Benson hung an interior, *The Gold Screen, Sunlight Study,* and two marines, *Summer Night* and *Shimmering Sea*—the latter was seen for the first time the previous January at Benson's one-man show at the St. Botolph Club (plate 84).

By 1911 the critics were beginning to grumble. The year before a mere thirty-three works had been shown by The Ten; this year the number was only twenty-one. Benson only hung one work, but it was *Summer,* one of his best. The only other time he had hung just one work was at The Ten's second show in 1899, when he had been ill with typhus for almost half the year. Although *Summer* had received strongly enthusiastic reviews in almost all the Boston and New York papers, the critic for the *New York Sun* granted it faint praise before delivering a scathing judgment of the group as a whole. While he felt that their technique was flawless and their quality excellent, he longed for a vision of the new. Calling them "an elderly band of conservatives hopelessly imprisoned behind the bars of a few outworn pictorial conventions," he saved his most stinging comments for the New Englanders.

"The Boston contingent, Benson, Tarbell and De Camp," he wrote, "has not succeeded in escaping its icy, intellectual environment. Their production is brilliant but without warmth. It has light, not heat." In a blanket depreciation of the whole group, the critic called them "a body of refined, middle-aged men . . . no longer seduced by the siren of the moderns; they have filled their pictorial sensations to the vanishing point and are content with simple phrases, jeweled cadences."[29]

In another article, whose headline tellingly still called the men "successionists," the writer complained that the artists' works were so similar to things seen in the past that viewers had a distinct sense of déjà vu. In retrospect, these comments were not unforeseen. For the past several years, reviewers who before had been unanimously positive, began to express dissatisfaction. It was as though the critics were still expecting these "rebels" to be at the forefront of new things because of their succession. Reviewers' continued praise for excellence, technical brilliance, pleasing and pretty subject matter was, in point of fact, what the artists had hoped to present at their small exhibitions. But the

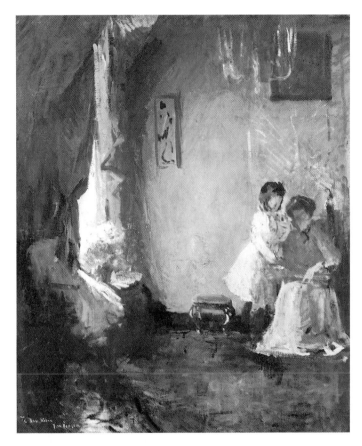

PLATE 82
Study for The Lesson *(also incorrectly titled* Artist's Wife and Daughter*), c. 1911. Oil on canvas, 35 × 25". Private collection.*

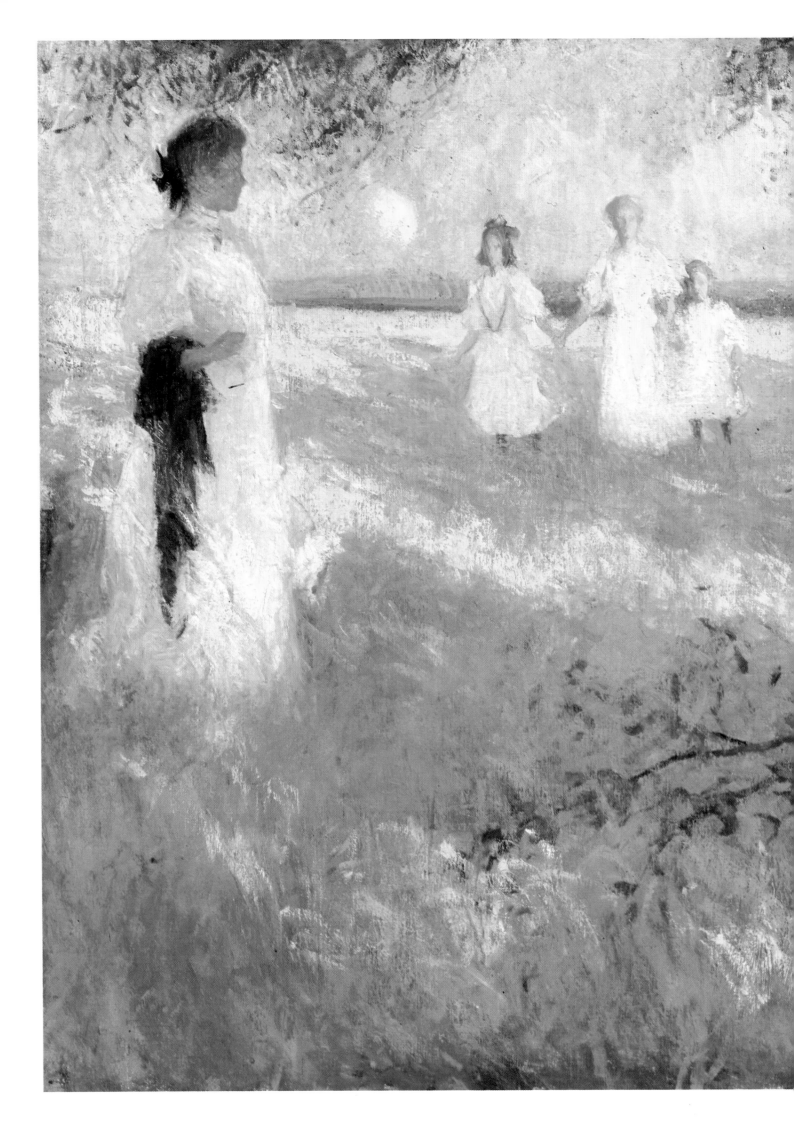

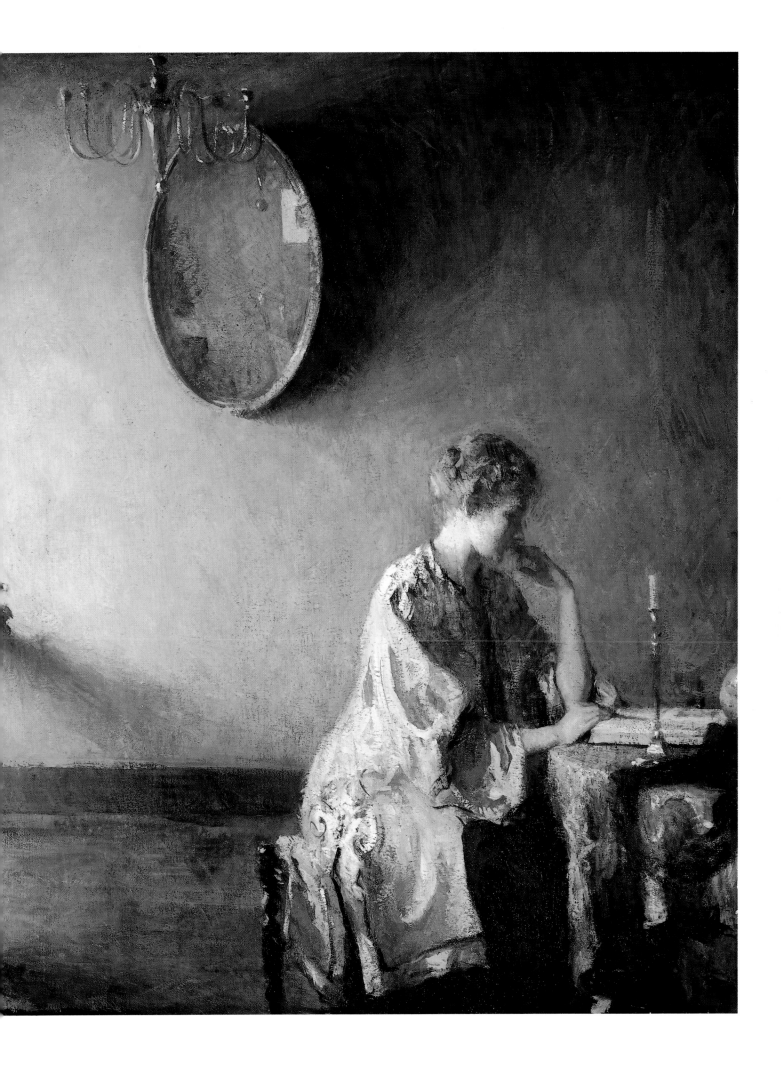

of a large blank space between the window on the left and the painting on the wall is echoed time and again in Benson's ensuing interiors. Vermeer's reliance on a canvas or mirror high up on the wall behind his model was to be seen in several of Benson's later paintings. In *Young Woman with a Water Jug,* the model reaches toward the window in a pose reflected in Benson's North Haven interiors, the recently completed *Young Girl by a Window* and his later *My Daughter* (plate 92).

Although one critic singled out *Young Girl by a Window* for praise, calling it an "attractive pictorial effect," and enjoyed *Sun and Shadow* for its "personal and distinctive manner," the headline of one review of The Ten's 1912 show was scathing. "TEN AMERICANS GOING STALE," it announced. While acknowledging that in "these men there is no want of good workmanship: one and all are accomplished craftsmen to whom the art of painting has long since become second nature," the writer felt their art had become "too matter-of-fact, too conscious of its own superiority." Delivering the coup de grace, he declared, "It is an art of bespectacled and bloodless bipeds who live in an atmosphere of rigid aloofness from all matters pertaining to real virility."[11] In a similar article, Royal Cortissoz, the influential critic for the *New York Herald Tribune,* singled out only Benson, Weir, and Dewing for praise.

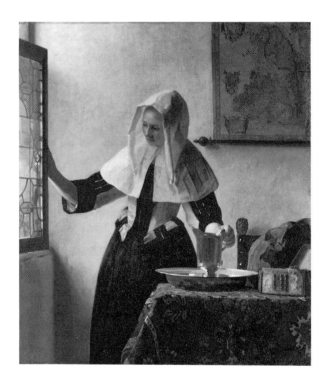

Despite what critics called the "perfunctory mood" of the show, several reviewers heartily approved of the separate room in the gallery that was devoted to drawings by The Ten. It was the first time that Benson appears to have exhibited his wash drawings. This new direction was not merely a reaction to the critics' desire for the new; Benson had been painting his delicate black-and-white drawings of wildfowl for the past fourteen years. He enjoyed dashing off these little sketches and had given many to his hunting companions; several already decorated the walls of the farmhouse at Eastham. Of these works a critic noted, "The three drawings . . . are suggestive notes that adequately express the character and movements of these fowls."[12] The wash drawings were undoubtedly a result of Benson's personal desire for change and variety in his own art combined with a need to portray his early love—birds in the outdoors.

Hearing of Benson's new experiments, John Trask, the director of the Pennsylvania Academy of the Fine Arts, wrote to Benson asking for a group of watercolors for their annual show. Benson responded, "Once in a while, I take a notion to make wash drawings . . . and I make a lot of them, tear up the bad ones and then someone buys the others. All I had have been sold. I don't know where and I couldn't possibly get any together. . . . If I can ever make any more, which I may or may not, I will remember that you want these for exhibition."[13] The critics' good words, the sale of his drawings and Trask's request may all have combined to set Benson on the course of creating the many wash drawings that were to bring him considerable renown and financial success. The following year he did fulfill Trask's request and sent two wash drawings, *Geese Flying before Gale* and *Ducks Alighting* to the Pennsylvania Academy's watercolor exhibit.

Using a wash of various shades of black and gray, Benson let the white of the paper portray highlights—the tips of waves, the sheen of a duck's back. In his oils, Benson conveyed texture by carefully laid up brushstrokes; in his wash drawings the softness of down or the choppiness of the sea were produced with the density of application of watercolor and the blending of values. Sea and sky are shown as negative space or by a faint wash of color that changes in value where the two meet.

In 1914 a critic wrote of these new works, "Every essential of good art is there. Always there is good design. There is beauty of line. There is elimination of all save that which is necessary. There is a fine sense of values. The medium is a wash of ink with beautiful gradations which give one a sense of color."[14] This fascination of "color" in

black-and-white was to dominate Benson's creative efforts for years to come both in wash and in etching.

Little did Benson realize, as he returned from The Ten's exhibition to his teaching and painting, that the smooth surface of his own life would soon be broken by a troubling rift. The pupils in the course of Design at the Museum School had complained that "the instruction was inadequate, that Mr. Walker came regularly but seemed to have no initiative, and only did what [his assistant] Miss Childs told him to." Furthermore, they charged that the problems in design which they were given were constantly changed and students "were sent to the museum to study without sufficient instruction." The Council of the Museum School felt that this "occurrence was very unfortunate and very harmful to the school if it should become generally known."[15] In hopes of radically improving the department of design, they appointed a committee to look into the problem.

The committee's recommendation was that "a director for the whole school be appointed with the understanding that the department of Design receive his first attention and the organization of the department of Drawing and Painting [Benson's and Tarbell's domain] remain intact *for the present*." They recommended hiring Huger Elliott of the Rhode Island School of Design to fill this newly created position, noting that "Mr. Elliott perfectly understood the circumstances [and] the importance to the school of the instructors and the regular course and the advisability of not interfering with them."[16]

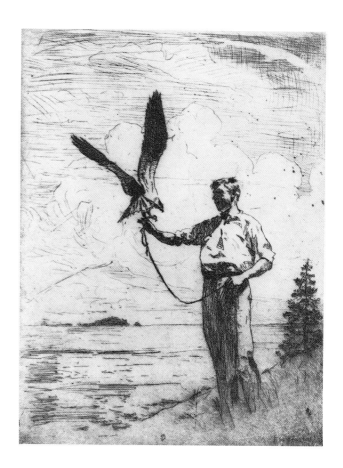

However, the *Boston Herald* ran a prominent article detailing the changes before the council had an opportunity to draft a formal announcement. Noting that the school had grown to such proportions that the need of an administrative head had become apparent, the article also stated that the school would be "directed in its work by the faculty as heretofore." To many, the council's move looked like a slap in the face to Benson and Tarbell, the two men who had been the directors of the school for so long.[17]

Two weeks later the teachers stated that "no director was needed, that the instructors formed a democratic, self-perpetuating body" and wrote a letter of protest to the council on the grounds that "their relations to the school would not be the same as in the past and they feared it would end in the breaking up of the school."[18] Elliott was caught in the middle of this maelstrom. Twenty years later, he remembered that "Tarbell apparently led the revolt against an administrator and Tarbell, Benson and Hale served notice to the trustees of the school that, if a director was appointed, they and perhaps the whole faculty would walk out bag and baggage." Elliott wanted to back out of the whole messy situation as he thought that "it would certainly injure [his] professional standing if it was publicly stated that the moment [he] became administrator of the school three nationally-known painters walked out."[19]

PLATE 91
Tame Fishawk, *1912. Etching on paper, 8 × 6". Paff no. 3, ed. 7.*

After much discussion the council announced that Elliott would be merely the director of the Department of Design and would have charge of the Education division of the Museum of Fine Arts. The department of drawing and painting would be under the management of Miss Brooks (the former executive secretary) while the faculty would still govern the school. Although the faculty's immediate objections were resolved, feelings obviously still ran high. After a meeting with one council member, Benson wrote to Hale that this member had assured him that the council "would not think of allowing us . . . to be disturbed for the sake of any change." But Benson added with a note of frustration, "It's d—d hard to fight with people who tell you all kinds of nice things and hand you a vote of confidence and a good cigar before you begin. But I told him that, if

141

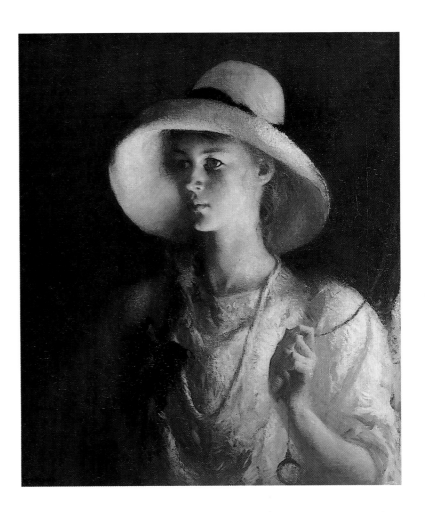

PLATE 92
My Daughter, *1912. Oil on canvas,
30¼ × 25¼". Corcoran Gallery of Art,
Washington, D.C.*

the damage to the school had not already been done, it would be if they forced the matter further. He assured me that they would drop it as far as our part . . . was concerned and they wished us to be as we have always been doing the public a great service."[20]

After the turmoil of the spring, it must have been a relief for Benson to get away from Boston. A diplomatic, easygoing man, he often made firm, unwavering stands on principle, but such upheavals wore him out and his migraines returned with a vengeance. His Maine island truly became a "northern haven" for the emotionally drained painter. Upon arriving, Eleanor wrote, "Flock of white-winged coot living in our cove. Millions of mosquitoes, and all hungry."[21] Benson did several wash drawings of these coot as well as other birds on the island. One of these, *Fishawk on Nest,* is no doubt a picture of one of the "hatcheries" from which George obtained his yearly pet osprey.

The simple contrasts of black on white must have fascinated Benson, for, in addition to continuing to work on his wash drawings, he took up etching again. He found the total concentration necessary for their creation was relaxing and provided a good distraction from the events at the school. His first few efforts as an art student had resulted in an excellent etching, *Salem Harbor,* which was used as the frontispiece for *The Art Student* in 1882, when he was on its editorial board. Despite his evident success with the medium, he had not practiced it for thirty years. Many scholars have wondered why he abandoned etching after making such a good beginning.

In a letter to a prospective etcher, Benson explained that he was not pleased with his initial efforts: "Though I studied drawing from nature for two or three years I found I did not know enough of drawing to be able to make etchings." But now, eager to try his hand again, he realized that "etchings and paintings are based on scientific knowledge which cannot be imparted to another but must be dug up by your own effort."[22]

Benson's first experimental plate of 1912, *Two Girls,* was copied from an old photograph and depicts two of his daughters in unrelated poses. Its crudeness of line and form demonstrates that he was merely trying to establish the effects of various aspects of the mechanical process of etching. This plate yielded only two impressions, one of which Benson sent to George Gage of Cleveland, who had been collecting etchings for twenty-five years and was well known in the art world as a connoisseur of the medium;

Gage eventually became his etching agent. Benson's second experimental plate is much more finished: his son George, with one of his tame ospreys, stands on a hill in North Haven against a backdrop of sea and sky (plate 91).

Although fascinated by the effects of black lines against white paper, Benson did not abandon his work in oils that summer. A rainy day forced Benson inside to create *My Daughter*, a study of Sylvia in a summer hat (plate 92). *My Daughter* made as much of a sensation when it was hung briefly at the Copley Society as *The Lesson* had the previous year. The critic Arthur Philpott wrote, "This latest painting is . . . destined to rank with the great portrait paintings of the world, not only because of its technical excellence as a picture but also as a type of American girl. It is a fine type of the sensitive intelligent American girl who looks out on the world from under her broad brimmed negligee summer hat with a steady, frank inquiring gaze. . . . The quality of luminosity in the whole picture is one of its greatest charms."[23]

In the many positive reviews this painting received, critics kept returning to their praise of his "unassuming beauty" and "natural refinement." A writer for the Brooklyn Institute of Art and Sciences contrasted this work with that of Abbott Thayer: While Thayer created a picture of a woman for "adoration and worship . . . a noble ideal," Benson, "while not presenting less of the grace and beauty of young womanhood, makes a natural [girl], such a one as we might expect, in rare good fortune, to meet."[24]

Perhaps it was Benson's strong desire to see this "truthful appearance of young American womanhood" more frequently portrayed that caused him to make an uncharacteristic public statement to the *Boston Post* that fall. "Pen and ink sketches that the public has continually placed before them and which depict the American girl as she is supposed to exist are far from being truthful," he fumed. "They are misconstructions and are not true to life."[25]

Benson was undoubtedly referring to the extremely popular illustrations Charles Dana Gibson was publishing in several magazines. While Benson was using black and white to depict graceful birds, Gibson was turning out black-and-white drawings of another graceful creature—the American Girl or, as she soon came to be known, the Gibson Girl. Gibson's famous creation influenced an entire era. She was imitated by women from pigtails to dowagerhood. Gibson didn't like bangs; women stopped cutting them. Gibson Girls were tall; women began buying higher heels and piling their hair to tremendous heights. Fashions carried her name; china, fabric, spoons, even wallpaper bore her likeness; the hit song of 1906 was *Why Do They Call Me a Gibson Girl?*

Although both artists' women are beautiful, there the similarity ends. Benson's girls are wholesome and natural while the Gibson Girl is stylized, with an impossibly small waist and an elongated neck. Benson's dismay in the lack of "truthfulness" portrayed in Gibson's drawings may stem from their exaggerated anatomy. Benson may have felt that by holding up the Gibson Girl as the way American women were "supposed to exist," magazines were doing serious injustice to the majority of girls who could never hope to attain such a look. But Benson may also have been concerned with the pursuits in which the Gibson Girl is usually depicted, namely, the pursuit of men. Benson's girls are shown in quiet domestic endeavors or exuberant enjoyment of the outdoors while the Gibson Girl was content merely to entice men. Benson's own lovely ladies of leisure on sunny hillsides, while not necessarily representing the average American girl, were modest and demure. Obviously, Benson felt that Gibson Girls were not. It is clear from the many reviews of *My Daughter* that Benson was regarded as the champion of the "graceful and comely maid," a position to which he did not object. As his own daughters were becoming women, he depicted them as his ideal of American womanhood—not a Thayer-esque angel replete with wings and halo, nor a Gibson *femme fatale*, but a vigorous, unaffected, and natural girl.

When Benson sent Sylvia's portrait to the annual show at the Art Institute of Chicago, it won the Gold Palmer medal and a prize of one thousand dollars. The announcement of this prestigious award brought letters of congratulations to Benson from all over the country. The Boston artists hand-delivered short notes ("Beans—It's a beaut. Joe [De Camp]") and telegrams arrived ("We . . . congratulate you on having yanked the

Palmer Prize for your bully canvas. Metty. [Metcalf]").[26] Even old friends from Benson's Paris days sent words of congratulations. When *My Daughter* was hung at the fourth biennial Exhibition of Contemporary American Painting at the Corcoran Gallery of Art, Anna Seaton-Schmidt, an art critic from Boston wrote, "No exhibitor has received higher praise than Frank W. Benson. . . . the directors . . . have shown their appreciation of his work by purchasing the painting . . . for their permanent collection. One of [them] tells me that he considers this an 'inspired picture' and that, if he could choose any painting in the entire exhibition to live with in his own home, he would choose *My Daughter*."[27]

Such praise may have helped distract Benson from the turmoil in Boston. At the Museum School, the gathering storm broke in early December of 1912 when Tarbell resigned. "WHY MR. TARBELL LEAVES" was the headline of an article detailing the past "unpleasantness" and noting that the council had "gracefully yielded" to the staff's objections. The writer added, "The cause for all dissatisfaction on the part of the instructors having thus been removed, it was taken for granted that all was serene and peaceful once more." The writer then suggested that there might be a "little . . . resentment at the thought that the committee was seriously capable of proposing . . . a director of the school."[28] Benson resigned a few days later. In early February, Paxton followed suit.

Although pressured by Tarbell to add his name to the list of resignations, Hale chose to stay. Before resigning, Tarbell and Benson were able to appoint their own successors. As Huger Elliott, recalled, "It would have been a natural thing for Hale to have taken charge of the advanced painting [but] probably owing to Tarbell's influence, this was not done. . . . The appointment of two youngsters barely out of the school . . . as instructors . . . was a great scandal not only in Boston but elsewhere. It was a poor piece of politics on the part of Tarbell and Benson."[29] The controversy was a crucial turning point in Hale's life and permanently embittered him. Dozens of students quickly switched their curriculum so that they might spend the spring term working in the last portrait class Benson would ever teach.

The school's uproar filled the local newspapers with outraged letters. The American editor of the *International Encyclopedia* wrote that "to deprive the rising generation of artists the instruction of men like Tarbell and Benson is well nigh criminal."[30] Although Benson agreed to stay on as visiting professor and Tarbell agreed to sit on the Board of Trustees, their twenty-four years with the school were over. The school that they had taken on when it was running at a loss and virtually made over into one of the finest art schools in the country would find it hard to regain such a level of prestige.

Nineteen thirteen was not only a turning point in Benson's career as artist and teacher, it was a turning point in the direction of American art. On 17 February, in New York City, the Armory Show opened. Held in the Sixty-ninth Regiment Armory, which occupied the entire block between Twenty-fifth and Twenty-sixth streets and Park and Lexington avenues, this show had been conceived as a mammoth display of American art by the twenty-five-member Association of American Painters and Sculptors. However, the new president of the association, Arthur B. Davies, felt contemporary European art should be featured as well and, together with Walt Kuhn and Walter Pach, he embarked on a tour of European galleries and studios and brought back to New York the most controversial collection of European art to be seen in America.

Due to extensive publicity, the Armory exhibition of the works of over three hundred artists became a "blockbuster" long before the term was ever used in association with an art show. Although many well-known artists, such as Ingres, Delacroix, Courbet, and the French Impressionists, were shown, it was the Cubists and Fauves the public had come to see and mock. With outrage reminiscent of the reception given to the French Impressionists when they first exhibited in Paris, the press erupted with impassioned diatribes and invective. Many school children were barred by their teachers from seeing this "corrupting" show, and newspapers held contests for the best solution to the meaning of the paintings.

Although such artists as Cézanne, Picasso, Braque, Vlaminck, Dufy, Redon, and others were well represented, the derision seemed to focus on two particular paintings:

Matisse's *Blue Nude* and Duchamp's *Nude Descending a Staircase*. The public found the Matisse nude an effrontery. Her contorted, bulbous figure horrified viewers.

The greatest ridicule, however, was saved for the Duchamp painting. Described variously as looking like an explosion in a shingle factory, a dynamited suit of armor, or a mixture of leather, tin, and broken violins, it immediately earned the alternate title *The Rude Descending a Staircase (Rush Hour at the Subway)*. Despite the insults, Duchamp's *Staircase* was bought sight unseen by a collector in San Francisco, and his other three entries sold quickly. Picabia's Cubist works inspired dozens of cartoons transforming old masters into boxy little drawings. One cartoonist suggested that the "Original Cubist" was actually a grandmother stitching up a patchwork quilt, and another urged that anyone who had been drinking should not see the show.

A few days after the Armory Show's opening, the men of the Académie Julian held a reunion at Brevoort's, a restaurant in New York. Lampooning the "Cubists, Nuttists, Topsy-Turvyists and Inside-Outists," they tried their hand at imitating these incomprehensible works. But to be a genuine Cubist, they decided, one had to be genuinely and unquestionably mad. When slightly more than half of the exhibition's thirteen hundred works traveled to Chicago, the reception was even more hostile than in New York City. Matisse's *Blue Nude* was burned in effigy and ministers urged their congregations to censure the Art Institute for hosting such a vulgar display. When the show finally arrived in Boston, only two hundred fifty of the works were hung at Copley Hall. Undoubtedly many of Benson's friends and collectors viewed the show, but their response was apathetic at best. Despite the ridicule, the effect of the Armory Show on American taste in art was electrifying. In the following year, several galleries specializing in modern art opened in New York and older, more established dealers began showing a smattering of "the new art." More than two hundred fifty works were sold directly from the show and the French art outsold American works four to one.

Of the fifteenth anniversary show of The Ten at the Montross Gallery on Fifth Avenue however, Hassam wrote to Weir that nothing was selling. The writer for *International Studio*, although pleased with the annual display of sunshine and beauty, nonetheless commented, "Scant change has marked their production from season to season.... They are unsympathetic, not to say hostile, to the more recent manifestations of contemporary endeavor, and this attitude has not been devoid of influence upon their development.[31]

Obviously, The Ten were not unsympathetic to the new. Many of them had adopted Impressionist techniques when such a mode of painting was reviled as "grotesque" and "offensive." But within the framework of Impressionism, the precepts The Ten felt to be important—namely, attention to the academic concepts of form and structure, harmony of composition, realism, and pleasing subject matter—were all present. This could not be said of the new art seen at the Armory. Benson himself respected what "the most honest of the modernists" were trying to represent. Speaking of such art to his daughter Eleanor, he noted, "The plain fact does not interest them. They say 'I will not say D-O-G spells dog, because that is stupid and literal.' So they make something else, liberate themselves to say the same thing in another, more interesting way. But the others, less honest, merely look at the fact of liberation, do not understand what they were liberated for, and merely think they can make anything and call it ART. They are not happy about it, don't enjoy what they do."[32] Although Benson thought the best work of such artists "interesting," he found the majority of modern art deeply upsetting.

Despite what the critic for *International Studio* may have thought about The Ten, when their show left New York in April to hang in the Copley Gallery in Boston's Newbury Street, the reception was much warmer. One critic, remarking on the show's "originality, its distinctions and its interest," added that it was a "collection that has not been excelled by any of the preceding shows of The Ten."[33] Benson hung several of his new wash drawings as well as *September Afternoon* and borrowed *My Daughter* from the Corcoran. Of his newly completed *The Gray Room*, critics noted the beautiful play of light on the satin gray walls and the soothing, understated color scheme.[34]

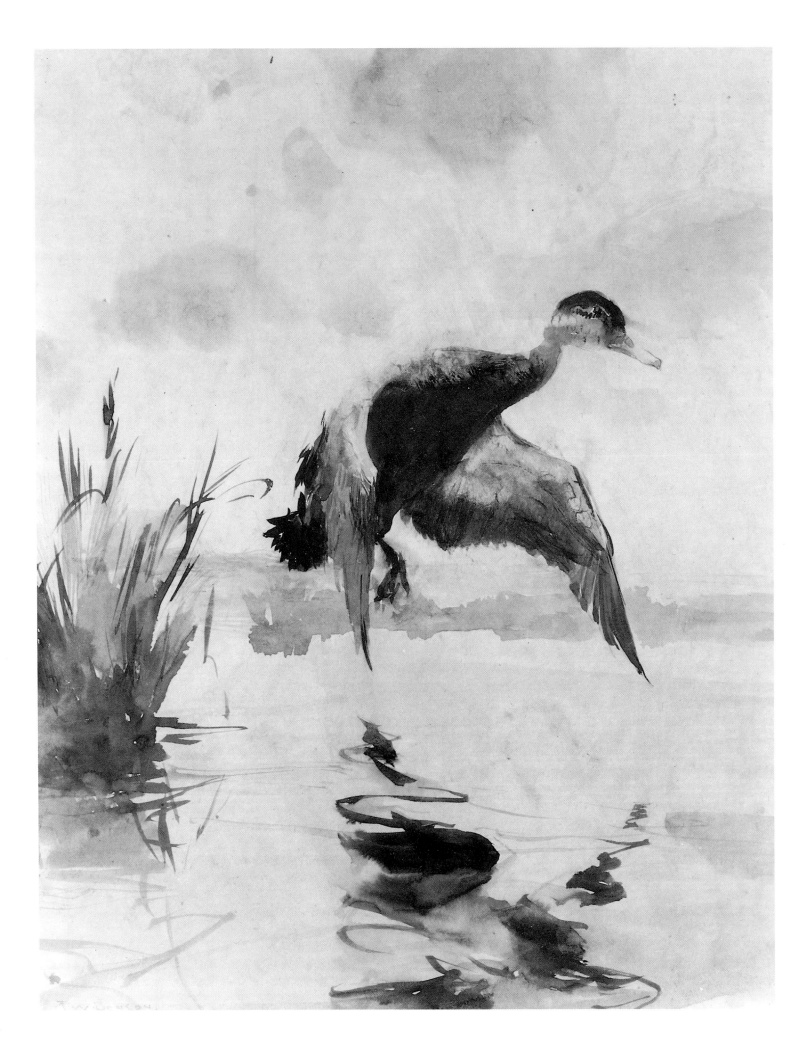

BLACK AND WHITE

W hile Benson continued with his experiments in etching, he contemplated a life with more time for his art, one without the responsibilities of teaching. The previous summer, months before he knew that he would be resigning from the museum, Benson had taken up the etcher's needle again after a gap of thirty years. Now he would have the time to experiment freely with this medium.

Benson's plates of 1913 show a marked improvement over those of the previous year. Some were done in the etching studio he had set up in his home in Washington Square, others were done in North Haven. At the end of the summer he wrote to Charles Woodbury, an old friend who taught summer art classes in Ogunquit (on the southern coast of Maine): "I shall hate to leave [North Haven] as I have a perfect printing shop with a bully press and a bench ten feet long so that all my paper is laid out conveniently and my heater and everything is always in its place. I can never have so good an outfit anywhere else, I am afraid. My studio is 40 feet square so [the etching] doesn't interfere with [my] painting work."[1] Of the eleven etchings done in 1913, at least four or five appear to have been made in Maine. *Smelt Fishermen* depicts seven boats busily engaged in that thriving North Haven industry. A somewhat static *Fishawk* could well have been one of George's pets. *Maine Fisherman* is not likely to have been done anywhere else.

Benson's early plates reveal the artist's wrestling with the difficulties of etching. Foul biting and over- or underexposure to acid baths mar these initial experiments, but his progress is clear. Most of the 1913 etchings were printed in editions of under ten, although several of the better ones number up to thirty-seven pulls. He continued his practice of giving away most of his prints to family and friends. Fellow artists Ignaz Gaugengigl, Bela Pratt, Charles Woodbury, Edmund Tarbell, and Gertrude Fiske all received presents of Benson's earliest etchings. His old friend Dwight Blaney was presented with Benson's second etching and would continue to receive one of almost every early print that Benson did.

In the autumn of 1913, the house on Washington Square was full of the hustle and bustle that attends a daughter's wedding. On 18 October Eleanor married Ralph Lawson in the big granite Unitarian church on Essex Street where her parents had been married twenty-five years before. They honeymooned at the house on Nauset Marsh in Eastham.[2] Benson's studio in Boston was probably a welcome haven from all the preparations and the endless stream of seamstresses and well-wishers. He was working prolifically in his newest medium—wash drawings—and when the Copley Society asked Benson to hang a one-man show of these new works, he eagerly agreed. The loss of his salary at the Museum School had left a large hole in the family budget; he hoped his new watercolors would meet with approval.

Benson's show at the Copley opened to extremely positive reviews. He had completed twenty black-and-white wash drawings with titles such as *Mallard Alighting* and *Coot in Surf*. The eye of the naturalist and the hunter is evident in these delicately

PLATE 93
Black Duck Rising, *1913. Ink wash, 11¾ × 9½". Private collection.*

147

wrought drawings. They were immediately accepted by the public, and museums and galleries began clamoring for exhibitions (plate 93).

In January 1914 the Milwaukee Art Society held an exhibition of Benson's "Drawings of Game Birds" that then traveled to Chicago, Detroit, and Cincinnati. The *Detroit Herald Tribune* described it as "a remarkable collection. . . . So life-like are the feathered subjects . . . that the enthusiastic huntsman on viewing them, might well be worked to a dangerous pitch of admiration."[3]

One cannot help but note a hint of an oriental influence in the spare composition and delicate brushwork of Benson's wash drawings. Indeed, when they were seen the previous year at The Ten's show in New York a critic noted, "His drawings of geese and ducks in the corridor are in the true Japanese spirit."[4] The influence of Far Eastern art on French painting (and hence to American art) can be traced to 1856, when the French artist Félix Bracquemond found a book of Japanese woodblock prints by the artist Katsushika Hokusai. To the French eye, the decorative qualities and linear approach of these Japanese prints were unique. The flattened forms and space, the high horizons, the sinuous line, the cropped elements, and the spare composition all offered a new perspective to the European-trained artists. By the time Benson arrived in France to study art, *japonisme* had become extremely fashionable in English and French literary and artistic circles and the collection of Japanese prints was *de rigueur*. European exposure to oriental art was assured by a lavish Japanese exhibition at the Paris Universal Expositions of 1867 and 1878. The year Benson arrived in Paris, Georges Petit Galleries held an exhibition of three thousand works of Japanese art that Benson undoubtedly attended.

The expatriate artist James McNeill Whistler became one of the first Americans to employ both decorative Japanese accessories and techniques in his works; in 1864 he painted his mistress, Jo, studying Japanese prints while dressed in a kimono. In 1887 Theo and Vincent van Gogh organized an exhibition of Japanese woodcuts at the café Le Tambourin and not only did van Gogh copy a Hiroshige woodcut but he also painted a portrait of Père Tanguy surrounded by Japanese prints. Many of the French Impressionists collected Japanese prints, and their influence can be seen in Pissarro's aquatints and Manet's images of cats, done in lithograph or woodcut and in his etchings.

Perhaps the best-known expression of the Japanese influence on a French artist is the set of prints in drypoint, aquatint, and soft-ground etching that Mary Cassatt created in 1891. Edgar Degas, whose own work had shown this influence as early as the 1860s, encouraged his close friend Cassatt to experiment with Japanese techniques. Following her attendance at the large show of Ukiyo-e woodcuts at the Ecole des Beaux-Arts in 1890, she began collecting the work of Utamaro, whose themes she almost literally copied.

Exhibitions of Japanese art were beginning to be seen in America as well, not only at the World's Columbian Exposition in Chicago but also at a Boston Museum of Fine Arts show, held in 1893. Soon several American artists, notably Weir and Twachtman, began experimenting with abstract compositions, high horizons, flattened forms and space, and strong diagonals.

Similar elements had been present in Benson's work for quite some time. In his early portraits (*Portrait in White*, 1889) and interiors (*Twilight*, 1891), Benson placed the subjects off center. In later works, such as *Sunlight* (1902), he cropped the figure and employed a very high horizon. In several of his plein-air works, from his earliest *The Sisters* (1899) to his portrait *My Daughter Elisabeth* (1915), Benson diagonally inserted delicate branches on the top edge of his composition.

It is not surprising that Far Eastern influences can be seen in Benson's work; he had lived with them all his life. As his sea captain ancestors plied the China trade, they filled their houses with oriental porcelains, brass, carpets, and fabrics. It was only natural that, when looking for an accessory, he would simply bring something to his studio from home. In *Twilight* (plate 27), one of the family's blue-and-white porcelain jars can be seen on the tabletop (the same jar is seen in the *Black Hat* of 1904). A similar jar is used in a still life of 1893, and others can be seen in *By Firelight* (plate 26; 1889) as well as in many ensuing portraits and interiors with figures. Benson often used oriental screens as

PLATE 94
Portrait of Elisabeth, *c. 1913. Oil on canvas, 29⅜ × 24¼". Private collection.*

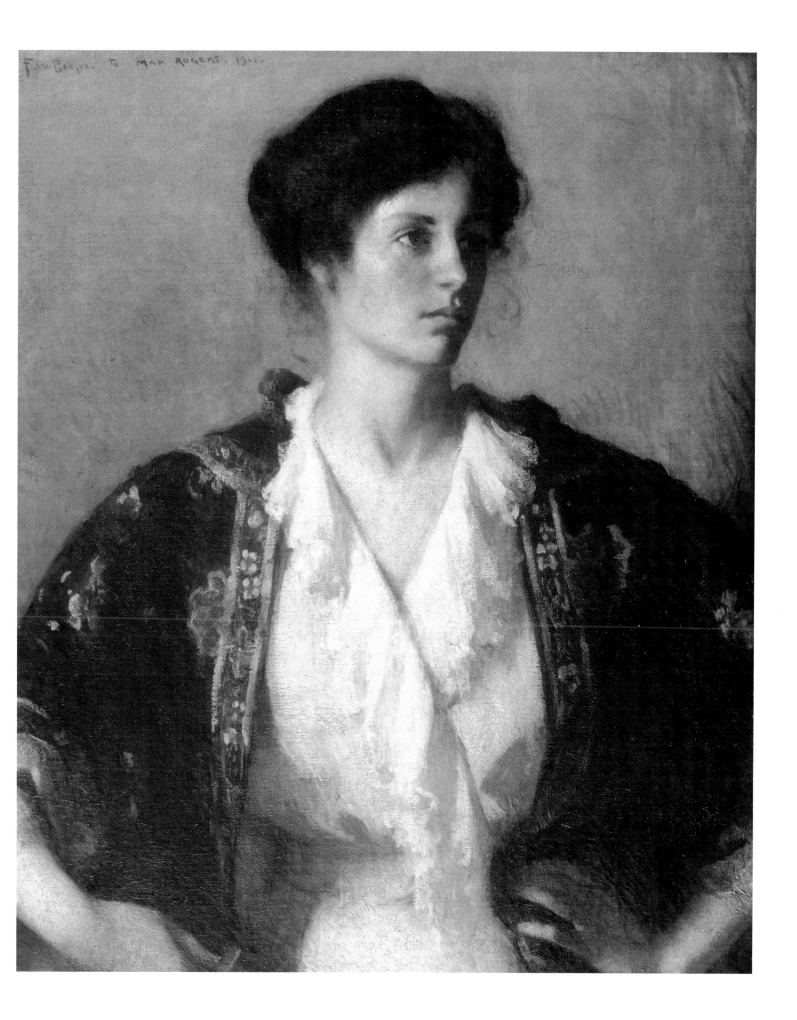

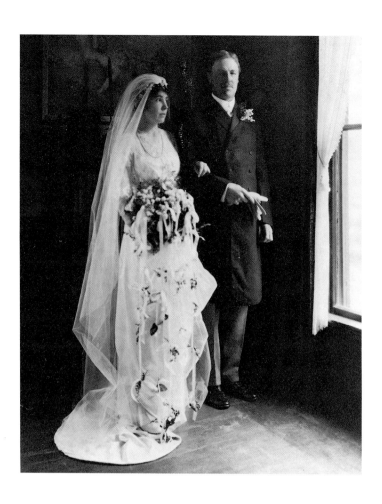

PLATE 95
*Frank W. Benson and Eleanor Benson
(Lawson) on her wedding day, 18 Octo-
ber 1913. On the wall hangs* Orpheus,
now unlocated.

a backdrop; in his later still lifes, these screens combine with other Far Eastern objets d'art to create some of his most striking compositions. He also made frequent use of the beautifully embroidered silk coats from the East that, in New England, were perennially in fashion as wraps; many of the hand-embroidered ones Benson used in his paintings are now fragile with age but still worn by family members. Their shimmering colors and rich designs figure in over half a dozen of his paintings over the next decade (see plates 88, 89, 94, 104, and 115.)

At the import house of Yamanaka on Boston's Boylston Street, Benson and many of his friends bought the accessories so important to their paintings of interiors. In a letter to Benson, the manager of Yamanaka's, R. S. Hisada, discussed several ginger jars which he had set aside for Benson; he then closed with his impressions of Benson's latest exhibition, which featured several wash drawings. "None of your paintings impressed me as much as your black and white watercolors," he wrote. Continuing in his charming English, he added, "They are for growned peoples. Appreciation and oil paintings in colors are for children. I did but admire your ducks."[5]

The response to his wash drawings was extremely positive. Writing modestly to James Gest that "they seem to interest people a good deal here," Benson asked if Gest would accept some for the spring show in Cincinnati.[6] Whenever he could, Benson began to send his wash drawings, along with his usual oils, to the major annual shows. In addition, this new medium opened membership into numerous watercolor societies in whose shows Benson began to exhibit.

However, Benson did not slow down his output of oils. His recently completed portrait of his daughter Elisabeth impressed the Boston art critics when it was hung at the Copley Society shortly before Eleanor's wedding (plate 95). F. W. Coburn, a Boston art critic, wrote, "A new picture by Frank W. Benson is always an event . . . " but he grumbled that all of Benson's best works seemed to leave town. In an article entitled "WILL BENSON'S NEWEST PAINTING LEAVE BOSTON?" he declared that Boston had really lost a wonderful opportunity "to show succeeding generations of art students how decoratively handsome a portrait may be made" when it allowed his award-winning portrait *Sylvia* to be bought by the Corcoran Gallery the previous year. Taking a swipe at the acquisitions committee at the Museum of Fine Arts, he stated that Benson's brilliant

150

new *Portrait of Elisabeth* would probably end up in "one of the live, progressive museums" elsewhere in America (plate 94).[7]

Putting down his brush and taking up his gun to join the men of the clan for their annual post-Christmas shoot at Eastham, Benson was inspired to do a marine of one of his comrades rowing a boatload of decoys out into deep water. Combining his observations and sketches from his trip with recollections from his youth of hunting coot near Salem Harbor, Benson returned to his studio and completed an oil, *The Coot Shooter*, in time to hang it in the Copley Gallery in the first week of January 1914. The stark contrast of the man and boat silhouetted against the lighter sky over a lonely section of sea off Blackledge Rock outside Salem Harbor intensifies the stormy quality of this painting. Benson's years of observing birds stand him in good stead, though simply expressed, these wildfowl could only be coot.

Calling the painting a "South Shore Epic," F. W. Coburn wrote in the *Boston Herald*, "On a sloppy and choppy day under a broken . . . sky, a hunter rides his dory with a stern full of decoys up towards a gaunt ocean reef. . . . Above and beyond a few coots are hurtling through the air. The huntsman, his oars poised in the air, is presumably [trying to decide] whether or not it is time to let loose the decoys."[8]

This dramatic work is among Benson's first known excursions into sporting scenes in oil. Until this time, he had rarely painted men other than in portraits. As his interest grew in depicting the outdoors, hunters and fishermen began to appear more frequently in Benson's major oils. This painting was so successful that Benson painted another version in 1915. Known as *Hunter in a Boat*, the new work is virtually identical to the first painting except that the canvas is wider and a lighter palette is used (plate 96).

This was yet another direction for Benson. As his interest in etchings and wash drawings began to take up more of his time, and his oils of sporting scenes proved to be as commercially successful as his previous works, his old motifs began to disappear. Gradually, his canvases of lovely ladies in white on windblown hills followed into the past the portraits of girls in velvet dresses illuminated by firelight. The numbers of plein-air paintings of his daughters dwindled to a trickle as his much-beloved models grew up, married, and left home and as his newly created hunting scenes found a ready and eager market. Benson's last known outdoor painting of one of his daughters was *The Watcher*, a painting of Sylvia, dressed in a flapper sweater and skirt, gazing out over the sea; it was completed in 1921.

With the demands of teaching gone and his children growing up, Benson had more time to hunt and fish, and his art began to reflect these pursuits. One wonders if men he painted in the outdoors were friends and family or were they representations of himself, vicariously enjoying on canvas what he so loved in real life? The identity of some of his subjects for these paintings is known but the remainder may well be the artist himself.

Publicly, Benson and his fellow Boston artists were enjoying critical success, but there was a lingering suspicion that they formed a strong clique that prevented other artists from winning prizes. By 1913 various factions in the art world appeared to be working to shut these successful men out of the hierarchy of the established shows. In late January 1914, Boston papers rumbled with indignant stories of Bostonians being slighted by various exhibitions. Together, the city's artists had submitted nearly two hundred and fifty canvases to the jury of the prestigious Pennsylvania Academy of the Fine Arts for its annual exhibition. Only twenty-three had been chosen. The feeling that there was discrimination involved intensified during the next few weeks when only a few Boston artists were invited to show at the National Academy and the Philadelphia Academy of Design. Accusations were hurled and emotions ran high. "The cry of machine politics has been raised," stated one paper. "It is asserted that certain of the accepted paintings are by artists who have no merit as artists but are known to be buyers."[9] The final blow came in early February 1914 with the opening of the Boston Art Club show. The exhibition did not include the work of any Boston artists.

On 3 February, Boston headlines announced, "BOSTON ARTISTS REBEL AGAINST 'RING' METHODS . . . NEW GUILD WILL CONDUCT OWN SALES." The accompanying story noted that several prominent local artists had banded together and formed the Guild of

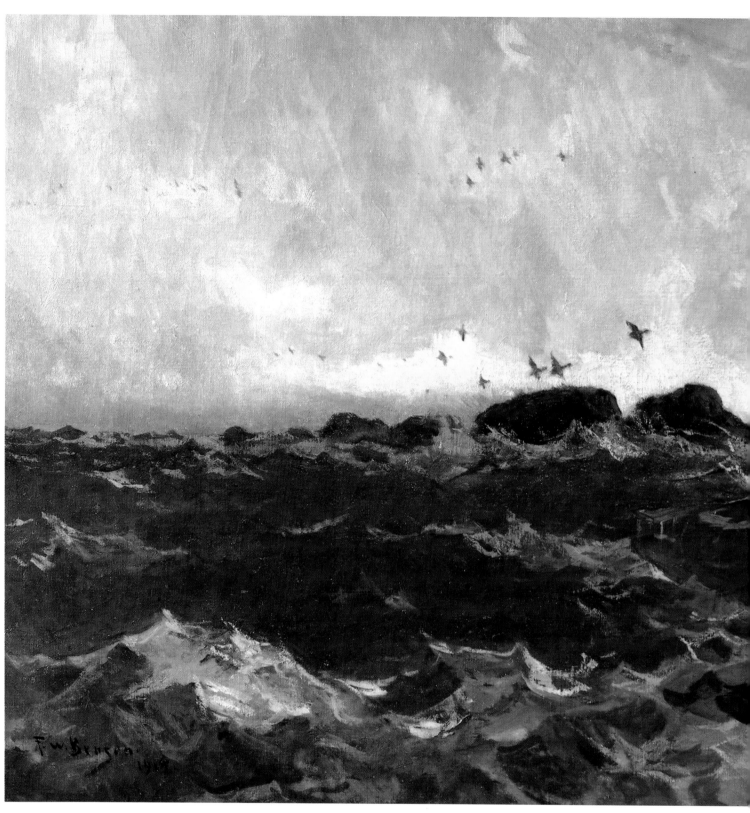

PLATE 96
Hunter in a Boat, *1915. Oil on can-*
vas, 33¼ × 66½". Private collection.

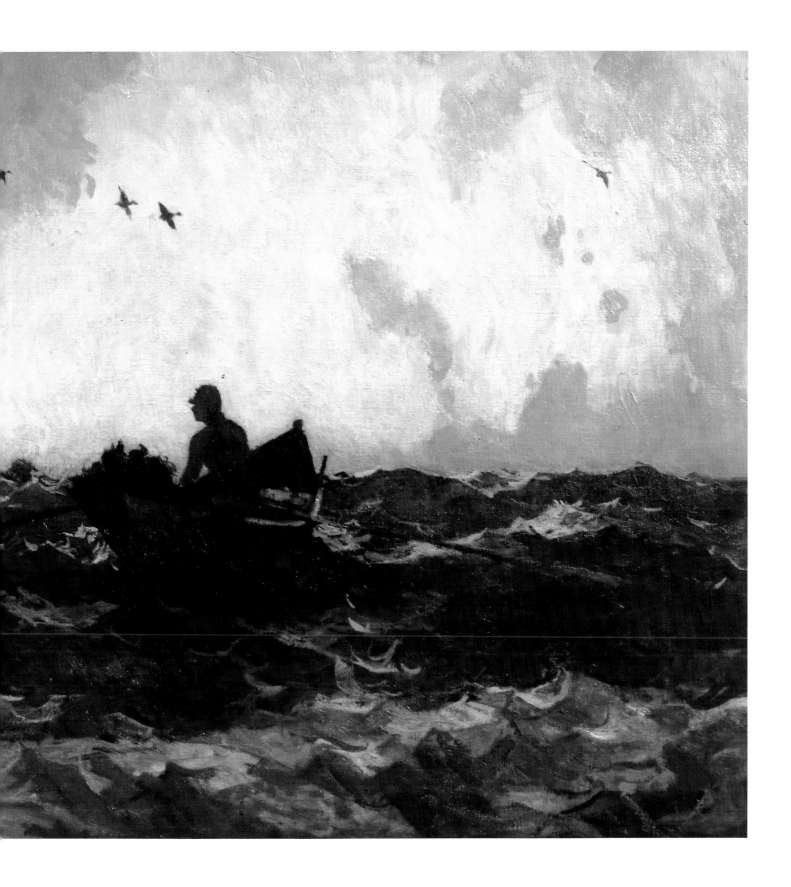

Boston Artists for the purpose of putting on their own exhibitions and sales independent of the establishment. In a move reminiscent of The Ten's break from the entrenched traditions of the New York art world, the Boston artists quickly found themselves labeled secessionists. However, whereas the formation of The Ten had engendered anger and hostility in both the press and the art world, the creation of the guild seems to have met with resounding approval.

Many of Boston's best-known artists and sculptors joined the guild. In addition to Benson, the six others who founded the guild and whose names are on its charter were his close friends: Tarbell, Woodbury, and Pratt, as well as Ignaz Gaugengigl, a fellow Tavern Club member, William Churchill, and Lilla Cabot Perry. Perry, who had been a close friend of Monet's, was a well-known figure in both the artistic and social circles of Boston. She used her considerable influence to convince many of her friends to become associate members of the guild, whose privileges included previews of openings, visits to artists' studios, and occasional gifts of prints of the various artists' works. Over the years, Benson contributed several wash drawings to the guild to be reproduced and given to members and associates.

Under the headline "BRILLIANT EXHIBITION OPENED," a Boston critic wrote of the guild's inaugural show the following fall. Benson submitted a study for another *Elisabeth* as well as *Girl with a Dog*. This pensive portrait of Sylvia shows her, chin in hand, gazing down a hill while Togo lies beside her, veteran of countless North Haven paintings. Benson reused the figure of Sylvia in a larger work, *On Lookout Hill*, which was exhibited a few months later. Benson also hung *The Foxhunter* (see page 8). Calling the latter a "strikingly original canvas," the critic added, "The atmosphere and the light is diffused through a thin veil of grey clouds."[10] *The Foxhunter* has a very different mood from Benson's previous works. Following the success of his *Coot Shooter*, Benson ventured further into the area of men engaged in hunting. This new work, to quote one reviewer, was "a big work: with the sturdy figure of a gunner poised on a rock in a bleak pasture. The hints of winter are in the grey air and the stirring design is worked out in a vibrant grey sky and an irregular ellipse of narrow yellow haze where the sunset glow blends the edges of cloud."[11] The hunter is Benson's son George, and the dog sniffing about in the foreground is Togo. To the gallery-goer accustomed to Benson's vibrant, Impressionistic palette, the *The Foxhunter* was a startling departure.

For Benson, the guild's new quarters on Newbury Street quickly became one of his best showcases. The main picture gallery was at the rear of the ground floor and was flooded with natural light from a large skylight. Adjoining it was a long exhibition hall where each of the forty-three active members could display pictures on the walls. Now, instead of hanging his most recent paintings at the Copley Society, Benson hung them on the walls of the guild. Over the next thirty years, its main gallery would be devoted to many one-man shows of his works. Here also began what was to be the most financially successful period of Benson's career.

His finely drawn watercolors were being eagerly snapped up by collectors all over America. In addition to the one-man shows they had been given in Milwaukee, Detroit, and Chicago, his drawings (as these watercolors were most frequently called) were featured at the annual exhibition at the Cincinnati Museum of Art. Responding to the encouragement of the director, James Gest, Benson sent eighteen wash drawings as well as his oil *The Coot Shooter* to the museum's annual show. The majority of Benson's contributions to a two-man show of paintings (with George L. Noyes) at the Worcester Museum of Art in March 1914 were wash drawings as well.

Wash drawing and continuing experiments with etching filled Benson's summer of 1914. He began only two oils, *On Lookout Hill* (and its related works) and *Afternoon*, a study of Benson's two youngest daughters and their cousin. Never exhibited and now unlocated, the painting was copied in an etching that Benson did in 1915 (plate 97).

Following his return to Boston, Benson spent the next few months assembling the paintings that would make up his first one-man show at the Guild of Boston Artists. The show was a perfect reflection of Benson's work of the period, for it was a mixture of the old familiar paintings in oil—portraits, some figure studies, and plein-air—combined

with nine of his new wash drawings and twenty etchings, which he reluctantly included at the urging of friends. William Howe Downes called it "the best exhibition that Benson has ever made and that is 'going some.'" Of the new summer painting, *On Lookout Hill,* Downes wrote, "[It] will rank among his best works. The sky is superb in its luminosity, its depth, its delicacy." This painting shows Elisabeth, standing, her navy blue dress swirling about her, while Sylvia sits to her left, her hand on her dog's head, and Eleanor reclines on her right, shaded by a parasol and reading a book.

On Lookout Hill is an example of one of Benson's major paintings that is a composite of two separate works and also the inspiration for two others (plate 99). The fact that Eleanor was not present in North Haven the summer that *On Lookout Hill* was begun, combined with hints contained in family correspondence and the very different treatment that her figure is afforded in the larger work, makes it likely that her reclining figure was painted during a previous summer and added to *On Lookout Hill* to give the larger painting balance. But it does not work well, for Eleanor's figure is too dissimilar to those of her sisters; its dreamy, Impressionist quality is in sharp contrast to the crisp treatment of the two other figures. Writing of Eleanor beneath her parasol, Downes even remarked on the disparity: "This reminds us to remark that Benson's landscapes with figures are, in their spirit, something like Watteau's," he observed, "though we doubt if he has ever had Watteau in his mind when painting them." The rest of the figures in *On Lookout Hill* are contained in a small but quite finished study that Benson first painted in oil on paper. It would appear that Benson then pulled these two compositions together to create *On Lookout Hill.* Once the larger work was finished, Benson drew out Sylvia and Togo to create *Girl with a Dog* (now unlocated), the first of the four related paintings to be seen when it was exhibited at the inaugural show of the Guild of Boston Artists. Although not finished until 1921, the painting of Eleanor, reading her book, eventually became *The Hillside,* in which Benson added a small forest and billowing clouds. Elisabeth, by herself on the top of the hill, became *The Hilltop* (plate 98).

Although Downes admired *On Lookout Hill* and Benson's other "big, glorious outdoor" paintings of "graceful summer girls with their crisp white frocks, their golden hair blowing in the breeze" and thought Benson's treatment of interiors with figures to be "entirely original and novel," it was the "stunning series of new and beautiful painter-etchings" that he felt were "a fresh revelation of creative individual art work of distinctive importance."

In what is undoubtedly the first published critique of Benson's etchings, Downes noted that Benson was devoting his evenings to etching and did all his own printing. "He is an original and remarkable etcher. . . . To say the etchings are as good in their way as the paintings is the highest praise possible. . . . The very ecstasy of flight is expressed in the swift gliding of these birds in the air. It is as natural as breathing; and to see them flying is to feel that you, too, could fly."[12] Those remarks were to be echoed time and again in the dozens of articles about Benson's etchings. Books were written and magazines devoted entire issues to his work. For a time, a month did not pass without an article about his prints appearing in a newspaper or magazine. With this success, Benson was joining a small group of other American artists who had shifted media in mid-career with great success. After 1900, John Singer Sargent moved to watercolors, which were as well received as his oils had been. John LaFarge, who had been acclaimed as an oil and watercolor painter, made an name for himself as a stained-glass artist in later life. Degas's sculptures are every bit as engaging as his paintings. But that Benson should achieve success in all four of his media—oil, wash, etching, and finally watercolor—is remarkable.

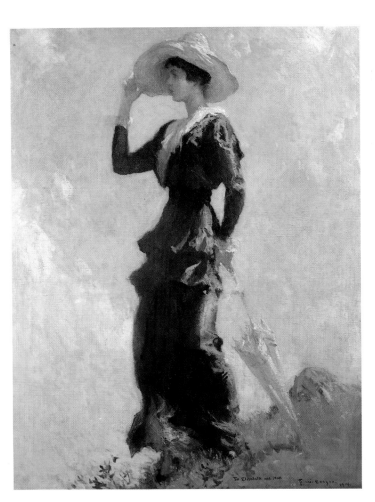

PLATE 98
The Hilltop, *1914. Oil on canvas, 40 ×
32". Private collection. This painting of
Elisabeth was exhibited extensively un-
til 1924, when it was finally inscribed
"To Elisabeth and Max" (her husband)
and given to them as a wedding present.*

PLATE 99
On Lookout Hill, *1914. Oil on can-
vas, 50 × 65". Collection of The Detroit
Athletic Club.*

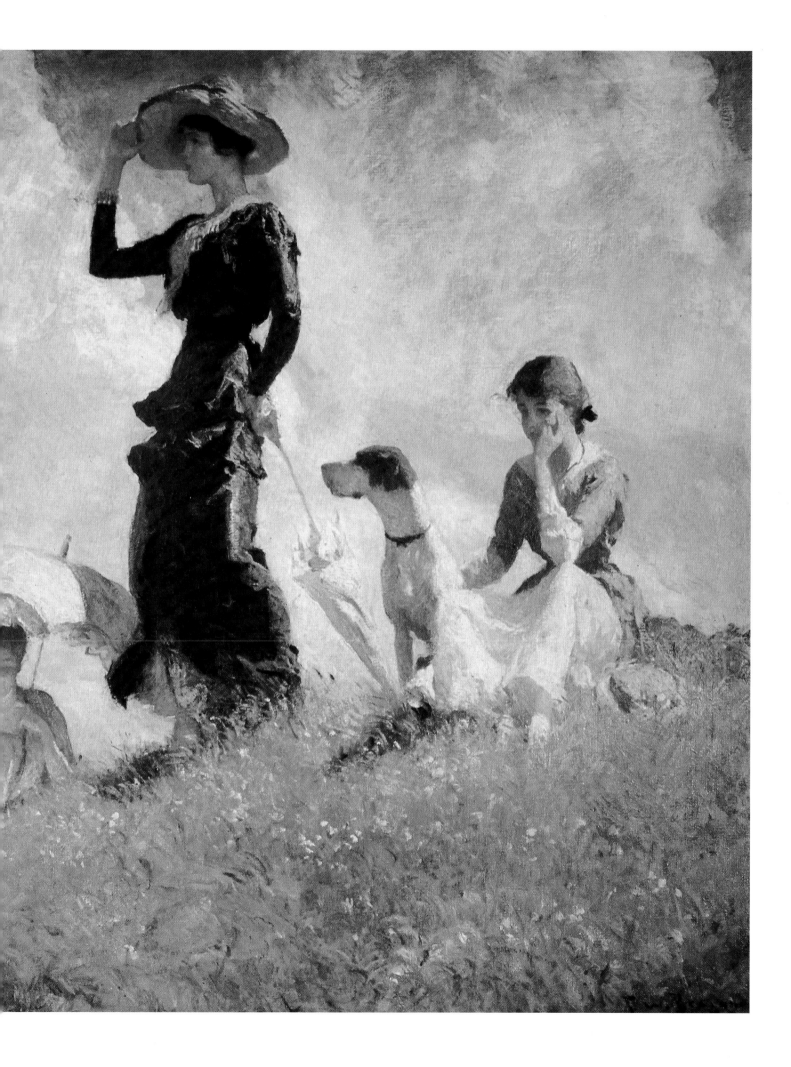

Benson continued with etching in 1914 but still considered his experiments elementary and not worthy of exhibition. The selection he reluctantly hung at the guild show was merely titled "A Group of Etchings." The response was immediate; the opening was only a few hours old when the etchings began to sell. Before the end of the first week, the guild's manager, George Sloan, telephoned Benson for more. The astonished artist brought in several more etchings and additional prints of the ones that had sold out. At the close of the show, not a print was left.

The demand for etchings had Benson working at his press almost constantly. In the next year he was extremely prolific, completing fifty-two etchings in editions that sold out almost before the pressing was complete. Working alone, without the aid of a "dry hand" assistant, Benson was etching and printing more than one etching a week. As the demand for Benson's prints grew, he asked George Gage of Cleveland to be his agent. The following summer Gage wrote, "I do not deserve any credit for selling your prints as they sell themselves. . . . I do not know of anyone today in the etchings field who is doing as good work as you are. I mean absolutely what I say when I tell you that."[13]

While in New York for the opening of The Ten's 1915 exhibition, Benson stopped by the gallery of Robert Macbeth, who had been handling his work since about 1912 and had had great success in selling his wash drawings. Although Macbeth's was the first gallery to represent Benson in New York, it was soon joined by the Milch Gallery. George Gage appointed the Kennedy Gallery (which he told Benson was "[one of] the three leading print houses in the world") Benson's agent for etchings in New York.[14]

Unable to keep up with the demand for his wash drawings, Benson consented to the reproduction of seven of his black-and-white watercolors by the Elson Art Publishing Company. Although these look very much like photolithographic prints, a catalogue from the Kennedy Gallery (which sold them at the first showing of his etchings in New York City in December 1915) describes them as intaglio engravings. Each reproduction was numbered from an edition of one hundred, but not signed. It must have pleased Benson to know that his paintings, thus reproduced, were now within the reach of the average American. He saved in his scrapbook a thank-you letter from a young mother in Ohio who had always yearned for one of his wash drawings but considered them quite unattainable. Her delight at being able to afford an intaglio engraving and thus introduce her children to excellent art obviously touched him. His desire to share his art with others was the motivation for his donation of a large, decorative panel for the Tavern Club. When the painting hung at the Copley Society, the art critic for the *Boston Transcript* wrote, "these clouds take on the beautifully tinted lights of a golden hue from the sun."[15]

After the close of The Ten's 1915 show in New York, Benson's three paintings (*The Sunlit Room, Red and Gold,* and *On Lookout Hill*) were sent to the annual show at the Detroit Museum of Art, where *On Lookout Hill* was bought by the newly organized Detroit Athletic Club. In an article in the club's newsbook, which featured Benson's painting on the cover, a critic said, "The luminous summer world of this painting . . . is a fine example of Benson's American translation of French Impressionism. . . . The easy unsophisticated poses of the three girls standing and sitting on their hilltop follows the Impressionist emphasis on the most natural treatment of informal subject. Even the presence of the unaristocratic dog complements this glimpse of a relaxed moment."[16] This painting was Benson's last plein-air work of his daughters. Never again did he gather a group of young women to pose beneath an immense expanse of August sky.

Although Benson's outdoor works were but a brief coda in a career that spanned more than sixty years (fewer than twenty of which were spent doing Impressionist painting), their theme was a refrain seen over and over in his art. They are about light. He once said, "I simply follow the light, where it comes from, where it goes."[17] This fascination with light or the absence of it is the one constant that binds together all of Benson's periods and media.

The success of Benson's etchings both astonished and pleased him. At the age of fifty, he had taken up etching more as a form of relaxation than for any expectations of profit. After the favorable response to his etchings at the guild show, Benson, ever the businessman, quickly realized the ramification of their popularity and began to promote

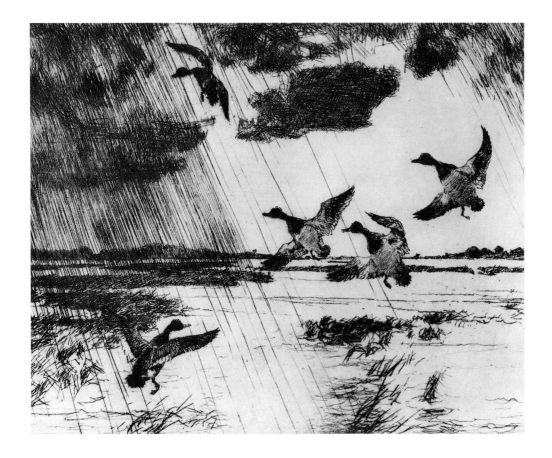

PLATE 100
Rain Squall, *1931, Etching on paper,*
6⅞ × 8¾". Paff no. 317, ed. 150.
Private collection.

them. He wrote to James Gest, "I have been making etchings for three years but have not shown them until this Spring and they have proved quite successful in pleasing people in Boston and Cleveland, the only places I have shown them. I have sold over a hundred in these two places and I want to send them about to other places."[18] Before 1915 ended, Benson was given seven one-man shows of his etched work, and he submitted etchings to several annual exhibitions. In order to keep up with the demand, Benson completed an etching a week in the year following his first print show of them at the guild.[19] Although Boston gallery-goers were treated to the first glimpse of Benson's etchings at the guild show, it was at the Copley Society in December 1915 that the full range of Benson's skill with the etcher's needle was actually seen. William Howe Downes, reviewing this first comprehensive exhibition of etchings, noted that Benson was a "natural etcher and takes to it as [naturally] as a duck takes to water. It is as if he was using a language made familiar to him by a lifetime of employment."[20]

Benson used the etcher's needle to translate the observations of nearly five decades of hunting and fishing into exquisitely rendered portraits of wildfowl. His birds were never static creatures; rather, their motion was vital and crisp. The movement of feathers is well conveyed as a flock of ducks descends to a marsh, wings slapping at the moment of touchdown. Reeds and rushes appear to bend and sway as ducks silently glide through them; the heavy beating of wings as a goose surges upward is forceful. Benson could capture accurately the startled explosion of a flock of blackbirds or the solid stance of a pelican on a dock.

By placing his subjects in their native habitat, Benson tried to integrate them into the landscape rather than to describe them as specimens. Whether this landscape was his own Nauset Marsh, the streams of Canada's Gaspé Peninsula, the waters of the Chesapeake Bay, or the dawn-lit skies over Lake Erie, the perfect harmony between setting and subject is not merely observed but felt. His careful handling of values, ranging from pale gray to velvet black, creates the mood and atmosphere of a cool New England dusk, a sultry noonday in Florida, or a rain squall over a marsh (plate 100). One particularly sparkling print of gunners standing out in sharp relief against a dramatic sky caused a critic to write to Benson, "I see you are etching in color now."[21]

159

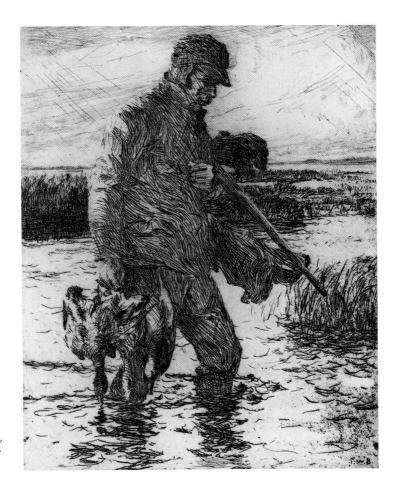

PLATE 101
The Gunner, *1915. Etching on paper,
9⅞ × 7⅞". Paff no. 52, ed. 50. Private
collection.*

The majority of Benson's 355 etchings depict wildfowl (including twenty-two dif-
ferent species of duck and over two dozen different birds). He portrayed them in practi-
cally every aspect of their lives. They fly, swim, eat, and drink and are even shown as
part of the hunter's kill. As one critic wrote, "He is without a rival as no other artist has
approached him in his ability to accurately reproduce the rapidity of motion of these fly-
ing creatures . . . the marvelous illusion of actual birds beating against the sky, over-
coming the effects of gravitation, soaring the ethereal blue."[22] But Benson found etching
subjects everywhere; he did landscapes and portraits, hunting and fishing scenes. Ben-
son's very first etching had been inspired by boating in 1882. In search of new motifs, he
again turned to the boats that were so much a part of his life. Canoes, punts, and even
brick barges appear in Benson's etchings. However, it is the graceful sailboats that seem
to have held the strongest appeal for him (see *Bound Home,* plate 146).

In choosing to pursue such a physically demanding art form, Benson demonstrated
his love of a challenge. As he later told his daughter Eleanor, "The only fun in life is try-
ing hard to accomplish something you can't quite accomplish."[23] He spoke often of the
endless hours needed for mastery of this skill and the opportunities for frustration in-
herent in a medium that demands complete concentration and long periods of trial and
error before achieving a successful result. However, as a diversion from the demands of
teaching and painting, etching made an ideal medium for Benson.

One of the challenges of printmaking is the complexity of the techniques them-
selves, which can often produce an unexpected result. While dictating an essay on etch-
ing to his daughters, he noted, "One of the greatest difficulties to the beginner is the fact
that after the plate has been partly etched it practically disappears as a picture. The etch-
er is working with faith in his intention which was first shown on the plate but which
has disappeared, in patches, if not completely. . . . etching, if followed seriously, leads to
many experiments. . . . A line made is practically irrevocable."[24] Even after his etchings
had reaped critical acclaim and were selling briskly, he continued to delight in dialog
with fellow etchers. His correspondence with Charles Woodbury reveals an exchange of

160

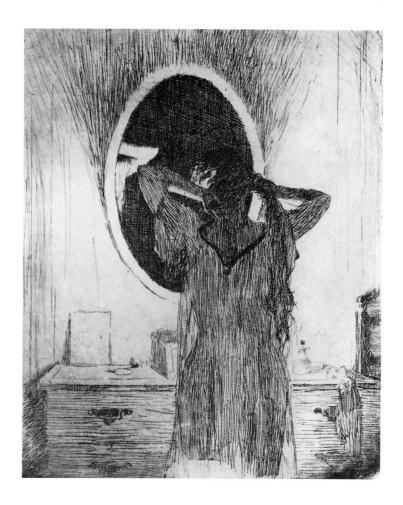

PLATE 102
Candlelight, *1915. Etching on paper,
9⅞ × 7⅞". Paff no. 62, ed. 50. Private
collection.*

prints, shared admiration for each other's work, and Benson's frustration with the new technique. Writing to Woodbury from North Haven he observed, "I was tremendously pleased to have your prints and to see the etched lines of another. Mine are getting stupid to me and I spent all last evening going over yours with great pleasure. . . . I shall enjoy having them around me while I am doing my own and I will send you some as soon as I can, though I have only made a paltry twelve and some of those disappointing. I've made one drypoint that I think my best, however, and I have certainly learned a lot, but it's fascinating work." Complimenting Woodbury on his prints, Benson noted "This summer's work will be a great thing for you and you have done it in the right way, I think. I like the prints, they show the most contrast in their values—after all, if you cover the whole plate with lines, there has got to be contrast—and some of the most slightly done are among the best."[25] Benson obviously heeded his own words, for some of his most striking works, are spare compositions. A soaring hawk cut off by the upper corner of the plate, or three geese in an asymmetrical, off-center composition show a definite Japanese influence.

Several of the etchings made during this first summer of serious print work were shown for the first time in New York City in December 1915. Long accustomed to the beautiful oils Benson had displayed there over the years, the Manhattan art community and the critics responded as enthusiastically as the Bostonians to his exhibition at the Kennedy Gallery. Writing in the *New York World,* Frederick Eddy declared, "The spirit of these etchings will commend them to those who know the haunts of wildfowl and who have seen the joyous abandon with which they disport themselves when free from the hostile approach of man."[26]

While this sportsman-artist reveled in his ability to capture his observations of happy days on lake or marsh with the etcher's plate, he did not totally discard his love of the human figure. Many of his plates depict his friends as they hunted or fished, fetched their quarry, or merely waited patiently for the moment of action (see plate 148). *The Gunner* represents the bone-tired weariness of a man at the end of a long day of hunting

(plate 101). With his quarry dangling from one hand, his gun resting over his arm, the exhausted hunter trudges slowly through the icy waters, his collar turned up against the chill wind.

Long thought to be a self-portrait, this etching in fact probably depicts Tom Nickerson, the caretaker of Benson's house at Eastham. The confusion over the subject's identity arose from the book *Modern Masters of Etching: Frank W. Benson* written in 1925 by the British art critic Malcolm Salaman. Benson sent a copy to Dan Henderson as a birthday present. Annoyed by Salaman's assumption that *The Gunner* was a self-portrait, he wrote to Dan that "the writer of the text let his imagination run a little free, for example, when he says that this or that one is a portrait of the artist."[27] His etched portraits reveal a mastery comparable to that of the premier portraitist of the time, Swedish etcher Anders Zorn. Like Benson, Zorn brought a painter's vision to the copper plate. Zorn's works were known for their fresh pictorial vitality; their closely laid parallel lines carried well the illusion of form. Although some critics felt that Benson's figure studies were not as strong as his wildfowl works, several portraits were singled out for commendation. One of the best was of his wife, Ellie, as she prepared to retire for the night (plate 102). Ellie is shown, arms upraised, standing before an oval mirror, plaiting her hair. The candle she has placed before her on the bureau gives off a soft glow. Candlelight is difficult enough to capture with color and a brush. That Benson's etched line can so well convey this delicate illumination is remarkable.

From very small (2 × 2") to large (almost 10 × 15"), Benson's etchings were bought in ever-increasing numbers all over the country. From The Print Room gallery in Hollywood, California, to Benson's own Guild of Boston Artists, the demand for his prints never slackened. Even in the years following the Depression, when many of Benson's patrons were forced to sell their major oils, requests for his etchings continued. On the eve of a celebration honoring Benson's twenty-five years as an etcher, the critic for the *Boston Globe,* Arthur Philpott, conservatively estimated that Benson had sold more than one million dollars' worth of etchings since he resumed his interest in the medium. However, the demand for his work and his inability to meet everyone's needs exhausted and distressed him. Writing to Albert Milch, a New York gallery owner, he commented: "We are not exactly happy over the etching question ourselves. A sudden

increase in the demand last year used up our stock in a month. This year they have been mostly sold in a week, apparently. Out of an edition of 150, we keep 25 to sell at advance prices when the first 125 are sold. Every agent but one or two has already wired or written for more prints and they are all issued except about 5 sets which I can sell ten times over. I am trying to take care of old customers, but the thing is beyond me."[28] The "we" in this letter refers to Benson and his daughter Sylvia, who was now helping her father with the business end of his career. As the demand for Benson's art grew beyond his ability to both create it and market it, she became invaluable. Benson's efforts in etching were appreciated abroad as well. In March 1917 he was invited to hang a show of his etchings at the British Museum; at the close of the show he donated twenty-five to the museum. From that point on, George Gage was kept busy bundling up packages for overseas shipment. Malcolm Salamans's book on Benson's etchings had introduced him to a wider British public, and the popular British periodical, *Country Life,* devoted several issues to his work. Benson's international exposure was heightened both by the inclusion of his prints in an exhibition at the Bibliothèque Nationale in Paris and the shipment of several etchings to Japan by his friend at Yamanaka's export firm, R. S. Hisada. As Benson's daughter-in-law recalled, Hisada's Japanese friends felt that Benson "truly made the birds fly."[29]

Etching is an exacting science, and Benson was a perfectionist. As his friend Samuel Chamberlain, himself an etcher and fellow Salem resident, recalled after twenty years of etching, Benson "still spends a good deal of time working on [etchings], pursuing the elusive perfection which many critics think is already his own."[30] In Benson's opinion, fully eighty-six of his etchings were worthless; from those he pulled less than ten prints and never offered them for sale. Even during the late 1920s, at his technical zenith as an etcher, he often pulled only five prints from a plate. Although many of these etchings appear to be excellent works, to Benson's highly trained eye there was something obviously wrong with each. The same man who could scrape a day's work in oil off his canvas could just as easily slash a large X in the soft copper of an offending plate.

In 1926 Harvard University made a film for the Museum of Fine Arts of Benson at work on an etching, providing a unique opportunity to see Benson creating an etching.[31] Filmed in the workroom of Benson's house on Chestnut Street, the movie catches the air of calm purpose with which Benson plied his craft. The film was an immediate success, and word of mouth swelled the crowds far beyond the various sponsoring museums' expectations. In St. Louis, the planned showings had to be expanded from two to six to accommodate all the people who wanted to see it. It became necessary to accept reservations and sell advance tickets for the first time in the twenty-year history of the museum's lecture series.

Many of Benson's drypoints and etchings were completed from memory. There does exist, however, a scrapbook (now in the Essex Institute) that Benson had filled with magazine clippings of wetland scenes, hunting photographs, and drawings of birds in the air or on the water. These pictures probably were saved to be used as inspiration for etchings, and several have been reworked by Benson. In one, he penciled in two additional curlew (plate 103); in another he added a clump of trees and extended the river into the marsh. Each addition or change markedly improves the design and composition of the picture. These illustrations seem to be points of departure or memory aids in the creation of the many designs Benson used for his work. Despite the inspiration that Benson sometimes found in photographs, his etchings never mimic photography. The delicate lines, the play of light, the "color" values, the use of empty space, and the graceful depiction of his subjects all are more "painterly" than one would expect an etching to be. The term "painter-etcher" was an oft-used and apt description of Benson.

At the beginning of his renewed interest in etching, Benson wrote to Woodbury, "I don't suppose it would be any fun if you could do it every time. . . . I must say, it grows more fascinating every time."[33] Benson's continued fascination with the etching process lasted well into his eighties, when failing eyesight made the delicate and demanding work impossible for him.

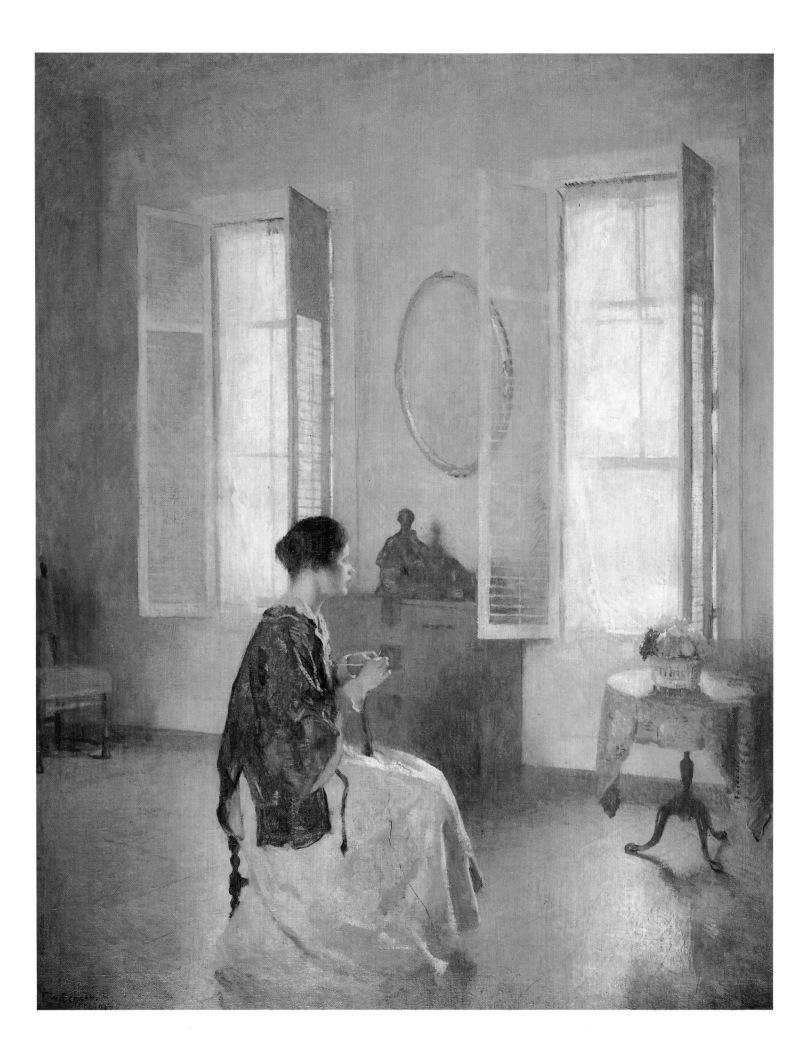

ENDINGS AND BEGINNINGS

W ith the war in Europe gathering momentum, Benson wrote to his early mentor Abbott Thayer of his hope that Thayer's theories of using natural coloration for camouflage would help France and her allies; "I never realized how I loved France 'till this war," he wrote on the eve of Thayer's departure for Europe. "She is too great to go under."[1] Benson's own contribution to the war effort included designing posters to promote the sale of war bonds and donating paintings to various relief funds. In addition, he painted landscape backdrops for target designation lectures at nearby Fort Devens. These large panoramic canvases represented various countryside scenes not always found in the areas surrounding the training camps. Of such canvases, one newspaper noted, "The most conspicuous record of achievement has been reached by Frank Benson. Although his time has been much taken up by many commissions for war portraits, he has already contributed 11 canvases. . . . His familiarity with the rifle makes him peculiarly well qualified for this kind of work."[2] Benson did indeed receive many commissions from families of soldiers bound for Europe. Several of his war portraits (he is known to have completed at least ten) were painted posthumously and given in memorial to the subject's alma mater by fond classmates. Typical of the many war portraits Benson completed was one of Norman Prince, Jr., the man considered to have been the founder of the famed French flying squadron, the Escadrille (plate 105).[3]

The realities of war seemed to recede as the Bensons boarded the steamship in Boston for their voyage to North Haven. That summer Eleanor brought her son, Frank Benny, to spend several weeks on North Haven. It must have been a relief, after months of painting young men in uniforms, to paint this chubby one-year-old and his mother on the garden bench. Caught in uncharacteristic stillness by his grandfather's brush, Frank Benny smiles with delight at his mother (plate 108). The following year, Benson copied this picture in a larger format and sold it almost immediately after its exhibition at the Corcoran Gallery in 1916. Benson delighted in his growing brood of grandchildren (which eventually numbered eleven) and always seemed to have time for them in his busy schedule (plate 106). Two years later, Benson painted Eleanor's second son, Ralph, Jr., as he toddled down the slope toward his Aunt Elisabeth. In *Boy in Blue,* Elisabeth is dressed in a long white dress, her shoulders wrapped in a shawl. A shade hat lies on the grass beside her as she encouragingly holds out a hand to little Ralph. Last exhibited at the Cincinnati Art Museum in the spring of 1921, the location of this larger work is not known. It may be that the present *Boy in Blue,* or one of the two other existing versions, was cut from the larger work and the figure of Elisabeth discarded or sold (plate 107).

Benson wrote to Woodbury that summer to say he had started another painting of his second daughter, which is probably *My Daughter Elisabeth* (see page 6). This new painting was more a portrait than his other plein-air canvases. Rather than the bright glare of an August noon, the lighting is subdued and diffused. Elisabeth is dressed in the mode of the day: her summer-browned face is shaded by a white hat and she is

PLATE 104
An Open Window, *1917. Oil on canvas, 52¼ × 42¼". Corcoran Gallery of Art, Washington, D.C. Between the windows, on a small chest, rests the statue of Artemis that Bela Pratt gave Benson in 1909.*

165

warmed from the cool island breezes by a plum-colored sweater coat worn over a simple white dress. Benson was particularly fond of this painting; when he sold it to the Detroit Institute of Art, he wrote, "I feel that I shall be represented in your collection by one of my best."[4] Completing what he considered to be a "paltry" twelve etchings that summer in North Haven, Benson wrote to Woodbury that he looked forward to "spoiling a lot of copper" at the new studio in Boston that he and several of his friends had built and named Riverway: "I hear that our studios are nearly done. It's going to be quite exciting moving into a new place."[5] Located on the marshes of the Charles River, the Riverway was Benson's last studio. He celebrated his arrival there by etching his view from across the marshes. *The Squall* depicts a slanting rainstorm lashing across the Boston skyline with a steeple piercing the mists. Its atmospheric qualities are reminiscent of the first etching Benson bought as a young art student, a landscape by Sir Francis Seymour Haden. The influence of Haden's print of a little English village can be seen clearly in the massed lines in Benson's first Riverway etching.

Through Haden's influence, Benson's printmaking can be seen as an extension of the etching revival that flourished through England and France and then America between 1866 and 1896. The movement was initiated in France as a reaction against the encroachment of the camera and its mirror-like images into artistic realms. Etcher Alphonse Legros led the movement, suggesting to M. Cadart, a publisher of prints and amateur etcher, that he start an etching society. Their cause was taken up by the leading art critics of the time, including Théophile Gautier and Charles Baudelaire, and soon interest was spurred in artists, collectors, dealers, and publishers. The enthusiasm was transferred to America primarily through M. Cadart, who traveled to New York to exhibit modern French etchings, and Maxime Lalanne, whose treatise on etching was translated into English and published in Boston in 1880. Benson bought a copy of this book and used it as his "bible." Another important influence on American printmaking was the work of James McNeill Whistler, one of the first Americans to take up the new art with great success. Whistler's brother-in-law, Seymour Haden, a famous surgeon as well as amateur etcher, organized an exhibition of the Society of Painter-Etchers in London in 1881 and invited several Americans to participate. That same year, the year that Benson enrolled at the Museum School, the museum itself held a large exhibition of the work of American etchers and a few Europeans. When Haden lectured at the museum in 1882, Benson was in attendance. Haden's lecture tour received wide press coverage, and by the time he returned to England, the etching revival had a firm footing in America.

The continued success of Benson's career was due in part to the achievements of the Guild of Boston Artists. As Benson returned from North Haven and prepared to move his studio, Boston's newest gallery was celebrating its first anniversary. In the first six months alone, more paintings were sold there than by any other Boston gallery, and numerous commissions had been secured for the members. Just like The Ten before them, the guild's members discovered they did not need the hierarchy of the established art world. The careers of many of the artists flourished. The guild's spring and fall shows attracted large crowds, and Benson never failed to exhibit several of his newer works there.

But if the guild's artists were gaining positive critical review, The Ten were not. In 1915 the artists had originally considered not having the annual show due to the "disorders" of the war. At least one critic thought they should have not reconsidered. Although he felt that Benson's *Red and Gold* was the "popular success" of the show, he found the exhibition of this "fixed and inexpensive institution" to be "weak and wabbly."[6] The ever-blunt Hassam wrote to Weir, "It is a rotten show as a whole and will get Murray Hill from almost everybody who knows anything."[7] The exhibition had been held at the Knoedler Gallery, ostensibly because Montross had filled their usual slot

with an exhibition by younger, more radical painters, such as Glackens, Prendergast, and Man Ray. Montross was also now championing Matisse, whose work some of The Ten found so abhorrent that they may well have wished to sever ties with Montross anyway. Although Royal Cortissoz admired The Ten for being independent and not buckling under to the "current crazes," as he referred to modern art, he was not inspired by the 1915 exhibition. After giving a slight bow to their work, he wrote of the Boston trio that they had "an indubitable skill but no purpose, no tangible beauty. That at least the skill is there, the vigor, the attack of a clever man in his hands is characteristic of the exhibition of the Ten." Their annual exhibit in 1916, which was held again at Knoedler's, drew a lukewarm response in New York. There was much damning with faint praise, and the only comment that Benson's *Interior* received was that it was odd and more of a still life than a figure study.

By 1917 The Ten, reduced in number to nine by the death of Chase the previous October, had returned to the Montross Gallery. As a memorial they hung one of his still lifes with fish, but there was no talk of replacing him, as he had replaced Twachtman. *The New York Times Magazine* gave The Ten a most positive review, saying the artists "bring their own standards with them, and offer collectively so imposing a presence that it is impossible for even the unsympathetic to approach them flippantly, to take liberties with the established conventions, to look at them otherwise than with respectful admiration for achievement so complete and finished."[9] Yet the writer felt there was a "note of finality" to the group's showing and questioned the reason for continuing. No one doubted the group's skill and technique, but many felt that its time had passed. Benson reaped praise for the "delicacy of color and soft luminosity" of *An Open Window* and for his "invigorating" paintings of birds. When the show was hung at the St. Botolph Club in Boston, a local art critic ran his story beneath a headline that declared "THE TEN AMERICANS, NOT A VERY THRILLING SHOW." "So far as their significance as a group is concerned, the Ten have long since ceased to count for anything special," he wrote. "One feels that they have very little in common, that they are not homogeneous and that whatever of consequence there was originally in the movement that resulted in the organization, nothing of it important survives."[10]

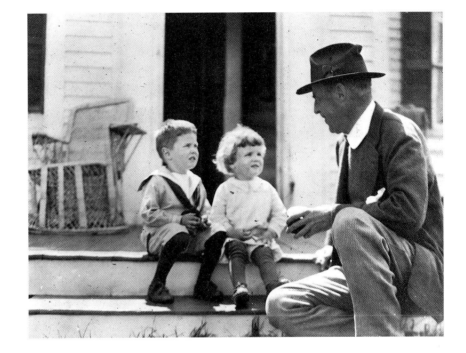

Still supposing that the group had sprung from some "movement," critics bemoaned the fact that its "purpose" had become distilled over the years. The original purpose, that of showing their best and newest works to great advantage in a tasteful and artfully arranged show, was still alive; the world of art, however, was changing. Younger critics were beginning to view the venerable, talented members of The Ten as unfashionable; in fact, it became chic to malign the successful and able group. (Benson, however, was often singled out for praise as one who had kept his art alive and vital by constantly trying new techniques and media and exploring new motifs. Benson's forays into black-and-white wash and etching met with approval whenever he showed them. His inclusion of a few of these works in his showings at The Ten's exhibitions were greeted by the critics as welcome additions to his ranks of elegant oils.)

That The Ten continued to turn out excellent, pleasing, salable works was not enough for the critics. In the aftermath of the Armory Show, the reviews of their shows grew smaller and smaller and slipped to the bottom of newspapers' art pages, and the reviewers questioned whether continued exhibitions were needed or relevant. The

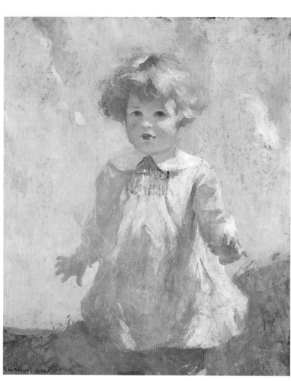

PLATE 107
Boy in Blue, *1918. Oil on canvas, 40 ×
32". Private collection. Benson gave
Eleanor this painting of her second son,
Ralph, Jr., but not before he had painted
two other versions.*

PLATE 108
Eleanor and Benny, *1915. Oil on can-
vas, 25 × 30". Private collection.*

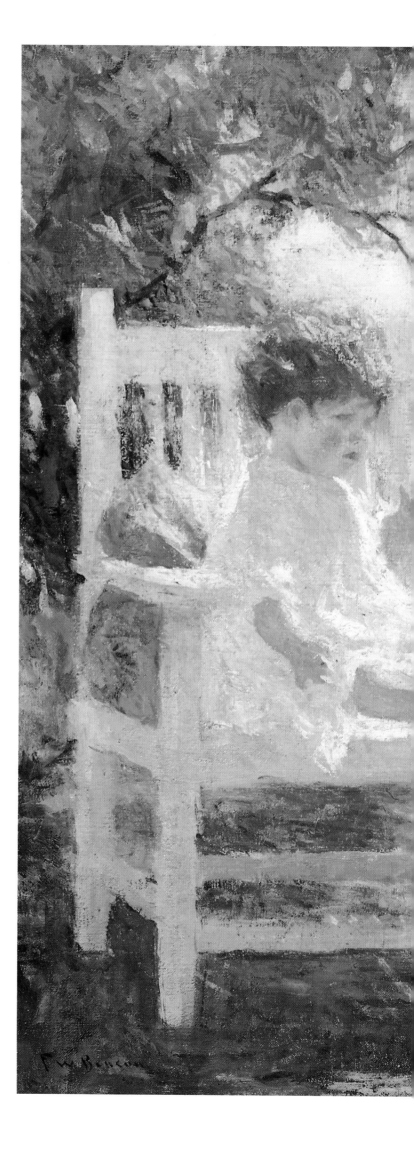

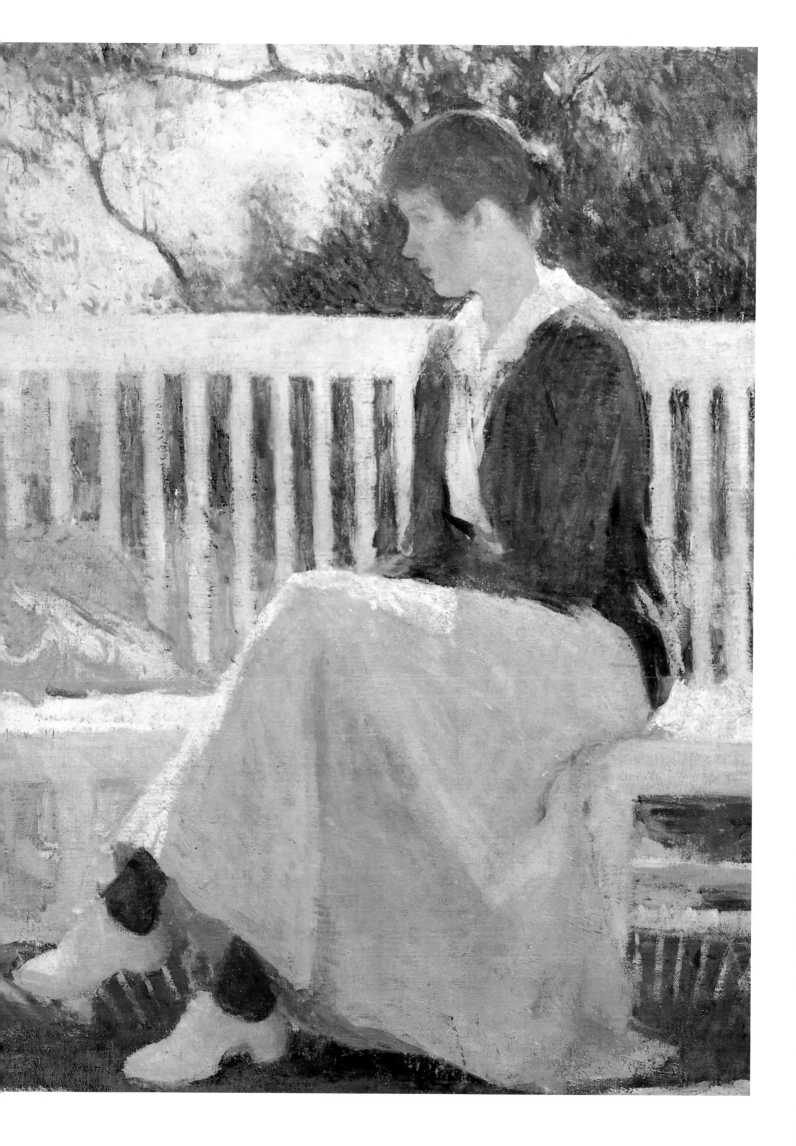

following year, 1918, the group did not have a show. The reason given was the war, but the continued lack of enthusiasm in the press could have been responsible.

That summer in North Haven, Adam Paff, curator of the prints at the Boston Library, visited Benson to discuss publication of a catalogue of Benson's etchings. The catalogues, eventually numbering five, were an immediate success and each became a collector's item in short order. The first volume, an edition of 275, disappeared within a week. In 1924 Benson wrote to Dan Henderson, expressing amazement at the book's popularity: "I am sending you Volume III of my catalogue which . . . was published the first of the year and, like the others, was sold out in about three days! . . . I wish I could add the first two [volumes] but they are not to be had. One sold at auction a year ago for $350 in New York."[11]

Many of Benson's etchings and later watercolors were inspired by the landscape and hunting scenes made at the Long Point Club in Ontario, founded by a group of Canadian businessmen in 1860 for the express purpose of keeping their favorite hunting ground from being depleted by almost year-round shooting. In his fishing diary, Benson recounted his first trip to the club:

> Woke up at Buffalo and breakfasted on whitefish as we passed Niagara Falls. Rainy morning. . . . We took two motors and bumped over nine miles of road to Simcoe, where we took another train on a jerkwater railroad for Port Rowan, arriving there at one o'clock. We had a banquet at the local hotel and then took the club launch with all our luggage and ammunition and sailed for Long Point . . . The Point looks like a Florida mangrove key—just a few trees that appear to be growing out of the lake.[12]

That first afternoon out he shot and retrieved fifteen ducks. That evening he wrote, "Had a wonderful dinner of venison and black duck with currant jelly, peach pie and cream and coffee. The prettiest afternoon's shooting I ever had." The same sense of humor so often seen in his writings about earlier expeditions reveals itself in the diaries he kept of his trips to Long Point: "I shot better than usual and got 70 with 155 shells," he wrote. "When we tried to eat lunch they kept coming just the same and I almost loaded my gun with a sandwich."[13]

It is difficult to reconcile Benson the ardent naturalist and ornithologist with Benson the hunter. The same man who watched in awe as what he estimated to be twenty-five thousand ducks flew over head one October morning in Canada, could, during the same visit, shoot eighty-three of them in a single day. John Ordeman, himself a hunter, takes pains in his book on Benson's etchings to clarify the circumstances under which Benson did his shooting.

> In fairness to Mr. Benson, whose sportsmanship might be questioned by those who consider his bags of game reported in his diaries excessive, it should be pointed out that his shooting was done before hunters were aware of the necessity to conserve game and before laws limiting the number of birds that might be shot had been passed. By the standards of contemporary American gunners and of the English gentlemen shooting upland game driven to them by beaters, Mr. Benson's harvest of scores of birds would seem modest. His sportsmanship and his respect for the game he shot are evinced by his diary accounts of the efforts he made to retrieve the birds he had downed and of the shots he passed up. By the standards of his day, he was a sportsman of the highest ethical order.[14]

Indeed, when the hunters of America finally became aware of the dwindling numbers of wildfowl, they founded Ducks Unlimited to save the ducks' breeding grounds. Benson was an active member from the first. He designed the masthead for their newsletter, which was used from 1938 until recently and, in 1943, designed a certificate featuring Canadian geese to be awarded to members. Benson's friend Jay "Ding" Darling convinced him to design the second duck stamp, the sale of which helped conservation efforts. Today, Benson's 1935 federal duck stamp is the rarest issue among collectors. The etching of the design for the stamp was Benson's last.

Returning from Long Point, Benson wrote to Woodbury that the effects of the war were widely felt in Boston. Now on the Museum School Council, Benson told Wood-

bury that the enrollment at the school was so low that there was concern that it might have to close its doors for the duration of the war. Worried about the school and his own son George, awaiting assignment in Europe, Benson was devastated by the news of the death of Bela Pratt, who had taught by Benson's side at the Museum School since 1893. It was perhaps just as well that the Bensons had planned to spend the summer of 1917 in Jackson Hole, Wyoming; North Haven would have been a lonely place without Pratt. In Wyoming Benson fished the mountain streams, rode horseback to the ranch's far-flung outposts, and spent hours bird-watching.

After three weeks of doing nothing but "loafing about," Benson began to grow restless. "I am rather tired of playing . . . and have begun to work as recreation," he wrote to Eleanor. "I am painting a picture of the mountain, but as I can't work on it until 3 P.M., I don't work very much of the time. My work is so interesting that I never really live fully or feel the day to be important unless I have something going on and I am sure I shall never be happy long without work."[15]

Two of his western paintings were finished in time for his one-man show that fall at the Guild of Boston Artists. In addition, he hung eleven other oils, five of them new portraits, as well as fifty-one etchings and drawings. His large Jackson Hole painting, *Peaks of the Tetons,* garnered much praise. A fellow artist, overheard by a critic as he admired this now unlocated painting of a glimpse of serrated summits towering over dark pines and the tufty floor of a Wyoming plain, declared, "That's a good landscape. . . . Sargent never made anything more interesting out there."[16]

William Howe Downes felt this landscape would "rank among the painter's most perfect essays in this field." He noted that it was a "remarkably handsome canvas showing the sharply defined outlines of a ridge . . . in a beautiful afternoon light which brings out the violet and purple tones in the shadows of the mountains. The sky is notably fine being filled by filmy, silver-grey clouds almost [like] . . . steam and with a spiral upward movement so that they might be taken for the exhaltations of the mountains—the breath of the range."[17] The critic for the *Boston Herald,* having seen the beauty of Benson's works, was inspired to rail against the current fads in "modern" art. "These are days when much that is sane and substantial is lost sight of behind the barrage fire of the 'isms' and art resembles nothing so much as a peripatetic pinwheel broken from its axis gyrating in mad arcs across the sky." Obviously heartened by Benson's exhibit, he closed his review by stating, "Beneath this pyrotechnic disarray, such a show as this assures us the work that counts is pursuing its undramatic and surefooted way. . . . Because of his rational conservatism—and because he is not a painter of 'gallery pictures' —the artist does not startle his onlookers but each year . . . adds to the goodly store that yields to appreciation and study."[18] This critic seems to have put his finger on Benson's continued appeal. His masterly translations of American scenes were pleasing to collectors who felt assaulted on all sides by change.

Requests to mount one-man shows of his etchings continued to pour in and, despite the demands on his time, Benson took over the presidency of the Guild of Boston Artists. Edmund Tarbell, the first president, had accepted a position at the School of the Corcoran Gallery of Art the previous spring. In contrasting Benson's presidency with that of Tarbell, the *Boston Transcript* commented, "He is quite as independent in his way as Mr. Tarbell, but perhaps has a rather more ingratiating manner of presenting his case."[19] Perhaps it was Tarbell's presence that caused the Corcoran's director, C. Powell Minnigerode, to explore the idea of holding an exhibition of The Ten there. He had been disappointed when The Ten did not hold their annual show in 1918 but was interested to learn from his close friend Willard Metcalf that the group had planned to hold "a large retrospective, one in which we had hoped to present our maximum weight, as well as to collectively make our last bow." This plan having failed, Metcalf stated, "The whole matter of continuance became a dead letter."[20] About the cessation of The Ten's yearly exhibits, Benson was a bit more succinct: "I don't know why our yearly exhibition died out," he wrote to Minnigerode, "except that we are all getting old and perhaps more inert than we were twenty years ago."[21]

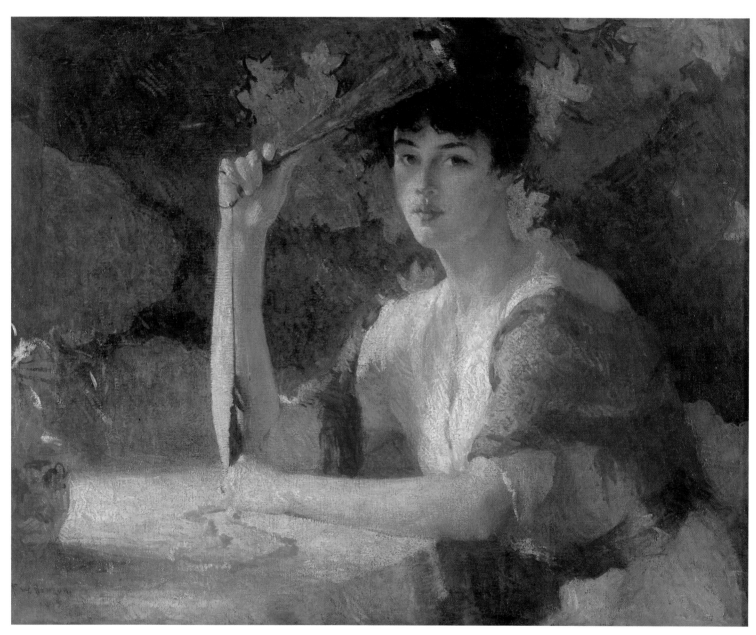

PLATE 109
Red and Gold, *1915. Oil on canvas,*
31 × 39". Butler Institute of Art,
Youngstown, Ohio.

PLATE 110
Nasturtiums in a Vase, *1926. Water-*
color on paper, 21¾ × 17⅝". Private
collection.

Undaunted, Minnigerode wrote to the remaining members of The Ten asking them to consider an exhibition of their work in Washington. Several of the men were luke-warm to the idea and tended to echo Metcalf's sentiments: if the others wanted to go ahead they would acquiesce. Benson's letter was an exception: "I shall be very glad to send to a show of The Ten, for, as you know, I am always glad to show with you at the Corcoran whenever you ask me to."[22] Held in February 1919, the show was a resounding success. Among Benson's works were the recently completed plein-air portrait of little Ralph and a study of a model entitled *Red and Gold* (plate 109).

Of the group, one Washington paper said they had "exerted a strong and beneficent influence upon the development of American art."[23] When the show moved to New York's Knoedler Gallery in March, the review by Royal Cortissoz had a quality of summation about it that seemed portentous: "The function of the Ten American Painters has, from the start, been to make exhibitions such as are not often to be seen anywhere else. It is not that they are forever producing masterpieces, but they are men of ability . . . who turn their backs upon the routine. [We can see] that personal force which first brought The Ten as a body into view."[24]

Minnigerode was very pleased with the exhibition and wrote to Benson: "We are all delighted with it and feel very strongly that it was so well worthwhile. It would have been a great loss to everyone interested in the development of painting in this country if this notable exhibition should have been abandoned. I hope it will keep up forever."[25] Minnigerode's hope was not to be; the Corcoran show would be The Ten's last. Weir's death the following winter, coupled with Chase's passing and the lack of support in the press for continued exhibitions, seemed to deprive the men of a reason to continue. The organization of the shows required a great deal of energy, and the group in general was feeling the effects of age. In reality, Minnigerode had coaxed The Ten out of retirement for what can now be viewed as their grand finale.

For Benson, the dissolution of The Ten by no means deprived him of adequate exhibition opportunities. He was besieged by requests from gallery owners and museum directors to send them something . . . anything. He sent works to at least fifteen exhibitions in 1919, both in America and abroad, where the Royal Glasgow Institute of Fine Arts hung several of his etchings. That same autumn he sent *The Hilltop*, his striking painting of Elisabeth on Lookout Hill in North Haven, to the Luxembourg Palace in Paris for the "Musée National d'Exposition des Artistes de L'Ecole Américaine." In the United States there were one-man shows of his etchings both in New York and Washington. One less show to enter, especially one such as The Ten's, which required so much time to organize, might almost have been a relief. That December Benson had to beg off jury duty for the annual Carnegie exhibition: "I find myself so pressed by work at all times that it is necessary for me, when I can leave my painting, to go out of doors for recreation."[26]

Despite Benson's grueling work schedule, it is interesting to note that in 1919 he was again "experimenting" with his art. Not content to be winning prizes for his figure work, mounting one-man shows of his wash drawings, and turning out etchings at a rate of one every other week, Benson wrote to his friend Minnigerode at the Corcoran, "I intend to send you the best thing I have. . . . It is a still life, but I think you will like it."[27] A few days later, obviously having added a few finishing touches and regarding it with his fastidious eye he added, "I have just been looking at it here and I think it the best painting as *painting* that I have ever done."[28]

Still lifes were something Benson had shown infrequently and he obviously was a bit concerned that Minnigerode would balk at the idea of a Benson still life. But Minnigerode had known Benson long enough and well enough to have implicit trust in the artist's own—often harsh—judgment of his works. Benson did indeed send this "best painting" to the Corcoran's exhibition along with *An Open Window*, which was awarded both the Clark prize and the Gold Medal and was also purchased by the Corcoran for its permanent collection (plate 104). It was the first time this new prize had been awarded. Clearly deserving of such honors, the painting's spare design placed Elisabeth in the center of a room so discreetly furnished as to be almost austere. The two tall, shuttered

windows of Benson's Riverway studio frame her and balance the rather orientalist composition.

Little is known about the still life that was exhibited in 1919. A few references in Benson's correspondence point to the possibility that it is the undated still life bought from Benson by the influential contemporary art collector Duncan Phillips, who founded the celebrated Phillips Collection in Washington, D.C. Now titled *The Dining Room Table*, it is owned by the University of Nebraska (plate 111).[29]

In one of Benson's most interesting still lifes (see plate 113), seven upright candles in a candelabrum mimic the crest of a cockatoo perched on a stand, while a plumed hat on a chair looks almost like another exotic bird itself. The folds of the luxuriant fabric are repeated in the curving arms of an ornate candelabra, and all are offset by the vertical lines of a screen. It is a masterful composition, but Benson did not like it. While keeping much of the painting as it was, he made numerous changes: drapery was removed, the ginger jar was replaced with another one full of flowers, and, most important, the plumed hat and the dark chair on which it hung were painted over. However, in the present version, the barest outline of the hat and its intense blackness can be faintly seen through the silver of the screen.[30]

When Benson hung the revised version of his painting in 1926 at the National Academy of Design, it was honored by being purchased by the Henry Ward Ranger Fund (plate 112).[31] The critic Royal Cortissoz heartily agreed with the fund's trustees in the selection of the still life for purchase: "There is one picture in the Winter Academy which by itself is enough to make the fortunes of the exhibition." Calling it a "superb piece of pure painting," he declared that Benson achieved beauty "because he is faithful to an immemorial tradition . . . exquisite in his feeling for the sensuousness in form, color and decoration [and] upholds the integrity of honest craftsmanship."[32] Such praise was echoed when another still life, *The Silver Screen,* was hung at the Guild of Boston Artists: "The perfect harmony of color and design of this picture gives absolute satisfaction and a rare quality in this age of modern hustling methods."[33]

The quality of light in Benson's still lifes evoked memories of his previous plein-air works. When *Still Life Decoration* won the Logan prize at the Art Institute of Chicago, the writer for the institute's *Bulletin* noted, "It has the luminosity and decorative feeling found in this artist's canvases of young girls on sun-lit porches and in reposeful New England interiors."[34] In choosing his objects, Benson was influenced by the fashions of the time, including the oriental decorations that surrounded him in his home in Salem. But although the articles Benson used in his arrangements were beautiful in themselves, when placed in his design they ceased to be objects but parts of a whole, fillers of a void, creators of shadows. Explaining to Eleanor that she must paint what the eye can see and not the outlines of objects, he encouraged her to view a still life as one more example of the effects of light. Of her mother's silver pitcher, the primary focus of one of Eleanor's own still lifes, he said: "That is . . . beautiful *because* wherever you put it, there are places you can't see, that lose themselves against the background. In arranging a still life you [must not get] carried away by the beauty of the things themselves, instead of arranging them so that light is beautiful. Don't paint anything but the effect of light. DON'T PAINT THINGS."[35]

It appears that Benson painted approximately one still life per year from 1919 to 1936. Most were oils of large format that were, according to Benson's records, executed largely during the winters in his Riverway studio. This could explain the almost total absence of flowers in vases or bowls, which are so often a component of typical still life composition. He did occasionally paint small potted plants, such as an orange tree or an azalea. A dogwood spray used in at least two paintings was clipped in late spring from the backyard of his Salem home and carried on the train to the Riverway.

With few exceptions, it is in Benson's later watercolor still lifes, usually done at North Haven, that he painted flowers with all their vibrant, colorful hues. Wooster Farm was surrounded by beautiful gardens that Ellie created. The refreshing mists of the island nourished lush patterns of shape and color within the borders and beds; colorful bouquets filled the farmhouse (plate 110). While in North Haven in 1919, Benson

PLATE 111
The Dining Room Table, *date un-*
known. Oil on canvas, 32⅛ × 39⅞".
Sheldon Memorial Art Gallery,
University of Nebraska, Lincoln.

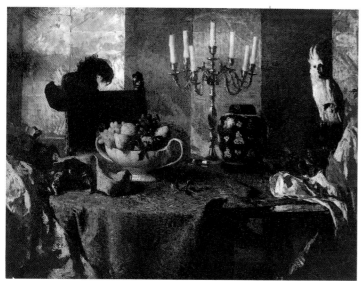

PLATE 112
Still Life, *date unknown. Oil on canvas, 54 ×59". National Museum of American Art, Smithsonian Institution, Washington, D.C. Henry Ward Ranger Fund.*

PLATE 113
Original version of Still Life, *date unknown. Oil on canvas, present version, 54 ×59" (see plate 112).*

also painted a study of Eleanor bent intently over her sewing. The bright light from the large window behind her diffuses the whole, giving the canvas a shimmering quality (plate 114).

In 1920 Benson's etchings enjoyed appreciable increase in sales in Britain due to several articles about them in *Country Life,* a magazine that was found in the drawing room of every British country home. The previous year his etchings had been the focus of a one-man show at the Kennedy Gallery in New York which drew sizable crowds and appreciative reviews. Noting that it had been three years since Manhattan gallery-goers had first seen Benson's etchings, critics remarked that his continued work in this medium only confirmed the fact that he was a true master of the etching process. As one wrote, "One does not need to be a sportsman to appreciate these beautifully drawn designs so full of life, movement and charm."[36]

It was undoubtedly the continued interest in Benson's work that prompted Minnigerode to write to Benson saying, "We want to put up the finest and most complete Benson show that has ever been exhibited . . . including your work in all mediums." He was planning it for the following spring, "the most attractive season of the year in Washington."[37] Benson accepted the invitation with great enthusiasm and began writing loan requests to the museums and private collectors who owned his works.

Although Benson usually declined invitations to attend openings of his shows, Minnigerode was a close friend; the whole family decided to travel down to Washington for this special exhibition. The show opened in March 1921, on the evening of Benson's fifty-ninth birthday, and by the time it closed, over fifteen thousand people attended. Later, Minnigerode gloated that his estimate of a total attendance was short by only four hundred. The show was extremely comprehensive and included 45 oils, 18 wash drawings, and 117 etchings. Few other artists of the time had ever been granted such a large exhibition. Reviews in the press were uniformly enthusiastic. Calling the show "one of the most engaging displays that has been held in this city," one Washington art critic wrote: "The work is not only varied in character, but interesting to laymen and artists, fresh, colorful and picturesque and at the same time technically individual and excellent. Furthermore, it is a thought-provoking collection. It covers a considerable period of production and it contradicts some of the theories that have come to be regarded almost as axioms."[38]

The exhibition was truly a retrospective. The oils dated from as far back as his 1888 portrait of Ellie in her wedding dress to a recently completed figure study of Elisabeth holding a mirror (plate 115). Writing to Benson, Minnigerode said he had been told by a visitor to Benson's studio that it was the finest picture he had ever done, and he hoped it would be finished in time for the show. Titled *Reflections,* this stunning portrait of Elisabeth posing for her father at his Boston studio is suffused with light. Her long, richly embroidered mandarin coat is a deep gold, and the opulent bit of drapery on the table and some of the luscious fruit in the glass bowl echo its color. Part still life and part portrait, this painting uses many of the elements that Benson employed again and again in his tabletop arrangements. The sumptuous folds and drapery of the skirt and coat lend a certain grace to the canvas. Benson took great care in the creation of these effects. Encouraging Eleanor in one of her later still lifes, he pointed out, "Describe the lights and shadows of the drapery in masses. Pay special attention to the direction of folds in relation to the design. Invent if necessary."[39] The curves and arcs of fabric are accentuated in the sweep of Elisabeth's long necklace, her round silver mirror, and the curved bowl whose arrangement of spherical fruit continues the graceful line. This truly elegant painting was one of the last in which Benson placed a comely young woman, handsomely dressed, in a richly appointed interior. By 1923 such oils disappeared entirely. *Reflections* was immediately bought by the collector Duncan Phillips, who had already loaned to the show the Benson still life he had recently purchased.

The Corcoran's exhibition of Benson's works drew congratulations from many of his friends, including Willard Metcalf, whose desire to "wet a line" again prompted Benson to include him in an upcoming vacation in Canada. It was a fortuitous decision, for out of this fishing trip came the only painting Benson ever did of Metcalf. Benson's

dislike of being away from his work too long and his grumbling about not being able to paint while he was hunting or fishing prompted his son George to suggest watercolors. Benson had tried watercolors from time to time but considered them too weak and delicate when compared to oils or etchings. Granted, his wash drawings were watercolors, but their strong contrast of black and white somehow removed them from the realm of a traditional watercolor. Nonetheless, George urged him to take a small easel and a box of paints to Gus Hemenway's camp, the Bon Salmon Club on the Bonaventure River on Quebec's Gaspé Peninsula.

Malin Run, a study of one of the streams near the club, was the first watercolor Benson did in a series that eventually numbered over 570. His second painting was a light, informal study of Metcalf, caught as he, too, worked on a small watercolor (plate 140). Metcalf's broad back is bent in concentration as the sun flickers on the rippling waters, the shining rocks, and his buff coat. A gay, red bandanna adds a bright note of color to the painting; the whole is bathed with the bright sunshine of a July day. While in Canada, Benson painted watercolors of a guide in a canoe, one of the best fishing holes, and the salmon camp itself. Back in North Haven, he painted in watercolor a scene with the tent in which George's friend Henry Chaplin and his new bride, Elsa, were camping on his family's land. He painted an arrangement of flowers from Ellie's garden as well as a study of Sylvia standing on a bluff gazing out to sea, her hand shading her eyes. (This watercolor, titled *The Watcher,* was also executed in oil that same year.)

At Eastham that fall, the watercolors continued: he painted the path between his house and the duck blind of his friend and fellow artist Dwight Blaney, the woods and the ponds and the autumn colors. Benson spent the fall of 1921 perfecting his watercolor technique. When a small collection of his new watercolors hung at the Guild of Boston Artists that autumn, almost all were sold. Benson's one-man show the previous spring at the Corcoran had been so successful that Minnigerode had asked him to hang a show of his wash drawings that December. His close relationship with Minnigerode made it difficult for him to deny the request, and Benson decided to add a few of his new colored watercolors to the black-and-white wash drawings. Once again, a new direction in Benson's art provoked glowing praise in the media and at least three paintings were bought on opening day. The show drew an enormous number of visitors to the gallery. On the last day, three thousand people crowded in to see the pictures before they were taken down and all but one of the twenty-three paintings had been sold. Minnigerode was eagerly planning another show of Benson's watercolors for the following June.

Perhaps it was the phenomenal sales of his watercolors at the Corcoran that prompted the Bensons to take a winter trip to the Bahamas. Perhaps Benson was coaxed by his good friend and fellow artist George Clements, who had already been painting there for some time. Whatever the reason, Benson wrote to Minnigerode from Nassau: "When one is living in mid-summer weather with coconut palms and banana trees waving outside the windows, it is hard to write letters or to believe in winter." In the three weeks he had been on the island, he had painted about twenty watercolors. The air was so brilliant and the colors so intense that he told Minnigerode that to view the paintings "you will need to wear smoked glasses." He marveled at the climate and the dazzling colors. For a man who had grown up so near the gray green New England sea, the turquoise waters of the Bahamas were startling indeed. He remarked that the local people "are all of a blue black color, the blackest I have ever seen."[40]

Many Bahamians found their way into his "Nassau paintings," a series of thirty-three works depicting the island's landscape, its people, boats, beaches, and buildings (plate 143). He painted *The Sarah Douglass,* a famous old clipper ship that had been well known in Salem's harbor, sitting awkwardly in dry dock. Evocative titles such as *Breezy Day, Nassau Harbor, The Rum Runner, The Loafer,* and *The Sponge Fleet* give testimony to the varied aspects of island life that appealed to the painter's eye.

Benson had hardly been home a week when visitors to his studio began to snap up the brightly colored paintings. By 1 May, when a one-man show of his Bahama paintings opened at the Guild of Boston Artists, nine of them had already been sold. The

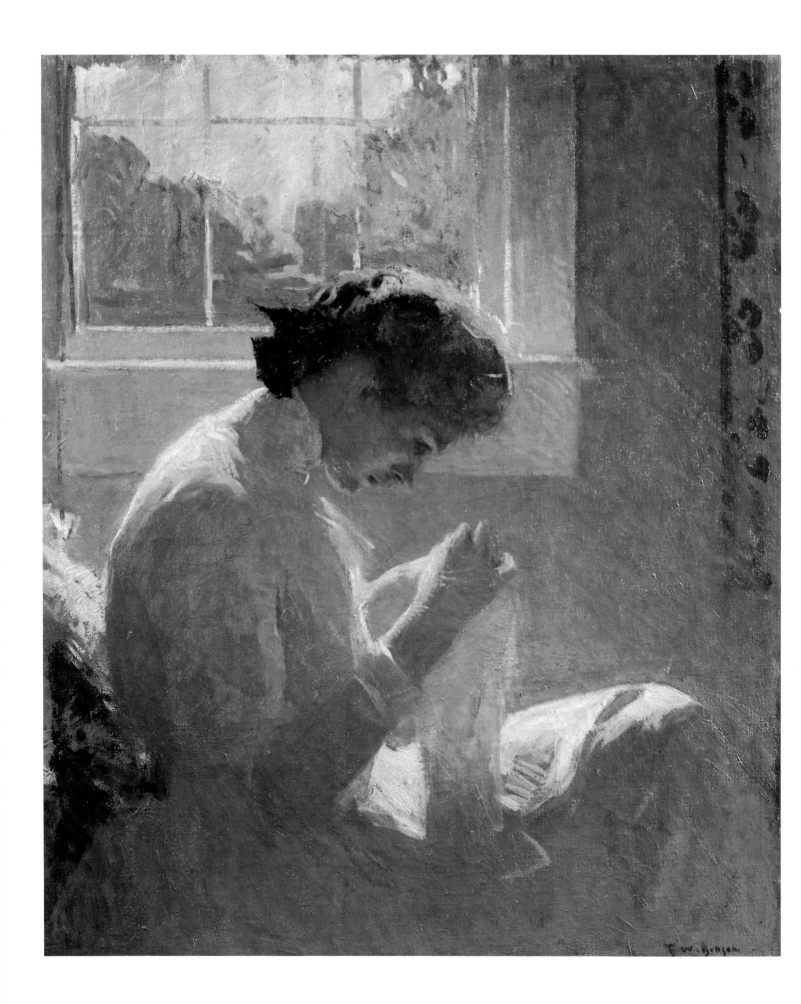

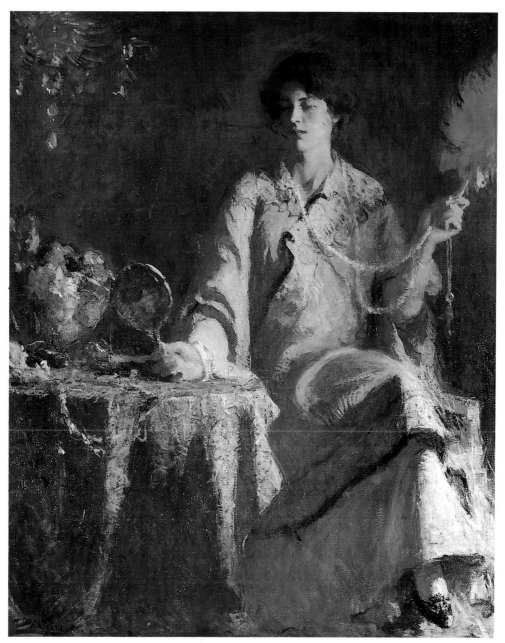

PLATE 114
The Sunny Window, *1919. Oil on
canvas, 30 × 25". Private collection.
In this North Haven interior, Eleanor
sits in front of the farmhouse window
that had so often served as a backdrop
for Benson's other paintings of his
daughters.*

PLATE 115
Reflections, *1921. Oil on canvas,
43¼ × 35½". The Huntington Library,
Pasadena, California.*

previous fall, when William Howe Downes saw Benson's sporting works, he had said that Benson's watercolors were suggestive of Sargent or Homer: "The love of the almost primitive wilderness which appears in many of Homer's landscapes also characterizes Benson's work, and the swift, sure touch with which he suggests rather than describes these solitudes of northern woods is very much like Homer's." Now, seeing Benson's Caribbean watercolors, critics noted an even closer similarity between the work of the two men (see also plate 132). More than twenty years before, Homer had done a series of paintings in Nassau with colors and arrangements that show a very similar perception of the Bahamian subjects. Benson's watercolor pursuits of fishermen paddling canoes and hunters with gun in hand frequently echo Homer's subjects (plates 116 and 117). There is little doubt that Benson was well aware of Homer's work, for it had been exhibited widely in Boston. In addition, Homer had been invited to join The Ten in 1898. It is not known who proposed him, but Benson is a possibility, given that the two men were distant cousins through Homer's mother, who was a Benson.

Both men tended to reserve the use of watercolor to their vacation periods, and their style, subject matter, and even techniques are remarkably alike. Both men's paintings are fresh and spontaneous, their simplicity and sense of color create a physical sensation. Both used the medium to create a quick impression on paper: their economy of stroke and pigment conveying the spirit of a moment. To Benson and Homer, watercolor had at first seemed too "ladylike" a medium. This was probably because, in England and America, watercolor painting was the preserve of amateurs, especially the privileged daughters of prosperous families who received polite educations that inevitably included instruction in watercolor. The formal composition and delicate washes that were typical of such work appealed to neither artist. Homer had begun his career as an illustrator; thus his first method of watercolor painting was to execute detailed drawings and then color them with washes, much as the popular Currier and Ives prints were produced. He quickly began to develop a new approach to watercolor, using the paper's ability to reflect light through transparent washes. Finding this made his colors more luminous, he discovered he could abandon detailed drawing and let his brushes convey broad outlines and delicate details. In Benson's work there is evidence that he studied the older artist's methods. Only large outlines are sketched; the majority of the painting is created freehand with brush and pigment. Both men captured well the shimmering quality of sunlight; in Benson's Caribbean paintings there is a sense of heat as well as humidity. He conveyed mists by soaking his paper and then blotting his paints; his flicking brushstrokes merely suggest the features of the black faces gathered on a dock. Only careful control allowed him to build up washes of color and still maintain transparency. Homer had been known as a painter of the sea; boats on water had been Benson's earliest motif. Their similar treatment of fisherman and hunters, turquoise Caribbean waters, and mountain scenes invited comparison.

Calling Benson's Caribbean paintings "the Jewels of Nassau," the critic for the *Boston Transcript* declared that, as he walked into the gallery, he was "struck with the joy of existence, the fact that merely being is an exhilaration and the convincing proof that youth is not a question of years." He found Benson's mastery of this new technique in so short a time staggering. "He has great knowledge of the limitations of aquarelle, knowing when to stress his medium or to have respect for the beauty of the white surface on which he is working, or with a brush full of color, express a brilliant note of sunlight through foliage."[41] Fellow artist Dudley Murphy wrote a letter to the editor of the *Boston Transcript* describing the "thrill of pleasure" that was given to him by Benson's paintings.[42] Benson's note of thanks to Murphy reported, "I feel it the more because the most gratifying thing of all in painting to me is to know that something I have done is stimulating to a brother painter—and I am conscious too that the stimulation occurs oftener than the expression of it."[43]

At the closing of the guild show, only a few watercolors remained. Benson had promised to send the whole group to Minnigerode for his June watercolor show at the Corcoran and was most embarrassed that his supply was so depleted. He promised Minnigerode that he would work hard to produce enough for a good showing in Wash-

PLATE 116
Winslow Homer, Canoe in Rapid, *1897. Watercolor over graphite on white paper, 13¾ × 20¾". Collection of the Harvard University Art Museums, Cambridge, Mass. Louise E. Bettens Fund.*

ington. "Don't be discouraged," he wrote, "I have just been fishing on Cape Cod and, besides the trout I caught, in four days I made four watercolors."[44] Benson's fishing club, The Tihonet, was the scene of many of his watercolors, several of which remain in the families of his fishing chums: *The Trout Brook, Frog Foot Bog, Slug Brook, Tihonet Pond, The Sand Pit, A Cape Cod Brook,* and *Flooded Pines* were all done at the club near Wareham that spring. Their titles well describe the environs in which Benson spent so many of his days.

As the time for the Corcoran's show drew closer, Benson painted *Spring Flood* and *Spring,* both on the Ipswich River. Writing to Minnigerode again, he told of another fishing trip in which he "got 60 trout and four watercolors." But the demand for his new medium was so great that, as quickly as his paintings were made, they were sold. He confessed to Minnigerode with some dismay that "I am beginning to doubt if I can keep up with the procession."[45] Macbeth Gallery in New York, which had handled Benson's work for some time, had been barraging him with requests for his watercolors. It is evident in his exasperated reply to Macbeth's letters that Benson was under considerable pressure to take care of everyone who wanted his new paintings. "I cannot make any

promises for next year as I have not the pictures. Several requests that came before yours I am not able to grant as I have sold all the watercolors—some 40 in number—that I made in the fall and winter and it is quite impossible for me to make any arrangements long beforehand. I am sorry, for I should like to do as you ask me to."[46]

The rapidity with which Benson turned out watercolors satisfied his collectors and agents, but it cut into his production of etchings. In the years prior to his discovery of watercolor, his yearly etching output had been averaging over twenty. Following his first showing of watercolors in the autumn of 1921, he rarely made over fourteen etchings a year and, in some cases, only three. Watercolors were far more portable that an etching press. From this time on, Benson was not without a pad of watercolor paper and a tin of paints, and he urged Eleanor to always keep a set of paints in the trunk of her car as "insurance" against the moment when she might come across a scene worth painting.

Benson's brother John was also busy painting. His marine scenes were admirable, and he wanted to be able to devote more time to his painting. Benson had encouraged him to paint full time but, as John's daughter remembered, he "couldn't afford to take a financial chance with four growing children." Now, those children were grown. Frank cabled him in England on his fifty-sixth birthday and bluntly said, "John—If you are going to paint—PAINT!"[47] That seemed to be all John needed to take the plunge. He painted the rest of the year in London and, when he sent a collection of fourteen paintings to Doll and Richards Gallery in Boston, all but one sold. Benson was delighted that, at last, John would be the painter he always knew his brother could be. Forty years before, their father had forbidden John from following his brother Frank to the Académie Julian, stating that he would only have one son become an artist. John had become an architect instead. Following the success of his exhibition in Boston, he sold his home in Flushing, New York, and bought a house in Kittery, Maine, where he created dozens of marine paintings: clipper ships under full sail, fishermen on glassy waters, small boats darting about a race course. In 1926, after the two brothers had spent a few days painting together, Benson wrote to Eleanor, "Uncle John came up and painted watercolors with me and had a great time. I think I infected him with the disease."[48]

The autumn of 1922 was a frantic time for Benson; between the October wedding of

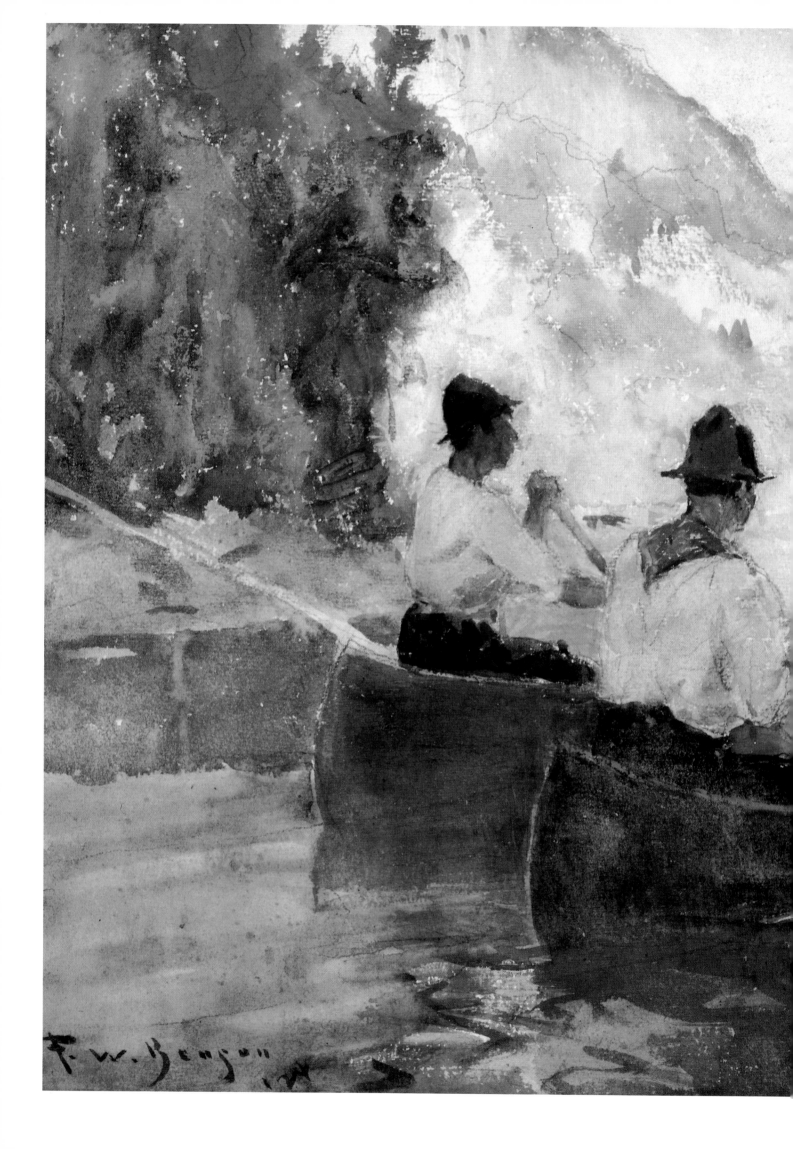

PLATE 117
**Salmon River
in Canada,** *1924.
Watercolor on
paper, 14 × 19½".
Private collection.*

Elisabeth to Max Rogers, a plantation owner's son from Alabama, and preparations for five one-man shows, Benson had little time to spare. But when Metcalf asked him to join him at the Fullerton Inn in Chester, Vermont, Benson slipped away for a few weeks. It was Metcalf who had introduced Benson to Edward and Albert Milch, the two brothers who, after 1920, looked after the business end of Metcalf's art. They had started out in the art world as framers, and their heavy, gold-leaf frames were much in demand by New York's museums and wealthy collectors. But, more important, the Milches often framed on credit, taking payment only when an artist's painting was sold. Gradually, their framing shop became more of a gallery and less of a framing establishment. Although their business became strictly a gallery following their move to West 57th Street in 1915, they continued to do a little framing, "just in case," in a small shop next door.[49] Benson's business association with the brothers began in 1921, when he sent them a still life and promised to try and send them a painting from time to time. Although Benson already had several agents in New York, he was impressed with the Milches; his relationship with them lasted many years.

Macbeth and Milch were rivals in the New York art world, and the tone of Benson's letters to the two reveals a subtle preference on his part for the latter. The Macbeth Gallery's pushy approach, discernible in several of its letters to Benson, was simply not his style. He was quite taken aback by at least two instances when the gallery asked for a larger than usual commission and, despite his polite refusal, continued to pursue the matter. A number of his letters to them are uncharacteristically short in tone. Benson's business dealings with Macbeth appear to have ended in about 1933, while his letters to Milch continue beyond 1940. Yet a study of Benson's correspondence reveals, above all else, his concerted efforts to be fair and equitable and to send each gallery an equal number of paintings.

It was at the Milch Gallery that Benson had his first New York showing of watercolors. A critic for the *New York Times* made an interesting comparison between Benson's etchings—by now familiar to gallery-goers in Manhattan—and his watercolors. Of the new paintings he wrote: "No one who sees them will be content to own Benson's etchings without the companionship of at least one Benson [watercolor] drawing. The etchings are the formal dinner party, full dress, careful manner, brilliant conversation. The [watercolor] drawings are the club or the camp, your choice of company, your smoke, your gun, your splendid old clothes. Both are fun, but the second are fun plus personality."[50]

Without knowing it, the critic, while describing the mood of Benson's two media, had also well described the two spheres of Benson's life. Born into an old Salem family, Benson had been well schooled in "careful manner" and proper dress, yet he preferred the world of the wilderness, of the rod and the gun. He often used the excuse of painting in the barn to escape a polite social gathering. He was never happier than when gathered around a campfire in "splendid old clothes." Never a man for lavish living, Benson's tastes were simple. When others of his circle were dressing for dinner every evening, he preferred to come to the table in a flannel shirt from L. L. Bean. European trips were twice yearly affairs for many of his friends, yet Benson's horizons hardly reached beyond Lake Erie or Quebec. He was a saver. After admitting to his daughter Elisabeth that he and Ellie were "tightwads," he added, "I [once] heard somebody say that when you wanted badly to buy something, and had saved enough to get it, the thing to do was to say, 'Now I can have it!' and then, not to buy it. . . . The money in the bank is there like the extra wheel you carry on your car and you'll find that the security is worth more to you than fading roses or what you might have had."[51] If Benson allowed himself one small indulgence, it was his gun. By 1919 he owned a custom-made Purdy, having been measured for the shotgun by an agent for the British firm who stopped in major American cities each year. Benson's fishing tackle was of similar quality. His rods and reel were handmade by an old Canadian guide who had a small private clientele of gentlemen, including many of Benson's fishing companions.

One of Benson's oldest fishing companions, Williard Metcalf, reading that the Art

Institute of Chicago had awarded Benson its Logan prize for *Still Life Decoration* and purchased the painting in 1922 for its permanent collection, sent Benson his congratulations as he had so often done in the past. Two years earlier Benson and Metcalf had held a joint show at the Macbeth Gallery in New York. Although the names Benson and Metcalf were guaranteed to draw a crowd, they didn't always draw blanket acceptance from the critics. The critic for *The Arts* magazine mourned the passing of what he called Benson's early "careless rapture" as seen in his plein-air works. Despite writing that Benson was "in no way a negligible figure in American art," the critic felt that Benson had recently slipped into complacency and had "gone on painting pictures rather than studies, showing off his knowledge, which is not slight, but not acquiring wisdom."[52]

Looking at a list of Benson's paintings, it is difficult to understand the critic's harsh opinion. Two of the canvases, majestic oils of wildfowl in flight, represented the new direction Benson's work was taking. Granted, the remainder were repetitions of familiar themes—marines, interiors, and plein-air paintings—that were so admired by gallery-goers. The criticism could well be ascribed to one simple perception: the work of these two skilled and effective painters was not avant-garde. It wasn't modern; it didn't jar, surprise, offend. These paintings were pleasing, tranquil, and real—skillfully rendered and technically elegant. That such work was going out of fashion did not keep it from appealing to the public and selling well. But the critic saved his most scathing comments for Metcalf's paintings: "[He] has fewer faults, possibly, than Benson, but he also has fewer positive qualities. His work at times is almost commonplace."[53] Although such words came at an extremely low point in Metcalf's life—his second marriage was falling apart—they did not diminish his joy in Benson's success. His note regarding Benson's prize in Chicago was typical of the generous praise he so often gave his friends: "I wanted . . . to give you a pat on the back over the Chicago prize. I am surprised only because I thought you had already taken it. Well now! there isn't anything left for you and someone will have to inaugurate some new prize somewhere." As if to vent his frustration at the current vogue for modern painting, he added, "Good work, Benny, it does my heart good to see the dedicated are still in the ring and occasionally heard from." Closing on a low note, he complained that, although he was doing a couple of good things, he wasn't feeling very well, adding, "I think my days now are few. . . . God, I wish you were up here with me!"[54]

Metcalf's letters to Benson are often long, rambling tales of woe. He had a history of drinking problems, probably not helped by his earlier membership in New York's Player's Club nor by his friendship with Childe Hassam. On a recent trip to Boston, Harold Milch had to be summoned from New York—perhaps by Benson—to take charge of Metcalf. That Benson was so concerned about this aspect of Metcalf's life is understandable in light of his childhood. His own father also sought solace in alcohol. A deeply principled man, Benson did not tolerate moral or spiritual weakness, least of all in himself, yet he was supremely understanding and accepting of the human condition. References abound to the steadfastness of Benson's friendship; his loyalty and devotion were legend.

Perhaps it was The Ten's dwindling numbers that caused Metcalf to dwell on morbid thoughts. He had recently heard from Mrs. De Camp that Joe had barely survived abdominal surgery. While Metcalf's days were not yet numbered, De Camp's were; he died the following year. Only three years had passed since The Ten had had their last show in 1919. J. Alden Weir's death the following winter seemed to bring to a close the group's collective efforts. In 1925, when Metcalf died of a heart attack, Benson wrote to Albert Milch, "I shall miss Metcalf deeply as time goes on. I think of him many times each day and the only consolation I have is that I chanced to go and see him that week before he died . . . I know that you appreciated his fineness of character. He had some hard times in his life and anyone who was liked by so many people must, on the whole, have had a happy time in life."[55] Within the next seven years all the members of The Ten save Benson, Dewing, Hassam, and Tarbell were gone. The men once considered "young rebels" were young no longer.

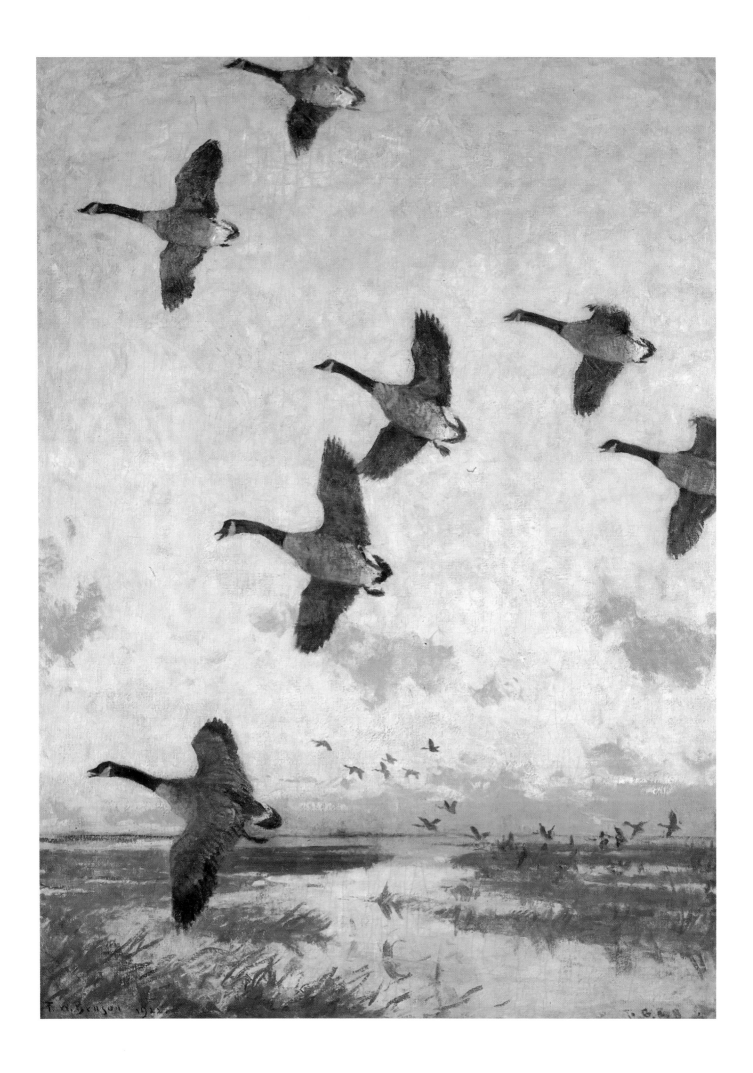

CHAPTER 11

A PORTABLE PALETTE

T he 1920s was a period of achievement, prosperity, and contentment for Benson. After the first few exhibits of his watercolors, there seemed to be no end to the invitations to show them at various museums and galleries. In 1923 alone, he had ten one-man shows both of watercolors and etchings. Responding to a request from the acting director of the Carnegie Institute, he complained, "It is an awful thing trying to keep up with the current exhibitions!"[1] Benson continued to exhibit at the annual shows of all the major museums, but the number of oils he executed decreased each year. Although he did two or three interiors with figures, some portraits, and an occasional still life, his interest in oils tended toward the wildfowl and sporting scenes he had portrayed in etchings and wash drawings. *Against the Morning Sky* is an excellent example of an oil from his sporting period (plate 118). Benson sent a print of the painting, clipped from a magazine, to Dan Henderson saying, "One year ago, as I lay in a marsh on Pamlico Island one morning with live decoys out. . . . I had geese over me like this again and again. I got 14 [geese] and a lot of black ducks and, at the time, planned out the picture."[2] The painting recalls the many times Benson and Henderson made early morning forays onto the marshes near Salem to shoot migrating geese just such as these. His hunting and fishing trips are recorded time and again in the oils of this period. Titles from 1923 and 1924, such as *Geese Decoying, Soaring Fishhawk, The White Heron,* and *Setting Decoys,* give testimony to the importance of these wildfowl both in his art and in his life. Fellow fishermen and hunters, the guides and porters are often depicted in Benson's watercolors. Even the most mundane scene was captured, as in the nightly preparation of dinner depicted in *Boiling the Kettle.* This study of a camp cook hunkered down as he keeps watch over the evening stew was undoubtedly begun while Benson awaited the dinner bell (plate 119).

The Gaspé Peninsula featured prominently in Benson's works. Returning from his annual Canadian fishing trip with his son, George, Benson wrote to Henderson, "I love the outdoor life just as well as ever and my boy is like me. I am in the busiest time of my life and I never enjoyed life more, which means that I am very fortunate."[3] He was correct. Few artists ever achieve critical, popular, and financial success within their own lifetimes. In a review of Benson's one-man show at the Guild of Boston Artists in November 1923, the critic quoted one of Benson's fellow artists as saying of the watercolors, "What a jolly time the man had doing them. [Painting them] must have afforded him great pleasure indeed." The critic continued, "That is perhaps the most important secret that [these paintings] have to impart: the value in painting is finding a motive that you very much want to get away with . . . are enthusiastic about, [and] you will somehow find the technical means for your task as you go along."[4]

It must have heartened Benson to have his work so appreciated at a time when modernists seemed to be making serious inroads. Several artists and patrons of the arts had formed a nonprofit gallery in New York City whose motto was "All that is Sane in Art." The Grand Central Art Galleries, so named for the proximity to the famous train

PLATE 118
Against the Morning Sky, 1922. *Oil on canvas, 32 × 25½". Pfeil Collection.*

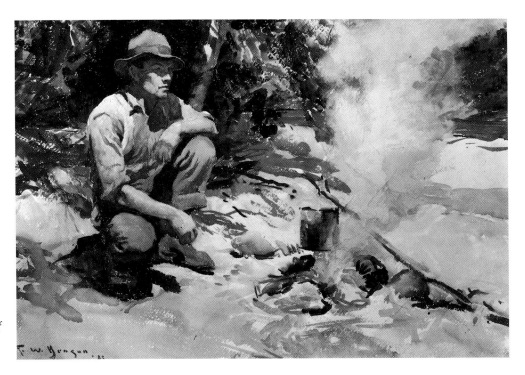

PLATE 119
Boiling the Kettle, *1923. Watercolor on paper, 14 × 20". The Art Institute of Chicago. Mr. and Mrs. Lewis Larned Coburn Memorial Collection.*

station, opened in the spring of 1923, and Benson sent *The Fox Hunter*, his picture of George poised on a rocky summit with mists swirling about him.

Benson's dislike of "the moderns" was echoed in the comments of his friend Charles Woodbury following a 1922 trip to Europe to select paintings for the international exhibition at the Carnegie Institute. Woodbury had traveled abroad with Charles Curran, and the two spoke disparagingly of "the scheme of French art brokers buying up the trash of the new movement and their expected flood of it to American buyers. They said there was "nothing to the modern stuff and, of the five thousand aspirants . . . which [we] both saw, there were six types of work shown and six men could have done the whole lot and these six should be incarcerated in some strong jail."[5] Benson had been invited by the Carnegie to take part in such trips to Europe but he always declined. The demands of his work and the time he gave to jury work, often at great sacrifice to his own painting, did not allow him such lengthy absences. He did, however, agree to participate in a large retrospective of his work at the Carnegie, which opened in January 1924. Homer St. Gaudens, the new director, had had to work hard to convince Benson to agree to another large show. Benson had already asked so many of his patrons for the loan of their works for his 1921 show at the Corcoran that he was reluctant to ask again. He finally agreed, but only on the condition that St. Gaudens make all the requests. Long before the days when "blockbuster" art exhibitions traveled unchanged from one major city to another, Benson's Carnegie retrospective was eventually seen—with only a few minor changes—in Pittsburgh as well as Akron, Ohio. It was also requested by James Gest, the director of the Cincinnati Art Museum, but, reluctant as he was to disappoint his old friend, Benson had to decline. He felt that the paintings had been away from their owners too long and most of the watercolors had already been promised for another show.

Many of the oils at the Carnegie exhibition had been shown three years before at the Corcoran. But instead of the wash drawings that were seen in Washington, Benson sent twenty-one colored watercolors to his show in Pittsburgh. Edwin C. Shaw, president of the Akron Art Institute and himself a Benson collector, was delighted to receive the major part of the Carnegie's show following its run in Pittsburgh. He considered the exhibition to be one of the best ever seen in Akron.

In addition to these two large shows, Benson had eight other one-man exhibitions in 1924, including etching shows in Baltimore, New York, and Boston. At the Chicago Society of Etchers show, hosted by the Art Institute, his prints won a prize for etching

190

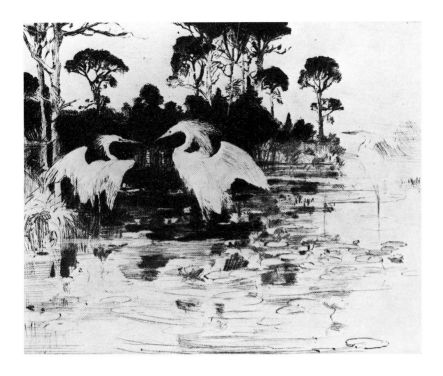

PLATE 120
Waterlilies. *Etching on Paper*, 7⅞ × 9⅞". *Paff no. 163, ed. 89. Private collection.*

funded by the Logan family, whose prize for oil painting had been awarded to Benson's *Still Life Decoration* two years before. Benson's work was also seen in London in 1924, when the Robert Dunthorne Gallery hung an exhibition of his watercolors.[6] Dan Henderson, interested as ever in his old friend's work, had sent Benson a clipping about the London show from the *Christian Science Monitor.* Benson was delighted to hear from Henderson and replied that it was "the first show I've had on the 'other side' of work in color and I was very interested to read . . . the *Monitor* [review]."[7] The writer of the *Monitor's* "Around the London Galleries" column noted, "I have seen no watercolors from America which better please me personally. He has the barest dash of the master, the freedom from technical embarrassment which comes from intense knowledge and with it all there comes a poetry pervading his work. This exhibition should do much to inspire London with a respect for the work of American artists."[8]

With dealers flooding his desk with letters requesting his work, museum directors wanting to hold one-man exhibitions, and collectors virtually knocking at his door, Benson felt, as he wrote to one dealer, "besieged from all sides." When his friend Albert Milch wrote asking for a few of Benson's sporting watercolors, Sylvia had to reply that "it is pretty hard work to hold onto the kind that you want. We try to do it by keeping them in Salem but people come and buy them out of the house when they had not come for that purpose at all!"[9] To the Macbeth Gallery's plea for more watercolors, Benson wrote, "I made one the other day at home and I looked forward to exhibiting it and almost before it was [finished] a visitor saw it and carried it off." Two weeks later he said, "I . . . have to refuse [requests for paintings] much as I should like to send whenever I am asked. It's my good [fortune] to be doing what people like, but it keeps me on the jump."[10]

By 1923 the Guild of Boston Artists had to open a special gallery for watercolors on the second floor. This room was painted a soft gray with silvery woodwork; its opening show was a one-man exhibition of Benson's watercolors. The critic for the *Boston Herald* wrote, "The expressed sense of beauty in Benson's sun-dazzled work is so vivid that, in the presence of his exhibition, you quite forget to consider the technical methods by which he accomplishes his results."[11]

Many of these "sun-dazzled" works, such as *Our Cove, A Southwester, My House,* and *Blue Hills,* were painted at North Haven. When Benson's works were shown at the Pennsylvania Academy's annual watercolor exhibition in 1924, they won the Dana Watercolor prize, awarded for "boldness, simplicity and frankness of work" (plates 121

191

and 122). The greater the demands for both Benson's work and his time, the more he looked forward to his summers on Penobscot Bay.

When Benson first began painting watercolors of the lily pool at the edge of the spruce woods at Wooster Farm, a critic was reminded of Monet's multiple studies of his garden pond at Giverny. "Perhaps following the Frenchman's distinguished example, Mr. Benson has constructed on a summer's day in Maine a watercolor that could not fail to attract a painter's attention."[12] *Iris and Lilies* illustrates his mastery of color and light as well as the effective use of the white of the watercolor paper itself (plate 123). Into this pool, Benson often placed in his paintings a single great white heron or a group of egrets (see plates 61 and 147). Although Benson exhibited several wash drawings of pelicans and egrets and did a stunning etching of egrets following his 1916 trip to Florida, the paintings were all done in North Haven or in his Riverway studio (plate 120). One grandson has recalled being amused that Benson "placed" such an exotic bird in his familiar little pool in Maine. The flowers and gardens of Wooster Farm also often found their way into Benson's watercolors. *Seaside Garden,* a bright study of a perennial border in full bloom, was inscribed by Benson "To Sylvia" (plate 150).

Among the many exhibitions of Benson's work in 1925 was one that opened at the Guild of Boston Artists the week after Thanksgiving. Two paintings were particularly striking: one depicts a lone fisherman standing beside his canoe at the edge of a stream while in the background his friends gather about a fire, and the other canvas shows gulls rising from a stormy sea. This latter painting was remarkable not only for its size (eighty-four inches long) but also because it is Benson's only known oil of this common bird. He is known to have painted only two wash drawings and four watercolors of gulls. An excellent example of his later wash drawing style is *Following Gulls* (plate 125). Shown for the first time in 1936, this painting portrays two fishermen plowing through choppy waters in their cat-rigged sailboat, the air around them full of wheeling and diving gulls. The titles of Benson's etchings and paintings indicate that he rarely depicted gulls. Considering the wide variety of wildfowl Benson painted and and his constant proximity to gulls' cries, it is surprising that he portrayed this bird so infrequently.

In 1926 Benson had numerous one-man shows of his watercolors. When Robert Macbeth wrote requesting a higher commission than usual, Benson replied: "If I choose to be patient I can sell them all in Boston. If I make one with figure or birds, it is commonly sold as soon as it is framed, and often before."[13] As if to let Macbeth know that he was lucky to get what he did, Benson added, "I have been asked for them by about every dealer in New York, but, of course, my best market is here and I have sent them of late only to you and a few to Albert Milch." In closing he wrote, "If I were to create any larger demand, I simply couldn't fill it."[14] His watercolors were not only in great demand, but they continued to win prizes. In 1926 a group of his watercolors won a gold medal at Philadelphia's Sesquicentennial International Exposition.

Benson's success as an artist may have made Eleanor somewhat shy about her growing desire to be a painter, but in 1926, following a visit to North Haven, she wrote to her father and told him that she wanted to be an artist. "You certainly did surprise me!" he exclaimed in a letter to her. "Why in the world didn't you begin when you were here and let me help you? I like to think of you trying to learn to paint. . . . It does seem funny that you should break out with this disease after having been exposed to it all your youth. But I think it is a fine interest to have."[15]

Eleanor wanted her art be more than an "interest." She attended classes at the Museum School and, at her father's urging, found a separate studio several blocks from her home. At her summer place, she painted—as her father did—in a studio created out of part of the barn. In both Salem and her summer town, she became quite well known and was in demand as a portrait painter. She wisely realized that she should not ask her own father to be her primary teacher. "There is no such thing as teaching a person anything," he told her. "You may be helped toward learning by a hint someone has given you, but anything you really learn has got to be learned by experience and only by working and solving the problem yourself."[16] Benson became Eleanor's staunchest supporter, as well

PLATE 123
Iris and Lilies, 1922. *Watercolor on paper, 14⅛ ×20⅝". Private collection.*

PLATE 124
Seaside Garden, 1927. *Watercolor on paper, 18 ×23¼". Private collection.*

To Sylvia — F. W. Benson

as her severest critic, and would often stop by her studio and give her a "crit" on her latest work in progress. She wrote his words down to preserve them for the time when she would finally understand what they meant, for, as Eleanor told her daughter, "I often did not understand what he was trying to tell me. I had not worked at my art long enough to know what he meant, sometimes. But he told me that one day, when I had been working long enough, all his words would become clear to me as indeed they have."[17]

For Eleanor, being the child of such a renowned painter was perhaps more of a burden than a blessing. Like her father, she set extremely high standards for herself. When she wondered why she hadn't inherited his natural talent, he told her that his ability had not been innate; he had had to work hard at it. He then curtly added, "Most people think painting is a God-given talent. It isn't."[18]

The two often went on sketching trips together, and he reveled in her growing ability. But she was frustrated by the years needed to acquire the necessary skills to paint well. Becoming a painter was "a product of hard work and intense mental effort and only those can succeed who have the capacity for work and the necessary intelligence," her father told her.[19] Eleanor drove herself hard, trying to succeed and to show her father that she had those qualities. In his later years, Benson's failing health and eyesight limited his work. Feeling that his own time for solving the complexities of art was quickly running out, he despaired of ever being able to pass on to his own daughter all that he had learned in a lifetime of painting; his frustration slipped over into his crits. "Get rid of that purple molasses," he snapped one day in 1944. "You draw things light-heartedly and slap on paint."[20] But, despite his frustration, he was evidently proud of her work throughout his life.

The year that his daughter decided to become an artist was also the year that Benson was awarded one of his most treasured medals. The Pennsylvania Academy of the Fine Arts awarded him its gold medal—its highest honor, given for "meritorious achievement in the field of art." The academy's annual exhibition was the first show Benson entered upon his return from Paris; in 1885 he sent them *The Storm*. Since that time, he had won thirty-three medals and awards, earning the title of "America's Most Medalled Painter." Few awards meant as much to him as this one; but it would not be his last.

It was about this time that Benson began a "snow series," paintings in both watercolor and oils that include some of his most beautiful work. With the beginning of his watercolor period, Benson found that cold weather didn't necessarily have to drive him indoors to paint. In the first flush of enthusiasm for the medium, he wrote to Minnigerode that he went out every Sunday during the winter and painted a watercolor. Their titles reveal travels as close to home as the small towns, marshes, meadows, and rivers surrounding Salem and as far afield as Mount Monadnock, which he had first painted when he summered in Dublin from 1889 to 1893 (see plate 139).

Sparrows and Snow is lively with the antic movements of the little brown birds hopping on frozen branches. *Snowladen Spruce* depicts the graceful shapes that these dark summer sentinels assume when clothed in blankets of snow. Benson was fascinated with the unique colors of shadows on snow: purples and blues, turquoise, and even chartreuse. He painted snow scenes from the time when the very first dusting of snow covered the fallen leaves to as late as April, when the sun reached the last of the snow hidden in the hollows (plate 126).

In sharp contrast to his snow scenes were the desert watercolors he and Eleanor produced on a trip to Arizona in 1928. Benson painted few works on his two trips to the West; the ones from Arizona depict cottonwood and eucalyptus trees, arroyos and desert scenes, little creeks and canyons (see page 11). He returned to Salem just in time for the opening of a one-man show at the Guild of Boston Artists. One critic wrote, "There is a quality of luminosity in the watercolors, a reality that you feel is absolutely true and natural and which nobody else seems to get."[21] A number of these watercolors portrayed scenes from the fishing trip Benson made the previous summer. *On the Restigouche* shows a figure strongly silhouetted against clear light. *Indian Guide* has a simi-

PLATE 125
Following Gulls, *1936. Wash on
paper, 12½ × 16½". Private collection.*

lar theme but with the added details of reflected lights to further define the boatman
and dog (see plate 144). "The guides we employ are all natives of the country and the
one depicted in *On the Restigouche* is a man who has been with me the last five years,"
wrote Benson. "He is of Scotch blood mostly, like many of the New Brunswick people
but with some Indian blood. These men are all keen sportsmen and good fishermen
themselves, and hard as they work poling the canoes up swift rivers, they never want to
go home to camp while there is a chance of another salmon."[22] Benson himself caught
plenty of salmon on his fishing trip that July. He sent several to his family and carried
home an equal number of watercolors. He painted boatmen on the Upper Kedgewick
and a pool on the York River (plate 127). His friends and guides were portrayed dip-
ping a tin cup into the clear stream or gaffing a salmon. The action and movement in
these works is exhilarating. In *Pool on the York,* the fisherman and his guide have pulled
their canoe halfway up on the shore of the river to keep it from hurtling over the rapids
in the foreground. The deep pool carved out by the swiftly moving water before it tum-
bles over the falls was a favorite of Benson's; it is mentioned frequently in his fishing
journals.

His oils of this period are no less dynamic (plate 129). *Gaffing a Salmon* is a large can-
vas of fisherman and guide that portrays the moment when the silvery fish is finally
gaffed after a long fight. The shimmering water offsets the dark figures of the tired
sportsmen; the energy of the moment is well expressed. Destined for its first exhibition
at the Pennsylvania Academy of the Fine Arts annual show in January 1929, it was giv-
en a heavy gold frame. As he had done occasionally in the past, Benson left smudges of
paint on the frame itself; evidence that he was still adding finishing touches to the paint-
ing right up to the moment of crating. The Impressionist approach can still be seen in
Benson's sporting works; the quick, light brushstroke, the importance of the play of
light on the water, the sense of a moment, an impression captured on canvas.

Unlike Britain, America did not have a rich tradition of sporting art. For the British,
such art mainly concentrated on horses, whether racing or hunting fox or other quarry,
and was epitomized by the work of George Stubbs, an artist and anatomist. In America,
portraits of noble animals or still-life arrangements of dead animals, birds, or fish
seemed to be the extent of sporting art until the appearance in 1852 of Arthur Tait's

PLATE 126
Shadows on Snow, *1931. Watercolor
on paper, 14 × 20⅞". Private collection.*

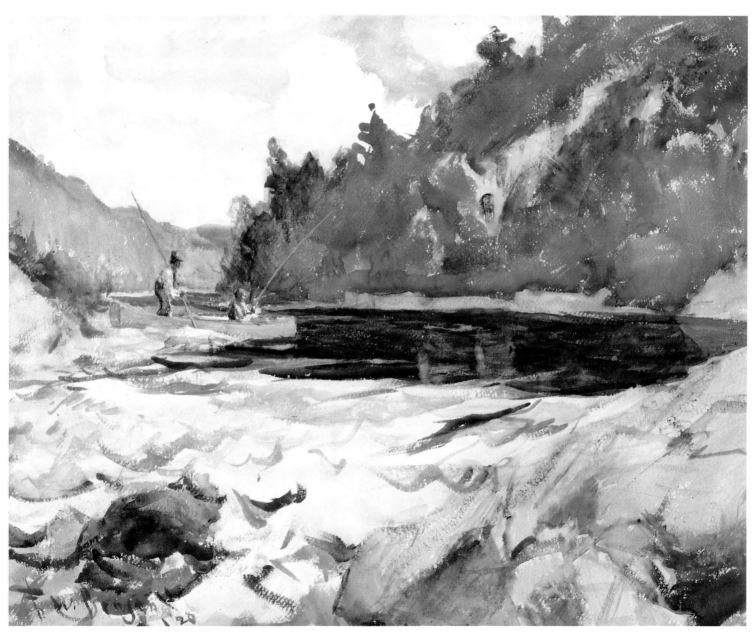

PLATE 127
Pool on the York, *1928. Watercolor on
paper, 19¼ × 24¼". Private collection.*

works of sportsmen, which were reproduced by Currier and Ives. Later in the nineteenth century Homer's sporting watercolors and the color lithographs of A.B. Frost portrayed not the English country gentleman and his prize-winning bull or race horse but the ordinary man engaged in hunting or fishing for food or sport in a truly American setting and manner. Benson's contribution to this field lay in the dynamic presentation of hunting and fishing scenes, the evocation of a mood. As one collector of his work said, "As I grow older, I don't have to go outside to feel the thrill of the shoot, I can just look at my watercolors and be there."[23]

Some of Benson's paintings of this period, especially his large oils, were often more landscape than figure study, more about nature than the people who inhabit it. In *Twilight,* Benson captured that peaceful time of day. The sun has set behind the deep blue hills, whose shadows reach across the water toward the lone figure of a fisherman standing in the stern of his canoe. His oar is poised in midair as he gazes alertly at a point near the shore. Perhaps he has seen a salmon leap, its arcing body throwing silvery spray against the cool evening air. He might be contemplating throwing out just one last line (plate 128).

This is one of Benson's greatest landscapes, for it expresses well his feelings about life in the wilderness. The tiny man silhouetted against a small patch of silver water is insignificant. His being is subordinated to the majesty of the looming mountains and the power of the swift stream. Benson was never happier than when he was outdoors. He worked hard and long to support organizations that fostered stewardship of the land and conservation of its resources. As he grew older, people figured less and less in his works and then only as harvesters of nature's bounty. The creatures of the sea and sky dominate his last works, observed but not captured. By the winter of 1929 sales of Bensons etchings and paintings had reached an all-time high. In the month of January alone, his income was $68,000. His works were seen as close to home as Boston and as far afield as Hungary, where his oil *Against the Morning Sky* hung in an exhibition in Budapest. Amidst this great professional success and prosperity, he could not have known that the age of the gentleman-sportsman, with his private hunting lodge and walls hung with Bensons, was coming to a close. On 29 October, 1929, while fishing in Vermont, Benson learned of the stock market crash on Wall Street.

Although the country's morale was badly shaken, for many months life continued much as it had. The Bensons remained fairly secure; both houses were owned outright and they had no debts. However, past experience had shown Benson one thing: art was the first thing to go. As he told his granddaughter, "People have to have food to eat, clothes to wear and a place to sleep but they don't really need art. It is one of the extras in life"[24]—an obvious yet surprising observation from an artist who spent money as a student on brushes rather than dinner.

Benson continued to send paintings to exhibitions and in January 1930 sent a recently finished still life to the Boston Art Club's exhibition of contemporary American painting. He had gathered together an old Chinese statuette, some fruit, and a little potted orange tree and arranged them in front of a window, through which could be seen a glimpse of snowy landscape. One critic described "the whole thing" as "a harmony of light, color and arrangement."[25] Setting a still life in front of a window was unusual for Benson, who more frequently employed a backdrop of a shimmering silver screen, a bit of drapery, or a wall accented by a painting or mirror. The statue and the orange tree were objects that Benson used repeatedly; the orange tree figured in at least three other paintings. Both it and the statue are seen in Benson's 1930 still life *Oriental Figurine* (plate 134).

In March 1930, the Jordan Marsh Galleries hosted an exhibition of works by contemporary New England artists. Keeping the title of the show in mind, Benson chose to hang *Essex Marshes,* a new painting of the marshes near his home. The critic for the *Globe* stated that out of two hundred paintings in the show, only one was actually needed to make an excellent exhibition:

> It is a view of the marshes through which the river winds its silvery course to the sea. . . .
> The . . . cool, delicate, shimmery glow of the sun, which has not yet reached the horizon,

floods the sky. The solitary wild duck has risen in uncertain flight and is the only living object to disturb the spacious silence of the scene. The spirit of the dawn is in it. It is simple but it is a masterly bit of painting and it will surely live as one of the great American paintings of all time.[26]

Benson loved to paint at dawn. The titles of many works reveal his fascination with the pale light of early morning. In his younger days hunting on the marshes near Salem with his brothers and Dan Henderson, Benson had spent many a chilly hour waiting for the sun to rise and the birds to fly. As a painter, the luminous quality of early morning challenged him time and again. Sunset likewise inspired Benson; at least ten of his works use the word "sunset" in the titles. Interestingly, Philip Hale's daughter, Nancy, recalls one of Benson's former students telling her that Benson had stated that sunsets were impossible to paint and advised her not to bother trying.[27] His own success with the subject would indicate that at some point he must have changed his mind . . . or maybe he just kept on trying to get it right.

In late March 1930, Benson cruised the Florida Keys on a one-hundred-foot yacht. His letters home describe a luxurious vacation in lavish surroundings. Though his vacation was a lazy one, Benson completed several watercolors. In *Souvenir of Florida*, one can almost hear the gentle lapping of the water as two fishermen doze over their lines, their boat scarcely interrupting the delicate horizonless unity of sea and sky (plate 132).

Such luxurious living was quickly drawing to a close. The collectors who had lined up for Benson's latest oils and watercolors were beginning to sell off their paintings. Gentlemen-sportsmen who had standing orders for each new Benson etching dissolved their collections. Benson's total yearly income for 1930 was only slightly more than he had made in his best month in 1929. He appears to have been right when he told his granddaughter, "Art is the first thing to go." He continued to send paintings to shows but made few sales. When Robert Macbeth asked the price of a painting Benson had recently sent him, Benson replied that it was five thousand dollars, then added dejectedly, "I don't know if anyone in New York City has that amount of money left, but that's the price."[28]

Despite the weakening economy, the spring of 1930 was a busy time for Benson. He sent two works to the Boston Watercolor Society's annual show, donated *The White Heron* to a benefit sale for the Museum School, and sent a collection of oils, watercolors, and etchings to the Milwaukee Art Institute for a one-man show of his works. In addition he sent *River in Flood* to the National Academy (plate 131). This stunning oil of two men poised to launch their canoe into the swirling rapids had been seen at the Corcoran as well as the Carnegie Institute's annual exhibition and was included in his one-man show at the Guild of Boston Artists before it traveled across the country with Seth Vose of the Vose Galleries of Boston. Purchased by the International Business Machines Corporation, *River in Flood* was displayed at the 1939 World's Fair in IBM's Gallery of Science and Art. On the walls hung works by an international group of artists such as Jonas Lie, Maurice de Vlaminck of France, Duncan Grant of Scotland, and John Keating of Ireland. Ten cash prizes were awarded and each artist represented in the exhibition received a personalized bronze medal. *River in Flood* was voted the second most popular painting in the People's prize competition. This painting was further singled out for critique and discussion in a short film made of the exhibition. *River in Flood* remained in IBM's collection for over thirty years and was one of its most frequently loaned works.

Only thirty-five years before, Benson also won praise and two gold medals for his work at the landmark Louisiana Purchase Exposition held in St. Louis. Those prizes were also for outdoor work, only of a very different kind. For those who think of Benson in terms of nineteenth-century genteel art, the four paintings he hung in St. Louis (*A Woman Reading, Summer, The Hilltop,* and *The Sisters*) were quintessential. However, though such subjects might have been passé in the late 1930s, Benson's current works were not. To be selected a people's choice at a fair in the mid-twentieth century is indication enough that Benson's longevity and adaptability allowed him to garner popular acclaim as well as critical recognition. He did not have to be a "modernist" to be modern.

In 1930 Boston celebrated its three-hundredth birthday. Held in Horticultural Hall,

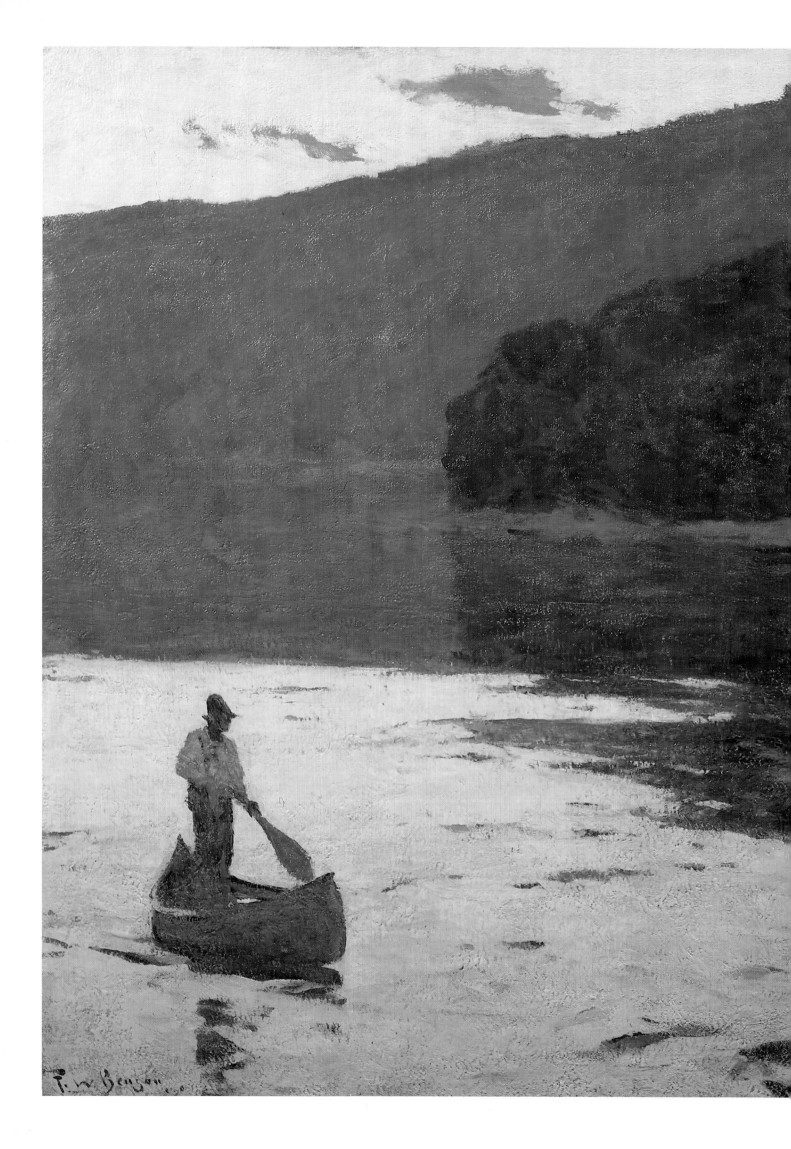

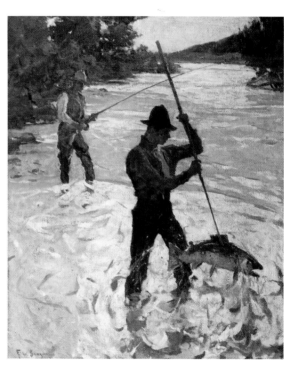

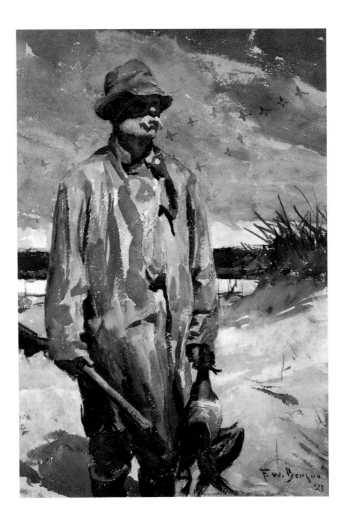

PLATE 130
Old Tom, *1923. Watercolor on paper,
20$\frac{1}{16}$ × 14$\frac{1}{16}$". Museum of Fine Arts,
Boston.*

the Boston Tercentenary Celebration involved many of Benson's old friends. Several of his classmates and fellow teachers from the Museum School hung works beside Benson's oil *Down on the Marshes* and his watercolor still life *The Orange Tree.*

Tarbell was represented and Philip Hale contributed art criticism to the book that accompanied the celebration. The gathering of many of Benson's old Museum School friends was a reminder to him of his concern about the school's direction. He and Tarbell had been actively involved on the council for many years. In 1930, when a fellow council member suggested that the sculpture department might benefit from some guest instructors, the faculty vehemently objected. The ensuing debate obviously rekindled the anger that Benson and Tarbell had felt in 1913 when an "outsider" had been brought in to run their school. Despite Benson's belief that the "Council must have confidence in the men they had placed at the heads of the departments," the council voted to invite guest lecturers.[29] Given these statements, it must have come as no surprise to the council when resignations from both Benson and Tarbell were read at the October meeting. Despite tactful assurances that they would always maintain a strong interest in the school and its affairs, the two proud and principled men felt they could no longer be part of an institution where the respect accorded the teachers and the sanctity of their relationship with the students was not valued. Benson wrote that it seemed fitting, that as he and Tarbell "had come into the school together in 1889, they should now leave at the same time."[30] The following year, the death of their old comrade Philip Hale marked the end of an era. After the turbulent school year of 1912–13, only Hale had remained among the senior instructors; he had continued to teach until his death in 1931. The following year, Benson wrote of his high regard for Hale: "He was a great teacher and he loved to teach to the detriment (I think) of his work—that is, he gave too much time to teaching, but his heart was in it and younger people got the benefit. . . . There must be thousands who owe a great part of what they know to him."[31]

As the effects of the Depression deepened and Benson approached his seventieth birthday, the number of annual exhibitions in which he participated began to dwindle. In 1931 it appears that only the Pennsylvania Academy received a painting from him for

their yearly show. His calendar for that year, however, shows a respectable five one-man shows, mostly etchings and watercolors. But despite critical acclaim, sales of Benson's work declined. That August he wrote to Eleanor rather despondently, "I can't seem to get any work done this summer and I couldn't sell it if I did, though I am just as anxious to do it."[32] A list of works assembled during the research for this book indicates that Benson's artistic output dropped in the early 1930s: in 1932, his etchings numbered only six, and he appears to have done only one oil, compared to the five previous years when his yearly output of oils averaged at least nine. Even watercolors, which he could dash off so quickly, dropped in number. During the 1920s, twenty watercolors were often documented for each year (and, based on information from exhibition records, another twenty more may have also been executed annually). In 1932, however, only two watercolors are known to have been completed.

Despite the grim news of layoffs and cutbacks, foreclosures and liquidations, the Boston Post devoted an entire page of its Sunday paper to a review of the newly released book from the Crafton Collection's "American Etchers" series. The volume on Benson was the last of the series and, many felt, the best of the twelve. Benson's devotion to the sporting life is clearly conveyed in his etchings. From his vivid whites to his velvet blacks, from spare, orientalist compositions to skies crowded with ducks, the range of Benson's etchings and drypoints continued to surprise all who saw them. One of the etchings featured in the little book was a reproduction of Old Tom. By the time this etching had been done in 1925, Tom Nickerson, the longtime caretaker of Benson's house on Nauset Marsh, had been dead for many years. The etching was undoubtedly copied from the 1923 watercolor Benson had painted of Tom in the same pose (plate 161). Both were based on affectionate memory and perhaps some sketches or photos. Tom made a picturesque and commanding figure in his flapping oilskins with his gun clasped firmly in one hand and a dead goose dangling limply from the other. The editor of the Crafton Collection book, Charles Morgan, called the etching "one of the most majestic figure subjects ever etched which for eloquence and power can only be compared with the greatest of Millet's powerful presentations of the human form."[33]

It is amusing that by 1932, when Benson hung six oils at the John Hammer Gallery in Detroit, the show was paradoxically titled "Paintings Made by a Famous Etcher." The critic for the Detroit News actually had to explain to his readers that, indeed, Benson had initially won his fame as a painter of portraiture, landscapes, figures, and still life before embarking on his career as an etcher: "His later exploits with the copper plate have become so well known that many persons never think of him as a painter, if in fact they even know that he ranks with the leading academicians in this field."[34] Despite the slow market for art in New York City, Benson hung a one-man show at the Grand Central Art Galleries in May 1932. He selected fifteen watercolors as well as nearly all of his rare etchings. Calling him the "greatest and most successful of living etchers," the critic for Art News added: "The fact that his watercolors are appreciated equally by collectors, fishermen and duck hunters testifies to his greatness in this medium both as regards technique and knowledge of field and stream."[35]

Benson welcomed opportunities to show his work, but the number of requests for one-man shows was decreasing. Nothing seemed to be selling anywhere, and gallery owners simply couldn't afford to stage exhibitions. Many were simply closing their doors. In 1926 Benson had written to Robert Macbeth of his watercolors, "I had several others but people saw them and bought them about as soon as they were dry—I sold eight last week and you get what you have because I hid them."[36] Such tactics were no longer necessary. By the autumn of 1933, Benson commiserated with Albert Milch, "I am sorry to hear things are going so poorly with you, but it is pretty near universal and I hardly expect to be here long enough to see the end of it. I try to be happy over the good days I have had and still think myself fortunate."[37]

One group that continued to show its work during the Depression was the Boston Watercolor Society. For many years, these exhibitions were held at the Vose Galleries, a large, four-story building on Boylston Street, opposite the Trinity Church on Copley Square. Robert Vose, Jr., recalled, "Each painter was allowed to bring three pictures to

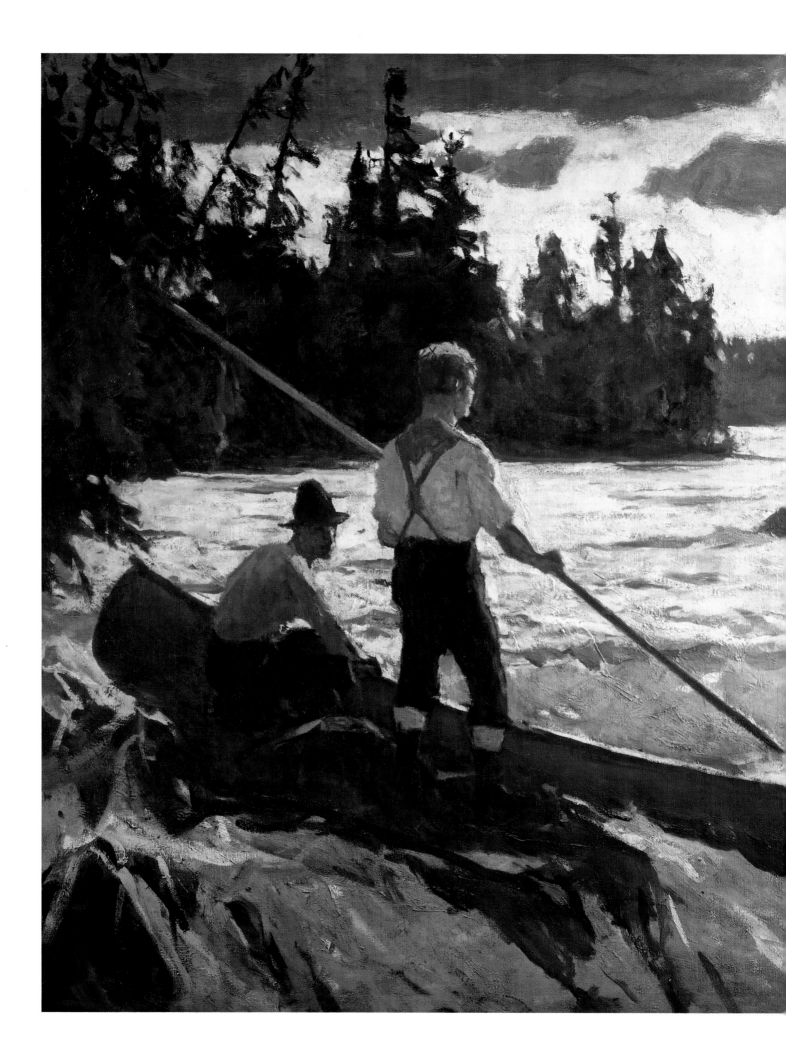

PLATE 131
River in Flood, *c. 1928. Oil on canvas, 36 × 40". Collection of Mr. and Mrs. Stephen Sloan.*

PLATE 132
Souvenir of Florida, *1930. Watercolor on paper, 19 × 24". Private collection. Painted while Benson cruised on board the* Pilgrim, *this watercolor captures the shimmering heat of noonday off the Florida Keys.*

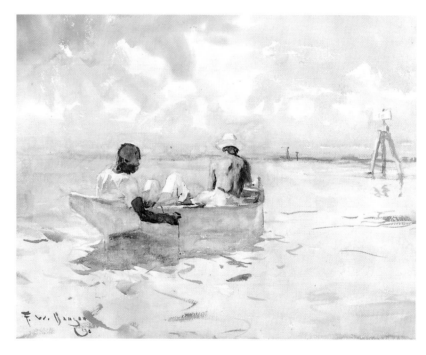

the show and Benson always had the three center pieces. They were always the most expensive watercolors in the show and always the first ones to sell, just like clockwork."[38]

During the spring of 1933 Benson showed etchings in three galleries. The Corcoran Gallery of Art and Brendann's Gallery in Baltimore both had one-man exhibitions of his work, and the print department at Grand Central Art Galleries hung several of his etchings and one of his newest experiments, a lithograph. *Art News* declared "By all the signs, he should find as immediate a response among collectors to this new phase of his work as that which has characterized his superlatively successful career as a designer of sporting prints."[39]

Although Benson may have begun working on lithographs in the early 1920s, the Grand Central Art Galleries appears to have been the first gallery to exhibit one. He is only known to have made seven lithographs: six of wildfowl and one of a still life. The latter, an arrangement of petunias in a pewter vase, is the rarest; only six prints were pulled from the lithographic stone (plate 133).

The first three lithographs, including this still life, were printed by the well-known lithographer Bolton Brown. It is not known who printed the last four. It is quite probable that Benson did the work himself, just as he had with his etchings. Compared to his etchings, Benson's lithographs have a softer quality, the lines are broader and they are closer to paintings than either etching or drypoint. It is a loss to the art world that Benson did not continue with his work in this medium. Brown was disappointed that Benson did not pursue lithography. In his autobiographical essay, Brown wrote:

> I thought something worthwhile really was going to happen when Frank Benson wrote me. I fixed him with stones, crayons, and a few remarks and he made an experiment or two. And then I heard no more of it. He could make ravishing lithographs if he would only learn how. But he did not seem to have any idea of learning lithography. His idea was simply to do as he had always done only do it on stone. I printed him two or three editions. They were as nothing compared to what he would have done if he had kept on.[40]

It is not known just why Benson stopped working with lithography so soon after he began. It may have been that the process was too precise: the images on the stone are reproduced just as they are drawn. With oils, he could scrape off the paint and start over; in etching or dry point he could correct unwanted lines; he could crumple up watercolors as soon as it was obvious they were going badly. The heavy lithography stones, however, accepted the greasy crayon lines and were not forgiving. There is possibly another explanation: by 1931, when his last lithograph was done, he was bothered by attacks of vertigo. An inner ear condition left him unsteady on his feet. Working with the very heavy lithography stones could well have been impossible for the seventy-year-old Benson.

PLATE 133
Still life, *1927. Lithography on paper, 22 × 18". Private collection.*

Benson let little get in the way of his fishing, however. Despite his vertigo, he made his annual trip to Canada. Staying at Camp Harmony in New Brunswick, Benson caught forty-four fish in eleven days in the summer of 1933. But, after 1934, there are no more records of Benson's treasured weeks by the banks of a northern salmon stream. So many of his old fishing chums had died and Benson was probably feeling his age as well. Childe Hassam passed away in 1935 leaving only Benson, Tarbell, and Dewing to carry the standard of The Ten. Nonetheless, it must have been a wrench to end the yearly pilgrimage that began so long ago when he wrote to Dan Henderson in 1895, "Salmon fishing seems to me the finest sport in the world."[41] The dozens of canvases and watercolors that had been inspired by these yearly trips had delighted collectors and gallery-goers for two decades. Although paintings and etchings with titles

PLATE 134
Oriental Figurine, *1930. Oil on canvas, 32 × 40". Private collection.*

such as *Trout Fisherman, Man Poling a Canoe,* and *The Guide* were executed well into the 1940s, these appear to have been done from sketches or memories.

His annual fall shoot probably ended about this time as well. Despite titles that would suggest certain paintings were done while Benson was on a hunting trip, it seems that his annual fall journey to Canada or the marshes of the mid-Atlantic coast ceased in the early 1930s; there is no mention of such trips beyond that time. Perhaps paintings of the late 1930s with such titles as *Duck Hunting, Retrieving Geese,* or *Setting Geese Decoys* were caught with what one critic called his "snap-shutter eye" and stored in his memory as future subject material. The images of his life as a sportsman lingered long in his memory and his paintings of that life continued to give pleasure, though the trips themselves had come to an end.

One of his wildfowl paintings became the 1934 Temple Fund Purchase winner when it hung at the Pennsylvania Academy of the Fine Arts. In light of the Depression, the academy asked Benson for the "very best price at which you would be willing to sell."[42] Benson responded "In consideration of present conditions, I put the price of my picture . . . as low as I could and very much lower than I have sold my pictures in the past."[43] Fortunately for the people of Philadelphia, the academy agreed to meet his price. It is their only Benson painting.

It appears that this was one of very few paintings that Benson sold in 1934. The man whose yearly income had once reached well beyond six figures and who once despaired of being able to keep up with the demand for his work was at the lowest ebb of his professional career. Not only was 1934 a low point for Benson financially, it seemed to be a low point in his faith in the integrity and values of the American art world. His abhorrence of recent trends in art had been mounting. European artists and their many "isms"—Cubism, Fauvism, Vorticism—were being enthusiastically embraced by American collectors. The search for truth in art, so long of central importance to Benson and his fellow members of The Ten, seemed to be abandoned in favor of theorizing and expressionism.

Benson was obviously disheartened by the direction art was taking in America. To him, the lowest blow was what he perceived to be a legitimization of modernists whose works were included in the annual exhibitions at major museums. Benson had also grown up in an era of privately sponsored shows and group exhibitions; he could not understand or adapt to the idea of government funding of artists via the WPA program. In July, Homer St. Gaudens, director of the Carnegie Institute, wrote to Benson that he was counting on him, as usual, to send something to the institute's annual fall exhibition. Benson's depression and frustration with the current state of affairs are evident in his terse reply: "I shall not send any work this year to the Carnegie Institute. What I do is so outside the trend of the painting encouraged by the exhibitions at present that I feel it would be quite useless for me to contribute."[44]

Obviously distressed by Benson's response, St. Gaudens wrote back immediately,

begging him to reconsider: "We need you very badly in our exhibition. We are not trying to set forth any trend, but all trends; and if a man of your importance disappears, the whole structure of our efforts collapses. For, we are not preaching any sermon, but setting forth a situation." Appreciating the depth of Benson's feelings about the current art scene, St. Gaudens admitted to a similar feeling of dismay: "You must know, too, that I, virtually born in my father's studio, am happier when I think of work of your type than when I gaze upon so much else of that which passes before me these days."[45] But Benson was adamant; he wanted no work of his to hang beside the works of the modernists.

The tone of Benson's letter is uncharacteristically bitter and can perhaps be traced to a spell of bad health and the effects of the Depression. Nonetheless, this letter illustrates his reaction to the modernists. He was not alone in his distaste. The following year St. Gaudens, perhaps reflecting on Benson's letter and others like it, wrote to Thomas Dewing saying, "I [had an] inclination to write you . . . because it makes me reminisce a bit of other days and other manners, of a time when art was gracious and the ultimate end of decoration was to charm and not to inflame the spirit. Sometimes, when I view the results of our annual show here, I feel as though I could qualify as an impresario for latter day prize fights or wrestling matches. . . . I become a little bilious in my occupation of 'handling' champions of garbage pails or virtuosos of pictorial calliopes who vomit shrieking steam up and down our galleries."[46] The following year St. Gaudens again attempted to persuade Benson to try to understand the position of museum directors: "What I am struggling so hard to do is to maintain a balance of all the various kinds of painting and, if the outstanding men of one group fail me, naturally the result looks as though it were propaganda for the other—which is not the case at all." Having seen Benson's sporting oil *A Northwest Day*, he added, "We need you, very badly indeed; and having seen the fine work by you at the Corcoran, I am even more eager to assure myself that we can have you on our walls this fall."[47] But Benson never again sent a painting to the Carnegie's annual fall show.

Benson was far from alone in his dismay over what he viewed as the deplorable state of American art. A letter carefully saved in his artist's scrapbook is the first of many between him and critic Lucien Price, a man with whom he obviously felt a kindred spirit. It read: "Your fight for honest craftsmanship is my fight. Our period has bred an intellectual proletariat irrespective of economic losses which produced a demagoguery of quacks and all the arts must fight for the integrity of their standards. . . . I do think it is profoundly significant that the Boston artists are to be found sticking to their guns."[48]

In 1934 Benson resigned from the American Institute of Arts and Letters despite several letters urging him to stay. A charter member of this organization since its inception in 1898, Benson gave no reason for his resignation. In 1904 the institute had formed an offshoot, the American Academy of Arts and Letters, whose membership was limited to fifty persons chosen for special distinction from the membership of the institute. By 1934 most of Benson's friends had been elected to the academy; he had not. For an artist of such stature, such an omission is astonishing. One can only assume it was an oversight. However, one wonders if Benson's resignation was a gesture of protest that he had not been nominated to the academy.

Within five years, many of America's museums were deaccessioning works by members of The Ten. Paintings by Benson, Tarbell, Weir, and other turn-of-the-century painters were put on the auction block to allow purchase of newer, more modern artists. *In the Woods*, the work that is considered the first of Benson's Impressionist period, was sold by Smith College. *A Summer Afternoon* was auctioned by the St. Louis Museum of Art. *Autumn*, which Frank Duveneck had once urged the Cincinnati Art Museum to buy, disappeared from its walls.

Such losses may be deeply regretted now, but by the 1930s the work of The Ten was out of style. In 1942 Royal Cortissoz wrote to Benson, "There has never been such a group [as The Ten] since and there is no sign in these chaotic days of there being another one like it."[49] But, while men like Cortissoz were reluctant to acknowledge it, the time for the group's aesthetic was gone. So were most of the members of the group. By 1938 only Benson was alive to carry on the tradition.

CHAPTER 12

TWILIGHT

lthough records show very few works completed by Benson in 1935, his interest in his art was still very strong. Quoted in an interview in the *Boston Herald*, he said, "I am seventy-three you know, and in this work of painting I see as many things ahead of me to master as I did when I was a young fellow just starting out."[1] Benson's never-flagging love of new challenges, combined with hopefulness brought on by a slight increase in his professional income, caused a resurgence in his work in 1936. Gus Mayer had invited him to show his etchings in New York that year, and the response to this exhibition undoubtedly prompted Benson, who had done no work with the copper plate for three years, to return to etching. The opening of Benson's show entitled "Rare Trial Proofs and States of Prints" at Mayer's gallery in New York City brought positive reviews from the New York press. One critic wrote, "Chickadees seen in trial proofs and completed state is one of the most pleasing works in the exhibition, a pattern of birds and leaves against the sky, almost Chinese in its delicacy."[2]

The reception to his show may have encouraged Benson to experiment once again in black-and-white watercolor as well. When his striking monochrome wash drawings made their first appearance in 1912, they received much acclaim and dominated his work in watercolor until the first showing of his colored watercolors in the fall of 1921. Benson's colored works were so popular that they almost totally eclipsed his wash drawings; fewer than a dozen washes had been executed since 1921.

Once Benson decided to take up this expressive medium again, a whole new body of work was quickly produced and exhibited at a 1936 fall show at the Guild of Boston Artists. It was a triumphant affair, his first one-man show at the guild in two years. Praising the thirty-four new drawings that hung on the walls of the guild, the critic Arthur Philpott wrote, "To the great ornithological work that Wilson and Audubon did in America 100 years ago Frank W. Benson has added something imperishable—an artist's dream they knew not; a knowledge of bird flight which places him in a class by himself."[3]

The action and movement of dozens of various birds were caught by Benson's brush as they hopped about in the snow, followed a fisherman's dory, settled into the water, roosted in trees, or soared in the sky. Widgeons, dowitchers, yellowlegs, turnstones, crows, and even the lowly gull were on display. One of the most dramatic of Benson's new works was *The Chase*, which portrayed a tiny bird being pursued by a large hawk. The terrified flight of the smaller bird and the headlong rush of the oncoming pursuer are vividly conveyed by the sure strokes of Benson's brush. In marked contrast to the open, spare composition of *The Chase* was another of the new wash drawings, *Flocking Blackbirds* (plate 137). The paper is crowded with the dark shapes of migrating blackbirds; they fill the air as far as the eye can see. The mood is distinctly orientalist; the grasses and reeds could have been executed with a rabbit's-hair brush by a Japanese master. Middle tones are sparingly used to convey the sense of a lowering sky, and a stark contrast of black against white is maintained through most of the picture.

PLATE 136
Woodcock, 1946. Watercolor on paper, 20 × 15½". Private collection.

213

These new wash drawings differ from Benson's work of thirty years before. The strokes are broader, the use of black more prominent, the brushwork more dramatic; they are more robust. The hundreds of colored watercolors that had superseded Benson's wash drawings had given him a confidence and mastery of the medium that had changed his style of wash drawings perceptibly.

Benson was delighted with the reception to his work. Writing to Albert Milch he noted: "Some twenty-five of the drawings were sold and others are going as people who heard of the show drift in. . . . Lately, I have sold alot of watercolors over the country, so it seems that prospects are reviving."[4] The following fall, Sylvia had to turn down another of Milch's requests for her father's work saying, "It so happens that many of my father's watercolors were sold recently and there are more demands to show them than we can fill."[5] The pleasure of being unable, once again, to fill the demands for his work sent Benson's spirits, as well as his artistic output, soaring. During the next four years he made many wash drawings and, according to exhibition records, an average of ten watercolors each year.

In 1937 Benson exhibited in at least seven shows, including a one-man exhibition of his watercolors at the University of North Carolina. When he sent four watercolors to the exhibition of the American Institute of Sporting Art, that society invited him to be honorary president. Benson also accepted the invitation of the Museum of Fine Arts in Boston to have a retrospective showing of both his work and that of Edmund Tarbell. The invitation came as quite a surprise to Benson. As he wrote to G. H. Edgell, the director of the museum, "I realized at once that it gives me the best possible opportunity that I could have to see in one group the work I have done in the past fifty years."[6] Tarbell was just as enthusiastic about joining forces with his old friend to produce what would be the best and most comprehensive retrospective of either man's work. Ordinarily, the museum did not make a practice of having shows of the work of living artists. But as Edgell wrote Benson, "It has always seemed to me a little ghoulish to insist on waiting until a man is dead and can get no satisfaction out of it, and then have an exhibition of his work."[7] Edgell may have regretted such words. By June, Benson had developed bronchitis and wrote in the Wooster Farm log that he returned home to Salem "intending to die if [he] didn't get better." Benson did not die, but his close friend Tarbell did. In his weakened condition, the shock of Tarbell's death threw Benson into a deep depression. Benson wrote in the Wooster Farm Log, "Ned Tarbell died August 1 and that made a dent in the summer for me. Did no work to amount to anything and the summer was a hollow one."[8] In mid-August, Benson consulted with Tarbell's family; all concerned felt that Tarbell would have wished to have the exhibition take place as scheduled, rather than to hold a memorial showing of his works alone. It was fitting that the man with whom Benson shared his first one-man show should share his last.

When the retrospective opened in November 1938, Benson's and Tarbell's indelible imprint on the direction of art was clearly visible through the historical perspective afforded the viewer. Regarding these two men as the finest examples of excellence that New England's artistic community could offer, one critic wrote, "The exhibition bears witness to the sanity in art of which we have heard much defense." He also observed, "Although the exhibit is more Benson than Tarbell, it is Benson's wish that the whole be regarded as a tribute to the memory of his friend." Although Tarbell's material was already well organized and many of the paintings had been selected by him, his untimely death may have prevented him from gathering together a larger showing of his work. Apart from comparing the numbers of works shown by each, a critic compared and contrasted the work of the two artists: "Tarbell's fine art looks backward and Benson's is amazingly abreast of its day. Tarbell's is that of an era just past. . . . [Benson's] art refuses to age, and it is his latest work, by way of miracle, that is his youngest. There is another difference. Tarbell is a seeker of sunlight for his pictures, it is Benson who really captures it." Many reviewers felt that Benson's wash drawings were among the most fluent and expressive items in the show; his status as the "Dean of American Etchers" was reaffirmed.[9]

214

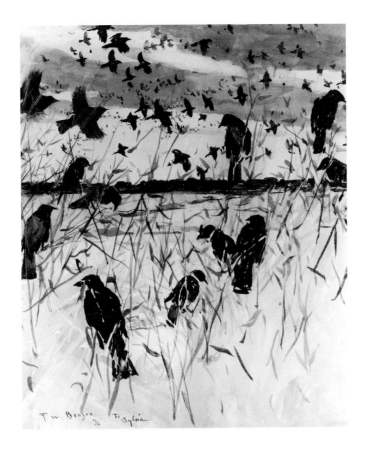

PLATE 137
Flocking Blackbirds, *1936. Wash drawing on paper, 19¼ × 16". Private collection.*

After the show, sales of Benson's work increased dramatically. He sold the water-color *Chickadees* to a fellow lover of nature, the poet Robert Frost. As he wrote to a friend, "The reception given to our show has given me a great kick and I am hoping again." Such renewed hope made him regret his actions of the previous spring. Recalling how he had reduced drastically all the prices on his etchings and destroyed most of his plates, he added, "My judgement was poor in destroying many of the plates . . . [but] I was so ill at the time that it seemed the best thing to do . . . I didn't want them to come into the hands of others. . . . Now, I'd give all my old shoes to have the lot of them back."[10]

Tarbell's death deeply affected Benson. In September 1939 he wrote to all the major museums in America offering thirty-four oils and two pastels for sale on behalf of Eme-line Tarbell saying,"Mr. Tarbell was one of the outstanding painters of his day; it is fit-ting that there should be examples of his work in each of the Art Museums of America. It would now be possible to obtain these pictures."[11] Few museums responded; many already had Tarbells on their walls. The Smithsonian's response was typical: they had no funds available for purchasing new works and they already had four portraits by Tarbell.

Many of these museums had traditionally sponsored international exhibitions, but the effects of the impending war in Europe forced them to change the scope of their an-nual shows to a more American orientation. Homer St. Gaudens, who had so persis-tently tried to convince Benson to exhibit at the Carnegie Institute's annual internation-al exhibition, visited him in the hopes of obtaining a painting for the Carnegie's upcoming show, "Survey of American Paintings." When Benson learned the names of some of the other exhibitors (and was relieved to see they were not the despised mod-ernists), he agreed to have a large still life included in what St. Gaudens had promised would be a "really important" show.

But for Benson, the truly important show of 1940 was a celebration of his twenty-fifth anniversary as an etcher, sponsored by the Friends of Contemporary Prints at the King Hooper mansion in Marblehead. The *Boston Herald* predicted it would be an "Orgy of Etching" in honor of this dean of American printmakers and announced that "some of the country's greatest masters of the etching needle . . . will combine to give an en-lightened demonstration. Each will be installed in a separate room . . . and each will un-dertake to make a complete print during Saturday afternoon and evening."[12]

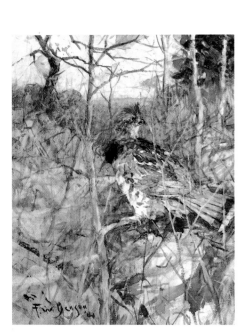

PLATE 138
Camouflage, *1941. Watercolor on
paper, 20 × 16". Private collection.*

PLATE 139
Snowy Hill, *1946. Watercolor on
paper, 16½ × 24½". Private collection.*

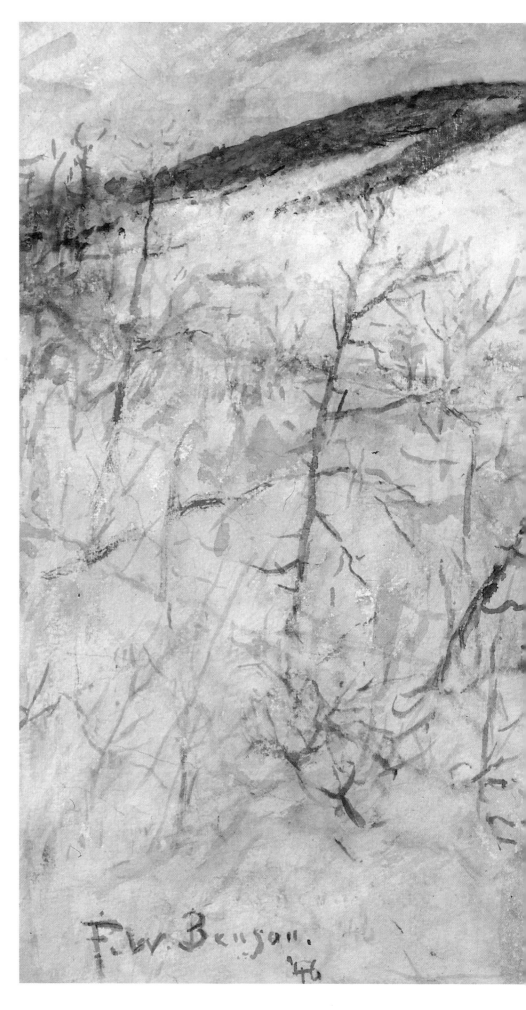

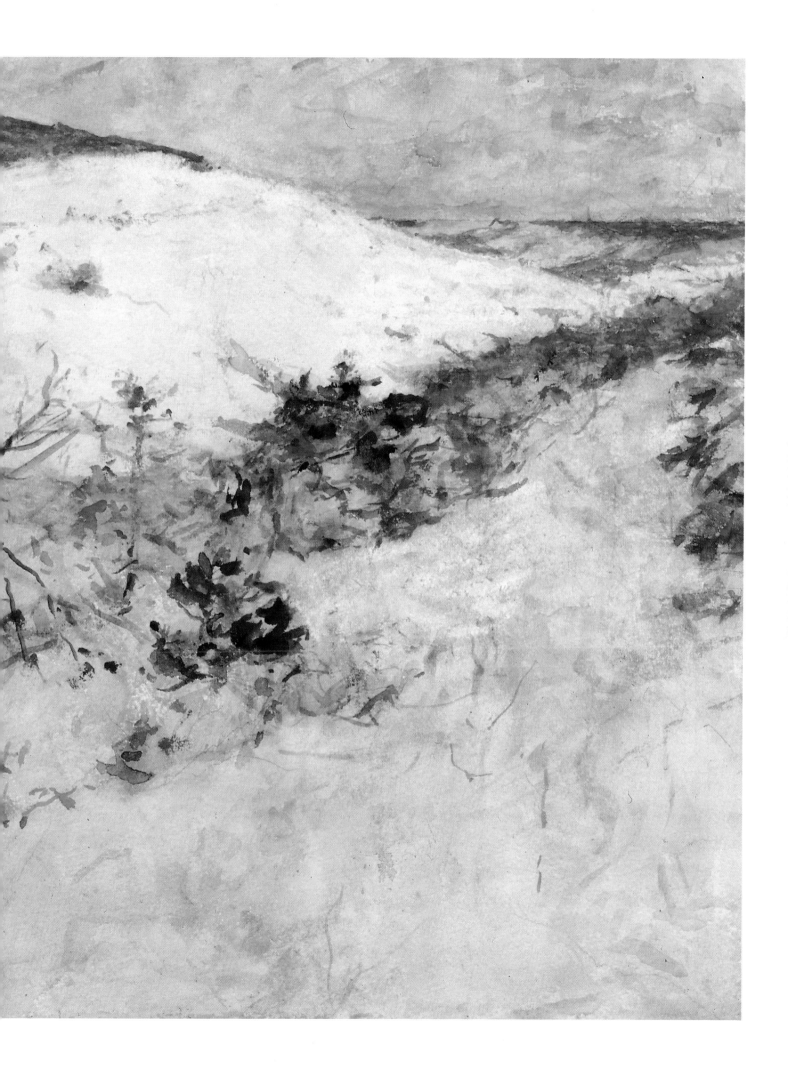

Samuel Chamberlain, a friend of Benson's from Salem, was one of the participants. In his book *Etched in Sunlight* he re-created that rather frantic day:

> John Taylor Arms brought his printing press [and] . . . demonstrated the art of pure etching as only he could do. . . . Arthur Heintzelman made a drypoint of a round faced little boy. . . . Thomas Mason, the gifted engraver from Connecticut, executed a delicate copper engraving and I made a soft ground etching of the King Hooper Mansion itself. For a plate printer we had the very best . . . Kerr Eby, whose dramatic etchings of World War I made him famous. He pulled prints from all four demonstrations under the friendly gaze of Frank Benson.[13]

Although Benson's etchings are catalogued in the Paff volumes, Benson himself had kept track of his watercolors since 1921 by assigning each a number (plate 140). In 1941, Benson apparently discontinued numbering his watercolors, but he did not stop painting them. During the next decade, he created at least forty-seven more. In light of his prodigious output in a medium which at times became almost an obsession, it is amusing to recall his earlier feelings about watercolors. He told a reporter that he had initially considered them "sort of lady like, not vigorous enough."[14] He said, "I had always looked upon watercolors rather indifferently, most of the ones I had seen had been soft and pretty. But, I came to realize that the medium was one which could be exceedingly strong and expressive."[15] In the nearly twenty years since Benson first seriously turned his attention to watercolors, he had listed and numbered 567, the equivalent of painting at least one watercolor every other week. This number does not take into account the paintings he gave to friends or the ones that were bought so quickly that he did not have time to name or number them. Recalling his lament that casual visitors to his house often snatched paintings off his easel before they were even dry, Benson's list of watercolors may be dozens shy of the true numbers he produced (plate 139). One watercolor, completed in 1941 and aptly titled *Camouflage*, demonstrates clearly the effect Abbott Thayer's theories of natural coloration had on Benson's studies of birds (plate 138). In some of Benson's works, the representation of the bird's coloration and its natural habitat is so accurate that it is difficult to see the subject! The author's list of works that Benson completed during his career (not including prints) currently numbers over eighteen hundred and is still growing. Equally amazing is that, except for the paintings he kept or gave to his friends and family, almost every work Benson ever did was sold during his lifetime. "Such things as I have produced ought to last anyway," he once wrote to Eleanor, "and I think myself fortunate to have had so much good fortune."[16]

Galleries and museums continued to ask for one-man shows of his work. Guy Mayer, having found Benson to be an extremely popular artist in New York during the show of his prints in 1936, staged another exhibition in November 1941. This time, the gallery included a large selection of watercolors as well. One of these paintings, *A Good Day for Ducks*, portrayed a group of ducks struggling against the hard slant of a rain. Inscribed to Dr. John C. Phillips, it was used as the frontispiece to Dr. Phillips's book, *The Natural History of Ducks*. Phillips and Benson had been longtime friends; together they founded the Essex County Ornithological Society. Both were members of the Long Point Hunting Club—although Phillips shot only pictures, not birds.

It may well have been *A Good Day for Ducks* that the New York critic Royal Cortissoz found so charming when he reviewed the Mayer show for the *Herald Tribune*.

> In mid-career [Benson] adopted the etching needle and immediately achieved a new distinction. This was due in large measure to his brilliance as a craftsman, but it was due also to a rather curious circumstance. He had been an ardent sportsman, an expert duck shooter and he carried into the world of such a man all the faculties of an artistic observer. Nature, by chance, met him halfway. The flight of ducks makes a pattern against the sky and into this pattern Mr. Benson has added felicity of composition.[17]

Unlike many of his contemporaries, Benson appears never to have done any illustration work, although several of his paintings were reproduced in magazines and even used as covers. In addition to the frontispiece for Phillips's book on ducks, Benson did a watercolor of a woodcock for Phillips's later book, *Classics of the American Shooting Field*. This little bird was one of Benson's favorites, and he painted it often (plate 136).

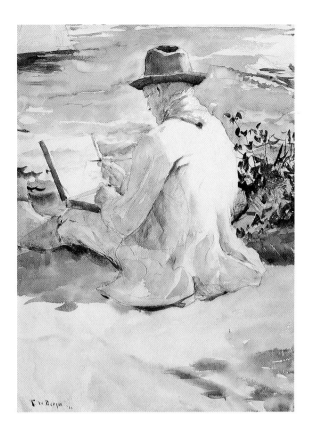

PLATE 140
Portrait of Willard Metcalf *(Artist's title:* Metcalf Painting*), 1921. Watercolor on paper, 20 × 14". Colby Museum of Art. Gift of Mr. and Mrs. Ellerton M. Jette. This painting marked the beginning of Benson's watercolor period, a thirty-year span, during which he produced hundreds of works.*

Perhaps the closest Benson ever came to illustration was a set of wash drawings he did for a small book entitled *The Concord River: Selections from the Journals of William Brewster.* The Concord was an ornithologist's paradise. Benson had canoed its length, from the marshes of central Massachusetts to the Atlantic, several times and was inspired by the writings of Brewster. His watercolors of many of the species seen along the river's banks—grouse, chickadees, crows, woodcock—were as close as he ever got to fulfilling his boyhood dream of being an illustrator for ornithologic texts. It is our good fortune that, after his many years of training, Benson's interests in painting diverted him from his original goal.

It is curious that Benson never published writings about his art. For many years he had been asked to publish his memoirs, to philosophize on paper, to write a book on painting. Although publishers and family alike asked him to put fifty years' experience down on paper, he refused. "Don't expect me to become one more writer on art," he wrote Eleanor in a letter telling how he had been "pestered for a long time by the *Monitor* people to write for their paper."[18] He finally agreed to see a persistent young reporter, however, who offered to let Benson read what he had written and cut out what he didn't like. In the article, which appeared in the summer of 1941, Benson spoke of the difficulty of teaching something and quoted Bernard Shaw, who said that what could be explained is the 95 percent that can be taught and the other 5 percent is the artist's personal contribution. It appealed to Benson's wry sense of humor that Shaw also added that the first 95 percent doesn't matter. Benson also dwelt on the importance of understanding nature under many aspects of weather and various times of day: "Thus is it possible to learn in time to see the essential line, the local tonalities, the elements of balance between the large and small shapes that make up the composition and finally the meaning of the spaces between the shapes."[19]

War struck America on the morning of 7 December 1941, when the Japanese bombed Pearl Harbor. The Bensons immediately sought ways to contribute. Grandchildren enlisted or worked in hospitals and factories, filling positions vacated by soldiers. Eleanor's family took in a child from England who had been sent to America to escape London's blitz. Benson donated ten etchings to be sold for the defense fund and bought war bonds. And everyone planted Victory Gardens. When the smoke of war had finally cleared, the Bensons were too frail to ever again make their annual summer journey to the farmhouse by Wooster Cove. Sylvia continued to summer in North Haven for several years more, but the big house was too much for her. Knowing her parents would nev-

PLATE 141
Dory Fisherman, *1941. Oil on canvas, 25 × 30". Private collection.*

PLATE 142
Bald Eagles (The Eagles), *1941.*
Oil on canvas, 39½ × 31¾". Private collection.

PLATE 143

Nassau Docks, 1922. Watercolor on paper, 15¼ × 19⅛". Private collection. Benson's 1922 series of Caribbean watercolors, called "The Jewels of Nassau" by one critic, were so popular that he often was unable to keep up with the demand for this medium.

er be able to return to their island home, she sold Wooster Farm in 1950 to the Strongs, who had been summer friends for many years. Mrs. Strong had been Sylvia's childhood companion and studied art with Benson in his barn studio when she was in college.

The new owners have kept Benson's studio just as he had left it. The vast, high-ceilinged room is now still and quiet; dust swirls softly in the sunlight which slants through the open screen door. Pushed against the wall is an old table, its top crusted with paint and cluttered with half-used tubes of oils, empty jars, and a tin full of brushes. One section of rough boards is covered with slashes and blobs of paint made as Benson removed extra oil color from his brush before washing. But the pungent scents of paint, linseed oil, and turpentine disappeared long ago, having drifted away in the hot summer air like the girls in white on the hillside, now grandmothers themselves; drifted away like the little boys with their dogs and toy sailboats who now had sons of their own.

Despite the war, the Museum of Fine Arts sponsored a large retrospective show of works by members of the Guild of Boston Artists in the fall of 1942. It was appropriate that Benson chose to hang several recently completed watercolors. By the time the guild had been founded, his "girls-in-sunlight" paintings were slowly being replaced by his etchings and wash drawings and, later, watercolors (plate 143). A Boston critic, seemingly amazed at the continued excellence of Benson's work wrote, "He is more than 80 years of age and still going strong. Mr. Benson is exceptionally gifted."[20] In a critique of some of his watercolors another noted, "In *A Good Day for Ducks*, ducks fly against the hard slant of the rain. His *Salmon Fisherman* is the kind of picture only next year's taxes, if even they, could keep a sportsman from buying. In *The Lobstermen* not only is the water very wet, but the [air is] hot [and] humid as well, an effect few artists can approach Mr. Benson in."[21]

The Lobstermen now hangs in the Farnsworth Museum in the little town of Rockland, Maine, where for so many years, the Bensons waited to take the ferry to North Haven. Many of Benson's marines include a far-off cluster of these lobster buoys or the tiny figure of a lobsterman, standing in his dory, hauling in his traps. It was a vital industry to the island; lobsters were plentiful and traps were rarely pulled up empty. The waters off North Haven had inspired Benson for forty years. His memories of sights seen from Wooster Farm found expression in his last known watercolor and one of his final oils (plate 141). In *Dory Fishermen* a broad expanse of silvery sea surrounds two At-

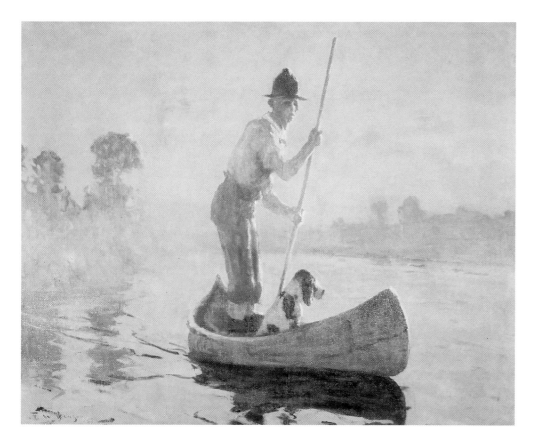

PLATE 144
The Indian Guide, *1927. Oil on canvas, 32 × 40". Collection of Mr. and Mrs. Charles Hermanowski. Painted on one of Benson's fishing trips to Canada, this work depicts Benson's guide, Quonah, poling his canoe down the quiet river while his dog, Skookum, sits patiently at his feet.*

lantic dories in the center of the painting as bright reflections dance and sparkle on the water and a few hopeful birds swoop low over the fishermen's heads. The date on the painting is 1942, but it could have been inspired thirty years before. The Bensons' enormous hauls of mackerel were caught in just this manner. Perhaps this is the artist himself throwing out the nets while his son, George, waits to help. In another late watercolor, done in 1948, Benson painted a very similar fishing scene—two dorymen in a boat. The dashing brushwork and loose handling of the water were easy enough for Benson's tremulous hands to manage. The drawing is remarkable and the colors are intense, but it is a painting meant to be seen at a distance. Up close, the wavering brushstrokes are more evident though nonetheless effective (see plates 136 and 139).

The striking difference between Benson's cramped, shaky writing and his effortless painting becomes clear in his last-known watercolor. In 1950 Sylvia, who had been studying watercolor, was having difficulty with a painting on which she was working. Turning to her father, she asked him just how one creates the particular deep, oily green of low tide at North Haven. Finding it hard to explain, Benson took Sylvia's pad and with a few swift strokes deftly sketched the granite cliffs and spruces of their cove at Wooster Farm. But in the lower left corner, Benson's signature and the date are painstakingly written in an unsteady, spidery script.

Although the effects of his age were beginning to appear in his work, Benson continued to receive honors. In 1943 his oil *Bald Eagles* (plate 142), which had been exhibited widely the previous year, was selected as a frontispiece for the *American Girl* magazine; the American Artists Professional League awarded Benson its 1943 prize for his etchings during "American Art Week"; and the Boston Public Library held a one-man show of his etchings.[22] As Benson worked with Arthur Heintzelman, Keeper of the Prints, he reminisced that both had taken up etching for fun. Benson confessed, "For my [part], 'though I never reached the heights I hoped for, yet find myself in the grand position of being sought for."[23] Benson's humility is touching, perhaps because the personal ideals he set for himself were so high that they were unattainable. Certainly, the art critics unanimously felt that Benson had taken contemporary etching to such a level of expertise that he set the standard for generations to come. In the show's catalogue, Heintzelman pointed out: "Unlike England, America has no school of print-making that has created individual expression; each artist sets down in his own way the particular subject that interests him most. This individualism is nowhere more strongly indicated

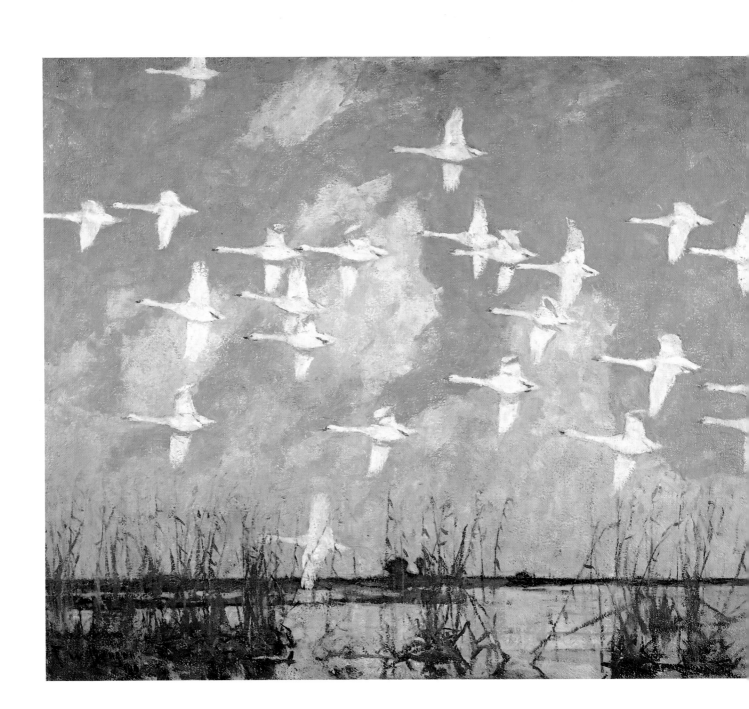

than in the work of Mr. Benson. . . . The prominent place held by Mr. Benson in the graphic arts has done much in securing recognition for America in the realm of contemporary prints."[24]

Benson's last-known oil painting, a still life completed in 1944, was probably the final work done at his studio in Boston. Even after failing health made it difficult to continue his commute, Benson maintained his rooms at the Riverway, finally relinquishing them in 1944. Benson had opened his first Boston studio almost fifty years before. That year, 1888, he had earned only four hundred dollars. By the time he closed his last studio, he had won almost every honor and medal in the American art world and had become financially successful beyond his wildest hopes. After he had moved all of his painting equipment into his home on Chestnut Street, his etching studio fairly bulged with easels and brushes, stretched canvases, and tubes of paint. There was little space to move about in the small room, but it did not really matter; Benson was not able to produce an etching anyway. "I've been working on a plate," he wrote his brother, John, "but it's no use. I can't see the lines and I'm practically blind at night. Sometimes I think I must be hard to live with. When alone, I curse and swear at my work and, if others hear me, they take no notice of it . . . [but] when I'm washing my brushes I can enjoy the success that I have had in full measure." Despite his frustrations, he added, "I think only of my work."[25]

Despite his periods of frustration and seeming inability to paint, the paintings he managed to complete were outstanding. Two shows in November 1944 clearly demonstrated his continued creativity. The one-man show of his paintings at the Guild of Boston Artists included eighteen watercolors, one oil, and a group of wash drawings.

Among the colored watercolors, the majority were of birds in many different settings: blue jays, fishhawks, geese, snipe, grouse drumming on logs, ducks diving across lowering skies, and swans skimming across a brightly colored sky. Four years previously Benson had completed his last known oil of swans, a magnificent pattern of two dozen swans sailing silently over a marsh. The sky behind them, filled with small billowing clouds, accentuates the sharp design made by their long necks and outstretched wings (plate 145). This painting recalls the first wildfowl work Benson is known to have exhibited, *Swanflight,* of 1893 (see plate 34).

The Museum of Fine Arts's November 1946 exhibition, "Sport in American Art," was tailor-made for Benson's paintings. He selected two oils and three watercolors from his own collection. The *Worcester Evening Gazette* reported, "[No] exhibit of this sort could be complete without Frank Benson, loved of hunter and fisherman. . . . He can fill an atmosphere with moisture as almost no one else can. He can also fill it with light superlatively. He is a brilliant colorist."[26] Laurence Dane of the *Boston Herald* interviewed Benson in Salem after viewing the show in which Benson's paintings hung next to those of Thomas Eakins. Calling Benson the "Dean of Yankee Masters," Dane was amazed that he "does not consider the goal has yet been reached. . . . He is still trying to get at something more of which he has never put down in paint."[27]

Benson had often discussed his elusive goals with Joseph Lindon Smith. In a letter to Smith, written in 1945, Benson reminisced about their days in Paris where they lived for two years in rooms "not much bigger than a wardrobe trunk. . . . You are right about the painters of our time," Benson agreed, "there is no product today in the country that ranks with that of the nineties and later. It was done with enthusiasm and that's why I think we were lucky to be born to that part in time."[28]

John Taylor Arms, a well-known etcher, obviously felt that Benson's own work ranked highly enough to qualify him for inclusion in the American Academy of Arts and Letters. In 1945, when Arms proposed Benson for membership, the correspondence regarding the nomination reveals that all concerned were aghast that he was not already a member of this august body. Benson graciously accepted the honor and added that he would be proud to have his works hang beside those of the other honoree, Edward Hopper, at the exhibition accompanying the induction ceremony. Several of his New York collectors agreed to loan six oils (plate 144). Benson also hung five watercolors—all of hunting scenes or wildfowl—plus sixteen etchings.

PLATE 145
Flight of Swans, *1940. Oil on canvas, 31½ × 39½". Private collection.*

225

In his speech, John Taylor Arms called Benson "a poet at heart," adding, "He always seems to have something in reserve and, for all the frankness and directness of his statement, one is conscious of power of imagination and sensitivity of thought held in reserve, suggested but not completely revealed." By 1945 Benson's name had become synonymous with the portrayal of wildlife, and Arms stated that Benson had founded a "school"—that of the modern sporting print. Arms said his etchings were "but a medium for a far subtler interpretation, the expression of movement in terms of linear pattern, and it is to this, rather than to any choice of subject matter or technical skill of execution, that Frank Benson will owe the lasting fame as an artist which he so richly deserves."[29]

Although Benson was not well enough to travel to New York for the induction ceremony, he continued to paint, albeit with mixed results. As he wrote to his brother John, "I draw the damndest things sometimes and say to myself that I'm all done. I burn the results and next day do what I think is pretty good, yet I don't see how it can be. I have one good eye, the other lies like the devil and puts me to shame. I'm going to wear a patch on it and see if I can paint with one eye."[30] Patch or no, Benson executed at least nine watercolors between 1945 and 1948.

By 1951 Benson's life centered on his home on Chestnut Street, where he spent his mornings with Ellie, now an invalid, and his afternoons visiting with family and listening to music. By autumn Benson, too, was requiring round-the-clock nursing care. Confined to his bed, he was visited daily by his children, grandchildren, and great-grandchildren. His room was full of the things that had been most important to him in his life—photographs of his family and several of his works. On the walls hung three watercolors: a small still life, a silver salmon leaping from a stream, and ducks rising from a marsh with water dripping from their outstretched wings. At the foot of his bed he asked to have hung his favorite etching, *Bound Home* (plate 146). The family has long believed this to be a portrait of Benson and his son, George, returning home after a day fishing in the waters off North Haven. Although the wind pulls the worn sail taut and the little dory heels a bit to starboard as she slides swiftly through the water, it is nonetheless a quiet picture. George is poised alert at the tiller while his father rests back in the boat, tired but relaxed after a long day on the water. The etching captures a peaceful moment at the end of a long journey. On the afternoon of 17 November 1951, Benson died quietly. The family had requested no flowers at the simple service, but his friends could not be dissuaded. The church was full of bouquets. His children sent only a large, plain wreath of ivy. As Eleanor wrote to her daughter, Joan, "It was sort of like a victor's wreath. I liked the way it looked."[31]

He was indeed a victor. Returning from his training in Paris, he helped Americans overcome their reticence to accept their native painters. With Tarbell, he led a floundering art school out of debt and brought it prestige and national as well as international renown. He was awarded more prizes and medals than any other painter of his day, perhaps more than any other American artist. Each time he moved in a new direction with his art, success followed him, creating a demand for his work so great at times that he could not keep up with it. The demand continued until the day he died and beyond.

The tangible rewards of victory were present in Benson's life, but what he valued most was his work; he felt fortunate that he could work at what he loved: "My work is so interesting that I never really live fully or feel the day to be important unless I have something going on."[32]

He loved to teach and felt a deep involvement with the training of young people. He touched the lives of thousands of aspiring artists, who still speak of him to this day. And yet, in his humility, he felt that he was the one who gained from his years as a teacher. As a former student once quoted him, "Although I may have helped others, I learned the most!"[33]

Benson never lost sight of his good fortune. As he once said to Joseph Lindon Smith, his inseparable comrade from his Paris days, "We lived and worked in a fortunate time."[34]

PLATE 146
Bound Home, *1918. Etching on paper, 9 × 11". Paff no. 134, ed. 150. Private collection.*

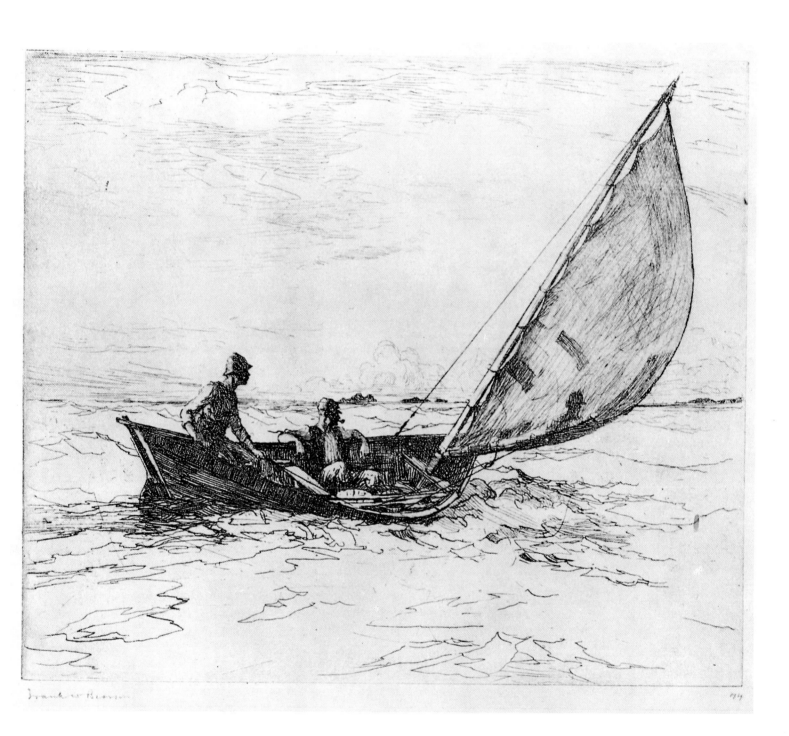

194

NOTES

Between 1972 and 1991 I conducted interviews with Frank Benson's family and friends, some of whom wished to remain anonymous. Out of respect for their privacy I have not listed their names in the Notes.

CHAPTER 1

YANKEE ROOTS

1. Blanche Willis Howard, *Guenn: A Wave on the Breton Coast* (Boston: James R. Osgood & Co., 1883), 25.
2. Nathaniel Hawthorne as cited in *When I Lived in Salem, 1822–1866*, by Caroline Howard King (Brattleboro, Vt.: Stephen Daye Press, 1937), 43.
3. In 1880, No. 52 Forrester Street was changed to No. 46 Washington Square.
4. After the turn of the twentieth century, Salem's port was only deep enough to accommodate lumber boats and barges.
5. As a boy, Benson was often called Frankie, a name he detested. In 1943 he wrote to his daughter Eleanor upon the birth of her grandchild, Frank Benson Lawson: "I was glad to hear Benny [Eleanor's son] forbade calling him Frankie. That used to burn me up when I was a kid." Frank Weston Benson (hereafter abbreviated as FWB) to Eleanor Benson Lawson, 13 September 1943, Benson Papers. Essex Institute, Salem, Mass. (Hereafter abbreviated as Benson Papers.)
6. A Salem neighbor reported: "We took our horse and . . . went to Peach's Point to make a call on George Benson and family. They are very nicely fixed there on the Point in a charming spot—a good house, furnished, and will spend the summer there." Journal of Nathan A. Frye, 24 June 1883. Salem, Mass. Private collection.
7. FWB to Dan Henderson. 26 March 1882 and 21 January 1883, Henderson Papers. Essex Institute, Salem, Mass. (Hereafter abbreviated as DH and Henderson Papers.) A close childhood friend of Benson's, Henderson left Salem for Colorado in February 1882 to recover from tuberculosis; their correspondence continued until 1926.
8. Ibid., 12 January 1895.
9. Samuel Chamberlain, "Frank W. Benson—The Etcher," *Print Collector's Quarterly*, 25, no. 2 (April 1938): 167.
10. FWB to Eleanor Lawson Benson. 31 August 1926, Benson Papers.
11. George Benson as remembered by his niece RH, interview with the author, September 1986.
12. The Ten American Painters was a group of established painters who resigned from the Society of American Artists in 1898 in response to what they felt were mediocre shows and low standards. Dubbed "The American Impressionists," their main raison d'être was to hold small, tasteful, well-hung shows of a few of their best works.
13. H. Winthrop Pierce, *A History of the School of the Museum of Fine Arts* (Boston: Museum of Fine Arts, 1930), 37.
14. Ibid., 85.
15. Unpublished memoirs of Joseph Lindon Smith, no date, Joseph Lindon Smith Papers. Archives of American Art, Washington, D.C. (Hereafter abbreviated as JLS and Smith Papers.)

16. Dr. Ware as cited in Dr. M. Mahdi Allam, *Joseph Lindon Smith: the Man and the Artist* (Cairo: Ministry of Education, April 1949), 93.
17. Benson family journals, 4 November 1881 and 5 December 1881. Private collection.
18. Benson's family was also aware of his problems in painting hands, fingers, and other parts of the figure realistically; they sometimes jokingly referred to certain paintings as "Mary with the Little Pig Feet" or "Miss No Neck."
19. Benson family journals, 27 October 1881, 5 January and 10 February 1882.
20. Ibid., 28 January 1882.
21. FWB to DH, 23 September 1883, Henderson Papers.
22. Benson family journals, 26 February 1883.
23. See plates 66 and 67.
24. FWB to DH, 26 March 1882, Henderson Papers.
25. Ibid., 21 January 1883, Henderson Papers.
26. Benson family journals, 14 December 1882.
27. FWB to Mr. Gibb, February 1932, Benson Papers.

CHAPTER 2

PARIS DAYS

1. FWB to DH, 14 October 1883, Henderson Papers.
2. John Greenleaf Whittier, cited in memoirs. Smith Papers.
3. JLS to parents, 28 October 1883, Smith Papers.
4. John Shirley Fox, *An Art Student's Reminiscences of Paris in the Eighties* (London: Mills & Boon, 1909), 118.
5. Philip Hale, n.d., Philip Hale Papers. Archives of American Art Microfilms. (Hereafter abbreviated as Hale Papers.) In an 1891 painting by Jefferson Chalfant entitled *Bouguereau's Atelier at the Julian Academy*, a large, high-ceilinged room lit by a skylight or a row of high windows is represented.
6. JLS to parents, 28 October 1883, Smith Papers.
7. Philip Hale, Hale Papers.
8. Rodolphe Julian, as cited by William Rothenstein, *Men and Memories* (London: Faber & Faber, 1931), 39.
9. JLS to parents, 25 April 1884, Smith Papers.
10. Although several of these men were at Julian's while Benson was studying there, he did not consider them close friends and he mentioned them only once or twice in correspondence. Years later, following a stint on the jury of the Pennsylvania Academy of the Fine Arts, Benson wrote to J. Alden Weir, "Give my regards to Twachtman 'The Hairy.' I grew to know him better during those four days in Philadelphia, than two years in Paris." FWB to J. Alden Weir, 20 December 1895, J. Alden Weir Papers. Archives of American Art Microfilms. (Hereafter abbreviated as Weir Papers.)
11. JLS to parents, 28 October 1883, Smith Papers.
12. FWB to DH, 26 October 1883, Henderson Papers.
13. Ibid., 20 and 18 November 1883.

14. Ibid., 30 November 1883.
15. J. Alden Weir as cited in Dorothy Weir Young, *Life and Letters of J. Alden Weir* (New Haven: Yale University Press, 1940), 123.
16. Samuel Benjamin, *Art in America* (New York: Harper and Brothers, 1880), 192.
17. FWB to DH, 18 November 1883, Henderson Papers.
18. FWB to DH, 3 February 1884, Henderson Papers.
19. JLS to parents, 28 October and November, n.d. 1883, Smith Papers.
20. From a collection of stories told by Joseph Lindon Smith to his daughter, Mrs. Lois Scheifflein, and written by her in an unpublished book form (Winter Park, Florida, 1941).
21. JLS to parents, 23 December 1883, Smith Papers.
22. JLS to parents, 23 April 1884, Smith Papers.
23. JLS to parents, 16 June 1884, Smith Papers.
24. Edward Simmons, *From Seven to Seventy* (New York and London: Harper and Brothers, 1922), 118.
25. JLS to parents, 1 June 1884, Smith Papers.
26. JLS to parents, 27 June 1884, Smith Papers.
27. Diary of Ellen Perry Pierson, 29 August 1884, private collection. (Hereafter abbreviated as EPP diary).
28. EPP diary, 2 September 1884.
29. JLS to parents, 31 July 1884, Smith Papers.
30. EPP diary, 20 September 1884
31. Ibid., 3 and 6 September 1884.
32. JLS to parents, 30 September 1884, Smith Papers.
33. Ibid., 22 July 1884.
34. Ibid., 13 July 1884.
35. Ibid., 8 November 1884.
36. EPP diary, 5 December 1884.
37. *Boston Sunday Herald,* 9 June 1935.
38. JLS to parents, 20 December 1884.
39. EPP diary, 10 March 1885.
40. *Art Amateur* 10 (January 1884): 42.
41. FWB cited in Eleanor Benson Lawson, *Advice on Painting from F.W.B. Notes Taken after Criticism by E.B.L.* Entry dated 2 January 1943, unpublished manuscript, Benson Papers. (Hereafter abbreviated as *Advice*.)
42. JLS to parents, 22 March 1885, Smith Papers.
43. JLS as remembered by his daughters, Rebecca Lindon Smith Bird and Lois Smith Scheiffelin, in interviews with the author, 26 December 1987, 6 April 1988, respectively.
44. FWB as quoted by his granddaughter JA, interview with the author, 1987.
45. JLS to parents, Paris, 22 March 1885, Smith Papers.
46. Ibid., 3 April 1885.
47. FWB to JLS, 12 June 1943, Smith Papers.

CHAPTER 3

NEW BEGINNINGS

1. Smith's work attracted the attention of Harvard professor Denman Ross, who asked Smith to give him art lessons. Smith accompanied Ross to Europe in the spring of 1886—the beginning of a life abroad.
2. EPP diary, 18 December 1885.
3. Arthur Dexter quoted in William L. Vance, "Redefining 'Bostonian,'" in Trevor J. Fairbrother et al., *The Bostonians: Painters of an Elegant Age, 1870–1930* (Boston: Museum of Fine Arts, distributed by Northeastern University Press, c. 1986), 17.
4. Malcolm Johnson, secretary, St. Botolph Club, interview with the author, Boston, December 1987.
5. *Boston Evening Transcript,* 23 January 1886.
6. Unidentified newspaper clipping in Benson file, Museum of Fine Arts, Boston.
7. Arthur Hoeber to FWB, n.d., artist's scrapbook, Benson Papers.
8. Desmond Fitzgerald, in *Loan Collection of Paintings by Claude Monet and Eleven Sculptures by Auguste Rodin* (Boston: Copley Society, March 1905), 3–4.
9. New York artist John McDonald taught classes under the auspices of the city's Art League in 1884, 1885, and 1886. School catalog of 1888, Portland Museum of Art Archives.

10. *Boston Evening Transcript,* 20 January 1887. See Chapter 5 for a discussion of Benson's difficulty with anatomy.
11. John F. Weir to J. Alden Weir, 3 February 1877. Cited in Young, *Life and Letters,* 118.
12. *The Nation* 46 (3 May 1888): 373. Originally cited in William H. Gerdts's essay "Frank W. Benson—His Own Man" in *Frank W. Benson: The Impressionist Years* (New York: Spanierman Gallery, 1988), p. 38.
13. Benson had also received letters in Paris from his instructor Frank Crowninshield, who moved to New York in 1885 and was replaced at the school by Joseph Rodefer De Camp.
14. Letter from Ellen Peirson Benson to her mother, Ellen Perry Peirson, 21 October 1988. Private collection.
15. FWB to Eleanor Benson Lawson, 3 September 1914, Benson Papers.
16. Years later, Ellie would laugh and say of this painting, "It only took Frank a little over a week to do that one." Then she would add with mock disgust, "Now, when he was painting my first portrait in Concarneau, during our courting days, he needed six whole weeks to finish!" EPP as remembered by her grandchild NB, interview with the author, May 1987.
17. Benson's "Firelight Series" is believed to include four works: *By Firelight* (1889), *Twilight* (1891), *Firelight* (1893), and *Lamplight* (1893).
18. Eleanor Benson Lawson, as remembered by her daughter JA, interview with the author, October 1976.
19. *International Studio,* 7 (2 April 1892).
20. *New York Sun,* 9 April 1892.
21. Hamlin Garland, *Crumbling Idols: Twelve Essays on Art Dealing Chiefly with Literature, Printing and the Drama* (1884; reprint, Cambridge, Mass.: Harvard University Press, Belknap Press, 1960), 104.
22. Minutes of the Museum School Board Meeting, 23 May 1889. Museum School, Boston, Mass. (Hereafter abbreviated as Minutes).
23. JLS to parents, 21 June 1889. Private collection. Joe continued, "It is splendid, the fine notices he has had in the newspapers about his pictures. I am very glad for him . . . With all the pleasant things said of his work I am sure he will have some portraits to paint this winter."
24. Rebecca Lindon Smith Bird, interview with the author, 26 December 1987.
25. In a letter written to his mother from Venice, Smith tells of running into Frank's brother John, who said, "Frank and Ellie are talking of going to Dublin this summer where they will see Abbot Thayer and his work." JLS to Mrs. Smith, 21 June 1889. Private collection.
26. Benson's fishing journal, 15 September 1890, Benson Papers.
27. During World War I, Thayer waged what often seemed like a one-man campaign to have his theories of natural coloration as camouflage accepted by the European and American governments.
28. The only other known painting to include a halolike element in the background is *Seated Lady in White,* done in 1896 and inscribed "To my friend [Frederic P.] Vinton."
29. Years later Benson recalled his summers in Dublin in a letter to Thayer's wife, Emma, "I keep always the warmest feeling for you all and interest in Abbott's work. . . . What he was to me in my early years is not to be expressed by any words. Without doubt, he helped me more than any other influence in the world and the help he gave me is continuing in its influence today. . . . " FWB to Mrs. Thayer. 5 November 1915, Thayer Papers. Archives of American Art Microfilms. (Hereafter abbreviated as Thayer Papers.)
30. *Boston Evening Transcript,* 22 July 1889
31. Ibid., 9 March 1891.
32. Ibid., 1 October 1889.
33. Ibid., 9 March 1891. This painting is faintly visible on the wall behind Benson and his daughter in plate 111.
34. Willard Metcalf to FWB, 5 November 1921, Benson Papers.
35. Of this painting of Emmeline and baby Josephine, now at the Museum of Fine Arts, Boston, Tarbell's granddaughter notes, "In 1892, *Mother and Child in a Boat* was done that summer when Mr. Tarbell was there. I have a stretcher with the info on it in pencil—that's all written in Emmeline's hand writing—they were at Dublin Lake, N.H." Mrs. Mary Josephine Ferrill Canon to author, 29 December 1988.
36. Minutes, 22 September 1890.
37. Ibid., 18 May 1881.
38. One of his students, Beatrice Whitney Van Ness, a well-respected Boston painter and teacher in her own right, wrote to the Museum of Fine Arts on the occasion of its centennial celebration, "I do not regret

the time spent in teaching. Just as Mr. Benson said it would be: although I may have helped others, I learned the most!" Cited in Elizabeth M. Stahl, *Beatrice Whitney Van Ness, 1888–1981, The Privilege of Learning to Paint* (Boston and New York: Childs Gallery, 1987).
39. Miriam Pratt to Albert Kennedy, Hale Papers.
40. FWB to John Trask, 14 April 1906. Pennsylvania Academy of the Fine Arts. In refusing Trask's request, Benson added, "Mrs. Benson laughs at the idea of my teaching in two places at once. [She] says I would not make the journey more than twice!"
41. FWB to Albert Kennedy, 20 May 1932, Hale Papers.
42. *Advice*, 6 January 1930.

CHAPTER 4

PORTRAITS AND PRIZES

1. *Boston Transcript*, 9 March 1891. The formality of Benson's inscription "To Mrs. Tarbell" amuses Tarbell's family, for they fondly recall the easy, close friendship that the two men—and their families—had. In contrast to the flowery dedications that his friend John Singer Sargent often added to his paintings, Benson usually inscribed only the recipient's name, even if paintings were given to his own children. The most effusive dedication he ever added was "To my friend, Vinton." Benson took his painting very seriously and his family has stated that elaborate dedications would not have been viewed by him as "professional." Although many of his close friends had given each other nicknames—"Muley" Hassam, "Stuffy" Tarbell, "Metty" Metcalf, John "The Hairy" Twachtman—they did not use these for signatures on paintings. In a letter to "Benny," his good friend "Metty" tells him he is sending a painting as a present. Yet the painting is signed formally, "W. L. Metcalf, en souvenir."
2. *Boston Transcript*, 9 March 1891.
3. Ibid.
4. *Chicago Morning News*, 27 October 1891.
5. *Boston Post*, 7 March 1891.
6. Ibid.
7. *New England Magazine*, n.s., vol. 6., no. 5 (July 1892): 601.
8. John Twachtman, cited in Young, *Life and Letters*, 175–76.
9. Greta, *Art Amateur* 24 (May 1891), p. 141, cited in Fairbrother et. al., *The Bostonians*, 54.
10. FWB to Wyman Richardson, 27 August 1940. Private collection.
11. FWB to DH, 14 November 1894, Henderson Papers.
12. FWB to J. Alden Weir, 20 December 1894, Weir Papers.
13. FWB to DH, 3 February 1895, Henderson Papers.
14. *Philadelphia Times*, 21 January 1892.
15. *Philadelphia Press*, 31 January 1892.
16. FWB to Mrs. Kimball (registrar), 4 March 1920. Smith College Archives, Northampton, Massachusetts.
17. Arlo Bates, Eastham log, 15 June 1894.
18. Sadakichi Hartmann, *A History of American Art*, vol. 2 (1901; reprint ed., Boston: L. C. Page, 1902): 237–241
19. M. A. DeWolfe Howe, *A Partial (and not impartial) Semi-Centennial History of the Tavern Club, 1884–1934* (Boston: privately published, 1934), 9.
20. *Boston Transcript*, 29 April 1914. Museum School scrapbooks. The picture hangs opposite a plaque on which the club lists its "Billiard Immortals." In the 108 years of the club, only nine men have combined the special qualities required to have their names painted in gold on "The List"; one of them was Benson. Asked what those qualities were, one member, who fondly remembers Benson, replied that it was more than being a formidable billiards player. Being an "Immortal," he said, "meant being a good sport, being kind, being thoughtful, and having the kind of humor that cheers but doesn't insult." Another added, "You know, Sargent was a member here too, and they were good friends. Sargent was liked by all but not loved. Benson was loved." He added, "Benson's devotion to the club and its members was thoroughly reciprocated. After his death, at the memorial service in his honor, the club had to turn people away for lack of space." F. Murray Forbes and other members of the Tavern Club, interview with the author, Boston, 12 May 1988.

21. Clarence Cook in *The Studio 7* (2 April 1892): 163. First quoted in Gerdts's essay "Frank W. Benson: His Own Man" in *Frank W. Benson: The Impressionist Years*.
22. In 1921, when the director of the Corcoran Gallery, C. Powell Minnigerode, wanted a Sargent painting for a show, he wrote to Benson: "Knowing that you are probably his most intimate friend, the thought occurs to me that you might be able to squeeze such a picture out of him." C. Powell Minnigrode to F. W. Benson, 21 October 1921. Benson file, Corcoran Gallery of Art Archives.
23. FWB as cited in Lawson, *Advice*, 29 December 1929.
24. Frances Wilkinson, interview with the author, September 1987.
25. FWB to Gustave Schirmer, 22 June 1891, Frank W. Benson Papers. Archives of American Art Microfilms.
26. FWB as cited in Lawson, *Advice*, 24 April 1948.
27. Hale's many years in France, particularly in Giverny, where he worked with Monet and with other budding American Impressionists, greatly influenced his work. In the 1890s, he was considered the most Impressionist of all the Boston figure painters. He focused mainly on the landscape aspect of his figural work, and in many of his brilliant garden paintings the figures appear almost to dissolve in the sunlight. His daughter said, "I recall my father and Tarbell exchanging a picture, but we never had a Benson in the house, although I recall meeting him once when I was a small child. My father had the greatest respect for his work." Nancy Hale Bowers, interview with the author, March 1987.
28. *Boston Transcript*, 19 May 1893.
29. Annual Report of the Museum of Fine Arts School, 1893. Museum School Archives.
30. Marjorie B. Staley (Edmund Tarbell's daughter-in-law), telephone interview with the author, December 1987.
31. *The Bostonian* 1, no. 5, (18 February 1895).
32. Ibid.
33. Ibid.
34. *Boston Transcript*, 25 January 1895.
35. Unidentified, undated Boston newspaper clipping. Charles Woodbury's scrapbook, private collection.
36. FWB to J. Alden Weir, 10 January 1896, Weir Papers.
37. Pauline King, *American Mural Painting* (Boston: Noyes, Platt & Company, 1901), 205.
38. Charles Caffin, *Library of Congress Handbook*, 1897, 119.
39. Ibid., 122.
40. Simmons, *From Seven to Seventy*, 274.
41. Undated, unidentified newspaper clipping. City Hall scrapbooks, page 39, Philadelphia Historical Society.
42. Minutes of the Commission for the Erection of the Public Building of Philadelphia, 2 June 1896. Archives of the City of Philadelphia.
43. Royal Cortissoz in *Harper's Weekly*, 40 (18 April 1896): 392–94.
44. Samuel T. Shaw to James H. Gest, 27 February 1897. Benson file, Cincinnati Museum of Art Archives.

CHAPTER 5

THE TEN

1. FWB to Dorothy Weir Young, 9 July 1938, Weir Papers.
2. *Art Interchange* 38, no. 5 (May, 1897): 119.
3. FWB to Dorothy Weir Young, 9 July 1938, Weir Papers.
4. Ibid.
5. Homer, cited in Young, *J. Alden Weir*, 198.
6. Edward Simmons wrote in his autobiography, "We never called ourselves the Ten, in fact, we never called ourselves anything. We were just a group who wanted to make a showing and left the Society as a protest against big exhibits. At our first exhibition at the Durand-Ruel's Gallery we merely put out the signs—'Show of Ten American Painters' and it was the reporters and critics speaking of us who gave us the name." Simmons, *From Seven to Seventy*, 221.
7. Unidentified newspaper clipping, 10 January 1898, Weir Papers.
8. Unidentified newspaper clipping, Weir Papers.
9. *New York Sun*, 12 January 1898.
10. FWB to DH, Salem, November, 1898. Henderson Papers.
11. *New York Herald*, 31 March 1898.

12. *New York Times,* 30 March 1898.

13. Ibid., 18 April 1899.

14. *Commercial Advertiser,* 4 April 1899.

15. Years later, Benson's youngest daughter, Sylvia, wrote, "This oil was probably painted about 1899 in Newcastle, New Hampshire, and the girl was my eldest sister, Eleanor, and the boy, my brother George. At this time, my parents spent their summers in Newcastle, which is on the short seacoast of New Hampshire." Although Sylvia is off in her dating of the picture by one year, her mention of her family's stays in Newcastle is correct. Sylvia Benson Lawson to M.R. Schweitzer, Salem, 25 January 1965. Benson file, Schweitzer Art Reference Library.

16. *Mail and Express* (New York) 4 April 1899.

17. *The Artist,* May–June 1899.

18. FWB cited in Lawson, *Advice,* 17 February 1939.

19. Although *Elisabeth* is not dated, the fact that a work of this name accompanied *The Sisters* to the annual show at the Carnegie Institute in the fall of 1899 would seem to indicate that this portrait of Elisabeth, her long hair of the previous painting now bobbed, was also completed in the summer of 1899.

20. *Boston Transcript,* 13 January 1900.

21. William Howe Downes, "Frank W. Benson and His Work," *Brush and Pencil* 6, No. 4 (July 1900), 145–157.

22. FWB cited in Lawson, *Advice,* 19 November 1942.

23. Granddaughter JA, interview with the author, August 1991.

24. FWB cited in Lawson, *Advice,* 3 February 1929.

25. Ibid., 28 January 1939.

26. Ibid., 29 December 1929.

27. In 1989, I stated in the catalog for the Benson retrospective at the Berry-Hill Gallery in New York City, that this painting was the first known instance of Benson's drawing of a figure from a larger painting for replication. I am indebted to Paul Swisher, curator of the Richard Pfeil collection, for pointing out that William H. Gerdts, in his new volume *Masterworks of American Impressionism from the Pfeil Collection* (Alexandria, Va.: Art Services International, 1992) notes that the small head entitled *Young Girl in Profile* appears to have been copied from the larger work, *Profile,* which Benson exhibited at the first show of The Ten. While it is an interior painting, its date, 1898, makes it currently the earliest known example of such a technique.

28. Mrs. Henry Chaplin, interview with the author, August 1987.

29. Other than these sheep and the tiger in *Orpheus,* the only animals Benson appears to have painted were a rather poorly drawn horse in a very early student work (Peabody & Essex Museum), some horses in an etching, and the family dogs and cats.

30. Wooster Farm log, 1907. Private collection. (Hereafter abbreviated as Log.)

31. *New York Daily Tribune,* 2 April 1902.

32. Log, 14 July 1907.

33. Benson's grandchildren well remember the court's most famous tennis player, Charles Lindbergh, whose wife, Anne Morrow, was a neighbor. Flying back to the mainland, Lindbergh's little plane dipped low over Wooster Farm and waggled its wings as if to say "goodbye" as the excited grandchildren stood in awe on the lawn. Granddaughter JA, interview with the author, October 1986.

34. Log, 31 August 1906.

35. Frances Welch, interview with the author, October 1987.

36. Bela Pratt to Charlotte Barton, November 1910, Charlotte Barton Papers. Archives of American Art Microfilms.

37. Frank B. Lawson, *F. W. Benson as Remembered by His Grandchildren,* typewritten manuscript. Private collection.

38. FWB to Eleanor Benson, 9 May 1907, Benson Papers.

39. Frank B. Lawson, *F. W. Benson as Remembered by His Grandchildren.*

40. Ibid.

41. Log, 1903.

42. *Boston Transcript,* 13 January 1900.

43. *New York Times,* 17 March 1900.

44. Ibid.

45. When James Gest of the Cincinnati Museum wrote to Benson inquiring about its purchase, Benson replied, "I am very glad to hear a good word of my *Decorative Figure.* It was a favorite of mine. I had rather have one picture owned by such an institution than a dozen in private hands." Benson sometimes reduced the price of his paintings so that museums could purchase them. FWB to James Gest, 27 March 1900. Benson file, Cincinnati Art Museum.

46. *Philadelphia Times,* 20 January 1902.

47. *International Studio* 27, no. 108 (January and February 1906): LXXXIII–LXXXIV.

48. Several small oil studies exist for the various "Reader" paintings in which Benson experimented with different poses of a person reading. As Ellie wrote in her diary when Benson painted her portrait in Concarneau, "He is painting a profile. Not a hard position to keep as I am looking down and can read if I like." EPP diary, 8 September 1885.

49. *New York Times,* 22 April 1903.

50. *Philadelphia Times,* 20 January 1902.

51. Knowing that Benson would share her joy, she wrote him immediately, "You must know from me before anybody else has a chance to tell you of my engagement to Stephen Codman. Mr. Tarbell has given me his blessing. Perhaps you will give me yours. In the meantime, think of me as being the most fortunate and happiest person in the world." Mary Sullivan to FWB, 8 March 1905. Collection of the author.

52. *Philadelphia Times,* 20 January 1902.

53. *Commercial Advertiser,* 19 March 1901.

54. Minna C. Smith, "The Work of Frank W. Benson," *International Studio.* 25, no. 140 (October 1908): civ.

55. *New York Daily Tribune,* 2 April 1902.

56. *New York Times,* April 1902.

57. FWB as cited in Doreen Bolger Burke, *American Paintings in the Metropolitan Museum of Art.* 3: 441.

58. *Evening Post* (New York), 20 March 1901.

59. *New York Times,* 19 March 1901.

60. Unfortunately, Benson's use of similar titles for many canvases and the penchant of museum directors and art critics to create new titles for his works generated a good deal of confusion. Research has turned up as many as five titles for the same painting; given the lack of illustration for most of his oeuvre, that confusion will, no doubt, long remain. Benson had an intense dislike for the naming of paintings. Rarely resorting to poetic descriptions, most of his titles simply reflect the painting's subject. Granddaughter JG, interview with the author 1986.

61. *New York Times,* 2 April 1902; *Boston Daily Advertiser,* 24 April 1902.

62. *Boston Transcript,* 21 March 1901.

63. FWB to James Gest, 5 September 1902. Benson file, Cincinnati Museum of Art.

64. *North American Review* 176 (April 1903): 554.

65. *New York Daily Tribune,* 21 April 1903.

CHAPTER 6

NORTH HAVEN SUNLIGHT

1. When the new school building opened in February 1909, Benson's large classroom was on the north side of the building with a view of the Charles River. Next to it were Tarbell's room and two rooms for master classes.

2. Supplement to the Annual Report of the Museum School, 1897. Museum School Archives.

3. FWB to John Trask, 14 April 1906. Benson file, Pennsylvania Academy of the Fine Arts.

4. Annual Report of the Museum School, 1905. Museum School Archives.

5. In 1904 Benson offered to send a first sketch of this large canvas to the Cincinnati Museum for its spring exhibition. FWB to James Gest, Salem, 3 April 1904. Benson file, Cincinnati Museum of Art.

6. This exhibition also contained a second sketch, which may be the same painting as *Study—Boy's Head,* exhibited in December 1904. The latter title accurately describes a small painting of George's head which was probably a study for *Hilltop.* This study is in the same private collection as a large, horizontal copy of *Hilltop,* painted in a more unfinished manner and dated two years after the first version.

7. *St. Nicholas Magazine,* no. 36 (August 1909): 883.

8. FWB to James Gest, 11 May 1905. Benson file, Cincinnati Museum of Art.

9. Stephen Wheatland, friend of both Benson and Coolidge, interview with the author, February 1988.

10. Charles H. Caffin, "The Art of Frank W. Benson," *Harper's Monthly Magazine* 119 (June 1909): 109.

11. Benson sent Bela Pratt's mother one of two studies of the portion of the picture depicting Eleanor. He wrote, "Awhile ago I was thinking of you one day when my eye hit upon a picture of a little girl in a boat which I thought you might like. . . . It is a modest little picture, but it happens to be the first study I made for the three children fishing from the dory and I remembered that pleased you at the time I made it." FWB to Mrs. Pratt, 22 March 1913. Collection of Sherwood L. Pratt. Two other studies also exist for this work.

12. Mrs. Henry Chaplin, interview with the author, August 1987.

13. Caffin, "The Art of Frank W. Benson," 106, and *New York Sun,* 20 March 1903.

14. Granddaughter JA, interview with the author, August 1987.

15. A granddaughter recalled, "My sister and I used to run ahead of the rest of the family. We would sing and clap our hands to scare away the birds for, if Papa saw one, we would all have to stop and be very still and quiet so he could look at it. That took such a long time and was so boring." Granddaughter JG, interview with the author, November 1987.

16. FWB cited in Lawson, *Advice,* 22 February 1936.

17. Wooster Farm log. 1909.

18. Benson also painted a horizontal version of *Sunlight* in which Eleanor stands on a hilltop and is seemingly overwhelmed by the panorama of Penobscot Bay. The painting's sketchy treatment suggests that it may have been a study for *Summer,* but it is clearly dated 1912, three years after the original *Summer's* completion. Bought by long-time patrons of Benson, it was carefully installed in a custom-made panel in their mantelpiece.

19. Margaret's niece has explained, "The picture really was not a study for *Summer.* The Rev. Mr. Strong, Margaret's father, was so delighted with the likeness of Margaret in the *Summer* picture that he asked his friend . . . if he would paint for him the single figure of his daughter as she was in *Summer.*" Elizabeth Hayes to the author, 2 February 1988.

20. Bela Pratt wrote to a former model about a now unlocated work which was possibly a study for *Summer,* "I wish you could see the picture that Frank Benson painted and gave to me this summer. It is a red-headed girl against a background of blue water. It is the best thing Frank ever painted and hangs here over the table in the office. I gave him a bronze cast of Artemis which he admired vastly." This little figure of the Greek goddess was later included in at least two of Benson's interiors with figures (see plate 104, *The Open Window,* in which the statue is placed between the two windows). Bela Pratt to Charlotte Barton West, 1909. Charlotte Barton West Papers, Archives of American Art Microfilms.

21. FWB as cited in Lawson, *Advice,* 11 February 1946.

22. *Boston Herald,* 5 July 1914.

23. As quoted: by John I. H. Baur, *Theodore Robinson* (Brooklyn, N.Y.: Brooklyn Museum, 1946), 36.

24. As Benson added the last bit of paint to the murals, he spied a local man walking down the road. "Come in and see what I've done to the sitting room," he hailed. Looking about, the man enthusiastically observed, "Well that's real nice, Mr. Benson. It's 'bout as good as any wallpaper I ever seen!" This honest bit of heartfelt praise was both humbling and amusing to the painter whose works were now selling for five thousand dollars. Mrs. Henry Chaplin, interview with the author, August 1987.

25. One woman would not be put off. Insisting that she "just had to see his beautiful paintings," she pushed into the large room and began admiring the various canvases stacked up around the walls of the studio, several of them still wet. Swirling about, she brushed against one of the new paintings. "Oh Mrs. G.," Benson moaned, "you've brushed your skirt against that fresh paint!" Turning to view the ruined canvas, she chirped, "Oh don't worry, Mr. Benson, it was only an old summer frock." Benson told this story often, for he loved laughing at himself and told stories with relish. Mrs. Henry Chaplin, interview with the author, August 1987.

26. It was providential that Benson and Tarbell had moved from the Harcourt Studios to their space on St. Botolph Street. In the fall of 1904, a fire swept through the Harcourt Building, destroying the work of many artists. De Camp suffered such severe losses that most of what is written about him today is based on his post-1905 work. William Paxton lost close to one hundred paintings, which may have moved him to accept the position of instructor in antique drawing at the Museum School in 1906.

27. *Boston Globe,* 19 April 1927.

28. Up until the discovery of these paintings in 1985, this writer had believed that Benson confined his portrait work to the New England area and that the majority of his sitters came to his studio. However, a letter written to James Gest in April 1904 gives the first hint that Benson traveled to do portrait work. "I was sorry not to see you when you were in Boston," Benson wrote. "I was away from home engaged in some portrait work." The knowledge that Benson did, at times, travel far afield to do portraits is underscored by a letter he wrote to Chicago art dealer J. W. Young: "I would come west for portraits in the late spring if there was enough work to warrant the journey. My price is $2,000 net for each portrait." FWB to James Gest, 3 April 1904, Benson file, Cincinnati Museum of Art; and FWB to J. W. Young, 12 November 1909, Benson file, Rhode Island School of Design.

29. *International Studio* 27, no. 108 (January and February, 1906): 83–84. See plate 52.

30. *International Studio* 35, no. 140 (October 1908): cii.

31. William Howe Downes "The Spontaneous Gaiety of Frank W. Benson's Work, *Arts and Decoration,* March 1911, 1905.

32. Mary Van Ness Crocker, interview with the author, May 1988.

33. Unidentified newspaper clipping, 19 January 1907, Museum School scrapbooks. Museum School Archives. (Hereafter abbreviated as School scrapbooks.)

34. *New York Art Bulletin,* 5, no. 20 (17 March 1906).

35. FWB to James Gest, 22 April 1907. Benson file, Cincinnati Museum of Art.

36. Eleanor Benson Lawson's recollections of her father, told to her daughter JA. Interview with the author, September 1985.

37. FWB to Eleanor Benson Lawson, 3 August 1928, Benson Papers.

38. FWB to DH, 3 February 1895, Henderson Papers.

39. Fishing diary, 7 July 1919, Benson Papers.

40. Ibid. 25 July 1916.

41. For more information on Metcalf see Elizabeth de Veer's *Sunlight and Shadow* (New York: Abbeville Press, 1985).

42. Log, 9 September 1907.

43. This work hung in a place of honor in Benson's home until long after his death. It was given by his family to the Farnsworth Art Museum and Library in Rockland—the little Maine village where the family waited for the ferry to North Haven. Metcalf painted another, slightly different version of *Ebbing Tide* on the panels of the Griswold House dining room, once the site of the Old Lyme summer art colony and now the property of the Lyme (Connecticut) Historical Society.

44. Willard Metcalf to FWB, 17 January 1908. Artist's scrapbook, Benson Papers.

45. Unsourced newspaper clipping, 12 April 1908. Artist's scrapbook, Benson Papers.

46. *Museum of Fine Arts Bulletin* 6 (August 1908): 34.

47. *Eleanor* almost ended up in Indianapolis. In December 1907, Benson wrote to John Trask asking him to "label the 'Girl in the Pink Dress' as owned by the Indianapolis Art Association as they have bought it for their collection." He also wrote to Eleanor, telling her of the sale and sending her a check in payment for her posing for it. At the end of January, Benson wrote again to Trask saying that the people in Indianapolis had backed out. Benson's anger is evident as he continues, "I wrote [them] that his notion might prevent a possible sale in Philadelphia and that considering everything, I didn't want to mix with people like him anymore or to send any more pictures to his town." FWB to John Trask, 26 December 1907, and 20 January 1908. Benson file, Pennsylvania Academy of the Fine Arts.

48. *Arts and Decoration,* March 1911, 196.

CHAPTER 7

PRAISE AND POLITICS

1. FWB to James Gest, 2 May 1912. Benson file, Cincinnati Museum of Art.

2. Frederic Porter Vinton to FWB, 11 January 1910. Artist's scrapbook, Benson Papers.

3. *Philadelphia Inquirer,* 13 February 1911.

4. When Benson's 1906 portrait of his friend Isaac C. Bates hung in an exhibition of portraits at the Copley Gallery, it was called "masterly" and a "remarkable likeness." Unlike many of his contemporaries, Benson never had a traditional patron. However, Bates donated to the Rhode Island School of Design most of the Bensons in its permanent collection. Unidentified newspaper clipping, 1906. Museum School scrapbooks.

5. FWB to Mr. Ives, director, St. Louis Art Museum, 31 January 1910. Benson file, St. Louis Art Museum.

6. Writing to J. W. Young, an art dealer in Chicago, Benson mentioned that "three of the best from the St. Botolph show go to Berlin and Munich for a small American show by invitation of the German Emperor," FWB to J. W. Young, 12 November 1909. J. W. Young Papers, Archives of American Art Microfilms.

7. Frederic Porter Vinton to FWB, 11 January 1910. Artist's scrapbook, Benson Papers.

8. *Boston Herald,* 5 January 1910.

9. Metcalf, Reid, Hassam, Dewing, and Simmons, to mention but a few names, had all spent their early careers in Boston before departing for New York City.

10. *Boston Herald,* 28 February 1909.

11. Unidentified Boston newspaper, 25 July 1912, Private collection.

12. Poses such as these caused Eleanor to recall with amusement: "When we were in North Haven, Papa would often have us put on our best white dresses and then ask us to sit on the grass or play in the woods. We thought it was so silly and the maids made such a fuss when they saw our clothes afterwards." Granddaughter JA, interview with the author, October 1982.

13. *Boston Transcript,* 23 March 1909.

14. FWB to James Gest, 1 March 1911. Benson file, Cincinnati Museum of Art.

15. Ibid., 14 May 1911.

16. Granddaughter JG, interview with the author, November, 1987.

17. FWB to Eleanor Benson Lawson, 22 August 1927, Benson Papers.

18. Bela Pratt to Mrs. Pratt, 23 November, 1913, Bela Pratt Papers, Collection of Cynthia Kennedy Sam.

19. Ibid., 30 November 1913.

20. Ibid., 15 March 1914.

21. There are very few known works that feature Ellie: three portraits, two early plein-air works, and *Summer,* an allegorical painting which the family has always believed was posed for by Ellie.

22. *New York Times,* 15 March 1906.

23. Elizabeth de Veer, original manuscript for *Sunlight and Shadow.*

24. The exact location of this show is unknown, as the headline of an unknown newspaper clipping only says, "Ten American Painters Have Opened at a Beacon Street Gallery," Unidentified newspaper clipping, March 1907. Museum School scrapbooks.

25. *Boston Transcript,* 9 May 1908.

26. *(New York) Evening Post,* 20 March 1908.

27. *International Studio* 35 (July 1908): xxiv–xxvi.

28. *Boston Herald,* 14 April 1909 and Boston Transcript, 24 March 1909.

29. *New York Sun,* 22 March 1911.

30. Unidentified newspaper clipping, 12 June 1911. Museum School scrapbooks.

31. FWB to J.W. Young, 4 July 1911. J. W. Young Papers, Archives of American Art Microfilms.

32. Unidentified newspaper clipping, 24 May 1911. Museum School scrapbooks, Museum School Archives.

CHAPTER 8

CHANGES

1. Log, 14 September 1911.

2. Ibid., 17 July.

3. When *Sunshine and Shadow* was exhibited at the St. Louis Art Museum, the director wrote to Benson asking if they might trade their painting *Summer Afternoon,* purchased several years earlier, for this new one. Perturbed by the request, Benson replied that to effect such a switch would not be an even trade and he would require $3,000 for the exchange. "I think it very unlikely that I could sell the first . . . picture

again for the very reason that you had exchanged it, while the other is one that I am confident of selling at my price, both because it is a better picture and because my things sell so much more easily than when Mr. Ives bought the *Summer Afternoon.*" The museum declined Benson's terms. FWB to R. A. Holland, acting director, City Museum of Art, 16 October 1912. Benson file, St. Louis Art Museum.

4. In a photograph of the first version of this painting, Eleanor stands with a parasol to the right of her sisters. But the figure of Eleanor is stiff, awkward, and painted in a different manner from her seated sisters, suggesting that it may have been added later. Benson obviously decided that the standing figure was a distracting element and crowded the composition. He painted Eleanor out, but her "ghost" is plainly visible. In true pentimento effect, her vaporous skirt still swirls about the pier and a misty parasol still hovers above her sisters.

5. Roger Tory Peterson, "Bird Painting in America," *Audubon* magazine, vol. XIIV, no. 3, (May–June 1942).

6. FWB to E.S. Lumsden and quoted Lumsden's *The Art of Etching* (Philadelphia: J.B. Lipincott, 1924): 328.

7. Ameen Rihani, "The Etchings of Frank W. Benson," *The Print Connoisseur,* vol. 2, no. 4, (June 1922): 274.

8. Unidentified newspaper clipping, 19 January 1912. Museum School scrapbooks.

9. In the final entry Eleanor made in her transcriptions of her father's discussions on art, she quotes him as saying, "In the past five years I have so much more completely understood the principles that underlie design that if I had the strength, I could do work that would be far ahead of any I have done." FWB cited in Lawson, *Advice,* 1941 or 1950.

10. Granddaughter JA, interview with the author, October 1987.

11. Unsourced newspaper clipping, 23 March 1912. Museum School scrapbooks.

12. Ibid.

13. FWB to John Trask, 28 October 1912. Benson file, Pennsylvania Academy of the Fine Arts.

14. *Bulletin of the Detroit Art Museum,* April 1914, as quoted in the *Boston Herald,* 3 May 1914.

15. Minutes, 17 January 1912.

16. Minutes, 13 March 1912.

17. *Boston Herald,* 7 May 1912.

18. Minutes, 21 June 1911.

19. Huger G. Elliott, interview with Mrs. Gertude Hann, 26 February 1932, Hale Papers. Archives of American Art Microfilms.

20. FWB to Philip Hale, 25 May 1912, Hale Papers.

21. Log, 22 June 1912.

22. FWB to Mr. Gibb. February, 1935. Benson papers.

23. *Boston Globe,* 12 November 1912.

24. *Bulletin of the Brooklyn Institute of Art and Sciences.* n.d., Benson vertical file, Boston Public Library.

25. *Boston Post,* 19 October 1913.

26. Joseph De Camp to FWB, n.d. and Willard Metcalf to FWB, 5 November 1912, Artists scrapbook, Benson Papers.

27. Unsourced newspaper, n.d. Artist's scrapbook, Benson Papers. The Corcoran bought this work for their permanent collection.

28. *Boston Transcript,* 2 December 1912.

29. Huger G. Elliott, interview with Gertude Hann, 26 February 1932. Hale Papers.

30. *Boston Herald,* 9 February 1913.

31. *International Studio* 49 (May 1913): 52–53.

32. FWB to Eleanor Benson Lawson, cited in *Advice,* Summer 1941.

33. Unsourced, newspaper clipping, n.d.. Benson file, Museum of Fine Arts, Boston.

34. Although the whereabouts of the latter painting is now unknown, Benson used his sketches for it to create an etching called *Girl Reading.*

CHAPTER 9

BLACK AND WHITE

1. FB to Charles Woodbury, 7 September 1915, Charles Woodbury Papers, Print Department, Boston Public Library. Hereafter abbreviated as Woodbury Papers.

2. On the wall behind Benson hangs *Orpheus,* now unlocated.

3. *Detroit Herald Tribune,* 4 April 1914.

4. *New York Times,* 24 March 1912.

5. R. S. Hisada to FWB, 13 March 1915, Artist's scrapbook, Benson Papers.

6. FWB to James Gest, 26 April 1914. Benson file, Cincinnati Museum of Art.

7. Unidentified newspaper clipping, Benson family archives. In fact, this painting did not end up in a museum. It was exhibited for many years but was never offered for sale. Ultimately, Benson inscribed it to Elisabeth's husband, Max, and gave it to them several years after their marriage.

8. *Boston Herald,* 4 January 1914.

9. Unidentified newspaper clipping, 3 February 1914. Museum School scrapbooks.

10. Unidentified newspaper clipping, 1 November 1914. Museum School scrapbooks.

11. *Christian Science Monitor,* 3 November 1914.

12. *Boston Herald,* 9 February 1915.

13. George E. Gage to FWB, 5 August 1915, Benson Papers.

14. Ibid., 30 October 1916.

15. *Boston Transcript,* 29 April 1914.

16. *Detroit Athletic Club News,* July 1971: 9.

17. FWB cited in Lawson, *Advice,* 19 November 1942.

18. FWB to James Gest, 2 May 1915. Benson file, Cincinnati Museum of Art.

19. Unfortunately, Benson was physically unprepared for the public's demand for his etchings. He wrote: "I am still under the doctor's care and, by his orders, I must do no work at all for some time to come. . . . I have worked too hard and have used myself up and now I have just got to rest." Benson's state of exhaustion resulted in a sharp drop in his output of both etchings and oils. In 1915 Benson executed 52 etchings; in 1916, only 13. FWB to John Beatty, 10 October 1916. Carnegie Institute Papers, Archives of American Art. Hereafter abbreviated as Carnegie Papers.

20. *Boston Herald,* n.d., Artist's scrapbook, Benson Papers.

21. *Print Collectors Quarterly,* 25, no. 2 (April 1938): 179.

22. *American Magazine of Art* 21, no. 11 (November 1921): 370.

23. FWB cited in Lawson, *Advice,* 29 December 1929.

24. Article dictated by FWB to his daughters, Benson Papers.

25. FWB to Charles Woodbury, 22 August 1915, Woodbury Papers,

26. *New York World,* 5 December 1915.

27. FWB to DH, 11 November 1925, Henderson Papers.

28. FWB to Albert Milch, 9 October 1926, Milch Papers (unfilmed), Archives of American Art. Hereafter abbreviated as Milch Papers.

29. Daughter-in-law CB, interview the with author, October 1986.

30. *Print Collector's Quarterly,* 25, no. 2 (April 1938): 183.

31. This 168mm film was rescued from total disintegration by John Ordeman, author of *Frank W. Benson: Master of the Sporting Print* (Brooklandville, Maryland, Privately published. 1983).

32. FWB to Charles Woodbury, 7 September 1915, Woodbury Papers, Print Department, Boston Public Library.

CHAPTER 10

ENDINGS AND BEGINNINGS

1. FWB to Abbott Thayer, 15 November 1915, Thayer Papers.

2. Unidentified clipping, n.d., Artist's scrapbook, Benson Papers.

3. At the Prince's call from New York, Benson boarded the next train. By seven o'clock the next morning in the improvised studio in a suite at the Vanderbilt Hotel, Benson began painting. By dusk, he was finished. Norman's family treasured this work, for he died when his Nieuport crash-landed on the field at Corcieux.

4. FWB to Mr. Burroughs, director, Detroit Museum of Art, 23 October 1916. Benson file, Detroit Museum of Art.

5. FWB to Charles Woodbury, 7 September 1915, Woodbury Papers.

6. *The Sun* (New York), 21 March 1915.

7. Childe Hassam to J. Alden Weir, 17 March 15, Weir Papers.

8. *New York Tribune,* 19 March 1915.

9. *New York Times Magazine* clipping, n.d., Benson file, Corcoran Gallery of Art.

10. *Boston Evening Transcript,* 6 April 1917.

11. FWB to DH, 19 December 1924. Henderson Papers. Today, a complete set, with original frontispieces, is conservatively valued at twelve thousand dollars.

12. Fishing Diary, 8/9 October 1916, Benson Papers.

13. Ibid., 16 October 1916.

14. John Ordeman, *Frank W. Benson: Master of the Sporting Print,* 77.

15. FWB to Eleanor Benson Lawson, 4 August 1917. Benson Papers.

16. Unidentified newspaper clipping, 18 November 1917. Benson microfilms, Museum of Fine Arts Library, Boston.

17. *Boston Transcript,* November 1917, Benson vertical file. Boston Public Library.

18. *Boston Herald,* n.d. Guild of Boston Artists Papers, Archives of American Art Microfilms. Hereafter abbreviated as Guild Papers.

19. *Boston Evening Transcript,* 5 August 1918.

20. Willard Metcalf to C. Powell Minnigerode, 30 September 1918. Metcalf file, Corcoran Gallery of Art. First cited by Elizabeth de Veer in the original manuscript of her biography of Metcalf.

21. FWB to C. Powell Minnigerode, 29 December 1918. Benson file, Corcoran Gallery of Art.

22. Ibid.

23. *Washington Star,* 9 February 1919, Benson Papers.

24. *New York Tribune,* 19 March 1919. First cited in the original manuscript of Elizabeth de Veer's *Sunlight and Shadow.*

25. C. Powell Minnigerode to FWB, 9 February 1919, Benson Papers.

26. FWB to John Beatty, director, Carnegie Institute, 4 December 1919. Carnegie Papers.

27. FWB to C. Powell Minnigerode, 25 September 1919. Benson file, Corcoran Gallery of Art.

28. Ibid., 15 November 1919.

29. Benson produced more than fifteen known works in this genre and used the simple title *Still Life* for over seven of them. This often leads to confusion and frustration for the scholar who wishes to compile an exhibition record for a certain Benson still life or to list how many still lifes actually exist. Although this work of 1919 can be safely called the beginning of Benson's still-life period, it was not his first work of this sort. He had tried his hand at this genre as early as 1893, perhaps even before. From that date on the title *Still Life* occurs from time to time.

30. I am indebted to the National Gallery of American Art for X-raying its still life and confirming my suspicions that the "lost" work was actually hidden beneath its painting.

31. The stipulations of Ranger's will were that all paintings were to be the property of the National Gallery and the Smithsonian Institution but were to be loaned to various institutions that had a gallery open to the public. The paintings could be called back by them from the receiving institution between ten and fifteen years after the artist's death.

32. *New York Herald Tribune,* 28 November 1926.

33. Unidentified newspaper clipping, 28 May 1922, Museum School scrapbooks. This work was donated to the Museum of Fine Arts, Boston, by a collector who bought it from the family of Benson's tailor, F. L. Dunne. Dunne promised the artist a lifetime supply of suits in return for this striking work; the barter is carefully noted in Benson's books.

34. *Bulletin of the Art Institute of Chicago* 16 (December 1922): 91.

35. *Advice,* 2 January 1943.

36. *New York Times,* 17 December 1919.

37. C. Powell Minnigerode to FWB, 17 December 1920. Benson Papers, Corcoran Gallery of Art.

38. *Washington Sunday Star,* 27 March 1921.

39. FWB as cited in Lawson, *Advice,* August, 1940.

40. FWB to C. Powell Minnigerode, 10 March 1922, Benson file, Corcoran Gallery of Art.

41. *Boston Transcript,* 3 May 1922.

42. *Boston Transcript,* 2 May 1922.

43. FWB to Dudley Murphy, 22 May 1922. Edwin C. Shaw Papers, Archives of American Art Microfilms.

44. FWB to C. Powell Minnigerode, 19 April 1922. Benson file, Corcoran Gallery of Art.

45. Ibid., 3 May 1922.

46. FWB to Robert Macbeth, 11 May 1922. Macbeth Papers, Archives of American Art Microfilms. Hereafter abbreviated as Macbeth Papers.

47. Niece MB, interview with the author, 24 September 1987.
48. FWB to Eleanor Benson Lawson, 31 August 1926.
49. Background information on the Milch Brothers from Elizabeth de-Veer's original manuscript of *Sunlight and Shadow.*
50. *New York Times,* December 1922, Artist's scrapbook.
51. FWB to Elisabeth Benson Rogers, 22 December 1936, Private collection.
52. *The Arts,* Vol. l, no. 1, Dec. 1920.
53. Ibid.
54. Willard Metcalf to FWB, November 1922, Artist's scrapbook.
55. FWB to Albert Milch, 16 March 1925. Milch Papers.

CHAPTER 11

A PORTABLE PALETTE

1. FWB to Edward Duff Balkan, 20 February 1924, Carnegie Papers.
2. FWB to DH, 14 March 1923. Henderson Papers.
3. Ibid., 28 July 1924.
4. *Boston Herald,* 20 November 1923.
5. Unidentified newspaper clipping, n.d., Charles Woodbury's Artist's scrapbook, Private collection.
6. The Robert Dunthorne Gallery in England and the Gordon Dunthorne Gallery of Washington, D.C., which showed Benson's watercolors and etchings in March 1924, may have been owned by the same family. This may even have been the same show, seen in the American gallery in March and then sent to its London branch in May.
7. FWB to DH, 28 July 1924, Henderson Papers.
8. *Christian Science Monitor,* 24 June 1924, Artist's scrapbook. Benson Papers.
9. Sylvia Benson to Albert Milch, 14 July 1927, Milch Papers.
10. FWB to Macbeth Gallery, 31 March and 17 April 1926, Macbeth Papers.
11. *Boston Herald,* 20 November 1923.
12. *Boston Transcript,* n.d., 1923, Guild Papers.
13. FWB to Robert Macbeth, 22 February 1926, Macbeth Papers.
14. Ibid.
15. FWB to Eleanor Benson Lawson, 26 August 1926, Benson Papers.
16. Ibid., *Advice,* 6 January 1930.
17. Eleanor Benson Lawson as remembered by her daughter JA, interview with the author, May 1982.
18. FWB to Eleanor Benson Lawson, *Advice,* 6 January 1930.
19. Ibid.
20. Ibid., 18 July 1944.
21. Unidentified newspaper clipping, n.d. 1928, Guild Papers.
22. FWB to Mrs. McClellan, Secretary, 25 February 1929, Addison Gallery of American Art Archives.
23. Collector JS, interview with the author, September 1986.
24. Granddaughter JA, interview with the author, October 1986.
25. *Boston Globe,* 23 January 1930.
26. *Boston Globe,* 3 March 1930.
27. Nancy Hale, interview with the author, June 1988
28. FWB to Robert Macbeth, 29 April 1930, Macbeth Papers.
29. Minutes, 28 May 1930.
30. Ibid., 15 October 1930.
31. FWB to Albert Kennedy. 20 May 1932, Hale Papers.
32. FWB to Eleanor Benson Lawson, 15 August 1931, Benson Papers.
33. Charles Lemon Morgan as quoted in the *Boston Sunday Post,* 27 September 1931.
34. *Detroit News,* 17 April 1932.
35. *Art News,* 30, no. 10 (7 May 1932).
36. FWB to Robert Macbeth, 17 February 1926, Macbeth Papers, 37. FWB to Albert Milch, 18 October 1933, Milch Papers.
38. Robert Vose, Jr., interview with the author, October 1987.
39. *Art News,* 22 April 1933.
40. Bolton Brown, *My Ten Years in Lithography,* in Tamarind Papers, 5 (Albuquerque: Tamarind Institute, 1982), 49. First cited in Ordeman, *Master of the Sporting Print,* 33.
41. FWB to DH, 3 February 1895. Henderson Papers.
42. Secretary of the Pennsylvania Academy of the Fine Arts to FWB, 9 February 1934. Benson Papers, Pennsylvania Academy of the Fine Arts Archives.
43. FWB to the Secretary of the Pennsylvania Academy of the Fine Arts, 11 February 1934. Benson Papers, Pennsylvania Academy of the Fine Arts Archives.
44. FWB to Homer St. Gaudens, 4 July 1934, Carnegie Papers.
45. Homer St. Gaudens to FWB, 6 July 1934, Carnegie Papers.
46. Homer St. Gaudens to Thomas W. Dewing, 3 December 1935, Carnegie Papers.
47. Homer St. Gaudens to FWB, 4 April 1935, Carnegie Papers.
48. Lucien Price to FWB, 1 December 1934, Artist's scrapbook, Benson Papers.
49. Royal Cortissoz to FWB, 29 August 1942, Artist's scrapbook, Benson Papers.

CHAPTER 12

TWILIGHT

1. *Boston Herald,* 9 June 1935.
2. Unidentified newspaper clipping, n.d. Private collection.
3. Unidentified newspaper clipping, November 1936, Artist's scrapbook, Benson Papers.
4. FWB to Albert Milch, 19 December 1936, Milch Papers.
5. Sylvia P. Benson to Albert Milch, 27 September 1937, Milch Papers.
6. FWB to G. H. Edgell, 25 May 1938. Benson File, Museum of Fine Arts Archives.
7. G. H. Edgell to FWB, 20 May 1938. Benson file, Museum of Fine Arts Archives.
8. Log, 1938.
9. Unidentified clipping, n.d. 1938. Benson microfilms, Museum of Fine Arts Library.
10. FWB to Arthur Heintzelman, 20 June 1940. Benson file, Print Department, Boston Public Library.
11. FWB to the Smithsonian Institution, September 1939. Tarbell file, National Museum of American Art Archives.
12. *Boston Herald,* 7 June 1940.
13. Samuel Chamberlain, *Etched in Sunlight* (Boston, 1968): 108–110.
14. Unidentified newspaper clipping, n.d. (believed to be 4 July 1948), private collection.
15. *Boston Sunday Herald,* 9 June 1935.
16. FWB to Eleanor Benson Lawson, 3 September 1933, Benson Papers.
17. *New York Herald Tribune,* 19 October 1941.
18. FWB to Eleanor Benson Lawson, 9 July 1941.
19. *Christian Science Monitor,* Magazine Section, 5 July 1941.
20. Unidentified newspaper clipping, Guild Papers.
21. *Boston Sunday Post,* n.d.,Artist's scrapbook, Benson Papers.
22. The Boston Public Library has the only complete collection of Benson's work in etching (one or more of each print together with sketches and trial proofs). Benson donated his own collection which was augmented by that of Albert Wiggins. Dr. Hugh Williams, a Boston surgeon, willed his nearly complete collection of Benson etchings to the Library of Congress. As was Benson's intention when he donated his etchings, the collections at both libraries have been extensively used by scholars.
23. FWB to Arthur Heintzelman, 1 September 1943. Benson file, Print Department, Boston Public Library.
24. Arthur Heintzelman, *The Etchings of Frank W. Benson* (Boston: Albert H. Wiggins Gallery, Boston Public Library, 1943).
25. FWB to John Benson, 22 March 1947, Benson Papers.
26. *Worcester Evening Gazette,* n.d., Artist's scrapbook, Benson Papers.
27. *Boston Herald,* 18 November 1944.
28. FWB to JLS, 5 March 1945, Smith Papers.
29. John Taylor Arms, Address given at the Annual Induction of New Members, American Academy of Arts and Letters 19 May 1945, American Academy of Arts and Letters Archives.
30. FWB to John Benson, 22 March 1947, Benson Papers.
31. Eleanor Benson Lawson to Joan Lawson Andrews, 18 November 1951. Private collection.
32. FWB to Eleanor Benson Lawson, 4 August 1917, Benson Papers.
33. FWB as quoted in Stahl, *Beatrice Whitney Van Ness.*
34. FWB to JLS, 5 March, 1945, Smith Papers.

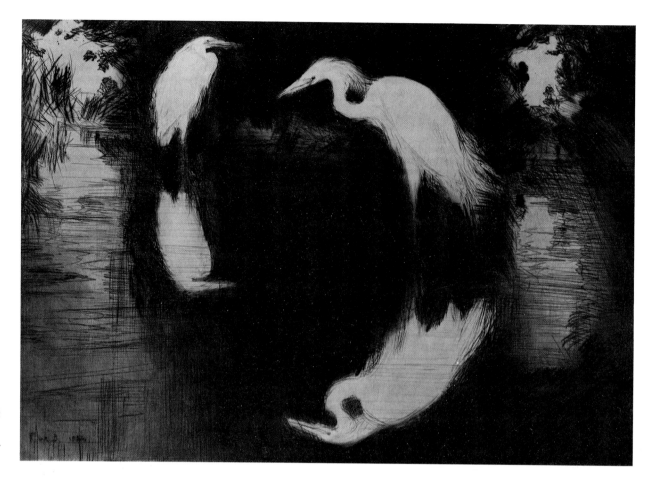

PLATE 147
Dark Pool. *Drypoint on paper, 8 × 11⅞".*
Paff no. 189, ed. 150.
Private collection.

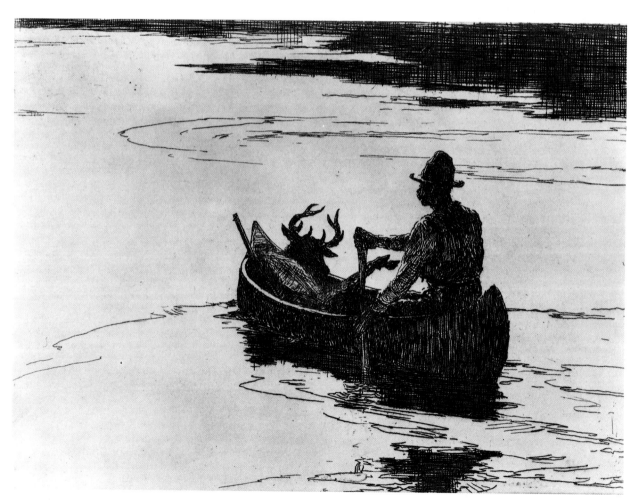

PLATE 148
Deer Hunter.
Etching on paper,
7⅞ × 10⅞".
Paff no. 229, ed. 150.
Private collection.

BIBLIOGRAPHY

In addition to those sources mentioned in the Notes, the following is a selected list of additional sources pertaining to Benson's life and work and to the art of his time:

BOOKS

Boime, Albert. *The Academy & French Painting in the 19th Century*. New York and Oxford: Phaidon Publishers, 1971.

Caffin, Charles H. *American Masters of Painting*. New York: Doubleday and Company, 1902.

——. *The Story of American Painting*. New York: Frederick A. Stokes Company, 1907.

Chamberlain, Samuel. *A Stroll Through Historic Salem*. New York: Hastings House Publishers, 1969.

Gammell, R. H. Ives. *The Boston Painters, 1900–1930*. Edited by Elizabeth Ives Hunter. Orleans, Mass.: Parnassus Imprints, 1986.

Garland, Hamlin, with Lorado Taft and Charles Francis Browne. "A Critical Triumvirate." In *Impressions on Impressionism*. Chicago: Central Art Association, 1894.

Gerdts, William H. *American Impressionism*. New York: Abbeville Press, 1984.

Hartmann, Sadakichi. *A History of American Art*. Vol. 1. Boston: L. C. Page, 1902.

Heintzelman, Arthur. *The Etchings and Drypoints by Frank W. Benson*. Vol. 5. New York: Houghton Mifflin Company, 1959.

Isham, Samuel. *History of American Painting*. New York: Macmillan Company, 1905.

Morgan, Charles Lemon. *American Etchers: Frank W. Benson, N.A.* New York: The Crafton Collection; London: P. & D. Colnaghi and Company, 1931.

Novak, Barbara. *American Painting of the Nineteenth Century: Realism, Idealism and the American Experience*. New York: Praeger Publishers, 1961.

Paff, Adam E. M. *The Etchings and Drypoints by Frank W. Benson*. 4 vols. Boston and New York: Houghton Mifflin Company, 1917. Vol. 2, 1919. Vol. 3, 1922. Vol. 4, 1929.

Robotti, Frances. *Chronicles of Old Salem*. New York: Bonanza Books, 1948.

Salaman, Malcolm M. *Modern Masters of Etching*. Vol. 6, *Frank W. Benson*. London: The Studio, 1925.

Smalls, Herbert. *Handbook of the New Library of Congress: Essays by Charles Caffin*. Boston: Curtins and Cameron, 1899.

CATALOGUES

Bedford, Faith Andrews, Bruce Chambers, and Susan Faxon. *Frank W. Benson: A Retrospective*. New York: Berry-Hill Galleries, 1989.

Dodge, Ernest S. *Exhibition of Paintings, Drawings and Prints by Frank W. Benson, 1862–1951*. Rockland, Maine: William A. Farnsworth Library and Art Museum, 1973.

Faxon, Susan. *Two American Impressionists: Frank W. Benson and Edmund C. Tarbell*. Durham, N.H.: University Art Galleries, University of New Hampshire, 1979.

Heintzelman, Arthur. *Memorial Exhibition, Frank W. Benson, 1862–1951*. Boston: Albert H. Wiggin Gallery, Boston Public Library, 1952.

Price, Lucien, and Frederick W. Coburn. *Frank W. Benson, Edmund C. Tarbell: Exhibition of Paintings, Drawings and Prints*. Boston: Museum of Fine Arts, 1938.

Price, Lucien. *Memorial Exhibition of Paintings and Water Colors by Frank W. Benson, 1862–1951*. Boston: Guild of Boston Artists and Print Department of the Boston Public Library, 1953.

——. *Frank W. Benson, 1862–1951*. Salem, Mass.: Essex Institute and Peabody Museum, 1956.

Sellin, David. *Americans in Brittany and Normandy: 1860–1910*. Phoenix: Phoenix Art Museum, 1982.

INDEX